Shooting Women

Shooting Women
Behind the Camera, Around the World

Harriet Margolis, Alexis Krasilovsky, and Julia Stein

intellect Bristol, UK / Chicago, USA

First published in the UK in 2015 by
Intellect, The Mill, Parnall Road, Fishponds, Bristol, BS16 3JG, UK

First published in the USA in 2015 by
Intellect, The University of Chicago Press, 1427 E. 60th Street,
Chicago, IL 60637, USA

A catalogue record for this book is available from the
British Library.

Copy-editor: Megan Jones
Cover designer: Holly Rose
Production managers: Heather Gibson and Steve Harries
Typesetting: Contentra Technologies

Print ISBN: 978-1-78320-506-6
ePDF ISBN: 978-1-78320-507-3
ePub ISBN: 978-1-78320-508-0

Printed and bound by Short Run Press Ltd, UK

Table of Contents

Acknowledgments

We thank all the women and men from around the world who have contributed in so many ways to this book—above all, to the camerawomen who have given their interviews, with special thanks to Kristin Glover for information about how unions really work and to Jendra Jarnagin for current information about digital camera technology and its implications for future camerawomen.

Our thanks go to those whose support was fundamental to the making of the global documentary film *Women Behind the Camera*: our Executive Producer and Associate Producer, Vanessa H. Smith; Associate Producer, Reseda Mickey; Editor, Katey Bright; Carole Dean, President of From the Heart Productions, Inc.; Diana Barrett for The Fledgling Fund; California NOW Foundation; the Roy W. Dean Video Award; Walden Trust; the Women in Film Foundation Film Finishing Fund; and the Office of Research and Sponsored Projects, California State University, Northridge.

We also thank all the unit producers, unit directors, cinematographers, and sound personnel who have helped to capture these interviews, as well as all the people who have helped to make these interviews possible, including those who have answered questions, technical and personal, to make the interviews mean just that bit more.

We thank all the people who have worked with these interviews over the years, researching, recording, transcribing, translating, and editing them. We are grateful to the Mike Curb College of Arts, Media and Communication, California State University, Northridge, as well as to Nancy Hendrickson, screenwriter/actor/director/teacher, for their financial support at a late stage of preparing the manuscript for publication.

We also acknowledge all those who offered childcare and other sustaining help that made our work possible. We are immensely grateful to everyone who helped bring this global project to fruition.

Authors' note: Unless otherwise indicated, quotations from camerawomen come from the interviews conducted for *Women Behind the Camera* and more recently for this book. Longer quotations from those interviews appear in italics. For production details of those interviews, see pages 297–314.

Prefaces

From Alexis Krasilovsky

I was excited by the prospect of being a pioneer in pursuing a feminist vision when I managed to become a camerawoman in the NABET (National Association of Broadcast Employees and Technicians) union locals of New York and Los Angeles, but I lacked the perseverance to fight for that career. When, in the mid-1980s, I joined Behind the Lens: An Association of Professional Camerawomen (BTL), I was amazed at the tenacity and courage as well as talent of those camerawomen who were succeeding. I decided their stories had to be told.

That led to *Women Behind the Camera: Conversations with Camerawomen* (Praeger: Westport, 1997), a book focused on the challenges of camerawomen in Hollywood, New York, and San Francisco. There you can find chapters on Liz Bailey, Sandy Butler, Jo Carson, Kristin Glover, Amy Halpern, Leslie Hill, Judy Irola, ASC, Estelle Kirsh, Laurel Klick, Geraldine Kudaka, Madelyn Most, Brianne Murphy, ASC, Emiko Omori, Nancy Schreiber, ASC, Alicia Sehring, Lisa Seidenberg, Sabrina Simmons, Sandi Sissel, ASC, Dyanna Taylor, Susan Walsh, and Juliana Wang.

Through BTL I had heard stories that maybe camerawomen in Paris were having an easier time of it. I kept hearing new names, increasingly from different countries. One book was clearly not enough. When it came time to make the film version of *Women Behind the Camera*, also entitled *Women Behind the Camera*,[1] I decided to go international. By emphasizing the extraordinary achievements of camerawomen around the world and, for example, comparing the experiences of camerawomen in the film industries of India and France, I thought we could pressure Hollywood to change its patterns of discrimination for the better.

I went to India for an interview with B. R. Vijayalakshmi, who had already shot twenty feature films as Asia's first female Director of Photography (DP) for feature films. Going to India revolutionized my concept for the film. In Ahmedabad, Unit Director Tavishi Alagh introduced me to Ela Bhatt, the director of SEWA (Self-Employed Women's Association)—a large nongovernmental organization that works on behalf of women laborers in India, 94% of whom have toiled as part of an unorganized labor force. SEWA has its own media group, Video SEWA, with its own training program. Video SEWA camerawomen were able to

help the rural Indian villages of Kutch "survive an earthquake that killed 20,000, followed by an extreme drought, by influencing policymakers with their digital video footage" (Williams 27).

That is when I realized that this project was much bigger than me. Beyond directing a documentary, I was serving as a facilitator across boundaries for women—and filmmakers— to connect globally. My Associate Producers, Unit Producers, Unit Directors, and I soon found ourselves with historic footage by China's first camerawomen of Mao's travels throughout China, a camerawoman's footage of the fall of the Soviet Union, and an interview with Rozette Ghadery, Iran's first female DP.[2]

With grants from the Office of Research and Sponsored Projects at California State University, Northridge, the Women in Film Finishing Fund, and the Fledgling Fund, along with a generous contribution from Executive Producer Vanessa Smith, a Roy W. Dean Award, and whatever I could spare out of my teaching salary, we were able to complete the film in 2007—seven years after starting production and 25 years after I first became passionate about the idea of getting camerawomen's stories and visions out into the world.

But the inquiries and interviews kept coming, introducing additional camerawomen from Australia, Indonesia, New Zealand, Poland, and Africa. The film version of *Women Behind the Camera* covers more and different material from that found in the book version of *Women Behind the Camera*, and we have approached this second book, *Shooting Women*, with a different objective yet again. While the words of our interviewees are at the forefront of this book, we have not focused on the individual women represented here as individuals. Instead, we have looked through all their words to find an introduction to what it has meant and continues to mean to be a camerawoman. From individual stories we have tried to make a comprehensive picture that, first, suggests the international possibilities shaped by local circumstances, and, second, the professional possibilities illustrated by the different professional activities in which our interviewees have engaged. Because this is a book rather than a film, we have been able to present a longer, more inclusive, and hence more comprehensive overview of what camerawomen have to say to us.

Our list of interviewees does not purport to be all-inclusive; happily, there are ever increasing numbers of women shooting material for viewing via the increasing number of platforms for screen material. The missing whom we know of include camerawomen such as Bonnie Blake, Cira Felina Bolla, Linda Brown, Sandra Chandler, Anette Haellmigk, Polly Morgan, and Lisa Wiegand in Los Angeles; Alice Brooks, Reed Morano, and Christina Voros in New York; Sally Bongers and Mandy Walker in Australia; Daniela Knapp in Austria; Roberta Allegrini and Francesca Amitrano in Italy; and Pooja Sharma, Anjuly Shukla, and Savita Singh in India; and others. Also missing are the currently unknown young women around the world who have started shooting their first documentaries, music videos, experimental films, webisodes, other Internet content, etc. Although we had no hope of keeping track of each newcomer, we have benefited from being inclusive about the different types of camerawomen whom we have included. We hope that our book opens a field of research to others who will continue this work.

From approximately 1,800 pages of transcripts from interviews with camerawomen around the world, Harriet Margolis, Julia Stein, and I have noted the many major accomplishments and awards that camerawomen have to their credit. For example, Sandi Sissel, ASC, acknowledges that filming *Salaam Bombay!* (Mira Nair; 1988) "changed my career. I got a lot of work based on the fact that it was nominated for an Oscar and won a prize at Cannes. I went from being an operator to being a DP." Vijayalakshmi received the Cine Techs Association Award and the Cinema Experts Award for Excellence in Photography in 1995, among other awards. In France, Agnès Godard won a César for *Beau Travail* (Claire Denis; 1999). In the United States, Emiko Omori received the Sundance Film Festival's Best Documentary Cinematography Award twice: once for her own film, *Rabbit in the Moon* (1999), where she filmed her older sister and other Japanese Americans about their experiences in World War II concentration camps, and another for *Regret to Inform* (Barbara Sonneborn; 1998), about Vietnam War widows on both sides of the conflict. Ellen Kuras, ASC, has won the Sundance Film Festival's Best Dramatic Cinematography Award an unprecedented three times.

Recognition has also come to camerawomen in the form of membership in professional organizations of their peers. Among cinematographers, it is a sign of prestige to merit using the initials ASC (American Society of Cinematographers) after one's name. In 1980 Brianne Murphy became the first woman invited to join the ASC, and "for fifteen years, Murphy was the only female member of the society" (McLellan). Current members include Sandi Sissel, Joan Churchill, Nancy Schreiber, Judy Irola, Amy Vincent, Ellen Kuras, Cynthia Pusheck, Tami Reiker, Mandy Walker, Anna Foerster, Lisa Wiegand, and Reed Morano. When the ASC admitted its first member "who works exclusively in animated films," Jendra Jarnagin told us, it invited a woman, Sharon Calahan, whose credits include Director of Photography on *Finding Nemo* (Andrew Standton; 2003), *Toy Story 2* (John Lasseter; 1999), and *A Bug's Life* (John Lasseter; 1998) as well as "Director of Photography: Lighting" on *Ratatouille* (Brad Bird; 2007) and "Lighting Supervisor" on *Toy Story* (John Lasseter; 1995).

Jan Kenny became the first Australian camerawoman to have ACS—the Australian equivalent of ASC—after her name. Some women have been president of their national cinema societies: Joan Hutton, CSC, served as the first female president of the Canadian Society of Cinematographers; Sue Gibson, BSC, was the first female president of the British Society of Cinematographers; and Inês Carvalho, AIP, was the first female president of the Portuguese Society of Cinematographers. Several American camerawomen have served as president of the executive boards of their unions as well.

Throughout this book, it has been clear that one reason these women have done well is their delight in the technological details of their profession, from their use of technical language to their ease in handling their gear. To be successful DPs they need other skills, especially managerial and people skills. However, without mastery of their craft, these women would not be cinematographers. One constant theme in this book is the need not only to master one's craft but to remain abreast of changes in that craft's technology. For many of our interviewees, e.g., Liz Ziegler, Lisa Seidenberg, and Jendra Jarnagin, being early adopters of new technology has played a large role in getting them work in the industry.

Every couple of years, it seems, another article comes out about some very special camerawomen who have broken all the boundaries, winning top awards, climbing mountains, or fighting in war zones. With such honors and achievements, it seems like we can breathe a sigh of relief: All problems blocking equality for camerawomen have been solved. Yet Martha Lauzen's annual reports show that the percentage of women working as DPs on the 250 top-grossing Hollywood films has varied from only 2-5% ("Celluloid Ceiling" reports for 2009-15).[3] When Sue Gibson was president of the BSC, out of 100 DPs there were only three women.

In Austria, Astrid Heubrandtner reports that, out of 100 members of the Austrian Association of Cinematography, there were also only three women members. She recalls when the word "cameramen" was always used at AAC meetings. "Once I took the opportunity to say, loudly, '-women' and '-woman.'" At first her interruptions just irritated other members, but eventually "they started to say 'people behind the camera.' Usage became either neutral or both genders were used. That's important."

Yet names and labels aren't everything. To achieve numerical parity between women and men working behind the camera, we will need more producers to agree to look at camerawomen's reels, and to hire more women based on talent and ability "rather than on whether they've been buddies or recommended by guys who only think of guys for hiring lists" (Williams 26). In recent years, the Los Angeles-based Alliance of Women Directors has maintained a "HotShots" list of highly recommended crewmembers, including female cinematographers, camera operators, assistants, and a loader. However, the dismal statistics for women working in the film and television industries, as recorded by Lauzen's "Celluloid

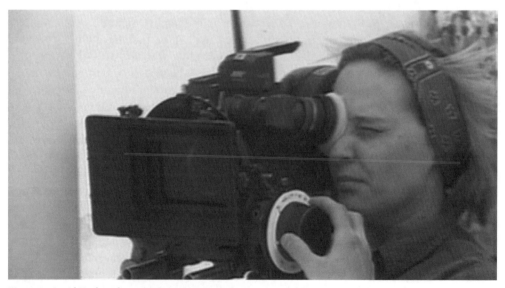

Figure 1: Astrid Heubrandtner, AAC. Austria.

Ceiling" reports, show "that the industry will not change of its own accord" and that it can't "be embarrassed into change (regarding gender)" (Silverstein, "The Celluloid Ceiling"). This book originated out of my desire to fight that status quo and came to fruition due to the tireless efforts of Harriet Margolis, with the additional help of Julia Stein.

Chapter 1 (How do women become camerawomen?) outlines traditional and nontraditional ways for beginners to learn the basic skills of the profession; it also demonstrates that women have benefited when training programs, workshops, and mentoring opportunities have been available. Chapter 2 (How hard can it be?) explores how, despite obstacles such as gender discrimination, sabotage, and sexual harassment, camerawomen have made their way into the industry and risen through the ranks. Chapter 3 (Documentary: A good and satisfying career choice that is statistically friendlier to women than feature fiction filmmaking) highlights a genre that has provided an entry point for many women filmmakers, from pioneering camerawomen in China through video journalists capturing current history to women who have enjoyed the personal and creative challenges that the genre often offers. Chapter 4 (Hollywood, Bollywood, independents, and short forms) looks at how filmmaking is affected by whether it is produced by and for mainstream audiences, from Hollywood and Bollywood films to news, music videos, avant-garde films, and videobirths. Chapter 5 (Special skills and creativity) covers the diversity of camerawomen's technical work, ranging from traditional 35mm camerawork in France, Hollywood, and Iran to helicopter camerawork in Austria and Asia, and underwater camerawork and handheld camerawork around the world. Personal experiences of shooting fill Chapter 6 (Shooting around the world), Chapter 7 (Can camerawomen also be women?) explores how the professional affects the personal, and how the individual copes, through considering such things as family support and childcare, and Chapter 8 (What's it really like?) provides details of a working day, from the hours of work to how gender issues associated with working with male crews and directors affect dress, language, and behavior as women try to adapt to working in a male environment. Chapter 9 (Magic moments, worst moments) presents some of the best and worst experiences women have had behind the camera, raising questions of personal and employer responsibility for safety. Chapter 10 (What do camerawomen see?) starts with some considerations of how women and men look as well as some opinions about differences in what they see. This leads to a discussion of ethics and, again, responsibility, which so many of our interviewees mention. We then look to the future, for aspirations, for some final advice for young women who want to be camerawomen, and for a summary of strategies to improve Lauzen's statistics suggested by our interviewees' experiences.

We do not need to be reminded that talented women abound; every year, more and more female film students graduate from film schools with award-winning films, only to find little or no employment opportunities compared to their male counterparts. Those who work in film and television in the United States work in some of the world's "most minority-free industries" (Goldstein).

What will it take to change discriminatory employment patterns in the film and television industries, "making sure that all of our stories are told" (Hunt, "Rewriting" 42)? Recommendations

and goodwill? No, doesn't work. Endless statistical studies? Investigative journalism? Naming names? Better access to childcare and birth control? Governmental pressure?

The ACLU (American Civil Liberties Union) is currently collecting evidence of discrimination against women directors. As we shall see, some camerawomen (Geraldine Kudaka and Jessie Maple Patton) have successfully sued (and Heather MacKenzie successfully threatened to sue) to end discriminatory practices. However, on 28 February 2011, the US Department of Labor turned down an appeal against discriminatory practices in the IA 600 election on the grounds that without Local 600-provided statistics on race, gender, and age discrimination—which the union refused to collect—there is no case. Yet the US House of Representatives passed legislation entitled "Fulfilling the potential of women in academic science and engineering," which would require "the White House science adviser to oversee regular 'workshops to enhance gender equity' [...] to be attended by researchers who receive federal money and by the heads of science and engineering departments at universities" (Tierney).

Since goodwill and raw talent are rarely enough, what else might work to combat sex discrimination? More women's film festivals? Cable television channels focusing on women's visions? Class action suits to withhold FCC license renewals until discrimination ends? Women's visions going viral on YouTube? Australian actress Cate Blanchett appealing to the American Academy of Motion Picture Arts and Sciences for change while accepting her Oscar in 2014 (Silverstein, "The World Is Round")?

I'm crying out to the international community to understand the enormous challenges that camerawomen have faced around the globe, making strides in an unequal industry. This book exists to celebrate their talents and achievements and to empower more women in following their own visions, wherever they are in the world.

Alexis Krasilovsky
Los Angeles, California
January 2015

From Harriet Margolis

My involvement with this project began in the early 1990s, when I called for contributions to a special topic issue of an American journal published by one of the organizations associated with university-level film studies. Alexis was alone in responding with a piece that fitted what I was after: considerations of women working as part of the production crew. She sent an interview with Leslie Hill, one of the women cinematographers included in Alexis' first book that, unlike this one, restricted itself to North American women. Although the special topic issue was never published, I edited *Women Behind the Camera* at Alexis' request because her publisher required significant cuts.

Because by then I had moved to New Zealand to teach, Alexis' first request for my help with *Women Behind the Camera* (the film) was to find New Zealand-born CNN news

camerawoman Margaret Moth and get an interview, which I failed to do. In New Zealand, few people remembered hearing of her. Even friends connected with filmmaking in New Zealand who had deep family roots from where Moth grew up could not put me in touch with her, although they vaguely remembered that Moth was not her original name.

Early this century I did manage to organize an interview with New Zealand's senior camerawoman, Mairi Gunn, although coordinating between Wellington (where I live) and Auckland (where Mairi lives) as well as between PAL (the video format used in New Zealand) and NTSC (the format used in the United States) had delayed us. Yet that was nothing quite like the more than a year that it took Unit Producer Setara Delawari to organize a safe, clandestine location for an interview with Mary Ayubi and other Afghan camerawomen.

I also sent questionnaires to some former students and fellow WIFT members throughout New Zealand and scattered overseas, wanting to hear from a young, sometimes newly minted generation of camerawomen. Since then young Kiwi[4] Rachael James has finished film school in London and joined the others in her journey as a woman behind the camera. Shortly before publication, American Jendra Jarnagin has also provided us with answers to a questionnaire, this time specifically about digital camera technology and its impact.

Much earlier, like American Lisa Seidenberg, I took up a camera provided by the local access TV station in the university town where I was a graduate student, and like Ellen Kuras (another American), I studied on the Paris Film Program, learning from film theorists such as Christian Metz and Jacqueline Rose. Since my mother, who was not allowed to pursue her education, made it clear that she would rather I have a "Ph.D." than a "Mrs.," I completed degrees in comparative literature (where film studies often was located academically at that time). It never occurred to me that I could make a living off camerawork. Unfortunately, it also never occurred to me that learning to use a camera plus experience in film production would enhance my marketability as an academic.

So I appreciate the New Zealanders who noticed the successes of fellow Kiwis Jane Campion (*The Piano*; 1993), Lee Tamahori (*Once Were Warriors*; 1994), and Peter Jackson (*Heavenly Creatures*; 1994) on the world stage and said, "Look at what they've done!" I have encouraged students whose attitude has been, "Why not me?" I admire their confidence that they too can walk along that path. Kiwi women, in particular, have had good role models among Kiwi producers, directors, and even camerawomen, perhaps because, although sexism exists here as elsewhere, this is also the first country to entitle women to vote at all political levels. In a geographical environment that has historically required women as well as men to be practical and self-sufficient, and for women and men to work side-by-side, it is unsurprising that some of that confidence in one's ability to master challenges—technological and personal—remains in the attitude of New Zealand's young women. Practicing camerawomen from around the world have told us that both self-confidence and ease working among men are necessary to succeed in the screen industries.

As practicing camerawomen acknowledge, the importance of role models for would-be camerawomen cannot be overlooked. Time after time in the early days of women's studies and feminist film studies, we realized that there were role models almost everywhere we

looked, even when it wasn't easy to find them. When history moves on and forgets the past, it takes an extra effort to rediscover what was considered too unimportant to record. While we have tried through this book to help newcomers find their way as professional camerawomen and –men, we are sure that the history we provide here has its own value.

Alexis and I, having worked on this project over the last three decades, obviously think that the women discussed in this book are important. We are both products of Second Wave Feminism as it developed from the 1960s on in the United States. We have a deep concern for the representation of women and for women's rights in the workplace. From our different professional experiences, we have come to see the involvement of women in camera crews as an issue worth years of our working lives.

This opinion rests first of all on the importance of images, which is even greater than it was in the 1960s. Second, because there is a fundamental sense that one can't have pictures without a camera and a camera operator, we are concerned to see more women producing the media images around us. Although digital technology may soon fundamentally alter what we understand by "a camera and a camera operator," we still want to see women involved in the production of media images around us. It may well be that the physical skills so many camerawomen have enjoyed developing and using may no longer be needed, but the requirement for the same or similar technical and intellectual skills will remain. In the pages that follow, many camerawomen together will be illustrating why no one group of people should dominate the media. The production and distribution of images has gone through several major changes since the inception of motion pictures, but issues about minorities' access to the control of images remain unresolved. That so few women work within the US screen industries that they can be considered a minority (along with, for instance, people of color) has itself been noted as an absurdity by our interviewees.

In the end, although this book is many things, it is neither a report on work relations nor a work of feminist film theory. On the basis of what camerawomen say, we reach some analytical conclusions throughout the book as well as at the end, when we sum up what this history has taught us about strategic options available to increase women's role in the media behind the camera. Along with a history of women's involvement in camerawork, we provide information on how the professional camerawomen got to be where they are and what advice they have for women who would like to work professionally behind the camera.

An important factor has been the technology involved, and our interviewees have had much to say about it. One thing we have learned is that women are not necessarily afraid of technology; in fact, many of our interviewees love the technology and some have pioneered its use and development. It may be that, with technological changes to come, some of the history recounted here will soon no longer be practically relevant. We think it is more likely to be the case, as many interviewees attest, that camerawomen will keep adapting to new technological circumstances very well, often becoming pioneers because they were early adopters. As pioneering American camerawoman and director Emiko Omori told us, though, being a pioneer is a lonely experience. We are hoping for a time when women will

not be the exceptions working behind the camera, and we don't think that technology has ever been nor ever will be an impossible obstacle.

The issues the camerawomen's interviews raise are usually practical, sometimes aesthetic, and occasionally theoretical. One reason we organized our material thematically instead of sequentially (one complete interview after another) was that we listened to the interviewees' voices. Although there were some questions used as a very basic guideline, and the questionnaires were standardized, we in no way restricted our interviewees from choosing to talk about things that mattered to them. Working inductively through a large and diverse body of material from women of different ages, social class, religious and ethnic backgrounds, and experiences within and outside the screen industries, we unexpectedly realized, for example, that we needed a section devoted to what camerawomen wear, because many of them talked about their personal dress code. Since they also talked about adjustments in their behavior when working with largely male crews, we also needed a section on "immasculation," entitled "Acting like men to fit in." Ultimately, we discovered that we could present an introduction to camerawork that is practical in nature and that simultaneously is an introductory history of the film industry. It is based not on the life of any one camerawoman located at any one place or time, but on the outline of a collective figure, "a camerawoman." Beginning with Chapter 6, where we present a collection of anecdotes by several interviewees about specific filmmaking experiences, we turn from shaping a general history to appreciating individual, personal issues. From here on, our discussion grows less practical and historical toward a more theoretical and speculative consideration of the future for women's involvement in camerawork.

The decade in which Brianne Murphy was no longer the sole woman on a Hollywood camera crew coincided with the rise of Second Wave Feminism in the United States. In the United Kingdom, this was a time for theorizing—and feminist film theory, as a body of work, arose there and then. In the United States, feminism in the 1960s and 1970s tended to be pragmatic, more inclined to social activism than intellectualizing about the issues. Although there were many women working in art and experimental film, often associated with film components of art schools, the need for visual material responding to the National Organization for Women's (NOW) call for nonsexist images of women led to an explosion of sociological and historical documentary material consciously produced for women by women. Examples of such films include Martha Coolidge's *Not a Pretty Picture* (1976) and Connie Field's *The Life and Times of Rosie the Riveter* (1980).

Not a Pretty Picture, neither a straightforward documentary nor entirely an "art film," is based on Coolidge's own experience of date rape. It lacks the production values[5] of well-funded commercially or institutionally backed films, but it worked well for the consciousness-raising discussions of the day, where content mattered more than production values. That different emphasis, along with the availability of what was the cheaper and lighter technology of its day, gave many women the opportunity to try—to make films that expressed their concerns, to learn how (or not) to work together on a project requiring teamwork, but mainly to use the equipment and gain skills.

Coolidge, an art school graduate, has had a successful career directing films and TV episodes for mainstream America, including serving as the first female president of the Directors Guild of America in 2002-03. However, having made her name with a film about young women and sexuality, Coolidge has often found herself frustrated by the limits on material—usually light comedies about teens and/or sexuality—that she has been asked to direct. As the camerawomen tell us about their efforts to move up within their profession, once one is associated with a particular sort of work, it's hard to get people to recognize one's other capabilities.

Part of our passion for this project comes from knowing that discrimination experienced by the pioneers continues, but learning that sometimes progress comes where Western women might least expect it. We learned that in both Turkey (Berke Baş) and India (Sabeena Gadihoke) women are making documentaries about women's issues and teaching their countrywomen to do the same. In India, we also learned, there are women (often well-educated and from elite families) at one end of the spectrum who work in the Indian film industries (Bollywood, etc.) and women at the other end, such as Leelaben Paben, an illiterate former market vendor whose documentaries have brought about positive social change where she lives. The very fact that women in Afghanistan and Iran have taken up cameras is likely to surprise Western women, bombarded as we are with stereotypical images of Muslim women as unable to have a professional life.

We have constantly been surprised by the generosity of the diverse women who have gifted us their stories. If there is an incomplete quality to our selection of interviewees, it's not for lack of trying on our part. For example, we had already included interview material from Israeli camerawomen when the possibility of including interviews with one or more Palestinian camerawomen arose, only to disappear when they declined to be involved in a project that included Israelis. We regretted their choice, but were glad to hear from Palestinian Fida Qishta, much of whose work has taken the form of video journalism and documentaries about Palestine. While we regret all the omissions that might be noted, we hope there will be readers concerned enough about them to produce their own, even more inclusive history of camerawomen.

Early in my professional career I wanted to prove that networking helps women get where we want to go. I read back issues of *Variety* from its inception well over a century ago up to the development of Hollywood studios, looking for references to women producers and directors; they were there, even if the women were not always credited on the films themselves. For decades I have been an avid reader of film credits; these days I find women credited in pretty much all categories. Of course, over the years the credits have gotten longer—which is good, because women are most likely to be in the lower ranks of camera crew, so the credits need to be comprehensive for them to get mentioned.

Things have definitely changed, just not enough. For some years we have had Martha Lauzen's studies of the film and television industries to provide us with statistical proof of gender bias along with social media activists such as Melissa Silverstein and her "Women and Hollywood" blog or Lore Haroutounian's blog based on her experience as a camerawoman[6] to bring these and other indicators of discrimination to the world's attention.

The most obvious changes in the screen industries at the moment follow the shift to digital production and the availability of digital cameras, opening up broadcast quality filmmaking to an ever wider population. However, experience making one's own films from home does not necessarily qualify a person as a cinematographer. The punch line to a story Jarnagin has about a director finding a DP from the latter's work online is that the DP "had shot everything himself on a DSLR with no crew. He knew NOTHING about film set dynamics, schedules, working with a crew, how to communicate, etc." Furthermore, even if almost everyone can own a device that captures moving images, as Jarnagin says, "A camera is just a tool, and cinematography is the art." In addition to technical skills, there is also understanding how to look—and listen—for ways to convey meaning to suit a purpose, and understanding how to work with the other people involved in producing and distributing that end result. As Lucas writes in a chapter on cinematography in the new millennium, "troubling questions remain for the future of cinematography as an art form and a profession" (133). We believe that women should be involved in providing the answers for that future.

Apart from being role models simply because they have been there, our interviewees are role models because they have experience from which we can continue to learn. In the end, often despite the horrible experiences many of them have been through, these women can still talk of the joy and pleasure, the satisfaction, they get from working behind the camera. And they encourage anyone with a similar passion to pursue the goal.

<div align="right">Harriet Margolis
Wellington, New Zealand
December 2014</div>

Notes

1 *Women Behind the Camera* appeared in 2007, with a running time of 90 min. In 2008 *Shooting Women* appeared, with a running time of 54 min. Cut with a TV audience and TV format restrictions in mind, *Shooting Women* nonetheless includes new material, since an interview with Margaret Moth had finally become available. This shorter version has aired in Spain, Brazil, and Israel. Women Make Movies, a major distributor of films by women for women, carries *Shooting Women* on its list. The common thread in Women Make Movies' films is their expression of a feminist perspective, whatever their subject—and their subject often is itself in some way a feminist issue, or connected to one. Women Make Movies distributes films anywhere on the spectrum from most experimental to most factual. If Women Make Movies were distributing Hollywood films, they would pass the Bechdel Test (see page 294).

2 Mania Akbari, another Iranian woman, is best known for the documentaries she has directed, but she worked first as a cinematographer on documentaries ("Mania Akbari").

3 Lauzen is the Executive Director of the Center for the Study of Women in Television and Film at San Diego State University. Her annual statistical reports on employment and

representation of women in film and television, which began in 1998, are widely cited by the popular media as well as academics. In 2004 Geena Davis founded the Geena Davis Institute on Gender in Media, which produces educational programs, research reports, and biennial symposia with similar goals to change employment and representation statistics for women and girls; it differs from Lauzen's work in its goal "to spotlight gender inequalities at every media and entertainment company," reflecting its position "within the media and entertainment industry" ("About Us").

4 "Kiwi" is recognized around the United Kingdom and Commonwealth nations as a nickname for New Zealanders.

5 Discussing the "connotations" of "film technologies," Keating writes, "For instance, cranes, high-powered lamps, and Panavision lenses might connote 'big-screen production value,' and the concomitant sense that crew members are there to allow these expensive machines to do their work" (4).

6 Http://ishouldwritethisdown.blogspot.co.nz/2007/12/about-me.html.

List of abbreviations

AC	Assistant Camera
ACS	Australian Cinematographers Society
AFC	French Association of Cinematographers
AFI	American Film Institute
AFTRS	Australian Film Television and Radio School
ASC	American Society of Cinematographers
BECTU	Broadcasting, Entertainment, Cinematograph and Theatre Union
BBC	British Broadcasting Corporation
BSC	British Society of Cinematographers
BTL	Behind the Lens: An Association of Professional Camerawomen
CG/CGI	Computer-generated imagery
CSC	Canadian Society of Cinematographers
DGA	Directors Guild of America
DI	Digital intermediate
DP/DOP/DoP	Director of Photography
DSLR	Digital Single-Lens Reflex Camera
ENG	Electronic News Gathering, e.g., video
FTI	Film and Television Institute of India
HD	High definition (hi def), a digital format
HMIs	"Lighting equipment that provides a perfect color temperature match for daylight" (Schaefer and Salvato 342).
ICG (IA)	IATSE International Cinematographers Guild Local 600
IATSE	International Alliance of Theatrical Stage Employees
IDHEC	Institut des hautes études cinématographiques (France)
NABET	National Association of Broadcast Employees and Technicians
NFB	National Film Board (Canada)
NOW	National Organization for Women
NYU	New York University
PBS	Public Broadcasting Service (United States)
SAG	Screen Actors Guild

SMPTE	Society of Motion Picture and Television Engineers
UCLA	University of California Los Angeles
USC	University of Southern California
WGA	Writers Guild of America
WIF, WIFT	Women in Film, Women in Film and Television

Job titles and some useful definitions

Being a cinematographer is 1/3 creative, 1/3 technical, and 1/3 managerial.

(Jendra Jarnagin)

Professional film terminology varies around the world, even among English-speaking nations. However, Hollywood dominated 20th century film production, when the global influence of cinema developed. As Hollywood itself developed, its wealth and technical superiority drew in the world's filmmakers, who sometimes took back to their home countries the language and practice of commercial Hollywood studio-style filmmaking.

Historically, as the Hollywood camera department grew larger because of technological advances, camera crews developed a structure and a hierarchy reflecting the individual crewmembers' responsibilities and experience. American camerawoman Kim Gottlieb-Walker's *Setiquette: A Guide to Working Effectively on the Set for Each Classification in the Cinematographers Guild* includes "definitions of the job requirements and appropriate protocols for each member of the camera crew and for publicists."[1] Section headings in the Contents include Directors of Photography (DPs), Camera Operators, Still Photographers, 1st and 2nd [sic] Camera Assistants, and Loaders, among others, covering film camera crews from top to bottom, in addition to digital classifications such as EPK (Electronic Press Kit) crews (2). These are the key camera positions on Hollywood productions, although our interviewees sometimes talk about other work experiences and job titles, especially outside the United States.

On a small project, the DP (or DoP in Britain and former Commonwealth countries) may be the sum total of the camera crew, responsible for everything about the camera, or sometimes s/he may work with one assistant. On feature films, the camera crew usually includes a DP, a camera operator, and one or more camera assistants. Gaffers—who work with lighting—and grips—who do heavy lifting and carrying—are also associated with camera crews. US unions usually require a production's DP to have an operator, but many DPs prefer to operate the camera themselves. On some crews a focus puller keeps the camera in focus. Increasingly, the first assistant is coming to be known as the focus puller. "I consider myself a focus puller at this point in my career, more than just an assistant," said Michelle Crenshaw in 2005, before moving up to camera operator. "My first responsibility

is servicing the cinematographer, or the cameraperson. I'm his assistant and I'm there to service him."

Some feature films and television programs involve more than one camera, in which case there is a primary unit, called the "A camera" or "first unit," and then the "B camera" or "Second Unit."

Different countries often use different job titles for the same work. For example, when American cinematographer and director Madelyn Most interviewed Sue Gibson, BSC, she asked, "Clapper loader—is that what Americans know as second assistant camera?" In *Setiquette* the loader is below the level of assistant yet is acknowledged to have great responsibility, not only loading and downloading the film but also serving as "secretary and yeoman for the camera crew" (Pahoyo 24).

Historically, in Hollywood and elsewhere, a distinction has sometimes existed between the cameraperson as operator of the camera and a more senior position of Director of Photography as the person responsible for lighting as well as directing what the camera operator actually films. Unions have sometimes required this distinction; sometimes it's a matter of tradition. According to Caroline Champetier, in France, "before the New Wave, the cameraman was one person, and the director of photography was another," but DP B. R. Vijayalakshmi currently operates her own camera in Kollywood—the second largest film industry in India, based in Chennai. "The light assistants," she says, talking about feature sets there,

could be labor class workers; they handle the light and the reflectors. The camera assistant shifts the camera from place to place and also does the focus pulling. The assistant cameraman carries out the cameraman's orders as to where to place the lights, and how to light up and do more refined things like shading.

How large a camera crew is often comes down to how much money the producer provides and/or how much cheap labor is available.

Uma Kumarapuram has moved up to the associate rank of the Malayalam film industry (based in Kerala, India), where the DP is in charge of three units: Light, Crane, and Camera. ("The chief crane operator and his boys take care of track, dolly, crane, vacuum grips, etc.") While there are paid employees in all three units "with definite call sheets and wages," there are also many assistants who "are not paid employees." Instead "we get what the DoP asks the producer to give us." Although Kumarapuram studied physics before joining the film crew and assisted on only three films before moving up, her willingness to work hard attracted attention. Once she became an associate she became the one "who takes care of lighting the set, meter-reading—whatever to make sure the shot is good." She has already become "a right-hand person to [the] DoP" and "the associate, who actually commands the light and crane crew."

Generally speaking, in the West, the DP gets credit for lighting although historically the DP's responsibility for lighting has varied. Jo Carson was credited as "the camera operator

on the bee sequence [in *Honey, I Shrunk the Kids* (1989)] but I was [also] in charge of lighting that sequence." While Amy Halpern admits that "*cinematographer* is also a beautiful word," she prefers to call herself a lighting cameraman. "'Lighting cameraman' appeals to me because it speaks to the task. You're framing, but you're also manipulating light, discovering the light that exists. As a lighting cameraman you're essentially the DP of a picture."

Halpern is not alone among camerawomen who refer to themselves as cameramen. Their strategy might be read as enhancing their authority over the camera through association with the job title in use that currently represents authority over an essential component of the production crew—or it might be read as deflecting attention from being different because they're female. Many of these women call themselves feminists, and they are pretty much all good feminist role models, but their feminism is primarily practical, through hiring other women, for example. Establishing "camerawoman" as a standard job title is a valid goal, but the camerawomen who first got through the door had enough to do just getting there.

Note

1 Gottlieb-Walker has been the elected representative for still photographers in the Cinema Guild (IATSE Local 600) since 1980. Best known for her photographs of musicians, her film work includes John Carpenter's most famous films; her TV work includes *Cheers*.

Chapter 1

How do women become camerawomen?

Cinematography is an elegant and desirable profession; it's a real struggle to get into it. It is more difficult for women, because we're a small percentage out there, and most of the crews we work with are male crews. So women have to empower themselves so they can be leaders, run a set, and work with men collectively. I don't think women get that from an early age.

(Zoe Dirse)

Learning on the Job

Today, almost anyone who can beg, borrow, buy, or steal a camera can learn how to operate it up to a point, given sufficient determination, with or without formal training. "The lower cost of high quality camera choices has made cameras, videos, and photography a huge part of our lives," Jendra Jarnagin observes, "and a major component of how everyone communicates, whether they are a professional or not." It has also made it easier for people to teach themselves how to use a camera.

You can experiment and immediately see the results and learn from your failures. I grew up shooting film; it was expensive to experiment, so the learning curve was much slower. Now you can just mess around with your frame rates and shutter speeds and play it back on the spot and adjust accordingly. It can make for more bold techniques because you aren't afraid of failure.

How does one become a professional? There were obviously no film schools in the 1890s when public screenings of films began around the world. Early equipment was simple; learning the basics wasn't an obstacle, yet women rarely operated the camera in cinema's early decades. Among the exceptions, though, are Margery Ordway, who worked in 1916 as a "regular, professional, licensed, union crank-turner" for the Hollywood feature *Her Father's Son* (William Desmond Taylor); its DP, Howard Scott, was a founding member of the Society of Cinematographers ("This is the New Fall Style"). Elsewhere during the 1920s Louise Lowell was also claimed as "the first and only camera-maid in the world"; she studied aviation and became an aerial camerawoman for Fox Movietone News ("The First Camera-Maid").

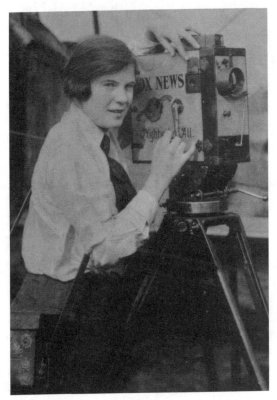

Figure 2: Louise Lowell, Fox News.

Around the world, most camerapeople learned on the job until relatively recently. Academy Award-winner Haskell Wexler, ASC, didn't go to film school, but having a little mentoring made a big difference professionally. Wexler had shot 16mm family movies: "Not only shot them, but cut them, and put titles on them and all that stuff." When he first started shooting, he learned by trial and error, and began shooting film for pay around 1947. Working professionally as an assistant in Chicago, Wexler was offered a job to shoot with a Mitchell Camera.

> *They asked me, "Can you shoot with a Mitchell?" I said, "Yes." "Do you know macro photography?" I said, "Of course." So I went to the library and read up on what macro photography meant. Val O'Malley, who worked at Wilding Studios, said, "I'll help you. This is how you thread a Mitchell, a standard Mitchell." He spent a couple of hours with me, and I got the job. I'll never forget Val O'Malley.*

Wexler has mentored many camerawomen, offering technical information, providing hours of work so women could join the union, and championing the cause of camerawomen generally.

Many women have learned on the job from male mentors. Lisa Rinzler says that after New York University (NYU) she worked briefly as a production assistant, immediately shifting to electric work and then camera assisting. She had a wonderful, unofficial mentor named Fred Murphy, who was a "terrific DP" and "a beautiful human being." He taught Rinzler how to work under the pressures of a set. "I don't think I light the way Fred lights, but on my first job he had me diagram his lighting for a movie he was shooting. I think I was working for free. None of that mattered: it was a fantastic opportunity to do drawings of someone's lighting style. I was completely fascinated."

American Madelyn Most trained at the London Film School and by working alongside Oscar-winning cinematographer John Alcott, BSC, who was DP on Stanley Kubrick's films. Most said that if she asked Alcott a question, he would explain in detail for hours until she understood.

I was nurtured by people who worked for the film, and making you a better person and teaching you. I wanted to be like that, always teaching people, always discussing photography, discussing the problems, the labs. It's not only knowing what you're doing on the floor; it's what they're doing in the lab.

Similarly, Spanish camerawoman Teresa Medina, AEC, had a "beautiful" internship with Vilmos Zsigmond, ASC, while she was finishing her studies at the American Film Institute (AFI) and he was finishing *Sliver* (Philip Noyce; 1993). "Anything I wanted to say, anything I wanted to ask, he was always willing to help me. I will thank him for the rest of my life." Among other things, Zsigmond taught Medina to respect the location for the shoot.

When we were working together, even within a studio where everything seems so artificial, I remember there being some translights,[1] and he told the gaffer he wanted to bring that same type of light into the décor of the set. He always respected his surroundings.

Medina also learned from her internship with Vittorio Storaro, ASC. One of the first female directors of photography to shoot a thesis film while at AFI, Medina was interested in technology: "How do you do this? How do you do that?" Storaro taught her, in addition, to trust in herself and to trust her intuition: "I learned to have an idea and to bring it to life. They are two different techniques: One wants you to respect the environment; the other wants you to bring something from within to the outer world. I use both."

In Japan, Akiko Ashizawa, JSC, whose male mentor was Ito Hideo, recalls that

I wasn't involved in cinematography before college. I had a hard time getting a job, except eventually at an independent production company that made "pink films" with nudity as their selling point. I found it a gathering of ambitious souls. One of them was Ito Hideo. He let me work as his apprentice assistant. The apprentice system helped me learn a variety of techniques. My training was never school-based.

Until recently, Kiwi camerawomen had few opportunities for formal camera training, so they learned on the job. In the 1970s Margaret Moth studied at Canterbury University in the fine arts class but switched to the new film class. She also learned on the job in a nation used to apprenticeships and on-the-job training for anything practical. She remembered that when "they were splitting the main [television] channel to be two channels, they were looking for camerapeople—well, cameramen. I had a big fight to get that job." She got it, first learning to shoot black and white film, and within a few months she had learned to film color. Decades later, compatriot Kylie Plunkett's experience has been similar. Despite a university degree and film school training, Plunkett says, "All camera training comes from real experience, on the job. Every job is different, so learning is every day. Technology is also changing so quickly." Mairi Gunn's experience in New Zealand also exemplifies what "coming up the ranks" from the bottom rung means for camera crews. She didn't go to film school but did take a short weekend course in London with a Bolex (the classic wind-up 16mm camera). She got her first unpaid job as trainee on a short film and then slowly got more work as a camera loader and as a focus puller. Now she shoots her own films as well as working for others.

Some Canadian women had a different experience than those in the United States or Europe, since Canada has a government-sponsored National Film Board (NFB). Zoe Dirse, CSC, was fortunate to go to the NFB. Once hired, she could feel sure she wouldn't be let go and she would shoot "six to seven films a year, which is a terrific training ground. Because there were editors, a lab, twenty other cinematographers you could talk to who had tremendous amounts of experience—the learning curve was high. I had a unique position as a woman." Because the opportunity she had no longer exists, Dirse thinks women now have a more difficult time. She explains how to become a DP in IATSE (International Alliance of Theatrical Stage Employees, a major union for film technicians): "You have to go through all the steps of training: second assistant, first assistant, operating, and then DPing. The difficulty lies in making that big step from camera assisting to operating, and then that bigger step from operating to DPing." Dirse willingly mentors young camerawomen through the ropes.

Many countries do not have film schools, while universities around the world were slow to include film production in their curricula. The first university film courses were usually in appreciation, history, and other variations on humanities courses in the arts rather than in the practical skills needed to make a film. Where practical skills courses were offered, they generally were associated with programs in the practical arts such as painting or sculpture, architecture, and design.

Exposure to film studies in the humanities section of a university often leaves a would-be filmmaker in the position of having to teach herself how to operate the camera. Turkish filmmaker Berke Baş recounts that during graduate studies at New York's New School she took "some camera editing classes, but there were no serious cinematography courses. There was no opportunity for us to hire a cameraperson. In order to make films, we had to shoot our own film. Digital technology helped us to get into the profession."

A university education can be useful for a camerawoman apart from learning specific technical skills that may or may not be offered. For example, Dirse's psychology professor at the University of Toronto taught his students about his research on "nonverbal behavior and facial expressions—which came in handy when I became a professional cinematographer, especially in documentary and working with people of other languages." At the NFB, based in Montreal, a lot of the work was in French, but she was not then proficient in the language. Her first big documentary, *Firewords* (Dorothy Todd Hénaut; 1986), is about three feminist French Québécoise writers. Dirse applied her psychology professor's ideas because "I had to rely on their facial expressions in terms of when to zoom in or change my frame, especially in the interviews."

In fact, being at a university can provide relevant opportunities in unexpected ways. For a while in the 1970s, when cable companies were getting established in the United States, they often had to negotiate with local city councils for access to public utilities, leading to the establishment of public access cable television stations. Such stations, apart from the larger cities, were often located in college towns. Lisa Seidenberg's discovery of public access video changed her life. After she received her degree in film and television from the University of Wisconsin, she returned home to Syracuse, New York (home of Syracuse University), and joined a video artist access program. She worked with pioneer video artists such as Nam June Paik and Carolee Schneemann, who were exhibiting at Syracuse's Everson Museum. This early exposure to video—which was then new technology—gave Seidenberg practical skills with the equipment that virtually guaranteed her an industry job and the status of pioneer. A generation later, Jendra Jarnagin "began shooting at the age of twelve as a member of a public access youth program" ("About"); she has become an expert user and promoter of new camera technology.

Having any other women employees around can make a camerawoman's life a little easier. In the mid-1970s NBC would have gaffers and camera operators come in to "day play" the news, i.e., work on a day-to-day basis rather than on permanent contract. That's when Sandi Sissel, ASC, met Alicia Weber, who had a few months' more experience and could mentor her. "I didn't know much, so to have someone like Alicia—and there was a soundwoman named Nan Seiderman and another one named Cabell Smith—to have these women in the networks made it so much easier to function in that environment."

First day at NBC, they check you out a camera. In those days it was a Frezzolini camera with two lenses and then your tripod. You would go all over New York. The DP drove the car; you carried your equipment, climbed stairs, and did whatever story they told you to do. It took me two weeks to realize that that additional lens was actually a wide-angle lens. I thought it was a spare lens.

Mary Gonzales described how Brianne Murphy, ASC, mentored her, taking her out of low-budget features and bringing her into network television. Murphy had worked as a cinematographer at NBC, Warner, and Columbia, becoming the first woman director of

photography in Hollywood Camera Local IA 659. Gonzales said that Murphy nurtured many camerawomen and was the single most important person in her career, teaching her what she needed to know "technically, politically, emotionally." Gonzales, who started working with Murphy on a freebie, was shocked that Murphy, who had years of experience, could still be doing a freebie. Gonzales was the second assistant camera on a two-camera Panavision film the first time she ever worked with professional cameras or professional crews.

> We had a great time, and at the end of the production, [Murphy] gave us a gift: "Here's a light meter. Learn how to use it." And we did. Not that long afterwards she had me shooting Second Unit on a TV series called Shades of L.A. She'd just quietly tell the producer/director, "Send Mary out to shoot these exteriors." Until she retired, I was pretty much her assistant and eventually B operator.

She and Murphy also became very good friends.

For Jo Carson, Estelle Kirsh was the mentor when Carson was first trying to get into live action camera work. Kirsh got Carson a job on a low-bucks or no-bucks movie: "It was a lot of fun, everybody was enthusiastic about it, we had a big crew." Kirsh taught Carson "how we start in the camera world, from the bottom up. She taught me how to be a loader and how

Figure 3: Mary Gonzales, camera operator. USA.

to do that right, and how to keep track of the records, load the magazines, keep everything shipshape. She did a good job of it. She knew what she was doing."

Canadian Naomi Wise's praise for Dirse is equally enthusiastic: If Wise hadn't met Dirse, she wouldn't have gotten trained—plus Dirse taught her "things the guys would never tell me." For example, Dirse taught Wise that if male crewmembers asked her to pick up a heavy case she should "tell *them* to pick it up first. Because more than likely, they can't pick it up either, and it's a two-man job." Thus Dirse taught Wise not only technical information such as how to change the film magazine but also "how to deal with the politics of the set."

Around the world, as we shall see, camerawomen have stories of family influences leading them into camera work. Some have informally apprenticed themselves to family members.

For African American camerawoman and director Jessie Maple Patton it was her husband, LeRoy Patton, a cameraman who "seemed like he was having a lot of fun. I asked him if he would train me to be his assistant and he agreed." Vijayalakshmi, who grew up with filmmaking and film studios in Chennai, India, came into the family business when she completed her education (in interior design, where she studied color) but didn't have a job. When her elder brother, J. Mahendran, started directing films, she started observing him at work.

On the set for *Nenjathe Killathe* (J. Mahendran; 1981), Vijayalakshmi saw another woman, named Suhasini, working as an assistant for Ashok Kumar, a well-known cameraman.

> She trained in the Madras Film Institute. Someone said, "There is a girl working here for the film industry as a cameraperson. Why can't you also just start working, instead of sitting at home?" Suhasini went on to become a film artist (actor, writer, director, producer); she never pursued her cinematography career.

When Kumar asked Vijayalakshmi to assist him, she asked him if she needed to train in a film school. He said, "It's not necessary. You can do your theory at home. The hands-on training is a must." She read through all Suhasini's notes and almost all the books that were being taught at the Institute, but Kumar said, "You can learn on the side and work as my assistant." She worked with him for five years before she started to shoot independently. She doesn't feel the lack of formal film education; indeed, she was chosen to serve on the selection committee for cinematography students for the Film Institute in Chennai.

Mentoring can occur at any stage of one's career. Some camerawomen, like Dominique Le Rigoleur, think they should hold back a bit and work on some aspect or another of their skills, often because they're working with a cinematographer whom they particularly respect and from whom they are still learning. Sometimes mentoring comes later in one's career as well as at the beginning. Jan Kenny, ACS, said she learned how to create an illusion by working on the film *We of the Never Never* (Igor Auzins; 1982). She said that cinematographer Gary Hansen was a "master of the art of the cheat" who taught her to look at nature differently, and for *We of the Never Never* she learned how to create the filmic look of the Australian outback. Though Hansen died in the early 1980s, years later Kenny still hears his voice in her

9

head when she has a problem to solve. He taught her that the simplest solution is the most creative and appropriate.

> Some shots [she was delegated to shoot] proved to be impossible to get. [For example,] they wanted dingos howling at night. So we went to the zoo, set up a backdrop of the bush in the dingos' enclosure, shot it day for night, and had somebody hold some meat so the dingo would howl and try to reach the meat. It was successful. It looked like a dingo howling and it looked as though it was in the bush. That was creative problem solving and a thoroughly enjoyable challenge as well.

When national economies are doing well, there may be money for minority opportunities, whether ethnic- or gender-focused. Patton describes pitfalls typical of various projects based on fragile financial commitments, for example, the National Education Television Training School. It was set up for African Americans to learn difficult behind-the-camera jobs in order to get into the union, but as Patton dryly concludes, "It was so successful that after one year they shut it down." She and others picketed "and did everything we could for this school to continue. Wherever they got the funding wouldn't give them another year." But in addition to this short-lived formal training, Patton also did volunteer work on films and trained at equipment houses to learn more.

When Michelle Crenshaw first worked in the American film industry, she also joined a training program. Then Peter Kuttner[2] in Chicago became a strong ally. Still Crenshaw says, "But a lot of it was my own. I had to really interact and just absorb, and gather information, take the good, take the bad, and move forward."

Knowing how to do one's job is essential to keeping it. The base line is a thorough knowledge of one's equipment: how to use it, experiment with it, and repair it. Russian camerawoman and director Marina Goldovskaya advises practice—until the camera no longer feels "alien," "so that you can say, 'I don't feel the camera; I am breathing with the camera.'" Around the world, successful camerawomen have taken diverse paths toward this goal, paths that often reflect their country of origin and the opportunities it can offer them as well as their status among women in that country.

With reductions in costs associated with digital technology that itself grows better and better, training in camerawork has spread globally. Whether working alone through material on the Web, getting help from a mentor, informal on-the-job apprenticeships, or formal training, learning the technical skills to become a professional cinematographer is an ever more attainable goal for women.

Still Photography

In the 1910s, as silent cinema's storytelling techniques grew more sophisticated and the industry's appreciation of a star's value grew, many cinematographers came from the ranks of still photographers who had "training in portrait photography" and could "create flattering

close-ups of the stars" (Keating 23). Still photography in general has continued to be both a training ground and a steppingstone for filmmakers, as many of our interviewees told us.

When Kiwi Margaret Moth was eight years old, she wanted her first still camera. Her parents said, "'You save up half and we'll match the other half.' I started taking photos of everybody, but I didn't think of it as a career." Kenny belonged to a still photography club in Australia. In Mexico Celiana Cárdenas, AMC, started still photography "when I was ten years old. My mother's partner was a still photographer. He gave me my first camera; my interest grew, and in junior high I took a still photography workshop."

Spaniard Teresa Medina took photography seriously from the beginning: "In my adolescence, a cousin brought over some postcards. I thought they were beautiful and at that moment I fell in love with photography. My family thought this was a hobby, but I knew it was more." Israeli camerawoman Irit Sharvit took photography so seriously that "when I was a teenager, I would carry my Pentax stills camera everywhere." She was unable "to enjoy a party if I didn't have with me two film rolls. After traveling a year in India, shooting all the time, I realized I was experiencing life through a filter." That led her to "abandon the camera for two years."

Mexican Hilda Mercado, AMC, started taking classes in photography when she was fifteen and developed her eye by working as a still photographer. She calls herself an observant person, "which allows me to see and analyze things, which in turn has allowed my eye to develop and to achieve some of the visual things I want to do." Mercado loves composition and still photography, whether she is shooting or analyzing others' work. "I also enjoy painting and sculpture, and borrow from all arts, especially when in search of inspiration. It is combining what you see with your ideas and influences [on] you since your childhood."

Other women filmmakers who began as still photographers include Lee Meily in the Philippines and Giselle Chamma in Brazil. Chamma laughingly reports that "one of my first features was a *Playboy* cover." "In my early years, I was a photographer," Agnès Varda remembers. "I picked up the habit of letting in beauty, ugliness, or the world's sadness via a frame, that of a camera. This exercise of letting in big images, small images, emotions, or details in a frame is a real pleasure for me." Although best known as a director whose films include work that influenced French film criticism and theory in the 1960s, Varda sometimes shoots her own films. Nurith Aviv, who has shot some of Varda's films, also began with still photography.

Liz Ziegler, ASC, majored in photography in college, developing a love for the mechanics of cameras. When her still photo studio in Hollywood wasn't doing well, she got a job inking and painting on the first *Star Wars* (George Lucas; 1977). Since she needed more camera equipment than she could afford, during her lunchtime and after hours she would go to the machine shop to build things "with guys that were nice enough to let someone who didn't know what they were doing have at it on the mill and the lathe. I got so involved in machine work that it led me away from photography."

Austrian Astrid Heubrandtner, AAC, is one of a number of camerawomen for whom still photography has been an important way station toward work in film. She studied theater and art history at Vienna University, but did not like the theoretical analysis.

In my last year of high school I had two friends who painted extremely well. They exhibited in our area, in Styria, which was exciting. They lived such a quote unquote "artist's life" that I also wanted the lifestyle. The only problem was that I couldn't draw and paint. So I arrived at photography. That was simply a method for me to create images, to express myself visually.

However, after studying photography at university, she realized that she couldn't imagine having a photo studio or working as a press photographer, so she applied and was accepted into Vienna's Film Academy, part of the University of Music and Performing Arts.

In Britain, Sue Gibson, BSC, also made the transition from still photography to filmmaking while in school. Since she also could neither draw nor paint, she took photographs and used them to make sculptures. She chose to attend Newport College of Art for its photojournalist course, run by Macklin Photographers, which was practical rather than a fine art degree course. An early assignment was to photograph a person at work, producing a series of photographs showing what the person is doing. Gibson compares the series of photographs to a storyboard or shot list that tells stories with pictures, which she calls the essence of cinematography.[3]

Initially all my photographic work was of documentary nature, and almost exclusively in black and white. But the thing that drew me to my subjects was the interplay of lights and that scenario. It was not something that I consciously sought; it is something I realized had happened when I was choosing the subjects to photograph.

After studying for three years at Newport, she decided to work in cinematography rather than photography since the latter "seemed egocentric and insular." She didn't like the commercial world of photography either because "I thought that was false. I went to England's National Film School for three years, and the rest is history."

Other camerawomen made the transition because they appreciated cinema's greater ability to capture the sequential as well as the aural aspect of an experience. For example, American Emiko Omori found that capturing movement with a camera made more sense for her than still photography because of her personality. She thinks she is not a good still photographer because capturing the perfect moment takes a lot of patience. Cinematography is more satisfying for Omori because it allows her to "tell a story in one shot. Something happened and you followed it over there or whatever. I tend to do things that are sequential."

For American Arlene Burns, the change from stills to cinematography happened because, with the latter, "you get the sound and the music and the movement." Likewise, for Gunn, "It was not a huge leap from doing stills to working with the moving image" because of film's ability to capture more of the moment than still photography can.

I started to take stills a lot when I was at Auckland University, for the [Student Association] magazine Craccum. *I enjoyed doing something practical other than academic work,*

something to show at the end of the day. Then I was taking stills of punk bands in England. That one frame wasn't going to be enough to show the breadth and depth of what was going on there.

Ellen Kuras, ASC, wanted to be a sculptor as a child growing up in America. However, since she couldn't get into a sculpture class while studying at Brown University, she took a photography class instead. She began to see light in a different way one day while looking at the light coming through her dorm window, "how it was hitting the light shade, and hitting the bottles on the other side of the light shade, and how it was refracting on the window shade. I'd never thought about that before. I started taking pictures of these new discoveries about light."

Kuras remembers a visiting photographer who saw something in her classwork and told her, "You have a very interesting way of seeing the light." She had never thought that her discoveries about light were unusual, but a whole new world was opened up for her, "where I was able to see in a different way. The outside world fell away. I still have that feeling every time I look through the viewfinder. I allow the world to fall away around me. It's enabled me to focus on discovery and revealing the world at hand."

Later Kuras went to France to study at the Centre Américain des Études Cinématographiques (the American Center for the Study of Film),[4] eventually becoming one of the world's top cinematographers. But one difference between still photography and cinematography bothers her:

We don't technically own our images as cinematographers. Photographers do, but we don't. I find that disturbing. Whatever creative property we have is open to change. And it happens all the time. You film a film, and they put it on DVD. They don't even bother to call you, and they change the entire look of the film.

Another American, Heather MacKenzie, was one of many people who discovered the camera in art school. She wanted first to be an architect but heard, "No, that's for the boys." She was also told that photography was for the boys. But in art school "I had a world open up to me where it didn't matter whether you were a boy or a girl. You could take the camera out and make wonderful little films. It was your unique vision."

Crenshaw experienced an epiphany that caused her to leave still photography behind when she was exposed to moving images as part of her studies. She grew up in a working class family in Detroit, Michigan, and graduated high school from Cass Tech.[5] There she majored in art, because she used to draw and paint. Once she picked up a camera and got excited by taking images of life on the street, she built her own darkroom.

After high school, Crenshaw attended Ray-Vogue School of Design, which offered a large-format photography class. She wasn't happy there but does remember "being in love with the 4 x 5 format,[6] and shooting." She felt she didn't know enough about using a light meter or how to deal with color balance, so when she heard that Columbia College in Chicago had

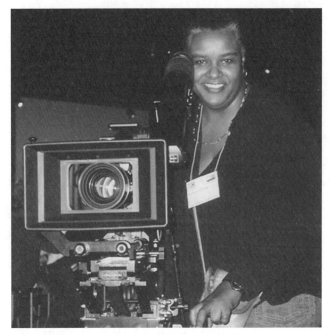

Figure 4: Michelle Crenshaw, camera operator. USA.

a film department, she became excited: "And that was it. Moving images, wow! The idea of thinking you could tell a story, not just with static, but moving images. I took one film class there and fell in love. I was obsessed ever since."

Film School

When I was a teenager, I thought it was like a secret to work on movies. I had no connection at all with this world. So I started studies for journalism. About six years later I decided to go to the national film school in Paris, called IDHEC at the time—L'Institut des hautes études cinématographiques.

(Agnès Godard, AFC)

In 1969, Chinese Malaysian Siew Hwa Beh enrolled in the film department at the University of California Los Angeles (UCLA). Beh said that the few women in the program "were not allowed to even touch the camera because the men did not feel that the women could be camerawomen. We would steady the tripod or carry the bags, make the coffee, do the sandwiches, everything—but we were not given major tasks." She remembers that the male students "would network, passing the camera to each other, never giving us a chance at the

Figure 5: Siew Hwa Beh. USA.

equipment." The professors went along with the men students. "We were not taught about lighting, staging, nothing."

Although also at UCLA film school in the late 1960s, Joan Churchill, ASC, had a better time.[7] Churchill's father owned an educational film company in Los Angeles, so as a student she had been able to borrow her father's camera to shoot a short film about a used car salesman. Thus, even before officially enrolling in UCLA's ethnographic film program[8] she had the crucial attribute of confidence in her ability to use the camera. When she "shot a film about a kid who was selling Christmas trees in my neighborhood," her professor, a

cinematographer named Steven Larner, ASC, saw the film and "told me that I really had talent and encouraged me to continue shooting" (Fisher, "Conversation"). When Churchill was shooting a student film about women trying on wigs, she got "a lucky break…There were two of us shooting. We were using Éclair NPR cameras, and the other cinematographer didn't check the shutter, so the footage from that camera was unusable. After that, a lot of students asked me to shoot their projects" (Fisher, "Conversation"). After she graduated, she got truly lucky: Her UCLA friends were beginning to get jobs as directors and called her to do camera on their professional films. As we shall see later in this section, this does happen.[9] More often, though, we heard about men from the same class as our interviewees who moved up faster to DP big-budget films because such networks didn't develop for the women.

NYU gets high marks for access from former students. Lisa Rinzler, who was a painting student at Pratt Institute in New York City, "was pretty sure from the get-go that [she] wanted to be a cinematographer." She transferred to NYU and started shooting as soon as she could. Rinzler called her student work "mostly very bad films that didn't get finished, but that didn't matter because the important thing is to be in the 'do' mode. To be lighting, shooting, getting comfortable with angles, setting up shots, making very bad lighting mistakes, which I did and continue to do to this day." For Brazilian Giselle Chamma, too, NYU was important for providing access to equipment. "I learned camera, editing, production—hands-on camera. At NYU, you study six months; then you shoot six months. I wanted to shoot as much as I could."

Along with access to equipment, another advantage one might get from film school is the opportunity to study with teachers who have had professional filmmaking experience or who are willing to take on their students as crew for a film project. Eva Testor, AAC, relates that in Austria, "So I could learn, my professor, Christian Berger, took me on as a gaffer, which of course was wonderful."

Mercado did not go to film school in Mexico but she studied at the Universidad Intercontinental for four years: journalism, still photography, radio, television, history of images, history of television, and cinema. Later, after working as a camera operator for about eighteen months, Mercado pursued film school in order to satisfy her intellectual curiosity and artistic drive. She mentioned two film schools in Mexico—CUEC (Centro Universitario de Estudios Cinematográfico) and CCC (Centro de Capacitación Cinematográfica; Mexico's National Film School). "When I realized I wanted to be in cinematography, I took all 20,000 tests they required. I really believe they were like 20,000 tests. [Laughter] I went through an interview, but that is as far as I got." Nonetheless, Mercado realized that she needed to continue studying cinematography, but

in a way that was less technical and more creative, that studied the form, the language. I needed an environment in which I could develop creatively, learning how to tell stories through images. I wanted time to observe and more artistic sustenance, more than I was going to get just through work.

She made a worldwide search for film schools, arriving at the AFI in Los Angeles to join its cinematography program.

> It was one of the best moments of my life, personally, emotionally, and professionally, because I spent two years watching, observing, breathing, and taking in everything to do with cinematography and film. I learned to distance myself a bit from the technical aspect of cinematography and to find the artistic tools of cinematography, which is what I needed.
>
> That was when I realized that cinematography isn't about lighting; it goes deeper. What colors, what forms, what subtexts, what psychology, what type of story are you telling, what kind of character, what kind of situations? That is what cinematography became for me. One never stops learning. Artists have to develop, to grow intellectually and emotionally.

Unlike Mercado, Cárdenas did study cinematography in Mexico. After taking a year of still photography classes from photographers such as Pedro Meyer, Graciela Iturbide, and Lourdes Grobet at the Escuela Activa de Fotografía in Mexico City, she studied to be a cinematographer at the CCC, beginning in 1987.

> There were twelve students per semester, which allowed us not only to learn the art and craft of being a Director of Photography, but also to have the opportunity to get to know other filmmakers that were my teachers at the time, such as Henner Hofmann, Santiago Navarrete, Carlos Markovich, and Rodrigo Prieto. It was a five-year program. Specialization in cinematography started in the third year and from there we would shoot documentaries, thesis films, etc.

Cárdenas followed these five years of studies with UCLA Extension cinematography workshops.

France established IDHEC (now known as Fémis) in 1943 as a film school for would-be filmmakers; students soon began coming from around the world. France has historically been more accepting of camerawomen and other minorities than other countries have been: Aviv, Caroline Champetier, Agnès Godard, and Dominique Le Rigoleur are among its early graduates. Aviv, who graduated in 1967, "was the first one. I did not know that there were no other women in cinematography. I was very naïve" (Dirse, "Women"). The experience could be professionally rewarding. "After passing the final IDHEC test" in 1976, Champetier says, "I was easily accepted in the field," adding, "My generation of women has needed to go through school in order to be able to integrate in a team. It was rare at the time. It's different now."

Kuras' studies at Brown University and then in Paris set her apart from most camerawomen, not least because the courses she took were intensely intellectual rather than practical. At Brown she was interested in propaganda, particularly how the image was constructed in terms of its meaning. In France she studied with such figures as anthropologist Claude Lévi-Strauss and film theorist Christian Metz.

I was interested in how things were put together. How is meaning created? What does the color yellow do to our perceptual senses as opposed to the color red? Where does it fall in the frame? It was deconstructing the image to understand how it worked, which can go only so far. Later on, when I started shooting, I started using that information, but way in the back of my head.

After finishing the Paris Film Program, Kuras got a job at the Galerie Zabriskie, one of the few European photography galleries at the time. There she made friends with many of the photographers who came through, but at her parents' urging Kuras returned to the United States, finishing her degree at Brown with majors in both semiotics and anthropology. She also took classes in "social structure through Marxist thought—classes about small-scale societies." She then worked at the Roger Williams Park Museum of Natural History in Providence, Rhode Island, where she put together a film series around Eastern European and Southeast Asian immigration. "It was a natural progression to use what I knew from my anthropological background to start photographing these people in the neighborhoods where they lived, and ultimately where I lived." Many people, following Kuras' path, found that it led to university teaching, but Kuras not only found work as a cinematographer, she also shot and co-directed the Oscar-nominated documentary *The Betrayal* (*Nerakhoon*; 2008), which had started in the 1980s as a friend's master's degree thesis project on Southeast Asian immigrant communities.

When Heubrandtner studied at Vienna's Film Academy during the 1990s, the program offered different courses specific to directing, scriptwriting, editing, producing, and camera. It accepted between ten and twelve students each year altogether; in her year there were three students specializing in camera. In the early 1990s, only one woman studied camera each year, but according to Heubrandtner the Academy later had more women—one year in the late '90s only women were accepted. At first, Heubrandtner's professors as well as her fellow students were all male but during her second year camerawoman Johanna Heer, who had lived and taught in America, became a film teacher at the Academy.

Heubrandtner generally did not experience sexism from her professors, although one older male teacher who taught basic camera said, "'Well, if as a woman one wants to do camera, then one must be sure to wear pants, not a skirt, because sometimes you'll have to stand high up, and the male colleagues would be able to look underneath your skirt.' These were relatively gross remarks, but no one took them seriously."

Testor found supportive teachers and fellow students at the same Academy:

I received a lot of support from my camera professor, Christian Berger, who also demanded a lot of me. There are feminine men and masculine men. He belongs more to the feminine, which I see as positive. Not so much a technology freak or macho man, but characterized more by the sort of sensibility that women value.

I had the good fortune [at school] to work with male and female directors with whom I have worked again since school. That is how I came to film my first feature, which has

won prizes. Many students who become directors after film school leave their student camerapeople behind. I studied with Jörg Kalt and Nina Kusturica and we have worked together since, which is very pleasant.

Iranian Rozette Ghadery also made the move into the industry because of connections she developed while studying. She began with genetics, but after she saw *The Peddler* (Mohsen Makhmalbaf; 1987), she chose to study cinema. In 1990 she enrolled in the art department in Tehran's university, majoring in film. After two years of general classes, she chose to concentrate on cinematography, although most women students opted to become directors.

At the time of the interview, one of the professors, Mr. Mohammad Reza Sharifi, questioned me: "Why cinematography?" He added, "If the owner of BL Camera Company asks you to marry him and transfers all his fortune and his company to you only if you quit your work and stay at home, what will you do?" I asked if male students were asked the same question. If so, I would answer the question. Everyone in the room burst into laughter.

After Ghadery read one of her first screenplays in class, a senior student, Majid Mahichi, invited her to work with him as part of a camera crew and her life in the cinema industry began. "For about a month we worked in the forests of northern Iran. I did not know much about filmmaking or the film industry then. Yet because of my persistence and interest, the director offered me another job less than three months later."

In some countries a national commitment to training film workers was embedded early on. Lenin, for example, who appreciated the power of movies to reach masses of people and move them to action, supported efforts to develop filmmaking. Throughout the Soviet Union and Communist Bloc there were film schools, sometimes associated with regional production units. In China, as well, there have been various government-supported production units throughout the country where newcomers could gain knowledge and experience.

In Moscow, Goldovskaya

entered the film school when I was sixteen, in 1958. When I graduated, I was twenty years old. We had a special department for cinematography, run by classical Soviet cinematographer Anatole Golovnia, who was [Vsevolod] Pudovkin's DP. His wife was a cinematographer, too—Tamara Lobova—but she hated women cinematographers. She influenced her husband not to accept women.

When Jolanta Dylewska was in her third year of camera studies at Poland's only film school, her professors said that she had a talent for directing but were otherwise unencouraging:

The female students were few and mostly foreigners. Why would the professors be supportive of me? There was this atmosphere: "No matter what we would do in that

camera class, we wouldn't get work anyway." At least my male professors—I only had male professors—thought that way.

Yanay Arauz was part of a new generation of Cuban filmmakers who studied at the Art Faculty of Audiovisual Communication Media in the Higher Art Institute (FAMCA). She filmed Jessica Rodriguez's documentary *Raul's World* (2010) as well as the Venezuelan documentary-in-progress *Never Ever Peter Pan* before she died at age 27 in 2013 (Almira).

In Jakarta, Indonesia, Angela Andreyanti Rikarastu studied cinematography at the Jakarta Institute of Art, the only institute with that major in her country. For the first two years she studied film in general, but in the third year students moved to specific departments:

From 30 students who wanted a cinematography major, I'm the only girl from among the three persons who could complete the theory, practical, and interview tests. In addition, the program includes things such as a students' festival, exchanging students with other broadcasting institutes, and workshops from Kodak or ARRI.

There was no hands-on training, so she learned from books. Since her college library lacked good books about cinematography she got "books from my lecturer and copied them. The best [were] from the Web, but not many websites offered free books." In the 21st century, there are more (and more free) resources available.

In India, cinematographer M. Shanti trained at the Film and Television Institute of India (FTI), based in Pune, which trains actors as well as technicians for the commercial film industry in Mumbai. As a woman studying cinematography, she was unusual. "From the family's point of view, it was all right. The battle started when I applied to FTI and went to the interview. The interviewer said, 'It's not easy. There are about 40 people applying, and ten people are selected.'" Bullied by questions from the interviewers that insulted her worth as a potential professional, she nonetheless says, "You don't let these things affect you." After film school she started working as a camerawoman in Bollywood.

Sabeena Gadihoke studied history as an undergraduate but for graduate work applied for a master's in mass communication at Jamia Millia Islamia University (Muslim National University) in Delhi. Of over 500 applicants for a new film course there, 33 were selected. In the first year Gadihoke studied photography, audio-visual production, introduction to the technical elements of sound (how to use microphones, how to record sound, and how to use a mixer), communication theory and research, development theories (targeting programs for particular groups of people), film history, film form, and film theory. In the second year her class learned how to make puppets and do puppet street theater, which is an important medium in India.

That is also when Gadihoke received her first training in the operation of both video and film cameras (Arriflex for film). "I suddenly found it very exciting. We edited on U-matic machines and learned editing on the Steenbeck machines. But—more than editing—the camera gave me a wonderful feeling, a tremendous sense of power, and it does to this day." During her second year she decided that this was the profession for her.

Jamia Millia also affected her life by politicizing her. She did not have strong opinions about politics until she came "face-to-face with articulate people who were political in their beliefs, who came from a left background, who came from or had links to the feminist movement." At film school she started to break rules her parents set for her. For example, during a film festival, when students got passes and saw films morning, noon, and night, Gadihoke started coming home late, traveling by bus on her own.

My parents were used to me traveling on the bus but they were not used to me coming home late. That was the beginning of conflicts at home about traditional boundaries for women. I learned a lot, and so did my parents, about the possibilities of what girls at home could do. It was a completely unconventional profession for its time. It isn't any longer.

Her film studies radicalized Gadihoke, almost inevitably because her New Delhi course, established in liaison with York University in Canada, was consciously "set up as an alternative to the Film Institute at Pune, which trains people for the Bombay fiction film industry." The New Delhi course set out to train filmmakers in documentary and nonfiction work—"socially relevant documentaries." The founders of the New Delhi center were Jim Beveridge, who was associated with the NFB; his wife, editor Margaret Beveridge; and Anwar Jamal Kidwai, who was the director of the institute: "They gave us a solid grounding in nonfiction. I remember attending this entire animation festival package of Norman McLaren's animation films. We saw all the early Grierson, Basil Wright's *Night Mail* (1936), and all those early, important UK documentaries." Now Gadihoke teaches in the same film center; she and the other professors try to keep to the agenda their training followed. "When I teach or select students today, I keep in mind that we are not training people to go into the commercial industry—though a lot of my students now do go into commercial television."

For some women, learning camerawork is one of the steppingstones towards becoming a producer or director. In Japan Naomi Kawase enrolled in the Osaka School of Photography with the intention of learning to become a television producer. Kawase is the cinematographer and director of nine documentaries as well as the youngest winner of a *Camera d'or*, for *Suzaku* (1997), which she also directed ("Naomi Kawase," IMDb and *Wikipedia*).

Whether for training in narrative features, documentaries, television, commercials, or new media, film schools continue to benefit significant numbers of students interested in cinematography. The top three film schools in the United States are arguably the University of Southern California (USC), NYU, and UCLA. Additional film schools in Southern California—which many students choose for its proximity to the Hollywood film and television industry—include the American Film Institute; the Art Center College of Design; California Institute for the Arts (CalArts); Chapman University; California State University Long Beach (CSULA); California State University, Northridge (CSUN); the Global Cinematography Institute (founded and run by Vilmos Zsigmond and Yuri Neyman, ASC, it has pioneered courses in digital cinematography and the evolving role of the cinematographer); Loyola Marymount University; and Los Angeles Community College.

Some of the best US film schools outside Southern California include Columbia College (Chicago), Columbia University (New York), Emerson College (Boston), Florida State University, San Francisco State University, and the University of Texas at Austin. Stanford University's documentary program is also highly regarded.

Internationally, some of the most renowned film schools include the All-Russian State Institute for Cinema (Moscow), the Australian Film Television and Radio School (AFTRS, Sydney), Beijing Film Academy, CCC (Mexico), FAMU (Prague), La Fémis (formerly IDHEC; Paris), FTI (India), Łodz Film Academy (Poland), and the National Film and Television School (United Kingdom).

Going to film school does not guarantee you a job upon graduation. However, in an email to the *Women behind the Camera* website, Miriam Bautista, a CSUN alumna, wrote that

> *it was important for me to gain experience handling a camera, learning the proper apertures, angles, lighting techniques, camera movements, etc., to achieve a certain look, as well as determining what the right composition for a frame or shot was. I've learned how to appreciate the depth of my craft: for me, this is a crucial step towards becoming a professional.*

Training Programs

Less formal but still professionally acknowledged training can take the form of nondegree courses or short-term workshops. Some of these are available through educational institutions, while others are offered by entrepreneurs or film-affiliated organizations. In addition, publicly funded broadcast and film production organizations—e.g., in Australia, Canada, and the United Kingdom—have sometimes offered training programs, their existence fluctuating with government policy and the state of the national screen industries. In some countries, training programs are accessible through unions.

Camerawomen's experiences in these programs have ranged from very good to debilitating. Fran Harris, training as part of the Women's Auxiliary Television Technical Staff (WATTS) at W9XBK-TV, Chicago, during World War II, said, "I felt like I was Alice in Wonderland. I went to bed that first night and thought, 'Did all of that happen to me?'" (O'Dell 62). Jean Minitz, nineteen at the time, said "…the boom mike, the two cameras, the control room….We were just deluged with information" (62). The eight women of WATTS—previously office worker, radio actress, commercial artist, electric appliance worker, router, and soda-jerk—were happy to get their "crash courses in how to handle cameras and anything else that would be necessary to go from show idea to final air" (62). But as World War II ended and the men returned from overseas, the women were replaced (66). There were no training programs for women again until the 1970s.

In Hollywood in 1978, former teacher and independent filmmaker Estelle Kirsh "participated in the [union-sponsored] Camera Assistant Training Program. It was a

ten-month training program that involved hands-on experience" and was meant to prepare her to pass the test for union membership. IATSE Local 659's test, similar to that given by the Directors Guild of America (DGA) for its Assistant Directors Program, consisted of a written section of several hours' duration, an interview, a test for color blindness, and a test of manual dexterity. Nearly 2,000 people took the test, but only ten were selected as trainees for the set assistants and five for special effects. Kirsh was told she tied for first place. She thought that the program, while a great idea, was executed poorly, possibly due to a conflict of interest.

> [Camera] assistants outside the Program had put in three years in the loading room before moving to Group One. Those of us who had been in the training program would get in Group One immediately. So there was resentment. Some people were up front about it: "I don't want you here." Other people engaged in sabotage. Messing with equipment. Putting people in harm's way. I often felt I was in the midst of a bunch of rednecks.

Kirsh also compares the atmosphere in the training program to a religious cult:

> The people I was working with were supposed to train me. Many of them resented the program and chose to keep it all guarded, like religious secrets. Maybe they decided if the trainees were not trained, the program would be disbanded. I was supposed to just sit and get coffee. Think of the waste. You had ten highly motivated people there, wanting to learn, in many cases changing their lifestyles. And there was nobody to rectify the situation.

Kirsh considered quitting but "was talked out of leaving because any woman in the program was not seen as an individual, but representative of all women in the program, representative of all women interested in camera work."

In the mid-1960s Australia lacked a film school, so filmmakers trained either at the ABC (Australian Broadcasting Corporation) or the Commonwealth Film Unit (now known as Film Australia). For Jan Kenny, hands-on training was only available to her as a production assistant with the Commonwealth Film Unit. While formally training as a production assistant, she started teaching herself to be a camera assistant by hanging out in the cinematography department. She "loved to assemble cameras, to play with them, touch them, clean them. I spent hours practicing loading and unloading magazines."

Kenny was one of about 23 production assistants who were trained in each department for six weeks before they were put to work on real projects. Kenny went first to the cinematography department, and never wanted to leave. However, she had to work her way back to cinematography:

> I tried to be a camera assistant but in those days they weren't interested in women doing that. This wasn't a woman's role; apart from that, there wasn't a women's toilet at that end of the building. But over the next three years, whenever I was on a shoot, I would turn

myself into the camera assistant. The crews then were tiny. There usually wasn't a camera assistant attached—only a director, a cameraman, and a production assistant.

So when we went away, the camera gear went with me, to my motel room. I learned to load and care for the gear; I spent hours every night cleaning and learning more about the equipment. I did it by default. I had to do all the production assistant work as well, but I was passionate about working with the cameras. It wasn't until some years later that I was able to formally become a camera assistant.

Both Madelyn Most and Katie Swain went for training with the BBC, although Most was seeking a short-term stint for her resume after having already gained other credentials. In fact, she left a well-paid job as a camera assistant to get the experience. Most applied without knowing that the BBC had no women in 1977.

During my interview the guy said to me, "We've never had a girl before. It would be unusual. What if you had to leave your boyfriend? What happens when you get your period?" I'd been through university, lived in different countries, and been through film school. I sat there and listened to this dinosaur. I said, "You think I'm stupid enough to answer those questions?"

For Swain, the BBC itself was her goal. When she left school at eighteen, she lacked enough experience to get a trainee post at the BBC, so she first worked at a facilities house, which serviced not only the BBC but other television stations in the 1980s: "I'd do a bit of boom swinging [for sound] and a bit of camera assisting: anything, really, and for most of the first year, working for nothing, and then gradually getting jobs that were paid. From there I got a posting at the BBC—holiday relief for staff." The cameraman she worked with on that recommended her for a traineeship the following year.

Swain was one of eight people in a yearlong BBC training program that gave them a comprehensive view of the filmmaking process. In the first eight weeks the trainees were in the classroom learning what happened to a piece of film from when it left the camera to when it went out via the television or the cinema. The trainees also had to make a short film. They spent time in the cutting room and some time doing sound. Swain was one of two women on her course, and only two other women were in the BBC Camera Department in 1984-85. The BBC had Ealing Film Studios, where the film section was, and BBC White City, where all the TV studio cameramen and women were. Swain's training was in the film section.

After the initial three months you were sent out as an extra pair of hands on a film crew. Film crews at the BBC were small. You'd have a cameraman, a soundman, and a camera assistant. I would be sent out as what [Americans] would call a Second AC, but they didn't have them, so you'd be out as a loader. You'd go out on a drama and be a Second. From there you'd go off and do a documentary where you'd be the only assistant, so you'd

be in charge of all the equipment. You'd turn up on a job and have 27 boxes of equipment to look after… It was a rigorous training.

Nancy Durham's two-day training at the CBC (Canadian Broadcasting Corporation, a national government media service) in 1994 was very different. Durham's bureau chief, John Owen, "saw in me a real eagerness to get out there and do firsthand story gathering." After her training, "The CBC gave me a small Hi-8 camera and my first assignment. This was an experiment. John had confidence in me. I had confidence in me. I was terrified at the same time. People thought it would be a one-day wonder." Over the course of the two days, she was given a "very good but very conventional training by a wonderful BBC camerawoman," during which she

learned how to use my tripod, and do wide shots and mediums. I didn't learn what a close up was. I actually thought at the end of that course a close up was where you stand at one end of a room, zoom all the way down the other end, and try to capture some emotional moment. Of course close ups are when you're so close you really feel it. So I shot too conservatively [at first]. After that, I went the other way; I started doing handheld, and probably too much wonky filming. Somewhere along the way—it took me months—I got a marriage of the two.

Two Examples of Feminist Groups: Women in Film and Behind the Lens

Feminist groups sometimes offer training in camerawork. One such group is Women in Film and Television International (WIFTI). Chapters, usually called Women in Film or Women in Film and Television, are widespread, including 23 chapters in the United States, 5 in Canada, 3 in New Zealand (combined as WIFT NZ), as well as WIFTIN (Nigeria), WIFTSA (South Africa), WIFTHK (Hong Kong), WFTV (United Kingdom), and others throughout the world.[10] Because the group was founded in Los Angeles as Women in Film in 1973, we shall use WIF for our general references to this organization.

Part of WIF's efforts to promote and support women within the industry includes acknowledging the success of its members through prestigious awards. The New York, Los Angeles, and Toronto chapters of WIF have all given awards to honor camerawomen. Membership is diverse in that it comes from across the screen industries and their ancillaries. Directors, producers, actors, sound technicians, costume designers, and others as well as camerawomen have been involved in WIF around the world. Individual chapters of WIF and WIFTI have sometimes been an important source of community for camerawomen.

Kiwis Kylie Plunkett and Mairi Gunn have been members of WIFT in New Zealand as well as more technically oriented associations. Plunkett is a member of WIFT because it is "specifically for/about assistance for women." Gunn admits that

sometimes I feel totally unsupported. When Women in Film and Television started up, it was like I'd died and gone to heaven...Meeting a woman who came over from Toronto [for the WIFTI meeting in 2004, held in Auckland], to hear her say, "Well done"—and this is what you can expect from WIFT—was incredibly exciting.

Gunn wishes that as a camerawoman she were not a rarity at WIFT events, but she enjoys being able to speak the technical language shared by camerawomen and –men when she's with fellow members of the technical guilds.

WIF chapters sometimes offer short workshops on specific topics led by local specialists in, say, sound or color grading, connected with friendly facilities houses that support local industry practitioners. Gunn, for example, "has organized a couple of cinematography workshops with support from Jan Kenny of Australia." But she points out that the organization is for women throughout the industry, so even its technical workshops tend to be accessible to a general industry audience.[11]

In some countries, WIF is particularly important for young members, even student members. The WIFT Wellington chapter honors the founder of WIFT in New Zealand, producer Robin Laing, with a scholarship in her name awarded annually to a female student at the Film School in Wellington that has sometimes assisted camerawomen. Mercado also acknowledges WIF among other institutions that "helped me to get my master's degree by giving me a bit more financial freedom to do what I wanted to do." The WIF Finishing Fund supplied the completion funds for the global documentary feature that led to this book.

While WIF is for all women in the film industry, and in some chapters includes male members, Behind the Lens: An Association of Professional Camerawomen (BTL) focused on camerawomen. Established in Los Angeles in 1984 and lasting until 1996, BTL's 1989 Membership Directory listed 45 camerawomen as active members, 44 camerawomen as apprentice members, 28 women associate members, and 25 supporting members (a category that included men).

Kristin Glover remembers that about ten Los Angeles camerawomen met first in someone's back yard to exchange information and to help each other get work. Susan Walsh adds that they "tried to find out about other camerawomen because it was prior to the [union] Local having a directory. The Local resisted having a directory for years, and it was just about impossible for us to find the names of other camerawomen unless we already knew them." Walsh says that they did research to come up with the names and contact numbers of "as many camerawomen as we could and tried to get them together for a potluck lunch." At that gathering they discussed founding a group to meet on a regular basis, to support each other in gaining skills. They asked Panavision, ARRI, Clairmont Camera, and other equipment houses to "give us demonstrations or training that you wouldn't necessarily be able to ask for if you were just one, two, or three people. We were, as a group, able to set up workshops so that we could get the kind of specialized training that we were looking for."

Walsh remembers that the 1984 Olympics were approaching, and credits their patron saint, the already successful camerawoman Brianne Murphy, with suggesting that they try

Figure 6: Behind the Lens: An Association of Professional Camerawomen. Brianne Murphy, ASC (center, second row). USA. © Kim Gottlieb-Walker.

to get women on the crews filming the Olympics. Walsh "worked on the Capi film, a feature documentary about the Olympics. Brianne and Margaret Ann Miller both turned it down. There were a couple of other women working on it, including Madelyn Most."

When Most arrived in Los Angeles in 1984, she made contact with other camerawomen in the area. Most had prior experience of women's support groups from working in London and New York, so when she moved to Los Angeles, she says, "I had my feelers out to meet

other working women." She also had "this little house in Santa Monica with a big back yard" to which she invited the BTL group to practice on borrowed camera equipment. She had access to equipment houses through her husband's connections. "I had enough clout with Panavision that I could borrow cameras for the weekend," and when she realized that many of "the women didn't have experience working on big 35mm cameras, on Panavision," she used that clout. "They needed to lace up cameras, to load magazines, to get their confidence together. That's what you have to do. You have to beg, borrow, and steal equipment in order to be trained." This session was essentially an early BTL workshop.

When Kirsh moved from New York to Los Angeles in 1978, her initial efforts to get women in the union to band together had been unsuccessful because the women were afraid or, as Kirsh claimed, the union had been successful at dividing the women among themselves. Kirsh said, "When BTL formed all those years later, I was surprised. There were more women on sets then, so perhaps they weren't afraid of coming." BTL spread from Los Angeles to New York because more camerawomen started talking with each other. According to Kirsh, "A lot of camerawomen [in New York] heard about Behind the Lens. In 1985, I think, several of us got together since I was visiting [from Los Angeles] and we had an informal meeting."

In Los Angeles, Kirsh was "organizing technical symposia. I organized a symposium in North Hollywood on how to mount cameras on helicopters. Everything having to do with shooting in, on, or around a helicopter." Walsh remembers that symposium well:

We had a training session for Tyler, the helicopter mounts,[12] that was wonderfully done. I can't remember how many hours it lasted, but it was an extensive introduction to their equipment. That kind of exposure is not just helpful, it's enormously vital, because when you're hired, there's so much that you're expected to already know, and when you go out and prep equipment, it's an enormous help if you know people at the rental house prior to that so that you know who to ask for, you know where to go, and it makes the whole experience a lot smoother and a lot more efficient.

Besides Most's husband, other men such as Haskell Wexler were highly supportive of BTL. Kirsh remembers that Bob Primes, ASC, "gave us a speech at Behind the Lens." Heather MacKenzie credits John Myrick as having hired five women to work at KABC-TV. The 25 supporting members listed in BTL's 1989 Membership Directory included fourteen male cinematographers in addition to Wexler and Primes, as well as two soundmen, a camera rental house owner, and a grip.

BTL was an important networking organization for women behind the camera beyond Los Angeles and New York to Mexico and Sweden.[13] For Celiana Cárdenas in Mexico, "It was something new to see that other women had the same interests I did in this branch of filmmaking."

BTL was especially good at helping members to learn new technical skills. Carson, who served as one of the first presidents of BTL,[14] worked with The Burbank Studios to set up a program to help women train as loaders in their camera department:

Some women were able to get jobs as a direct result. We also worked with the union to encourage them to hire more women into their Camera Assistant Training Program. They got more women, percentage-wise, than they had before.

One of the great things about Behind the Lens was that, because we met on a regular basis, people got to know and trust each other. We learned, just by being together, what the other people were doing. Because we became friends, we hired each other and that helped everybody.

By the mid-1990s, it became logistically difficult to maintain BTL as an organization, partly because the more successful camerawomen—successful in part due to BTL training and job networking—were too busy working to carve out time for active ongoing participation, while many less successful camerawomen were too broke to pay their dues. Also, rents had gone up at a time when BTL wanted to maintain an office and an archive in a space large enough for meetings and screenings.

After BTL ended in 1996, some of the camerawomen who had not already done so joined WIF. Others preferred the new group, CineWomen Los Angeles, founded in 1990, which seemed to them more actively inclusive of below-the-line concerns. Its membership renewal notice from around 2001 claimed, "Unlike other organizations, only CineWomen encourages creative and supportive environments where members can network and share resources and information. […] We collectively battle all discrimination in the industry, including ageism." It had several hundred members and supported emerging filmmakers through seminars, networking, a screening series, and events. Its networking featured subgroups for camerawomen, editors, directors, and writers to share information, ideas, and career strategies. CineWomen New York, founded in 1994 and incorporated as a nonprofit in 1996, included camerawoman Claudia Raschke Robinson on its Advisory Board. CineWomen New York described itself as "a grassroots, multicultural, multiracial organization, whose mission was to support the work and advancement of women in the film and television industries" ("CineWomen New York"). CineWomen New York merged with NYWIFT in September 2008.

In January 2012, Beth Dubber started Camerawomen Los Angeles on Facebook because "I saw a need for women on the set to communicate" (Dubber). Their mission is "to provide women, who work in the camera department of the film and television industry, with a place to discuss technological advancements, sharpen skills, generate ideas, showcase personal talent, and to improve and enhance the image of women both on-screen and off-screen" (Dubber). Two years after establishing their organization via word-of-mouth, they had 400 members (Dubber).

Women-Supportive Workshops and Production Groups

For me, as a teacher now, watching my students, it seems the hardest thing for women is getting the training and the opportunity.

(Naomi Wise)

Training via workshops has played a role in many camerawomen's careers. For example, in the early 1970s, a period of social change when the Australian federal government was freeing up legal and social constraints around women, Erika Addis heard about the Sydney Filmmakers Co-Operative. One of many Australian women who wanted to take up filmmaking as a form of political action and personal expression, Addis knew that women in Sydney and Melbourne were doing political work making films. But she was living in Adelaide, 1500km away from Sydney.

> There wasn't a corresponding group producing films, although there was interest. The entire Australian film industry in the '70s consisted of a small number of people working in Sydney. In Adelaide there wasn't a sense of there being a body of people to learn from. The group I was involved in, Womenvision, was instrumental in organizing for the training workshop to occur in Adelaide for women to learn how to make films.

In 1975 Addis, who had been working for the Bureau of Census and Statistics, participated in a three-month film production workshop financed by the brand new AFTRS.[15]

> It was the International Year of Women, and there was federal government support for programs encouraging women into the workforce. The group I was working in at that workshop got to make a film. Everyone in my group looked at me and said, "You can do the camera." We'd all been democratic about everything; everyone had the same experience with working with that camera. But when it came to the crunch, they were happy that I took it up, as was I.

After the workshop, Addis went to Sydney and studied cinematography at AFTRS for three years. "It was unbelievably intense, a minimum of an 80-hour week for two years."

Sharvit took a camera workshop to improve her technical proficiency. Returning to Israel at the age of 24, she attended film school at Tel Aviv University. Cinematography was a job for big, strong, serious men, she thought at the time. Another obstacle was that her film school emphasized being a director. They had a cinematography class only once a week, where Sharvit was shooting exercises for herself and colleagues. She worked for a few years as a director, making two documentary movies before realizing that her passion and talent were behind the camera. "Shooting my own films gave me confidence to say out loud that I want to become a cinematographer."

Sharvit knew she needed to improve her skills, but Israel seemed to lack any place to study cinematography that was supportive of women. She flew to the United States and took four cinematography courses at the Maine Media Workshops where her teachers were experienced gaffers and cinematographers from Hollywood. She found it to be "some of the most meaningful training I ever had." Her class had two other camerawomen (among nineteen students), a Canadian and a Norwegian. "There I understood how it should feel to be treated equal to men as a cinematographer. Because America has a long history in film, the attitude is much more professional and open than in Israel."

For Canadians as well as Australians, their central government's acknowledgment of feminist demands created opportunities in the 1970s. Naomi Wise reported that the Canadian government thought women needed opportunities in technical fields like camerawork, and therefore opened up programs for women. "I was trained at the National Film Board, partly with the regular program, but there [was] a program with Studio D,[16] a women's studio. They [had] training for young women in technical fields, both camera and sound." Dirse recalls that

> Studio D was very encouraging about trying to get more women technicians. When I moved on to be a cinematographer myself—which only took about three years because I was ambitious to start shooting—suddenly there were two cinematographers, Susan Trow and myself. And by then we'd already trained several women.

However, Wise notes, as this cohort of women tried to join the industry, they found it unsupportive. Furthermore, in Canada, Australia, and elsewhere, the waning of the women's movement combined with an economic downturn meant the loss of those training opportunities as government-supported media organizations once again closed off doors to women.

In 1999 the goal of changing the gender imbalance within the Swedish film industry led to an all-female network named Doris and, a decade later, to "The Doris Manifesto," which delared that

> The scripts are to be written by women.
> The films must have at least one female lead.
> All creative A-positions to be filled by women.
> Original score to be composed by women.

> ("The Doris Manifesto")

Despite an original lack of support from the Swedish Film Institute (SFI)—it agreed to consider the women's films only on a case-by-case basis—the Doris Manifesto resulted in seven short films. The DPs of these films were female, including Ragna Jorming, Ellen Kugelberg, Andra Lasmanis, Sophia Olsson, and Charlotta Tengroth.

For Doris Film, this was just the beginning; they wanted to increase the number of women directors beyond its 2009 level of 20% of all feature films made in Sweden ("The Doris Manifesto" 5).[17] By 2009 they were getting SFI support, at least for the brochure announcing their manifesto. Soon, the SFI itself would announce that

> the current National Film Agreement for 2013-2015 contains an equality directive which states that "the funding shall be divided equally between women and men" in the key positions of director, screenwriter and producer in those projects which receive funding from the Swedish Film Institute.

> ("Gender Equality in Swedish Film")

While the SFI does provide "statistics relating to the division of men and women in Swedish film," they are for "the key positions of director, screenwriter and producer" and do not include cinematographers ("Gender Equality"). Nonetheless, we can see that keeping statistics can help achieve gender equality in the workplace.

Filming in the Service of Social Activism: Video SEWA and Aina

In the middle of the last century, following technological developments associated with World War II, filmmaking equipment dropped in cost and weight, making it easier for nonprofessionals to produce their own visual images. For women in those countries where Second Wave Feminism had some impact, the need for consciousness-raising material prompted an interest in learning to produce such material themselves. In later years, in India and Afghanistan, for example, teaching women basic film skills has come from a similar desire to publicize women's issues, this time in relation to more specific, local problems. A bonus from this practice has been growing self-esteem among local women.

In India Video SEWA focuses on women's health and economic needs to increase public awareness and to press the government to take action. SEWA, the Self-Employed Women's Association, is a women's union based in Ahmedabad, Gujarat, India. Ela Bhatt, its founder, explains that, among other things, it has fought to improve the lives of members such as women market vendors by clarifying the laws about market vending and their implementation by the police. As a result the vendors, primarily women, have fewer problems with fines/bribes to be paid to the police. SEWA trained its own members, including Leelaben Paben, to work as part of a film crew.

Paben used to be a fruit and vegetable vendor in Ahmedabad. At SEWA, she saw a film for the first time "in a small box" (a TV monitor) and was delighted: "They showed the whole world in it. It is such a valuable thing. After seeing the film, we were told that if anyone wants to learn about [how to make a film], that's why they had come."

Video SEWA started teaching women video around 1982. Paben says they taught educated women, seamstresses, women who rolled cigarettes, and market women like herself.

> When I got into video, I was nervous at first since I was not educated. In India, video can be so helpful to women. Even educated women learn [through Video SEWA]. Poor women have learnt about cameras [despite being poor, and] getting this knowledge makes them feel proud.
>
> [For example, some] women produced a small film showing their miserable lifestyle as market vendors. Loads of questions came out. The film reached the Supreme High Court. They got help from outside in regards to licensing, police cars, and trafficking.

For "a film on water," Paben continues, the Video SEWA group showed that

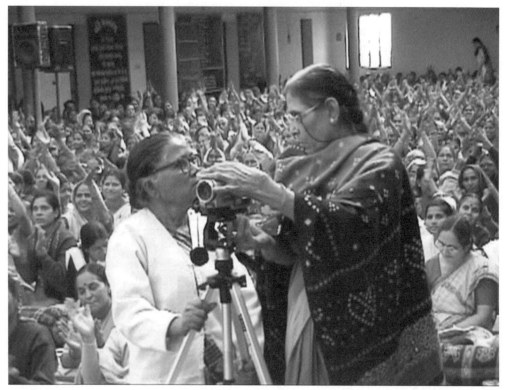

Figure 7: Leelaben Paben (center left), Video SEWA. Ahmedabad, India.

the slums only had two taps, so bathing is out of the question. Those going to work at 5am had to interrupt their work to go fill water. We got donations from outside to help this situation. The women got more time for work. They now have water for baths and there is decreased sickness. Now, in every house, there is a tap and gutter lines were installed.

Video SEWA has gone from strength to strength. Having made a film,

that film was shown in every village, and in those villages we then made films on women who have difficulties. We showed these women these films and they got strength that something can be done for them as well. Having these women talk [to] the camera and then show it to them—they feel proud and get encouragement. Most of these women have become camerawomen now. They hadn't even come out of their houses before.

In addition to influencing policy-makers through their work, simply seeing themselves on screen helps the subjects of Video SEWA's films gain self-esteem and sometimes status within their communities—as was the case for the women involved with documentaries as part of Second Wave Feminism. For Paben and the other women who have gotten involved, the respect they now receive is only part of the changes in their lives. Though Paben described herself as "uneducated," she and other women did not find it difficult to learn to use the camera. The camera is simply a practical tool she can use to document her world in order to change it. Paben and the others learned on old video technology, but now SEWA can offer its camerawomen new technology in order to make more wide-reaching films. Video SEWA has sent Paben and other women to Germany, a trip beyond their wildest dreams, as well as to Nepal. They have also taught women in Bangladesh how to use cameras.

The Aina Media and Culture Center in Afghanistan has similarly trained Afghan women to use cameras. Based in France, Aina is "a third-generation humanitarian association" that has trained women in Afghanistan to operate cameras, resulting in more women able to document the world around them through moving images.[18] Mary Ayubi explained that after the Taliban regime fell in November 2001, Aina gathered 20-30 young women together in Kabul, Afghanistan's capital. Aina gave the women cameras, teaching them how to do journalism and how to make documentaries. Two Finnish women, Anne and Christina; a British woman, Polly Hyman; a French woman, Brigitte Brault; and some women from other countries taught the Afghan women. "After three months, they selected six out of thirteen people to be employed," Ayubi reports. "I studied to be a doctor for one year, but when I heard about the training program for digital camera, I was so excited to take a camera and learn how to use it, and I did."

Ayubi and her fellow camerawomen's first film, the Emmy-nominated *Afghanistan Unveiled* (Brigitte Brault; 2003), was made in difficult circumstances. As Mehria Aziz, another camerawoman in the group explained, the camerawomen could not work individually because "it is not possible to go alone outside—the people would stab us." But while danger was pervasive, Ayubi adds, "If any one of us had problems, others tried to help. We supported each other in the hope that we as women could work with our cameras."

Distribution was just as hazardous for the Afghan camerawomen, when it came to trying to show their completed films in Afghanistan. After *Shadows* (2005), a film about Afghan women's rights co-directed by Ayubi, aired in Kabul, the Taliban stoned Ayubi. She and her immediate family currently live in exile in the United States.

Other women's organizations that have offered training in video skills to women include the Center for Mayan Women Communicators in Guatemala and Jerusalem Link. Jerusalem Link is "a group comprised of two autonomous organizations—the Israeli Bat Shalom and the Palestinian Jerusalem Women's Center," which offered an extensive introductory course in making videos to both Israeli and Palestinian women in the 1990s as an experimental approach to peacebuilding (McKay and Mazurana 39).

Collectives

During the early 1970s some US women got training by participating in New Left film collectives. For example, shortly after a group of men formed the "Marxist film collective" Cine Manifest in San Francisco in 1972, they invited Judy Irola, ASC,[19] to join (Fisher, "Red Reelers"). "The group was committed to pooling its talents and resources for the purpose of making films that reflected its idealistic social and political philosophies" (Fisher, "Red Reelers"). Irola took the opportunity and learned to shoot, leading to a long career behind the camera, culminating in her becoming the head of USC's cinematography program in 1999. Christine Choy got her first camera training in New York via Newsreel in 1971; she helped to found Third World Newsreel in 1972. A film distribution company, among other things, Third World Newsreel "remains the oldest media arts organization in the US devoted to cultural workers of color and their global constituencies" ("History").

Women-focused video groups and media collectives have appeared around the world. For example, feminist groups in Central and South America have included Cine Mujer in Colombia, Cine Mujer-Mexico, and Grupo Miercoles-Venezuela. In the United States, video groups have included the Santa Cruz Women's Media Collective, the Stand Up for Choice project in Washington, D.C., the Media Coalition for Reproductive Rights in Buffalo, and the Women's Video Collective in Boston, which made the video *Our Bodies/Our Choice* in the late 1980s. Pro-Choice video collectives such as ReproVision also functioned as important components of women's rights organizations "such as the Women's Health Action and Mobilization (WHAM!) in New York and the Bay Area Coalition for Our Reproductive Rights (BACORR) in northern California" (Larsen 27).

When NOW, the National Organization for Women, was founded, one of its key goals was to improve the representation of women. The need in 1960s Britain and America for documentaries to promote feminist causes and general consciousness-raising led women there to take advantage of equipment increasingly available to the nonprofessional. The technology for documentaries was now more accessible and the costs more affordable; meanwhile, there were lower expectations for production values in documentary. Many women—for example, directors Martha Coolidge, Joyce Chopra, and Claudia Weill— honed their skills making feminist documentaries before moving into other sorts of filmmaking.

Women's groups still exist, still producing and distributing documentaries through their collective networks. Sometimes it can be easier to get one's film screened to smaller, targeted audiences than to reach mainstream media. Ayubi, e.g., alludes to difficulties getting material shot by the Aina camerawomen onto Afghan TV screens; it was always more likely to be screened at a women's film festival or other specialized venues outside her own country.

Distribution is a problem for all filmmakers. Describing early 1970s Australian filmmakers' cooperatives formed in Sydney and in Melbourne, Addis notes that they distributed artists' films and documentaries in theaters and in the educational market.

At that time most of the films were not broadcast on television. So the Melbourne and the Sydney co-ops were both vital organizations; they were home to groups of women filmmakers whose work was distributed through those cooperatives. [My film] Serious Undertakings [Helen Grace and Erika Addis; 1982] was distributed by Sydney Filmmakers Co-Op.

In New York City, Joan Giummo co-founded the Feminist Video Collective in 1968, including women who had been working at the Public Broadcasting System (PBS). The PBS women "had been working in situations where the subject matter was not of particular interest to them. So they thought of this period of unemployment as breathing space. They could pursue what interested them." According to Giummo, Feminist Video Collective decisions regarding production and postproduction were made collectively and nonhierarchically. Within this collective Giummo got "enthralled with the idea of exploring stories. Real stories are terrific." "Technically," she said, the collective "was a haphazard affair. We had many mishaps learning how to use the equipment. But we never had any problems deciding what we wanted to explore in terms of content. The world seemed to be ripe with content."[20]

Madelyn Most got involved with the London Women's Film Collective. They put an advertisement in the magazine *Time Out* that they were "making a film about women and mental illness," which would deal with "image and being beautiful." They were a diverse group of women: "Anne, [who] became a producer/director at the BBC; Elaine, [who worked with] Cesar Chavez and the farm workers; Lenny, who now does lighting." They met on weekends, supported each other, and "developed films together."

Sabeena Gadihoke in India and Berke Baş in Turkey describe their collectives as being politically committed to bettering women's lives. With five other women, Gadihoke formed a non-hierarchical women's collective called Mediastorm Collective. For Gadihoke, it was good to work where no one gave orders but everyone took suggestions. At a time when "nobody would have taken me on as a cameraperson" because "it was unheard of for women to do the camera," she says, "if other women in class or in the collective required camera work, they would ask me to do it or I would offer. That helped me sharpen my skills."

The Mediastorm Collective made three films (although Gadihoke did not do the camerawork for all of them). The first was a

film on divorce legislation; the second film [From the Burning Embers; 1988] was on sati, an antiquated custom that was suddenly brought back in a village in Rajasthan, the state which has the lowest literacy rate and very poor status for women. Then the Mediastorm Collective made a third film on the rise of Hindu fundamentalism.

After the Collective made these films, Gadihoke says that individual members "started making individual films on underprivileged women all over the country, whether it was a film on literacy or on professions for women or a film on gender and technology." She herself has worked frequently with a university colleague, Shohini Gosh.

Berke Baş is a member of Filmist, a collective of six people—five women, one man—who are friends and filmmakers in Istanbul, Turkey. Baş describes how her collective has weekly meetings when, among other things, they discuss "how we can help each other realize our dream of making films [and] creating work opportunities for each other." They all shoot their own films and most focus on documentaries. If one finds a job, he or she hires a person from the collective. They have made a feature-length documentary about women candidates who were running for Parliament called *What a* Beautiful [sic] *Democracy!* (2008) that has screened at several national and international festivals, winning the Critics' Prize of the Turkish Association of Film Critics in 2008. It also aired on ARTE (French television) in 2010 under the title *Démocratie au Féminin* ("About Haşmet Topaloglu").

Rental Houses[21]

I ended up at Trata Films, the rental house that deals exclusively with Panavision in Mexico. There [Eduardo] de la Barcena gave me the opportunity to intern in his company and learn the cameras. This became a very important moment for practical training with cameras and opportunities to meet camera assistants and directors of photography.

(Hilda Mercado)

Over and over again, senior camerawomen advise beginning camerawomen to practice. Where do you go to find equipment to practice on? To a rental house, the surest place to find well-maintained equipment in the care of people who know how it works. Many women have found such companies to be helpful.

Glover and Walsh credit Denny Clairmont, President of Clairmont Camera, and Otto Nemenz, President of Otto Nemenz International, for supporting women entering the industry.[22] Both women found Clairmont and Nemenz amazingly kind and patient in letting the women, as Glover put it, "come in and play with the gear and check it out [and] borrow it." In addition to his patient teaching, Glover owes Clairmont for his introductions. For example, she was looking at some camera equipment at Clairmont's when Haskell Wexler came in: "Denny very kindly made a point of introducing me to Haskell Wexler, saying, 'This is Kristin Glover. She's a great camera assistant, Haskell, and you ought to hire her.'"

Several Los Angeles rental houses participated in events for CineWomen and BTL. For instance, a symposium on the Ultracam-35 was held for BTL members at Leonetti's Cine Rental in Hollywood in December 1984, with Leonetti's Steve Ullman on hand to demonstrate the use of the camera (Krasilovsky, "Ne Plus Ultra" 1). BTL member Laurie Towers also acknowledged Leonetti's attentive service while supervising the design of a multi-filter matte box for DP Ron Garcia: "Thanks to Steve and the rest of the camera department, the adjustable six-filter configuration was delivered and working within the week. They really went out of their way to be of assistance" (9-10).

Many rental houses have allowed women inside to "play," either as interns or paid employees, or even just to hang around. Once Sharvit decided to focus on camerawork she "started to read lots of books about cinematography, spending time in camera rental houses reading manuals and 'playing' with the cameras." Swain worked at a facilities house in London, Madelyn Most worked for "AKA, a noted camera company," and Alicia Craft Sehring worked for Otto Nemenz, getting to know cameras inside and out by learning to clean and fix them.

Canadian Kim Derko, speaking at a WIFT-organized panel in Toronto along with other camerawomen,[23] urges women—even those already working in the industry—to spend time in equipment houses:

> The only way for the women who are working in the industry to be really good [is to] go to the equipment house and practice every day on their day off. Perhaps they need to practice ten times more than a guy. Pull yourself up. You have to use that initiative and educate yourself.
>
> (Moffat)

Of course, not all rental houses are helpful and certainly not all the time. Glover, for example, met with sabotage from rental houses. Sometimes, when she was a camera assistant, she would go to the rental house to check out equipment, but "when it was shipped, they would have flipped the ground glass on the BNC[24] so that everything came out out-of-focus. That kind of stuff was far more prevalent and far more insidious [than physical harassment]." Glover became vigilant about rechecking her gear.

In India Gadihoke often had to demonstrate that she could handle the equipment before she was allowed to take it away. At first the "camera-hire shops" could not believe that she was the camerawoman.

> They'd say, "Do you know how to operate the camera?" It was tough because sometimes I didn't know all the cameras. You come out of film school and you know one camera. By now we were moving from U-matic low band to U-matic high band or high band SP into Betacam. I didn't know how to operate some of those cameras; they had new switches I wasn't sure about. I'd look at a new button and get scared; there was never that confidence to be able to ask. The thing with technology is that when you're already technophobic, it's added to by the mystification of technology around you.
>
> At the camera-hire shops they would say, "Fine, you're taking the camera. Aren't you taking the tripod?" By now, I felt more comfortable shooting on shoulder. They'd say, "But will you be able to take a steady shot?" I'd say, "Yes," and we'd do a test run. We'd be looking at the monitor and ten people would be looking over my shoulder to see whether I'd take a steady shot. It was always more or less steady.

Things have changed. By 2006 a camerawoman such as Jendra Jarnagin not only might not have to show that she could operate the equipment, she could herself be the one demonstrating

how to operate the latest in cutting edge technology. Indeed, for Jarnagin, "working as the 'resident DP' at Red's trade show booth at the National Association of Broadcasters in 2006, the year the [Red One] was announced, was a big turning point for me professionally in terms of my reputation for being a digital cinema expert and pioneer."

Extrapolating from the information in this chapter, we can conclude a few things about how to increase the numbers of women in professional camerawork. (The role that directors and producers play in augmenting the opportunities for professional camerawomen will be discussed later.) First, girls and young women need to know the possibility is there. In addition to putting role models in front of them through the media, girls need to learn about professional camerawork through the same channels they would learn about other professions. School counseling could be helpful, and perhaps the sorts of changes needed in this area can be promoted by more general women's organizations, such as the American Association of University Women and NOW. That is, organizations with an interest in women's educational possibilities generally might be persuaded by WIF and other groups more specifically associated with camerawomen to include camerawork when they promote girls' greater access to work previously thought to be for males. WIF itself, through its chapters, might engage with local schools, including offering speakers to promote women's work in professional filmmaking.

The camerawomen themselves who are living role models are generally generous with their time—but that isn't enough. Films and books such as *Women Behind the Camera* and this book contribute to publicizing women's involvement in the profession, as do academic studies and activist websites. Melissa Silverstein, for example, has built on the basis of her "Women and Hollywood" blog to become a regular contributor to mainstream media outlets such as *Forbes* and the *New York Times*; she regularly uses the Lauzen studies, for instance, to make her point. A more specialized source of information about camerawomen is the *American Cinematographer*, which increasingly includes camerawomen in its profiles of cinematographers.[25]

A second important strategy for increasing numbers of camerawomen is networking. Beginners at all levels need to look for mentors specifically for camerawork. One wants especially to find people who can offer work experience in camera crews, immediately and/or in the future. However, mentors from other professions, whatever the field, can also be helpful, because camerawork, as we shall see in later chapters, requires more than technical skills alone. So one's idea of useful networking connections needs to be broad. Social media sites such as, for example, LinkedIn, promote connections between people who might help each other professionally. Engaging in networking and some inevitable self-promotion may not be what the aspiring cinematographer wants to be doing, but it's a part of the job for most successful camerawomen.

Third, turning to more specific tips, aspiring camerawomen must be prepared to work for free to get started. Look for internships, but do research the nature of an internship for its value to one's own goals. Maybe an intern spends a lot of time making coffee, but perhaps one could learn from other aspects of the experience?

In any event, beginners need to remember—with internships, mentors, even the apparently least likely source of help—that they have a lot to learn. Always be polite and helpful. Be quietly persistent. Be present: Show up, show up on time, and show up ready to learn and work. When you get a chance to watch people at work, observe and listen; talk as little as possible. Being obsequious isn't necessary, but do be prepared to be subservient. Above all, show respect: for the people working, for the work itself, and for oneself.

We have also learned in this chapter that camerawomen continue to want and need further training after they've learned the basic technical skills. As Hilda Mercado and Irit Sharvit pointed out, although they ended up getting their further training in the United States, they researched their worldwide options thoroughly before making their choices. It is also important for working camerawomen to reach out to their peers for mutual professional support, but equally importantly for personal support. Until more women are working behind the camera, the psychological toll of isolation is more serious than people might realize. The good news is that the pioneers are no longer alone.

Notes

1 "Translights are enormous backlit photo transparencies" (Drexler).
2 Best known for his work on social activist documentaries, Kuttner has a long list of feature film credits as first assistant.
3 As a still photographer, Canadian Joan Hutton, CSC, said, "I'd been doing sequential slide shows—portraits of people—that were like a series of pictures. Rather than knowing I wanted to make films, I was doing it in still. It was a revelation when I discovered movies."
4 A CIEE program begun in the 1970s, known among its participants simply as the Paris Film Program. It involved a consortium of geographically diverse US universities. Today it is called Critical and Francophone Studies, with a lesser emphasis on film studies.
5 One of Detroit's oldest high schools and its first magnet school.
6 One of the basic professional photographic formats, 4 x 5 is used for large images.
7 Information about Churchill and quotations from her come from Fisher, "A Conversation with Joan Churchill, ASC."
8 Which has also produced such filmmakers as Sharon Alile Larkin and Charles Burnett.
9 Perhaps the most famous example of a director's choosing to stick with her camerawoman from film school is the collaboration between Jane Campion and Sally Bongers on *Sweetie* (1989). Both women have acknowledged the other's contribution toward establishing their careers.
10 See "Chapter Profiles" for a complete list.
11 Author's note (Margolis): Having participated in WIFT-organized workshops in the 1990s as well as a decade or so later after the appearance of the Red digital camera, I can support Gunn's point. In fact, these workshops seemed designed to help directors and producers understand the technical aspects of choices they would need to make, with the consequences in mind of the effect these choices would make on the budget and on distribution.

12 The Tyler Camera System helps to stabilize helicopter camera mounts ("Tyler Camera Systems").

13 Special effects camerawoman Laurel Klick joined BTL while in New York, before her move to Los Angeles, and before she changed jobs to digital video effects editor. Mia Turos, a Swedish cinematographer, was also a member.

14 Other BTL presidents included Susan Walsh, Liz Bailey, and Michele LeBlanc.

15 The Australian Film Television and Radio School began in 1973 as part of government initiatives in the 1970s to revive the Australian film industry. At the time there was concern about the country's national identity, which seemed to be under threat from outside influences, i.e., Hollywood. Gillian Armstrong was in the first class; Jane Campion and Sally Bongers also studied there.

16 The NFB supported Studio D between 1974 and 1996 (see Vanstone).

17 In contrast, women directed only 9% of the top 250 Hollywood films during the same year and only 2% of the top 250 Hollywood films were shot by female cinematographers in 2009 (Lauzen, "Celluloid Ceiling" 2010).

18 Aina's mission statement says that it "contributes to the emergence of civil society through actions in the area of education (particularly focusing on women and children), information and communication. Aina promotes independent media development and cultural expression as a foundation of democracy" ("Aina Mission").

19 This was at a period in Irola's career before she was invited to join the ASC.

20 One example of a Feminist Video Collective project was a videotape of interviews about menstruation from the points of view of menstruating women rather than of medical experts. [Author's note (Krasilovsky): I was briefly a part of the Feminist Video Collective, but left to direct and shoot *Blood* (1975), a fictional short on menstrual rage.]

21 In English-speaking countries, "rental houses" are also known as "equipment houses" (United States and Canada), "facility houses" (New Zealand and some other countries), and "camera-hire shops" (India).

22 Both Clairmont Camera and Otto Nemenz were listed as supporting members of BTL (*1989 Membership Directory*).

23 All quotations from Derko come from the transcription of this panel (Moffat).

24 The Blimped News Camera or Blimped News Camera Reflex is a type of mount for camera lenses. The blimped housing has technical advantages, but adds significantly to the weight.

25 Both the short forms appearing in print as well as the longer forms online. Since the 1970s these interviews have "provided a … forum for the members of the craft to tell their own history" (Keating 2).

Chapter 2

How hard can it be?

Gender Discrimination

The most obvious example of covert discrimination is when you don't get the job. You know it's not a lack of qualifications; it's either gender-based or ethnicity. Unfortunately, you can't prove it.

(Mary Gonzales)

When Polish camerawoman Jolanta Dylewska was in film school in Łodz in the late 1980s, the film school dean told her and a fellow student from Germany that if they wanted to be hired as camerawomen, they had to be better than the men. Dylewska agreed with her professor, although she thought the situation would slowly change.

Some of the reasons male film workers have given our interviewees for why women do not belong on film crews include the following: Working together with women can be awkward for men; there might not be a toilet available for women; women would have to sacrifice boyfriends or family for career (a sacrifice men apparently are not asked to make); women are not physically strong enough to do the job; women cannot cope with the noise, the stress, etc.

Many of the camerawomen interviewed have thoughts about the causes of discrimination as well as possible solutions. However, we will spend some time first with stories of individual camerawomen's experiences of discrimination.

Camerawomen working in the 1970s heard many negative comments from men. In Los Angeles, TV news camerawoman Heather MacKenzie would be told, "There you go, taking the food out of our kids' mouths." She would just smile back and think about her own family and their needs.

In 1974 Margaret Moth was being written up in newspapers as the first camerawoman in New Zealand. She also experienced discrimination on her first jobs. She remembers one reporter saying, "I don't want to have to work with a woman. I have to go home to my wife every night. Why should I have to work with a woman in the daytime, too?" Although such comments upset her, "I felt I shouldn't let it upset me. I should deal with it. Dealing with it makes you stronger. Things have upset me over the years, but everyone has things in life that upset them, at work, at home, that you have to deal with. I've tried to keep it in perspective like that."

The negative comments Moth heard then, she thought, would never be said decades later. But while Indonesian camerawoman Angela Rikarastu reports hearing similar comments today, she also shrugs it off, saying, "Actually, I like challenges."

American Kristin Glover, though, objects that job protectionism and chauvinism are not always possible to shrug off and that they take many forms, including men trying to get women fired. She remembers working as a camera operator on a situation comedy in the late 1990s:

> *My dolly grip and camera assistant were hostile from the start. They refused to take any direction from me and did their best to sabotage me. Perhaps they were jealous because I was making a little more money than they were. They seemed to hate having a woman as their immediate boss. I think their aim was to get me fired so that they could get one of their buddies in. I finished the season but it was hell.*

Also in the 1990s, Glover recalls being replaced on a job because, according to her boss, he needed to give his friend a job because his friend had a wife and child to support. Glover had herself and her own family to support, but the psychological impact of this firing was also damaging: "It takes time to recover from those kinds of blows. It makes you question your value. Even if you know it was political or chauvinist, it still undermines your confidence. Which is what it's meant to do."

Glover sometimes learned that she had been kept off a job because someone in the industry did not make the call to let her know that a DP had requested her. Later, someone, perhaps the DP in question, would say, "I guess you weren't available," and Glover would realize that she never received the call and that someone somewhere in the chain of command did not want a woman on the camera crew.

Once, in the mid-1980s, when Glover was trying to promote herself to DP, she showed her reel to a male colleague who was a successful commercial cameraman. "He looked at my work and said, 'Oh my god, it's terrific. It's really sad, because if you were a guy you would have been DPing years ago.' He was a supporter, he was being positive, but it's a depressing statement."

Camerawomen are not asking for special favors. American Estelle Kirsh made this clear around 1980.

> *A camera department head of a major studio, about to offer me a job for the season, first asked the First AC, "Would you mind working with a woman?" I often thought, would he ask, "Would you mind working with a black? Would you mind working with a Hispanic?" What I kept saying was, "Don't hire me as the token female, and don't deny me a job."*

Years later, Irit Sharvit faced much the same sort of discrimination in getting hired in Israel. In 2004, she thought the main challenge for camerawomen was to overcome the stereotypes of what women could or could not do since "many directors, producers, grips, soundmen,

and so forth, still find it strange to work with a camerawoman. Some feel threatened by the presence of women in such a dominant position. Some are afraid that the women are not strong enough to deal with the equipment." When Sharvit started her camera career in 2002, she thought everyone would support her. However, "there were cases when producers would search for a cinematographer, and a colleague would say, 'I have a great camerawoman for you,' but the producer would say that he wants a man." A decade later she could say that "the film industry in Israel is getting more and more mature, and there are always professionals that don't have any gender preferences."

What are workers supposed to do when there is discrimination? Sometimes threat of legal action arguably has a positive effect. Attorney Gloria Allred stated in 1987:

> Millions of women are affected by sex discrimination in employment, and they are economically disadvantaged by it. Where those women do sue and are successful, those cases are extremely important, because they are significant to millions of other women who do not know of their rights or who cannot afford to assert them. Camerawomen are in a difficult position because they are in a nontraditional job. A nontraditional job is a job that has been traditionally held by men and which by definition pays better. Exceptions to that are prostitution and nude modeling—the only occupations where women as a group can earn more than men as a group. Camerawomen are often in token numbers [...] They fear asserting their right to be free of sex discrimination because they fear being retaliated against by not getting a promotion, or by being demoted, or by being terminated, or by not getting another job, because they have stood up for themselves.
>
> (Krasilovsky, "Interview" 1)

Heather MacKenzie's long, exciting career in Los Angeles as a TV news camerawoman was in part due to involving the federal government. In 1977, she was working as a sound technician when a man in charge of the TV studio's camera work told her she would never be hired: "You'd be way too much of a distraction. You're too pretty and the guys would never be able to concentrate on their work." When MacKenzie and Marie Hernandez were camerawomen at ABC in the early 1980s, each woman was paired up with a man. The men shook on a pact not to let the two women shoot. When the two women found out, they complained to the news director who said, "We will not put up with this."

But in 1985, Capitol Cities took over ABC. The new owners eliminated jobs: They made only men camera operators, giving them the women's cameras, and they made all the women editors. MacKenzie, who had never edited in her life, was told she would be an editor until further notice.

They were so blatant about replacing us with the men that we took our case to EEOC [Equal Employment Opportunity Commission, a federal government agency]. We started to file. One of the ladies quit; she just couldn't handle the stress. The two other women, myself and Marie, we decided we did not want to go through the EEOC because they were

not handling the case right. So we dropped the case, but we got put back out in the field, which is what we wanted. They thought the women would be the least line of resistance. The new boss told me he didn't believe women belonged out in the field shooting, period.

To MacKenzie it seemed that camerawomen in 2000 still faced stigmas about being able literally to carry the weight, being able to take the pressure, being in a dangerous situation, and being able to cope. However, she is pleased to see more women in positions as news directors and producers because, believing in networking as she does, she anticipates a positive follow-on effect for the employment of camerawomen, women directors, and women producers.

Because most feature film production involves episodic employment, collective action and negotiation have largely been impossible. In a 2004 dialogue between Kristin Glover, who started doing Hollywood camerawork in the 1970s, and Liz Ziegler, who started in the 1980s, they discussed why there are so few female camera operators, Steadicam operators, and DPs. Glover believed that from the early 1970s to mid-1980s, the feminist movement made progress for camerawomen, but that was followed by a huge backlash against women, starting in the mid-to-late 1980s. She cited economic changes, including the outsourcing of Hollywood film work; she watched "white males get angry." This backlash has contributed to fewer women having been hired for the high-paying camera jobs in Hollywood (such as Steadicam Operator or DP). "The first people to get squeezed out are black or female, who are generally not on the 'A' list. And if you are not on the 'A' list, your chances of getting on it are very slim," Glover noted.

For perspective, Canadian Derko says that the number of women cinematographers in 1988 was 2.5% or a little less, and in 2008 it was still 2.5%. At that time, Derko remembers,

It was really only Joan [Hutton]. There were few people to look up to. I'm sad about the rate of attrition. We haven't helped each other up. I've seen amazing [women] focus pullers that haven't had the chance to be operators and step up in the union. I'm not sure what causes that. It's definitely social.

(Moffat)

Talking with Glover about camerawomen in Hollywood, Haskell Wexler observed that some cameramen get used to working with another male, and it becomes difficult for them to lose that relationship and work with a woman. According to Wexler, men pay lip service to having good cooperation with women, but he adds that cooperation should not be defined such that women have to be identical to men.

Women can give to the team process certain levels of perception and human interaction which most guys can't. That doesn't mean that some women can't be just as mean and tough and ornery and selfish as men. But as a man, as a filmmaker, I would like women to put into the pot not just their professionality, but their sensibilities.

Unions and Guilds

When I got in the union [in 1974] they just felt that women didn't deserve to be there.

(Sandi Sissel)

Not everyone likes unions. Arlene Burns condemns the fact that a union cameraperson cannot help a grip carry. The Hollywood feature film world she has experienced "doesn't encourage cooperation"; what it does do, she says, is to "encourage inefficiency because people train themselves to work longer and longer so that they can make more in overtime."

Israel and New Zealand differ in this regard from the United States: While working in the United States, Sharvit noticed that "the borders of each crewmember's duty are very clear and stiff" whereas "in Israel the line is blurry." "Pitching in," as part of the New Zealand national character, was frequently noted (and appeared in news coverage at the time) by American crew heads during production of *The Lord of the Rings* trilogy (Peter Jackson; 2001-03). Used to union jobs in the United States, the Americans were frequently surprised by the collective will to make *The Lord of the Rings* that they constantly met in New Zealand.

The inflexibility of union work does not always benefit those behind the camera. On *Eternal Sunshine of the Spotless Mind* (Michel Gondry; 2004), DP Ellen Kuras "operated the camera most of the time," but as she explains, "in a union situation you have to have a camera operator. It depends on where you are as to how much flexibility there is on that." This can be a problem, since "much of what I do is about operating the camera, because it is difficult to tell someone sometimes about a certain move."

Historically, camerawomen have had a range of union experiences, from founding and running union locals, to struggling just to gain admission into pre-existing locals, to struggling without a union at all. For example, Dolores and Adriana Ehlers helped found Mexico's first film industry union, "the Unión de Empleados Confederados del Cinematógrafo, affiliated with the Confederación Revolucionaria Obrera Mexicana (CROM)" (Rashkin 37). A photo of the Ehlers Sisters still hangs in the foyer of the cinematographers' union in Mexico City.

As recently as 1990, however, the Mexican union was rejecting female membership. For Celiana Cárdenas, this "proved to be good, because it motivated me to get out of Mexico, prepare myself, and continue working. I returned as a full-blown Director of Photography, now shooting my third feature film."

Turkey's union of cinema workers, Sine-sen, founded in 1978, does not include documentary film and video workers. The absence of a union in Turkey for these documentary workers, Berke Baş says, means that her camerawork is "not seen as a profession. You are not getting [medical] insurance; you're not getting pension rights. You have to provide all the resources yourself." Unions can be good for film workers in obtaining these and other benefits.

Documentary filmmaker Sabeena Gadihoke knows of no union in Delhi. But Vijayalakshmi, who works in the commercial film world and in a different part of India,

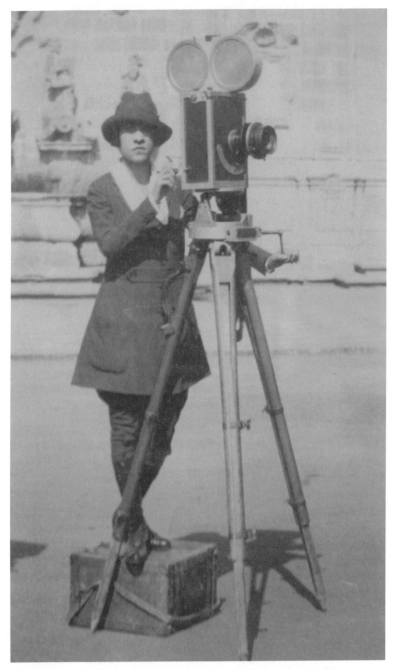

Figure 8: Srta. Ehler, Mexican camerawoman, 1910-20s. Photo courtesy of STYM (Sindicato de Trabajadores Técnicos y Manuales de la Producción Cinematográfica).

belongs not just to one but two cinematographers' unions: the Cine Technicians Union in Chennai and the South Indian Cinematographers Association. At time of writing, she was the only female member in both.

Similarly, Irit Sharvit reported, "There are three women DOPs out of 140 men in the [Israeli] union. There are another four-five camerawomen who are not in the union." The statistics for female membership show the same disproportionate ratio of men to women pretty much everywhere.

Zoe Dirse and Joan Hutton were the first two women in IATSE in Canada. Dirse got her "first job on an IA crew because I stood in a snow bank for two hours with a gaffer, and the crew noticed. I talked to the second assistant and asked him if he wanted some help. They invited me to lunch, and then they decided to take me on." Dirse said she got good training from IATSE and the people she apprenticed with. After working with the NFB, she joined another union in Montreal called AQTIS (Alliance québécoise des technicians de linage et du son). AQTIS readily accepted her because they allowed workers at the NFB "to automatically join without going through all the hoops —your point system and all that." Dirse became the first female DP in AQTIS. Dirse says that the "unions are opening up more now because there are so many women assistants. And the women are very, very good camera assistants."

When American Joan Churchill first went to England in the 1970s, everyone had to be in the union to work on films for British television. Churchill said,

> They had literally never heard of a camerawoman. In fact, twelve DPs tried to get me deported claiming I was taking food out of their mouths. The union finally took me in because a producer wanted to make a film about an abortion clinic and she needed a woman to shoot it. My first union card stated that I was a "lady cameraman."
>
> (Fisher, "Conversation")

In Hollywood's NABET (National Association of Broadcast Employees and Technicians) Local 531, it took until 1984 for a motion to pass—albeit unanimously—that "all future printing of NABET 531 materials (i.e., newsletters, contracts, etc.) will be non-gender specific" (Krasilovsky, "First Step" 4). The issue of nomenclature also extends beyond unions. In Austria, there is not much of a union for camerapeople, but there is an active Association of Austrian Cinematographers. When Astrid Heubrandtner managed to change the vocabulary of her colleagues from "cameramen" to "camerapeople" simply by always inserting gender-neutral language at meetings and in discussions, she did it because "only this way can it become possible for female colleagues and for camerawomen to break through the glass ceiling that exists."

We turn now, for the rest of this section, to look closely at the US camerawomen's union experience, for two reasons: Because Hollywood was for so long the dominant producer of films worldwide, with the largest union systems and membership, on the one hand; and, on the other, because we have had particular access to the history of these camerawomen's

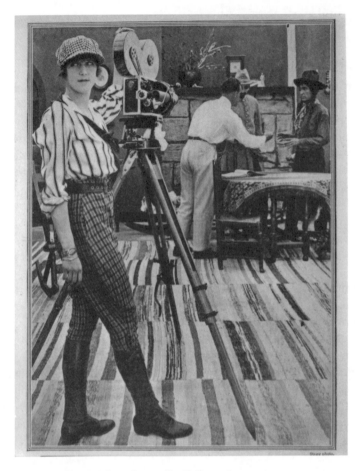

Figure 9: Margery Ordway, focus puller. Hollywood.

pursuit of gender balance at work. If, that is, the union is meant to care for the collective needs of its members, the camerawomen argue, then they and their needs should be of concern to the union. The men in charge have generally disagreed—and so there has been little or no union help, for example, with sexual harassment on set, paid parental leave, and other issues.

In the United States, screen industry unions and guilds formed early in film history. The first organization of cinematographers began at a time when cameras were hand cranked. The first "union camera maid" on record (1916) is Margery Ordway. When camerapeople were organized into IATSE (International Alliance of Theatrical Stage Employees) in New York in 1926 and Los Angeles in 1928, "camera crews finally had a voice at the negotiating table" ("History of Local 600" 3). By then, however, camera crews were male.

The decline of the Hollywood studio system in the 1950s meant that camera crewmembers—along with directors, producers, actors, and writers who also no longer had standing contracts—became independent contractors. How would independent contractors back up their claims to proficiency? From the producers' point of view, time is money, so camera crews need to work efficiently and quickly from the get-go. One reason that large-budget Hollywood feature films usually involve the unions is that it should guarantee that crewmembers come to the job with appropriate levels of training and experience. The union, in other words, has become an intermediary between producers and union members that vouches for workers' qualifications in the United States and other countries. At the same time, it demands certain standards of working conditions and pay from the producers.[1]

Although theoretically unions can do more, many camerawomen think that the most useful thing unions do for their members is collective bargaining for better pay and working conditions. Asked whether camerawomen earn as much as cameramen at ABC in Los Angeles, MacKenzie replied, "Only because there's a union that dictates that we all make the same wage."[2]

Over the years the US unions have gone through some permutations, and US camerawomen have sometimes participated in their unions' formation and leadership. Brianne Murphy's participation was key to organizing the Associated Film Craftsmen in Hollywood in 1953, which in 1959 became NABET 531. After NABET and IA[3] merged in the 1990s, she served on the Executive Board of Hollywood Local IA 659. Emiko Omori was the founder and first president of NABET Local 532 in San Francisco.

While getting into the union has often been a prerequisite for getting well-paid work in film or television, for many camerawomen, joining a union has presented insurmountable challenges. During the 1970s when racial discrimination was more blatant, Jessie Maple Patton had to deal with a white-male-and-sons union that had two white women members and Juliana Wang as the only minority woman member. "They didn't even have a card that said 'cameraperson'; the card said 'cameraman.' They didn't have any idea that black women would be interested in being a cameraperson, because that was a man's world," Patton recalls. As a black woman, Patton had two strikes against her, but being female was enough: "They [the union] had no respect for me or any other woman in the business. It was *their* business. The only thing they wanted a woman to do was bring them coffee, have their kids, and have them a good home-cooked meal when they got home."

Nonetheless Patton acknowledged support from her husband, a union member who understood what she was going through. They fought for each other, but there were few job opportunities for women at the three major television stations in New York—WABC, WNBC, and WCBS[4]—where the reporters and the camerapeople were male.

When they didn't want you, there were certain things that they did. The union would say that the station said that you can't shoot the news; the television station would say that the union said don't hire you. In order to break that chain, I had to go to court and sue all three networks for work. That was one of the things they had against me. I felt it was my

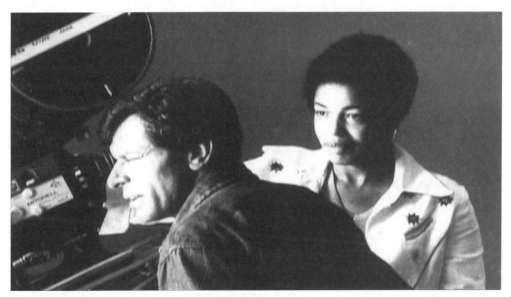

Figure 10: Jessie Maple Patton. USA. Photo credit: LeRoy Patton.

right to work. I was in a state where you had the right to work if you were in the union. After being turned down the first time, I won the case with CBS on appeal.

On Patton's first day working, nobody at CBS would help her; her husband walked her into the crew room, showing her where the camera and film were. "I withstood all the difficulties and abuses during that time," she remembers, "because I was strong and I knew what I wanted to be. I had to be focused because I knew they were going to test me. I had to be able to defend myself at all times."

Eventually, Patton recalls, things improved as the other technical staff got to know her and discovered that she was qualified, she did not belittle them, and she could do the job. She also still remembers a "1975 bulletin from the IA Union Local 644, known as 600 now. Juliana Wang[5] is on the cover. On the inside, I'm there and there are about ten women in different fields that they are featuring in 1975. They are so proud that they can say now they have some women in the business."

After *Ebony* did a five-page spread about Patton, she got many letters, cards, and telephone calls from males and females wanting to know how she had become the first black union camerawoman. As Jessie Maple, she wrote *How to Become a Union Camerawoman, Film-Videotape* (1977) to document her experience and answer questions. "It basically was a how-to book," she explains. "Each step I took to become a cameraperson and how I got into the union. Our company, owned by my husband and me, published the book. It was a small book but it helped both male and female, black and white."

In that same period of the mid-1970s, American Geraldine Kudaka tried for a long time to get into the union, having worked as a camera assistant for the previous five years (Krasilovsky, *Women Behind the Camera* 140). In 1975 she applied as G. Kudaka. She received a letter, as Mary Gonzales recounts, that said,

> *"Welcome, Brother Kudaka, you're in the union." She went to the union to raise her hand and swear in, and they went, "Who are you?" "I'm G. Kudaka." "No, no, no. We don't allow women in the union." She had to sue the union to gain entrance. That's one of the women who broke the doors down for the rest of us.*

Raising the money to join the union was another hurdle for women. Susan Walsh says that as trainees of a now-defunct training program in the late 1970s they were paid only $100 a week for working the same twelve-, fourteen-, sixteen-hour days as the regular crews. After the women finished their training, the union explained that they owed $1,500 for initiation fees and union dues before they could work—a rude awakening. Luckily, Walsh had worked as a trainee on *American Gigolo* (Paul Schrader; 1980), and DP John Bailey, ASC, told her, "When you finish this program we want you to come in as second assistant."

Walsh remembers her fellow trainee Candy Foster had a harder time since she had to work as a secretary to save the money to pay the union fees. Also, because her husband was out of work, Foster could not take a poorly paid camera job: "Ultimately she did a little bit of work, but this demand that she come up with this money really sank her. I approached the union at that time, asking can I pay this in installments and was told you had to pay it all up front before you could work."

Affirmative action enabled Sandi Sissel to join the union. Sissel graduated from university in 1970, when the women's liberation movement was strong, and was soon working in New York transferring sound at the DuArt film laboratory. Women and minorities had been lobbying to get camerawork and admission into the unions, forcing IATSE to search for minorities to fill positions for the three national television networks rather than be sued. Meanwhile, Sissel's friends, independent filmmakers Jill Godmilow and Ira Wohl, were encouraging her to be a camera assistant and also to shoot. Going to the IA office did not come naturally to her, but she applied. "They were truly looking for people with *any* experience. When I went back to DuArt that night and said that I was going to join the IA and shoot news, my boss smiled and patted me on the head. He thought that was cute." Sissel and other women at the time did not feel that camerawork was unusual for women, but learned what was "unusual was trying to do it in a legitimate way, which means in the union or in venues bigger than independent films."

Sissel lived in New York for ten years before moving to Los Angeles. She was in IA Local 644 in New York, but in Los Angeles the IA Local was 659. She came up against a Catch-22: "In order to work in Los Angeles you had to be on the [union] roster, and to get on the roster you had to have several days of work." She had met Haskell Wexler in New York, and in Los Angeles he hired her for the days she needed to get into LA Local 659. "Haskell always had

female assistants. He was supportive of minorities in general. It's funny for me to think of women as minorities, but in those days we were considered a minority."

Of course, accepting a handful of women did not make a union inclusive. Once women got into the unions, they still faced obstacles getting the unions to recognize discrimination against women at work sites and even sometimes within the union itself, where, as Kirsh noted, "women were clustered in the lowest positions possible." Glover and other women in the 1980s thought organizing a women's committee within IATSE Local 659 in Hollywood was needed in order to deal with discrimination.

Figure 11: Kristin Glover. USA.

So, years before the three cinematographers' unions merged into one national guild,[6] Kim Gottlieb-Walker and Glover approached George Dibie, then President of Hollywood's IA Local 659, and said, "We believe we should have a Women's Committee. This is a union dominated by men, it is a profession dominated by men, and women need a place to talk about whatever issues may affect them in the workplace. We would like to co-chair a Women's Committee." They were "allowed" to create a Women's Committee, which lasted from the late 1980s into the early 1990s. From Glover's point of view, the Women's Committee did excellent work. They had regular meetings every three or four months, with inspirational speakers—

> women like Liz Ziegler and Nancy Schreiber—speaking to women one on one. The women who were present could ask questions: How did you do this? What kinds of problems have you encountered? It was a forum where we were safe to discuss the chauvinism that we were experiencing on the set and figure out how to deal with it. We had someone talk specifically about dealing with sexual harassment, difficult personalities, and conflict resolution.

Despite their good work, the Women's Committee was ordered dissolved by presidential edict. In a fit of rage at the women's activism, Dibie proclaimed, "You have no problems! There is no discrimination! The committee is finished!"

For many years, the Cinematographers Guild (IATSE Local 659 and then Local 600) had no Women's Caucus or Women's Committee. Then in 2004, with the endorsement of Local 600 President Gary Dunham, Glover became Founder and first National Chair of the Local 600 Diversity Committee—the first ever in the IATSE. Lisa Guerriero was the first National Co-Chair, followed by Baird Steptoe. And there were regional chairs: Jodi Williams, in the Central Region, and Marilou Vetter, in the Eastern Region.

For the most part, Local 600 has refused to keep annual statistics on race, gender, and age or reports of discrimination and/or harassment. But recently it was disclosed that 13.6% of its 7,400 members are female (Lang). By refusing to keep more detailed statistics, the union can "pretend that there is no discrimination"—and avoid a federal court case for lack of evidence. However, during that brief progressive period in 2004, a "voluntary and anonymous" Local 600 Membership Survey revealed "that those members who did experience harassment and discrimination were too afraid to report it, did not know how or where, did not know their rights, or if they reported it, did not get satisfactory help from the union" (Glover, Letter to Parry 4).

Some of the comments made as part of this 2004 Local 600 survey included the following:

- "(From a women [sic]:) The discrimination is in the hiring practices by the members not by the production companies."
- "The only diversity should be competence."

- "This union does not support families. There is no childcare."
- (Regarding reporting discrimination or harassment:) "Went to a workers' rights attorney and (was) told I had a good case but if I pursued it I would be blackballed."

(Olds 29-30)

In *The Lives of Kong: Labor and Moviemaking in Three Acts*, Andrea Siegel states, "In the 2004 membership survey, Local 600's members—over 85% of whom are white males—were given an option about encouraging diversity in hiring. Over half—50.09%—reported that they did not want to encourage diversity" (238). Furthermore,

of the 511 people who reported experiencing discrimination...211 did not [officially] report it out of fear of reprisal. Forty-six per cent of the women reported that they had been discriminated against or harassed. The odds were two to one that if a member reported the harassment to Local 600, the member did not receive any help from the union.

(238)

What these numbers and comments show is that, while statistics are important, they can't help if lone individuals use them to make a case: A class action may be necessary.

How do the US camera unions compare with other major professional organizations that represent other screen industry workers? The Screen Actors Guild (SAG), the Writers Guild of America (WGA), and the Directors Guild of America (DGA) all have had active Women's Committees or caucuses since the 1970s. For example, among the DGA Women's Steering Committee's activities are the creation of the DGA Women and Ethnic Minority Members Contact Lists for Employers, an active mentor/mentee program, a Fellowship Program, and annual employment mixers where members can meet producers, production executives, and other professionals in film and television.

The Writers Guild of America, West (WGAW) commissioned a series of reports on women, minorities, and older people in screenwriting—all groups facing discrimination in a young-white-male-dominated industry. The WGA studied the employment numbers up close and made a series of recommendations, including the following:

- Mentorship programs.
- Gender-blind, color-blind, age-blind submissions of screenplays to producers.
- Timetables for producers to make the transition to more diverse employment.
- Encouraging development and production of films that show the points of view of women, minorities, the LBGT (lesbian, gay, bisexual and transgender) community, and older people.

(Hunt, "TV Staffing" 15–16)

In January 2014, the WGAW's Committee of Women Writers started a Women's Initiative, "whose mission is to raise the profile of women in the WGA and in the industry at large."[7]

The Producers Guild of America, which does not claim union status, formed a Diversity Committee in 2000 and has hosted a "Power of Diversity Workshop" since 2005. The Committee Chair, George Sunga, reported that in 2007 he was "invited to speak to the UK Film Council" along with WGA and SAG Diversity representatives. "We discovered that all the work the UK does in the area of diversity is financed by lottery and the government. They also were able to get 21 separate unions, guilds and organizations to sign an agreement to advance diversity in their individual organizations" (Sunga).

From 2004-07, the IA Diversity Committee conducted sensitivity training sessions to combat sexual harassment and employment discrimination. Yet in 2007, despite a Constitution and By-Laws (Article 11, Section 27) that required "Diversity Sensitivity Training for members and leadership in Local 600," all such activity ceased ("List" 2), and new president Steven Poster removed Glover from the committee she had created. The Diversity Committee continued to exist under a new series of Chairs—Baird Steptoe, Michelle Crenshaw, and Don Morgan—but it was far less activist.

For Glover, the Cinematographers Guild should be like other Hollywood unions and have a Women's Committee to help women with gender discrimination and harassment. In 2010, she wrote to Olophius E. Parry, Los Angeles District Director, EEOC (Equal Employment Opportunity Commission). Referring to SAG, DGA, and WGA, she noted that each guild

> has professional staff people assigned to assist minority members, specifically with regard to issues of workplace discrimination, harassment, etc., as it had been widely acknowledged...that minorities and women were (and mostly still are) drastically underrepresented in certain of Hollywood's working ranks.
>
> (Glover, Letter to Parry)

This staff person, assigned to help minorities, women, and older members so people can speak freely and report discrimination if necessary, could also gather statistics so discrimination can be documented.

On 10 May 2011, Glover (still an elected member of the Cinematographers National Executive Board) wrote to Matthew D. Loeb, IATSE International President, arguing that in tough economic times "minorities, women, and older workers suffer the most." She urged him to endorse Diversity Sensitivity Trainings in the IA overall (Glover, Letter to Loeb). He never responded to her letter.

Nevertheless, Michelle Crenshaw thinks that the unions have become a little more helpful for minorities. Crenshaw is currently serving on the National Executive Board. She still gets jobs on her own, but the union does protect her from horrible job situations such as

> *being abused by producers or directors and working fourteen-, fifteen-hour days, barely having any sleep and having a short turnaround when you've got to come back to work another twelve- or fourteen-hour day. The unions work more on a massive group basis, working with producers to protect members.*

When Crenshaw started in Local 600, she recalls three women of color: Dianne Farrington, Sabrina Simmons, and herself. Years later the percentage of women of color was still small. The Guild's last Membership Survey was taken in 2004; according to Crenshaw, "Out of 5,600 members, only 1,900 answered the survey." Based on the 2004 survey, the total breakdown for minorities (Latino, African American, Asian/Pacific, and Native American) totaled 7.8%. African American members of Local 600 (both male and female) totaled 1.7%. "And that's covering everything. Whether you're an assistant or any other position" in the camera crew.

As we saw in the previous chapter, camerawomen's groups keep emerging even when and where they have previously collapsed. The same has been true for professional guilds and unions, although with the work to produce images increasingly occurring in front of computer screens, the function—the *nature*—of the union is changing. In practical terms, filmmaking now occurs everywhere, produced by everyone. Can these individual filmmakers be represented collectively by a union? And will there still be something like the studios on the other side of the negotiating table?

When Cameras Were Heavy

When I first went to the United States and was working, people went, "Oh, isn't that a big, heavy camera?" and I'd say, "No, I'm a New Zealander. In New Zealand there are three sheep to every person. I'm used to carrying my sheep around on my shoulders!"

(Margaret Moth)

Fortunately, the question of physical strength need no longer arise, as the equipment's weight is no longer an issue. However, up to the recent past, the weight of a camera and its related gear has been a serious issue for all filmmakers—men and women. The equipment, though, has simply shrunk and lost almost all its weight since Marina Goldovskaya's "father always told me, 'The equipment is very heavy.' We used 35mm cameras, huge cameras." It never mattered, though; women have carried the weight.

Our Chinese interviewees speak often about the logistics of working with heavy camera equipment. Canadian cinematographer Sarah Moffat, CSC Associate Member, whose special skills include underwater cinematography, recalls working "with underwater equipment that weighs 80-100 lb loaded up with film inside. I'd muscle it over on a set and hand it off to the underwater shooter—who would ask, 'Which button do I push?'" (Moffat).

More usually, though, women have had to prove they were capable of carrying heavy equipment to get the job. They've had to do this not just for themselves, but for the sake of other women wanting to work in the industry. Madelyn Most felt she carried a huge collective responsibility while using a Vistavision camera on her first big film job in 1976.

Figure 12: Marina Goldovskaya. USSR/Russia.

The big blue monster that was sent out from Hollywood [to shoot Second Unit on Star Wars *in England] and did all the epic movies, that we did all the matte shots from, is big and heavy. It has one handle and weighs 40-50 lb. You have to hold the handle and climb the ladder to be on the rostrum. Going through my mind was, if you fall off this ladder and go splat, it's going to be all over the industry, and they're not going to ask back another woman for ten years.*

Though men, too, have found the gear heavy, equipment size and weight have been an important obstacle only for women because of assumptions about women's physical inability. Wexler says the "idea was that women were weaker and therefore they couldn't pick up heavy cases," but he calls this an excuse "to maintain the Good Ole Boy network." He thinks being a DP is not about carrying heavy equipment, "particularly since even I worked a lot with a little French camera, which was lighter, and a lot of shooting we did was not sound.[8] As years passed, that was not an issue."

Inspired by the women's movement, Sarah Pillsbury, who arrived in Hollywood in 1974 to produce films, is outspoken about the difficulties of women in Hollywood. Asked to explore typical producers' objections to hiring a woman as part of the camera crew, she responded that people used to be concerned

about the physicality of the Director of Photography, though actually on a feature the Director of Photography doesn't lift or carry very much at all. They have a large department of people to do that. But so many of the grips and electricians are men; the camera department as a whole is seen as male. To see a woman in charge of that department makes men too nervous!

After experiencing these attitudes, it was "a great revelation" for Glover to work on a feature in France. In Los Angeles she had been taught that a woman camera assistant must prove she is as much a "gorilla" as a guy is.

In France, the camera crew has a camera grip assigned to it, a big, burly guy who lifts all the camera gear, carries the camera, all that heavy lifting. Working in France taught me that being a good cameraperson is not about being a muscleman. At first I fought it because I had been trained, LA-style, to do all the heavy lifting myself. Working on the French crew made me reconsider what being a big, burly guy or girl has to do with becoming a great cinematographer. Nothing, absolutely nothing.

In particular, "It has nothing to do with the art of being a camera assistant, which involves mathematics and keeping equipment straight and having a good hand on focus and zoom and having all kinds of skills that have nothing to do with being a weightlifter."

Glover, who has permanent injuries from years of lifting heavy camera equipment, notes that requiring heavy lifting is potentially a source of harm as well as a roadblock for men as well.

Some great cinematographers, like Allen Daviau or Steve Burum, who didn't have to work their way up being camera assistants, never had to prove themselves as physical gorillas. Had they been forced to do that, they might not have been able to, and we would have been denied their great talent. The Hollywood system needs to adopt the European method.

From country to country, the availability of assistants to help with the equipment varies widely. For example, Priya Seth explains that, "in India, we have enough people to do our [lift and carry] jobs for us. But for all our foreign units," she adds, "as a camera assistant you do everything yourself, which I have for about two, three films. You have to be strong."

Digital technology means lighter cameras, but there is still gear to carry. MacKenzie says when she first carried a camera it weighed "about 30-35 lb," but before 2000 a camera's weight had "been reduced to 25, 22 lb, depending on what gear you have on top of the camera." Besides the camera, though, she used to carry the tripod, a "ditty bag," and "sometimes light kit on top of that. Nowadays [2000] we're working by ourselves; we don't have anybody to help us."

The irony, as she sees it, is that women have always dealt with carrying all sorts of things. She describes how, when she was in an elevator carrying a camera on her shoulder at the

same time as she carried a tripod, men would get on the elevator, looking at the male reporter and also at her.

I'm carrying all the stuff, and they'll go [first to me and then to the reporter], "Why are you carrying that? Why don't you help her?"

One time a man got in the elevator with a lady who had a baby on her hip and a big diaper bag on the other hip and a bag of groceries. The man said to me, "Why are you carrying all that stuff?" I just looked at the lady and we understood. A lot of women carry a lot of stuff. You don't think about it; it's part of the job.

In New York Joan Giummo managed to turn a liability into an asset, using her "mommy gear" for her camerawork. Her Portapak equipment[9] weighed twelve to fifteen pounds. She was doing street video, working with Elizabeth Sweetnam on a tape about homeless women. The Portapak was too heavy for the two women to carry around all the time, so they "put it in my child's stroller and we cruised around the street until we found a homeless woman whom we tried to interview. We covered a lot of ground, back and forth and up and down. So the stroller was ideal."

Some camerawomen work out to get stronger. Susan Walsh is five foot four inches in height and tries to stay in good physical shape. "I hike, I dive, I'm a technical rock climber, and I swim laps. I've been doing yoga since the late '60s, and I've done some work with free weights, but mostly with machines. Just constantly lifting and moving the equipment, if you do it consciously, you're still keeping yourself in shape."

For the relatively young Heubrandtner, "The weight of the equipment was never a problem. First of all, camera technology has evolved so that it's become easier. Those heavy cameras in blimps haven't existed for a while. Apart from that, I was never alone. There was always also a male grip, or a second AC, male or female." Remember that Heubrandtner works in Europe.

On location, new technology, including lighter cameras, is helpful for video journalists such as Nancy Durham, for whom "this kit is access. I can carry it around by myself, which means I can go anywhere, work independently, be my own boss." For other camerawomen, the lighter equipment can mean a return to work. Glover, for example, can no longer work with heavy camera equipment because of her past injuries, "but I can carry a lightweight camera. I'm really happy about that."

Helpful Men

[Dutch DP] Robbie Müller was a big influence on me, and I was a tremendous admirer of his work. The day I met Robbie, I had on a pink jumpsuit with zippers all over it, and in walks Robbie in a pink jumpsuit with zippers all over it. We were buddies from the beginning.

(Sandi Sissel)

Sometimes—but not always—the men who are most helpful to camerawomen are their husbands. Without hesitation, Durham says,

> *My husband, without question. Number Two is John Owen, no longer with CBC, who said, "I think we should get her a camera and give her a try." Very positive person, very encouraging, very enthusiastic. I think the people who really put me out there are men.*

Liz Ziegler goes so far as to say that

> *all of the breaks that I've got from this industry were from men. I can't think of one woman who has hired me, and I can think of a lot of men who have supported me. Partially that is because of my wonderful husband, because people are really close to him. It would have been a different story if I hadn't had Nelson[10] and that feeling of protection.*

Patton's husband, LeRoy Patton, helped her overcome blatant discrimination when she was first tested for union membership. She had to know seven cameras—"all the 16mm cameras, all the 35mm cameras, and the BNC cameras"—and she did know them. So she knew she would pass, but during her test one of the testing members put his thumb on the back of the lens:

> *You're never going to get the camera focused when it is like that. I was blessed at that time that my husband was a member of the testing committee. He observed [the offending thumbprint], so when the report came back and I didn't pass, he requested a meeting with the testing committee and the board members of the union. On that same day, before the meeting was over, I took the test [again] and passed with flying colors.*

Some men do become friends with camerawomen. As Ellen Kuras recalls,

> *My gaffer, John Nadeau, and I met on* Postcards from America *[Steven McLean; 1994]. He's still my gaffer, and one of my closest friends and confidant, and just watches out for me on the film set. He has been an incredible asset to my work, and a collaborator. I include him in everything that I do. He has a great eye, too.*

Often older men have established fatherly relationships, helping much younger camerawomen. Derko thinks that fathers who have daughters have a willingness to hire women: "90% of my work comes from the four men producers I consistently work with. All four of those men have teenage daughters. Maybe they hire me because they can see their daughters do anything in the world" (Moffat). Lisa Seidenberg also remembers help she received when she was starting out:

> *Generally it was older men who had daughters; they would take me under their wings for a bit and that helped me survive. When I went freelance, I had personal relationships*

with one or two cameramen who helped me enormously in my career. Although many men were in competition with me, a lot of men became my allies.

The most important way that cameramen have helped is by getting women camera jobs. While working on television dramas for the BBC as an assistant, Katie Swain was trying to get into feature film work. Men's help was crucial because, she explains, "as an assistant you're relying on the cameraman you work for on a regular basis to get a film." In France Caroline Champetier has "the impression of having been given much help, to the point even of being pushed, by the Director of Photography William Lubtchansky." Walsh and Glover name several helpful male bosses.

Glover says that without such bosses she never would have become a camera assistant, camera operator, or DP. Joe Steuban mentored and befriended her. She worked as Haskell Wexler's assistant for over a year. Steve Burum, ASC, a stalwart supporter, mentored her for years, also hiring her as assistant cameraperson and then as Second Unit DP on a major feature film. Finally, Hiro Narita, ASC, supported Glover when he hired her as his camera operator on *Star Trek VI* (Nicholas Meyer; 1991)—the first woman to operate A Camera on a major Hollywood studio picture—and then rehired her repeatedly to operate features for him. She says that Narita "was really the only one who ever had that kind of confidence in me in terms of operating first B and then A camera on feature films."

As the A camera operator on *Star Trek VI*, she got "quite an initiation into feature operating." The first shot was for a Steadicam, but the set designers had made the stairway too narrow.

I didn't know this, so I turned to Hiro and said, "So what's the first shot?" He said, "Walking downstairs backwards handheld." I laughed and said, "Right, Hiro, sure it is." And he went, "Walking backwards downstairs handheld." [Laughter] That was the first shot. And by God I got it, with someone behind me holding me so I wouldn't fall all the way down.

Susan Walsh also credits male help, starting with Richard Walden, who was the first assistant on *American Gigolo* (Paul Schrader; 1980) when she came on as second assistant. Walsh says that Walden fought hard to get her some film projects despite "tremendous resistance. Richard just wouldn't take no for an answer. I owe him a tremendous thank you. I have thanked him, believe me." Walsh also praises Chuck Barbee for hiring her on various projects, "starting with an underwater project where we were working at 200 feet in the Gulf of Mexico." She continued to work with him on a series of underwater projects as well as on news photojournalism and some commercials. "He was always very supportive, and his wife also. Allan Gormick was the first underwater cameraman that I worked for on a regular basis. Again, his wife at the time, Amy, was enormously supportive."

Australian Jan Kenny said that Russell Boyd, ACS, ASC, helped her reputation immensely, because, as Kenny often heard, "If you're good enough for Russell Boyd, you're good enough for me." When she met Boyd, he was surprised to see a female camera assistant because

there were none in the country. Before meeting him, she spent weeks refamiliarizing herself with the equipment he would use so that she could load and unload magazines extremely quickly.

> *He said, "Can you load a magazine?" I said, "Yes!" He said, "Show me!" I spent a few seconds on it, and he looked at me and grinned. He said, "When did you learn to do that?" I said, "Yesterday." He said, "You'll be all right."*

As the DP for *Summer of Secrets* (Jim Sharman; 1976), Boyd pulled rank and hired her, although other crewmembers had other people they wanted for the job, making *Summer of Secrets* the first Australian feature film with a female in the camera crew.

> *It was challenging because, apart from Russell, I wasn't getting support from anyone. I made a lot of mistakes; I tried to learn as I went along; I worked long and hard to do the best possible job. I got through it and went on to my next feature, which was* Break of Day *[Ken Hannam; 1976], again with Russell as DOP. By then I got the job sussed and did a better job. I was riding on the seat of my pants on that first one.*

The camera crew, Kenny remembers, worked under tough conditions on *Break of Day*, particularly recreating the battle at Gallipoli.[11]

> *It was desperately tough for everybody. We got through and were about to leave, when the focus puller said to me, "Well done. You're the best clapper loader I've ever worked with." The satisfaction and the thrill that gave me was incredible. It filled me with a new sense of confidence. I started feeling as though I did belong rather than feeling like an outsider. It was a turning point for me and I've never forgotten that he took the time to make that comment.*

Austrian Astrid Heubrandtner has had a "beautiful" friendship with camera colleague Moritz Gieselmann, who has always supported her as AC, operator, and then as camerawoman. When they worked together, he not only mentored Heubrandtner, but showed that he trusted her, valued her, and thought her work was good.

> *When someone doubted a suggestion of mine, he would intervene and say, "If Astrid suggests this, I believe her. It makes sense." He publicly encouraged me, and suggested me for jobs that were available. Sometimes I got jobs later because he had previously suggested me in a way that made it clear I not only could but should be the one to do a particular job.*

AFC founder Henri Alekan helped Frenchwoman Dominique Le Rigoleur, but cinematographer Nestor Almendros, ASC, was the great mentor. Almendros was an immigrant from Spain who had studied filmmaking in Italy, becoming a DP in France. Le

Rigoleur says Almendros took the side of outsiders because of his own personal problems. In the United States Almendros employed blacks; in France he hired women. "Thanks to that I was able to work for him. He was extremely important for me because I worked six years with him: with [directors] François Truffaut, Eric Rohmer, Maurice Pialat, Jean Eustache. Thanks to him I knew Marguerite Duras, the most important person in my future career." Le Rigoleur worked with Almendros and Truffaut on *Adèle H.* (1975; as camera assistant), *The Man Who Loved Women* (Truffaut; 1977), then *The Green Room* (Truffaut; 1978) as still photographer, and finally *Love on the Run* (Truffaut; 1979). "To work with François Truffaut on a film was to enter a very special world where sensitivity wove a framework for the shot. The same was true of Marguerite Duras. It was more than making a film; it was entering a magical world."

However, when Le Rigoleur worked with Almendros, she could not move up to operator because Almendros preferred to be his own operator. Yet in order to stay with him she worked as a still photographer so she could keep on watching him work, discuss camera subjects with him, and sometimes even operate the camera under his supervision. During this time period she was also taking a course to become a DP. "In three years I built up the two positions, which permitted me to learn enormously. So I was an assistant to Nestor for six years and then a still photographer for three."

Ssh! (Secret Sexual Harassment)

In 1975, when she was 27, Glover worked as a camera assistant on the documentary *Pumping Iron* (George Butler and Robert Fiore; 1977), which featured Arnold Schwarzenegger. As the assistant, Glover was responsible for loading and unloading film in a large black zipped-up changing bag. This requires concentration and physical skill; in addition, Glover could not take her hands out of the bag or the film would get exposed. Over a period of three to five months during the shoot, Glover recalls,

> *Arnold would come up behind me, grab me, tickle me, grope me constantly. I would scream at him, "Fuck off, leave me alone" at the top of my lungs and he would slink away, only to return later. I made enough noise that other people heard. But he would come back constantly over the duration of the shoot. I'm sure he saw it as playful, but I found it tremendously annoying and it did interfere with my work. Other people were witness to it. It was considered part of working with Arnold.*

While working on a film as a gaffer, Amy Halpern was sexually harassed by the soundman.

> *We broke for lunch, and passed in the doorway. He grabbed me—a man who'd never looked me in the eye and said anything up until that point. Although my instincts were*

to just smack him—and as a New York City woman I can be deadly—I like the guy. And I like film crews. I like people and working with them. So I said, "Careful! Don't turn on equipment that you don't know how to operate." He removed his hands right away.

Madelyn Most got harassed while working on *Star Wars*, shot in 1976 at Shepperton Studios in England. She was supposed to be clapper loader on the second camera. She found out that a "camera operator and his assistant had me in as a joke to piss off the cameraman. He didn't want women on the crew; at the same time, he was a womanizer." She remembers that the crew "didn't like me. Nobody spoke to me in the first week. The cameraman tried to get me fired. It was George Lucas and Marcia Lucas, I heard later on, who said, 'She does her job, she stays.' That was a good thing, because the cameraman could have said no."

In 1981 Most moved to New York where she grew comfortable as a camerawoman, finding New York film people sincere and hardworking. But when she moved to Hollywood she found the sexism "glaring and offensive. I didn't want to stay. You can get a lot of experience, but you were treated like shit." In Hollywood she was shooting documentaries on the side as well as working as a focus puller and camera operator.

I wasn't going to take any shit from some big football player of a cameraman who was rude. They were so nasty and they said such terrible, sexist things. Not to me, because I would clobber them, but to my friends. At our [BTL] meetings we had a discussion about somebody who said, "Get on your knees," and she said, "I've already got this job."

Most does not claim that the London and New York film worlds were free of sexism, but she found that Hollywood sexism took a particularly disconcerting form. Most said that the women she knew in the BBC and the London Women's Group were intellectuals, often frumpy, and older (in their forties), compared with women in Hollywood. In fact, she is highly critical of the image that women in Hollywood projected:

The few women [who were hired] were so cute and so pretty, and sometimes dressed in sexy outfits. I had an assistant with long nails and nail polish wearing a see-through jumpsuit.

In New York the men hired women; they worked with women more easily because they respected them. The guys I worked with were married to women who were producers, directors, writers. Being cosmetically enhanced with boob jobs and botox was not in the equation. I was totally sickened by what I was surrounded by in Hollywood and got out as soon as I could.

Many BTL women were afraid to go public talking about sexual harassment on set. Estelle Kirsh reports that they were afraid of being blacklisted, or of being thought controversial, or of being unable to withstand all the harassment. As a BTL board member she heard the stories they wanted to tell her, but they would not let her take the stories public any more than they would take them public themselves. "It's very hard," she said. "Like fighting smoke.

How is one person supposed to take on a system, and the individual in it, without having the necessary armaments?"

We would compare names. One guy would harass a series of women. Unfortunately, I was sworn to secrecy.

There was a woman who used to say, "Those who go along get along," and she went places. Those of us who did raise issues of racism, anti-Semitism, and sexism did not go places. We did not get rehired.

I did suggest that we circulate our own list of men to be aware of. That went over like a lead balloon. On the other hand, any type of list like that, you're dealing with innuendo. I had been warned about one cameraman I worked with that I had no problem with at all. I was a camera operator and maybe the person who warned me was a second assistant, a far more vulnerable position.

Glover agrees that women censor themselves, refusing to report sexual harassment for different reasons: "For instance, with Schwarzenegger, I was young and naïve, and I didn't have a definition for it. A lot of times women who are young and naïve don't realize that they are being harassed and they are fearful." Harassment can sometimes graduate to another level where the woman is assaulted. Nonetheless, Glover reminds us, "Women are afraid for their jobs. They're afraid that they are going to be blamed."

A second personal experience with sexual harassment occurred when Glover worked as a camera operator on several projects with a high profile cameraman. He said he was going to hire her a lot and help her career as a camera operator, but while working on a television miniseries where the cameraman was groping other women on the set, she was disturbed.

I would try to look away and concentrate on other things, but this director of photography, who was my boss, knew that I disapproved tremendously. We were supposed to go to Prague on a shoot. I was told by the production manager that I would not be going. This cameraman hired another man to replace me for that part of the shoot.

Glover consulted an attorney about bringing a lawsuit, who said that she had a good case but would risk being blacklisted for the rest of her career if she pursued it. A union representative would not help, saying the "problem was not in the union's purview and was not anything that they would ever deal with."

The union did have a Women's Committee at that time, but union leaders and representatives said sexual harassment was not a union issue. She recalls one meeting of Local 600's Women's Committee when several women did speak up about sexual harassment:

One young woman who'd been a second assistant said that somebody had come on the camera truck and locked her in the dark room and assaulted her, and that she had

been afraid to report it. She didn't know where to report it and what to do. Stuff like that happens. You can stick your head in the sand and pretend it's not happening, but it happens.

Despite this meeting, Local 600 maintained that sexual harassment was not a union issue.

Susan Walsh speaks about these issues from three points of view at once: as a camera assistant, a self-defense instructor, and a licensed marriage and family counselor. She says that a person being harassed is the one who defines sexual harassment. Though two women may differ, Walsh says that certain acts that a man does on a set are obvious harassment such as "grabbing women's body parts or speaking in a way that is obviously meant to make a woman uncomfortable." For her, sexual harassment functions as a means of social control.

Just look at the far end of the scale, like the way rape is used in prisons as punishment or to control behavior. Rape is on the far side of the sexual harassment scale. When a woman is being sexually harassed, she's being intimidated; it's a way of letting her know that whatever she's doing, she needs to do differently or maybe that she needs to not be where she's not wanted.

Walsh argues that sexual harassment is a method of making women so uncomfortable that they find it difficult to do their jobs, and if they remain on the job it is difficult to focus well on what they are doing. "If a man is relating to the size of my breasts, the shape of my derrière, makeup, the clothing that I'm wearing, the length of my hair," Walsh says, "he's not relating to me as a person and as a professional. I feel objectified, disregarded, irrelevant, and that, over time, has a powerful impact." Other types of petty hostility can be more physically intimidating and more about preventing a camerawoman from doing her job well. "Like when I'm rushing to break down the camera at the end of the day," Walsh remembers, "and the grip is there deliberately blowing his cigarette smoke in my face. When the dolly grip on the next camera runs the camera into me on at least a daily basis. When you know that nobody's that dumb that they don't know they're doing this, it's a difficult situation to deal with."

For Walsh, the way for women to counter this sort of intimidation is to seek out "people who respect us, personally and professionally, and try as much as possible to work with those kinds of people." For Glover, her friendships with Walsh and other camerawomen gave her that needed affirmation. But Walsh states that even without affirmation, pioneer women and minorities forced their way into film and other industries so that "we can show ourselves for the capable people that we are." Walsh says that personal support from men or women, their affirmation, helps camerawomen "go back into the fray and carry that knowledge within us: that we are worthwhile, that we are competent professionals, and that the fact that someone else fails to recognize it is their blindness, not our lack."

Sabotage

Bob Primes, ASC, was working as a freelancer—nonunion. He was sabotaged by grips and electric, which cost him the job. They did not want him there; they did a slowdown. He would ask for gels and it would take a very long time; the lights weren't hung correctly; all these tiny things. They ran overtime.

(Estelle Kirsh)

When coworkers do not want you among them, they find ways to make your life impossible. "Of course I've had my share of technicians fudging up the switches so that I don't know how to use them," Sabeena Gadihoke acknowledges. "But I could figure them out from early on."

No matter how tough a person is, being kept from doing one's job because one is disliked as a person can be frustrating. It is the sort of stress that takes all sorts of tolls: physically, mentally, economically, professionally, etc. Lisa Seidenberg's first job was at WPIX in New York in 1977, starting at a low level. She went from WPIX to UN Television and then to ABC News, which was considered the "crème de la crème" of shooting, where many people wanted to do camerawork. There she would be given equipment with things that were wrong. "I would come back with footage and it was out of focus. Then a couple of people—there were always one or two men who were friends—said, 'People want your job and if you're not careful, they are going to sabotage your equipment.'" Afraid to show emotions at work, Seidenberg, who was still young and did not know why these people were against her, would go home and cry.

As Seidenberg continued to work at ABC, she felt unwanted and was tired of fighting all the time; she thought it was her problem. "I left ABC News in 1982 partially because they wouldn't send me overseas, but also because I was so emotionally broken down at that point." Many years later she ran into other women she knew at other networks and other camerawomen she had worked with, and found out "they had quit just like I had; they couldn't take it. They were forced out, they got sick of it, or somebody trumped up a reason to get them fired. All the ones I had worked with were gone."

When coworkers resort to sabotage, they have moved to an elevated level of threat. Among forms of hostility, sabotage belongs to the sort that requires a response, even for camerawomen inclined to internalize how they feel about such problems.

Canadian Zoe Dirse describes one among various small but destructive acts by a camera assistant who wanted her job as the camera operator:

When he was pulling focus for me and I was on a tight shot, he'd lean on the tripod and the tripod would be moving. I would see out the corner of my eye that he was leaning on the tripod, and he would say, "No, I didn't." These things are painful to talk about. He was a disturbed young man—very abusive with drugs and alcohol—but he came from a powerful family.

Dirse said that this man even sexually harassed some of the talent, but the DP protected him. Despite complaints to the union and actors' guild he was not fired.

Dirse insists that if a woman DP is being sabotaged, she should act decisively by firing the saboteur. She cites the example of a woman DP, working on a big-budget film with a huge set, who had just come in from another country and did not know the crew: "She had a gaffer who was constantly undermining her. She had to fire him midway through the shoot, because her confidence was being collapsed from within. She did the right thing by firing him and hiring someone supportive of her. But that takes courage." Dirse observes that, because films have deadlines and budgets are important, a DP's reputation relies on her ability to deliver within the deadline. "It's hard to change those kinds of attitudes and opinions in a short amount of time, and you don't have time to be nice and chat with people and try to change their minds about how they're seeing things."

A typical form of sabotage occurred to several news camerawomen early in their careers when filming with many other cameramen at press conferences. When Mary Ayubi was the only camerawoman shooting in Kabul at a human rights conference, the cameramen maneuvered to block her, but, she says, "I fought and got the best spot." Three or four of them contacted her office a few days later wanting to buy a copy of her footage because they had no good shots.

In the 1990s, when Seidenberg worked for Worldwide Television News, an English news agency, she had a similar problem during her assignment to shoot Gorbachev's visit to America. Gorbachev had just been elected president, so his visit was a major event. The whole press corps converged on him in what was called a "gang bang." While she was getting her shot, the cameraman behind her pulled out his leg and tripped her:

I fell flat on my face and only got half the shot. If it happened to me today, I'd kick the guy in the balls, but I was too young and polite. I went back with what I got and the news director took me aside and said, "Are you sure you want to be in the news business? Are you sure you are cut out to be a camerawoman? Maybe you should try something else." I walked out and cried the rest of the night. [A long pause.] I don't know why, but I kept on. That guy was fired a few months later. His successor liked me and I got great assignments after that.

Aminata Wade may not have been deliberately blocked out by other video journalists while covering Senegal's presidential election in 2000, when the exiting president and the newly elected president were meeting at the presidential palace, but there were so many journalists standing in her way, she could not see over them to film.

A man came up to me and asked, "Miss, may I be of help?" I answered him, "How?" He responded, "I could lift you up so you could film." I accepted. I had no choice, since my goal was to bring back images at any cost. I was pleased both because it enabled me to get those images and to know that not all men are like those who discourage me.

Wade hates it when men "pity" her "each time they see me with my camera" and tell her, "Miss, it's too heavy. It's not for you." But her story does have a happy ending in that, like Ayubi, she came back with the shot.

Jessie Maple Patton also got her shot despite other cameramen trying to gang up on her and block her out. Her solution was to stand right in the middle of the shot and be in everybody's camera. "My story was clear and everyone else's had me all in it. They quickly changed and most of the time they would save a space for me."

Getting Paid Jobs

At first it was difficult because I had to prove that I can do things well. I acquired experience and my work proved that I can work sometimes even better than men. So I didn't have problems anymore.

(Marina Goldovskaya)

The increasing access to filmmaking technology includes teens and children, many of whom participate in filmmaking projects with immediate friends and family, with classmates, with members of the local film club, and on an ad hoc basis, for fun; in response to local, national, and international contests specifically for young filmmakers; for no particular reason at all. Often the reward for winning contests is help with future projects, in the form of educational opportunities, in-kind help (a day in the editing suite, the use of an expensive lighting package, etc.), and mentoring. For women, this could be the end as well as the beginning of their "paid" work as camerawomen. As we have seen, many camerawomen have worked on projects for free, even after reaching senior positions. One reason to accept unpaid work is the need to keep in practice.

Many women who do earn their living from their camerawork consider their professional careers to have begun with projects that were unpaid. Some young women explore the world of experimental and art films; making money from these types of films is the exception rather than the rule.

Another type of film and filmmaking process is documentary. Documentary has been and continues to be a good friend to women. For Second Wave Feminism, documentary films were not only useful but often a godsend—for their content. Here would-be camerawomen could practice, usually with little harm done to the project or the woman. In fact, many of these documentaries gave women a leg up in the profession. They won awards, drawing attention to all involved. They contributed to a showreel (a crucial collection of examples of one's camerawork that shows one off to best advantage). Some practitioners have chosen to stick with documentary for its own sake. Because it is where many camerawomen can be found working, the next chapter focuses on documentary.

The focus in this section is paid work, and much of the discussion is about availability of work. Getting paid work—with or without an agent who can help negotiate—is not an

opportunity that everyone gets. Even getting a first job at a higher rank after proving oneself at a lower level is not a sure thing. For Swain, the problem in England and elsewhere is the industry's nepotism: "People have found out about [jobs] here traditionally through family or friends of family. I'm sure it's the same in the States. There are a lot of people working in this industry who have family. I didn't hear about it at the career center at school."

Sometimes the first paid job comes because the person originally supposed to do the job becomes unavailable. In the Philippines Lee Meily got lucky and became "substitute DOP on *American Adobo* [Laurice Guillen; 2001] because the guy who was supposed to shoot it was a DOP for Ang Lee. He became very busy." Similarly, in India Vijayalakshmi started working for Ashok Kumar because "he was very busy. When there were two [simultaneous] film shoots he would ask me to shoot. People got to know that I could shoot independently; they could see the work that I turned out." Dirse has a similar story from Canada. Natasha Cherenkov was a camera assistant in Quebec for years until the day her camera operator broke his arm: "She got upgraded. She's never looked back. It's about the luck factor."

Of course, camerawomen do also get jobs by going after them. Beginning with no contacts in the film industry, Hilda Mercado realized she had to build her career proactively by meeting people in the Mexican film industry. After working on Mexican film productions for a year and a half, she saved money to go to the United States for the Maine Media Workshops. In a month-long course she took classes in photography and lighting as well as on being a camera assistant and camera. Returning to Mexico "with what I learned and with the people I met before I left, it became much easier to start working as a camera assistant and to know who to ask, and what to ask, to land jobs."

Shanti did projects during the third year of her training at FTI, which is in Pune. "In between projects," she explained, "most of us would come to Bombay and contact various cameramen, just to get to know the industry, and collect a few more telephone numbers of people you want to work with." These contacts helped her break into the Bollywood film industry.

Outside of Bollywood, Hollywood, and a very few other places, feature film production tends to be sporadic. Even with television, commercials, and corporate work, finding jobs can be difficult for anyone available around the world—and film work *is* international in scope. Addis finished her training with Womenvision in Adelaide, Australia, but stayed in Adelaide for about two years getting jobs on "every production that I could work on." She got excellent work experience shooting short films and documentaries with friends as well as camera assisting professionally on government films and commercials; she was also doing sound or electric work. When the male camera assistant in Adelaide who worked all the freelance jobs got a full-time job with one of the production companies in town, Addis was able to get the freelance camera assistant jobs. But sometimes she felt stuck with them.

Next door in New Zealand, Kylie Plunkett started work in TV in 1996 as an operations assistant for One Network News. For four years, she set up live interviews, recorded sound, and injected news items onto the air but she liked camera operating the most. Finally she moved to the film industry, working on feature films, commercials, and documentaries.

Plunkett knows that in the New Zealand film industry it is "hard to say no to working on anything, because as a freelancer, you never know where your next job is coming from."

Camerawomen who have begun to establish themselves in one place may find that, like cameramen, if they move, they have to work at re-establishing themselves. As social networking has developed, it is easier to put one's best professional face out there, but it is still good to know about face-to-face networking. After Michelle Crenshaw moved to Los Angeles in 1993, her Chicago network helped her get a meeting with a woman at Tim Reed Productions, which was starting to do some pictures for BET Entertainment. "My resume had nothing but camera, whether I was a camera assistant, or a camera operator, or even my independent stuff that I shot as a director of photography. When I came to the interview, she recognized that I was overqualified for the job—she was looking for a secretary."

Although Crenshaw said no to being a secretary and there were no camera jobs available, she did meet DP Isadore Mankowski at the production office, who told her that he already had a camera assistant. Crenshaw continues, "Two days later, the camera assistant wasn't available anymore and they offered the job to me." Crenshaw also met the camera operator,

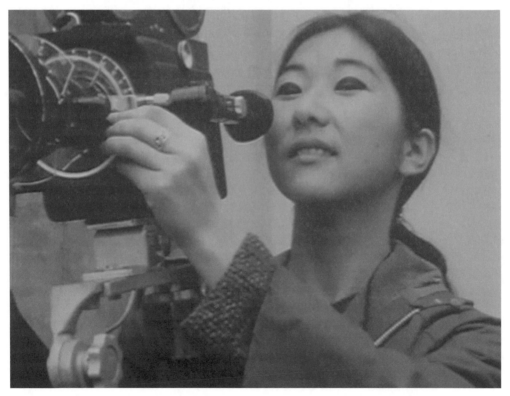

Figure 13: Emiko Omori. USA.

75

Johnny Simmons, a DP now in the ASC. She saw him as a frustrated DP who was stuck with camera operating.

He looked at me and said, "Where have you been all my life?" Maybe six months prior to that I had called Johnny Simmons saying, "I'm a new assistant in town." He was gracious and listened to me, but who's to say he was going to hire me? Thousands of people work in the industry here in LA. They get these calls all the time.

Breaking Out of Isolation

If being a pioneer means there weren't many of you, then I was a pioneer.

(Emiko Omori)

Pioneer camerawomen often comment on how hard it was being the only female production crewmember on set. "When I first went onto sets," Joan Hutton recalls of 1975-76, "people would stare at me like I had two heads." She was the only woman on Canadian sets, and "people didn't like it because it wasn't the norm. First couple of years were hell, but I'm a stubborn person. If I want something, I want it." She had to deal with

things like the electric who asked you, "Who are you sleeping with to get this job?" That kind of stupid stuff from stupid little people. That changed after the first two or three years. It really did all go away when people realized you were serious, you were there to stay, you were doing a good job, and you knew what you were doing. People got more supportive and cooperative.

In fact, things got so much better that Hutton could laugh about it.

I was working B camera on Stepping Out *[Lewis Gilbert; 1991], with Shelley Winters. The first time she came onto the set, she looked at me behind the camera and said, "There's a woman behind that camera!" which cracked everyone up. People in Canada had gotten used to me being there but it was still a surprise to someone from Hollywood, which I find amazing. It wasn't that long ago.*

Estelle Kirsh said that when she was on the Hollywood set people thought she was the assistant director because they had never seen a camerawoman before. "On a few sets they all came to look at me and said, 'She is doing camera! My goodness!' Actually, women in other departments came up and gave me support." Kirsh said that in her earlier days when she was bouncing from show to show, male crewmembers would approach her saying, "Gee, you're doing a wonderful job. You're so unlike other women who are lazy, incompetent, etc."

Despite the support, Kirsh also heard anti-Semitic comments, which she was unused to, and she was shocked by the sexist remarks, often said directly to her. "I'd be sent to the

camera truck to get equipment, and people outside [would be] talking about how women don't belong on the set, loud enough so they knew I could hear. Complaining that they didn't want a trainee and that they specifically did not want a female." These remarks were not isolated incidents. "I walked on the set," she recalls, and "they made a cross as though I were the vampire or something." What she resents is that these men did this without knowing anything about her skills, skills she had worked hard to acquire but which obviously meant nothing to them.

Although Lisa Seidenberg experienced isolation in New York when she was doing camera at WPIX, she says that there was usually one other woman where she worked—but still no camaraderie, which seemed unfortunate to her. "I hate to say it, but usually the other woman didn't have as much experience and was hired because she was related to somebody. They were not approachable. I was hired for a different reason"—her knowledge of the cutting edge technology of the time.

This sense of isolation at work was a serious obstacle for the pioneer camerawomen. As Betty Friedan taught us in *The Feminine Mystique* (1963), so long as we think a problem is individual rather than systemic, we are less likely to solve it. Furthermore, thinking that the problem is individual rather than systemic is more likely to damage the individual. When she was isolated on the Hollywood sets, Susan Walsh thought her problems were individual problems until she came into contact with Brianne Murphy in the late 1970s. When Murphy got into the union in 1979, she was one of the few well-established camerawomen working in the industry, yet she was still struggling. Walsh thought Murphy was an inspiration and a mentor for being not only a DP, but also supportive, open, and encouraging:

> If I hadn't had the connections with Kristin [Glover] and Brianne and Catherine Coulson and a number of other women who were contemporaries of mine, it would've been very difficult. For one thing, it offered me a reality check because I found that my struggles weren't unique to me, that there was something we all shared. That was important in being able to maintain my sanity.

If the absence of other women on set has been a negative, learning about other camerawomen working on other sets has been a positive. Katie Swain explains why it was important to her to have Sue Gibson get started before her in the English film industry: "She was there early on, one of few women in the industry, who must have struggled hard, and come out of it smelling of roses and highly respected. She hasn't helped me specifically, but you see the path someone's trodden, and you hope to follow it, and that inspires you."

Dirse's documentary workplace at Canada's NFB in the early 1980s boasted another camerawoman, Susan Trow. Dirse describes herself as six feet tall and physically strong, and Trow is equally tall. The NFB "had these long hallways that we'd walk down. The men would step aside and say, 'There go the two Amazons.' We'd just laugh. We were two; there is always power in numbers. We could support each other."

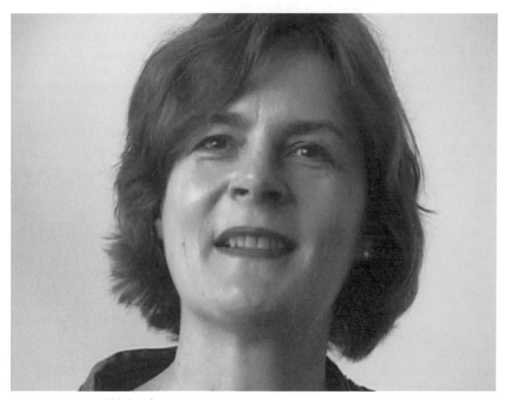

Figure 14: Zoe Dirse, CSC. Canada.

Years later, Dirse knows many camerawomen working in Toronto since she trained many of them. They

> were my former camera assistants. We're close friends, and we get together. We can talk about the issues that are concerning us, and vent some of our frustrations. If we can share that kind of information with each other, then it will make us stronger to go on with our work. Because all of us want to keep doing what we're doing.

During the first pictures she worked on, Australian Jan Kenny could feel eyes on her whenever she carried anything on the set: They were waiting for her to drop something. "There was a focus puller who did drop something on a film—the first Panaflex in the country—but he's gone on to a very fine career. If I had been the one that dropped it, that would have been the end of everything." She felt that she had to be excellent and that she was not going to be forgiven for any mistakes. So she had more pressure to deal with than the guys.

As the only female DP in Spain, Medina knows what it is like to be unusual: "Everybody questions you, and checks and checks on you." She wanted to be like anybody else walking around with a light meter and not have people checking on her so much. When Madelyn Most was on the set in the 1970s, she remembers that "what was hard was the distraction. Being the little girl, I'd get a thousand hellos in the morning. I just said, 'Please let me do my job, let me pay attention.'"

There haven't been many women on Indian sets either. B. R. Vijayalakshmi is used to seeing only hairdressers or heroines on the set. She has sometimes had to deal with almost 80 men and only four women. But she says she experienced no hostility because she worked for five years in the industry as an assistant, and men had seen her working. She has noticed one form of discrimination: If a man falls ill, people excuse him but "for a woman it would be pointed out. Because it is India, they would say, this is a woman doing a man's job, so she is ill. No excuses." She has made it a principle never to say she is too sick to shoot.

Senior camerawomen are remarkably modest about their achievements. In France, Nurith Aviv does not see herself as a role model, yet even she acknowledges that when other women see her, and "see that I am small and maybe not even strong, they think, if she can do it then anyone can do it" (Dirse, "Women"). Because she feels she has much to "discover, to get better, to go further," Agnès Godard also does not think of herself as a role model for other women, but for Dirse, Godard *is* her role model. When she sees Godard's work, Dirse thinks, "'Wow! That's fabulous, look at what she's done...' I looked at someone else's work when I was just an assistant and I could say to myself, 'This is something that I can do.'"

Sabeena Gadihoke notes that, 'because I was one of the early camerawomen, in Delhi at least, there weren't many role models for me." She can take pleasure in the fact that things have changed: "I am excited when I see my former students in mainstream television jobs as camerawomen." Hutton can say much the same about Canada: "There are a lot more women camera assistants, a few operators, some DOPs—though not many still—from when I started out. There were no role models; there was just nothing there. I've trained maybe ten, twelve, fifteen women camera assistants who are progressing through the ranks."

When Brianne Murphy became a DP, she wanted to hire other women as part of her crew, but it was a slow process over time. "As time went on I was able to hire more women, not because I was given the license to, but because they became available." Decades later Kuras regularly hires women on her crew, inspired in part by director Spike Lee, who might hire Kuras as his DP but who also makes a point of hiring as many African American crewmembers as possible. Kuras thinks a camerawoman can have more self-confidence when she is not "the only person" of her kind on set and she points out that

> when people over-emphasize gender differences, they're looking at the cup half empty instead of half full. I have a lot of women on my set. I see a lot of women on other people's sets. It's changing. The more you focus on the lack of women on set, the more you're going to be distracted by it. Just do your work, and try to give women a chance to work in the industry.

Emiko Omori is someone who has given other women a chance. Early in her career, "there were so few of us—for a while just me at KQED television station—but whenever I needed an assistant I tried to hire women. Some of them have gone on to be wonderful cinematographers: Dyanna Taylor, Judy Irola, Leslie Hill, Dorothy Littlejohn, and men like Michael Chin."

Many of these women became friends, in part because there were so few of them. Starting her career, Sissel thought of Churchill as the person who most influenced her. Sissel read an article in *American Cinematographer* about Churchill's documentary cinematography on *Punishment Park* (Peter Watkins; 1971): "Just seeing a woman with a camera on her shoulder was an unbelievably important image for me in those days." When Sissel started out, all of the women DPs could be counted on one hand, and in a decade "all of us could be counted on two hands."

While living in New York, Sissel became friends with Christine Burrill, a friend of Churchill's who was also a documentary cinematographer in California. Meanwhile, Judy Irola moved from California to New York and asked Sissel if she wanted a roommate. Sissel often had both Irola and Churchill staying in her loft in SoHo: "Those people made me feel like I wasn't so unusual. We were unusual, but having friendships with other women helped even though, because it was an era of all-woman crews, we would find ourselves going after the same jobs." Later when Sissel met Kuras, she was touched when Kuras told her that Sissel had been *her* role model.

Churchill introduced Kuras and Sissel. Both Churchill and Sissel had been Kuras' inspirations to become a camerawoman. Kuras says, "That's why it's important that I visit schools and do talks. I know that it helps. Not only other women; it helps other young cinematographers feel confident to try it."

Decades later Dirse feels that on feature sets in Los Angeles, Canada, England, and France, crews are more accepting of camerawomen because of the increased numbers of women directors, producers, and DPs.

There are a few instances when isolation comes with the job, primarily for solo documentary and news camerawomen, but it also sometimes comes with the territory covered by the documentary or news program. While filming river trips, Burns can find it hard to kayak and film simultaneously, but she does not doubt the ability of one-woman crews to capture an event. Durham also likes being a one-woman show because it enables her to pursue the sort of journalism she values. Moth did not generally see other camerawomen at work "because I will be from CNN, and the other women cameramen I know are from CNN, so often they will be somewhere else. Mary [Rogers, who also shot in war zones] and I at times ended up in the same situation."

The relative absence and scarcity of camerawomen in the past has meant that various sociological, aesthetic, and other questions about how camerawomen work generally cannot be answered on a statistical basis. As Kenny observes, "there was no conscious history of female cinematography," so we have a lot to learn.

Rising through the Ranks

There's more opportunity for women to enter on the ground floor. As you go up to camera operator, DP, the numbers shrink drastically.

(Liz Bailey)

Glover started camera assisting in 1972 in Los Angeles, working steadily until 1986 when she moved up to operator. By 1997 she was camera operating in features and television but still trying to get hired as a DP on union shoots. Meanwhile, she had been working as a DP for free on independent films, shorts, and documentaries. She thinks that in 2003 you could count on one hand how many female camera operators there were in the Hollywood feature world, though more women operated cameras in television, documentary, and TV news. "Feature camera operators are mainly men. It was disappointing," she admits, "but I made my living doing B camera, mainly."

Extrapolating from her own experience, Glover can explain why the number of women DPs in national cinema guilds around the world generally hovers around 2-6%. Glover's starting point is that, for men *and* women, practicing—doing the skill over and over—is necessary to improve any art form or technical skill. Hence, camera operators need opportunities to practice to develop and retain their skills. When Glover worked as a camera operator on several features with the same DP, she knew her skills were getting better and better. Then he moved to Canada, her work opportunities became sparse and intermittent, and her skills got rusty. Women, Glover argues, have fewer chances for constant practice than men have since most camerawomen are on the B list.

Even if we're considered competent, we're still at the lower end of the list of people who get called to do the work. You don't get to do the work so you don't get to develop your skills. So you never get to attain a level of accomplishment that the guys do, and then sadly, the guys can turn and say, "See, she's not as good as we are." Well, why would you be? You haven't had the opportunity to practice.

Glover made it clear that she was not implying women are inherently less competent than men.

Rising up the camera crew hierarchy can be beyond the reach of some workers for reasons beyond their control. For women, a big reason is sexism. "Right now in the union [in Canada] there are a lot of journeymen—women—that are first camera assistants/focus pullers who have been doing this for fifteen years," Kim Derko observed. "I've been working with men focus pullers who have been focus pullers for five years who will get upgraded faster" (Moffat).

Yet there are also some camerawomen who choose to stop at some particular level. Michelle Crenshaw worked as a camera assistant in Hollywood for eighteen years before moving up to camera operator. As a camera assistant, she worked on a number of feature

films—*Training Day* (Antoine Fuqua; 2001), *Home Alone* (Chris Columbus; 1990), *Home Alone 2* (Chris Columbus; 1992), *Only the Lonely* (Chris Columbus; 1991), *The Babe* (Arthur Hiller; 1992), e.g.—as well as on commercials, music videos, and television shows. She was second assistant/loader on many of these jobs, but when she moved up as a first assistant/focus puller, the feature world was "more like a day-play situation for me." She did move up again, though, working B camera on *Love Jones* (Theodore Witcher; 1997).

By then, however, Crenshaw had decided that becoming a feature film cinematographer was no longer her goal.

> *I know that, as of right now, I don't have the personality to be a cinematographer. I'm not into trends. I don't put myself out there and say things because I know somebody else wants to hear it. I'm down to earth. I'm assertive. At one time in my life I wasn't assertive; I was just listening and taking everything in and constantly being told what to do. Now I know who I am and I make decisions for myself. And if I don't like the way you deliver a line, I'm going to tell you I don't like it. And some people don't want to hear that.*

Crenshaw thinks that once she got caught up in networking and judging herself by the outside standards of the film industry, she "lost track and stopped shooting." In recent years, however, Crenshaw is working as an independent cinematographer, in addition to her operating on features, documentaries, commercials, TV episodes, and webisodes.

Some camerawomen think that rising up the ranks depends on getting respect for one's skills and for oneself. There are different stories of gaining respect, but they all share the basic points that one must work hard as part of the team as well as know one's job. From the beginning Vijayalakshmi was aware of the politics on the Kollywood sets. When she started out, "I had to learn my work from scratch from the light man on how to operate lights, then from the electricians, and then from the focus pullers." She made it clear she wanted to learn from the lighting assistants and the electricians; as a result, they did not resent her. As she worked her way up, others saw her "stand and work long hours, day and night, so a respectful working relation developed for each other."

Ziegler claims to have been unaware at first of the politics on the set, which she calls "80 or 90% of survival." Nevertheless, she pioneered Steadicam cinematography in Hollywood. Ziegler did not come up through the ranks with others showing her the ropes, but just showed up with her Steadicam gear. "I was so out of it that I can't tell you what peoples' real reactions were. I'm sure it was the whole gamut. I'm sure I was inappropriate and talked at the wrong time and parked at the wrong place, because I just didn't know." Still, Ziegler got respect from her fellow cameramen because of her excellent skills with the Steadicam.

In a 2005 conversation with Glover, Wexler said that women like Ziegler commanded respect and made breakthroughs into camera operating. "When I worked with her, she was pretty tough. She was very definite and very strong. For some kinds of jobs, it's important if women can muster that up without being abrasive. Men in authority can respect that. I've seen Liz Ziegler demand that respect and deserve it."

How long should it take to climb the professional ladder? There is no universally correct answer. Mexican Celiana Cárdenas notes that some people go through the early steps quickly, or simply skip them.

It takes between five and ten years [to become a DP in Mexico] but there are people who finish film school and start working as cinematographers in commercials and films. I do not feel there is a difference [on this point] between men and women. In my case, I left Mexico and lived in different countries. I started shooting about eight or nine years ago. Before that I assisted, operated camera, or did Second Unit work.

Most seasoned camerawomen agree that it *should* take time to climb the ladder. In Canada, Joan Hutton can think of only two people who became cameramen within three to four years of finishing film school. In general, Hutton thinks that it can take a camerawoman fifteen years of experience to become a good DP. Because camerawork is "a learned trade. It's that melding of technical and art," Hutton thinks that both women and men need to start at the bottom and take ten years to work their way up to DP. "Not everyone who starts out as a second assistant ends up being an operator/DOP, no matter what your sex. You have to have that drive and initiative and really want it badly."

In 1975, Hutton became the first female DP in Canada. When she started as a camera assistant, she enjoyed being a camera assistant and thought it was a good profession. "There was no possibility at that point that anyone was going to hire a woman to shoot." But she wanted to shoot. When Paul Jay, who had been her trainee, decided he wanted to direct, he called her up and said, "Let's start our own company. I'll direct, you'll shoot, and we'll make our own documentaries." She felt that would be a good way to get experience.

You're not going to get any experience unless you have experience. That's the Catch-22. People won't hire you until someone else has hired you. I got around that; I started my own company. It worked out well. We were partners in High Road Productions for twenty years.

Zoe Dirse, one of the first women to join IATSE in Canada, was interested in "the art of cinematography and not necessarily the job of cinematography." She had been working as a therapist and was moving up the ladder in that field, as well as teaching. Still, she wanted to express herself artistically, so at age 25, she started her cinematography career. Luckily she met a business agent at IATSE in Toronto whose wife was the niece of an original suffragist. "He was determined to support me and bring me along." Dirse took one or two years to get the training and to make the contacts.

I worked as a camera assistant for about a year and a half or two years in Toronto with IATSE. Then I went to the National Film Board of Canada and worked as an assistant for two, three years. I made a goal for myself that I would be shooting by the time I was

30 years old. I wanted to use my 30s to hone my skills so that I could start DPing and doing bigger projects.

When Katie Swain began at the BBC, a beginning assistant would work ten years to become a cameraman, but as time passed, the number of crews at the BBC diminished and it took longer. "Basically you had to wait for someone to die or retire before you got made into a cameraman." After five years at the BBC, with no sign of that progression, Swain decided to go freelance. After seven years as a focus puller, Swain finally made DP.

Kenny followed training at the Commonwealth Film Unit with work at the Australia Council of Film and Television Board as a Project Officer (reading scripts, going through budgets, talking to filmmakers, giving advice about how to find funds, etc.). After shooting little films on weekends, she found her first professional job on a documentary shot by Russell Boyd. There followed four or five years of camera assisting, first as loader and then focus puller. When she decided to work only as a camera operator, "It would have been easy for me to [continue to] accept offers of focus pulling work but I knocked them back until people started thinking of me differently. Once you're known as a focus puller or first camera assistant, it's hard for people to see you in another light."

In the United Kingdom, Sue Gibson, having come out of film school without any industry contacts, got her first job in special effects. Over the next eighteen months, though, she was clapper loader for *The Ploughman's Lunch* (Richard Eyre; 1983) and another picture, and also worked on commercials. "That's how I started. It only takes one person to give you a chance. It then takes you to have the courage to say yes and carry on from there." However, based on her experience in the British film industry, Gibson offers a sober picture of the future job market for camerawomen, and camera crews in general. Because film is perceived to be glamorous, many young people are so desperate to work in the film business they'll do it for nothing, and so producers will employ them for nothing. Consequently, Gibson notes, her salary doesn't go up, while "every day, every job you do, you're going to have to work harder. The older you get, the harder it becomes."

As digital technology increasingly dominates the production of images, and the Internet has increased the types and numbers of platforms for viewing these images, there has been what Jendra Jarnagin calls "the democratization of filmmaking." However, she adds, "There are plenty of drawbacks," including

a major de-valuing of the role of the cinematographer. Lots of people think anyone can shoot. I've seen a lot of smaller projects where the directors just shoot it themselves because they don't want to pay a DP. And whereas there was always a level of production where people worked for free as they were learning, more and more productions of a higher level expect a DP to work for little to no pay, and yet expect them to be beyond the entry-level where they would be justifiably working for free to get experience. Or if they are being paid but they own equipment, there is an increasing expectation that they throw in their gear for free. Many people are hired just because they own

a camera, with no consideration to their suitability to the project in terms of taste, talent, style, personality, or experience.

Some camerawomen make sure to own the newest cameras; others rent. Some feel they have to live in a part of town where they can socialize with other filmmakers who know where the jobs are; others live cheaply on the outskirts to be able to afford the new equipment and to work for free while building their reels. Camerawomen have found different ways to avoid poverty and acute, constant anxiety about their financial stability. American Arlene Burns recommends a simple lifestyle with few expenses. "I don't spend much. I'm not a consumer. When I do get work, I'll put it into technology—a new camera, a new lens, or something else. I don't spend if I don't have it; that's how I've found the balance."

Other camerawomen avoid financial risk by finding steady employment with TV, where there are other risks. At one point, Heather MacKenzie worked in both film and TV in Los Angeles. TV seemed like a pair of "golden handcuffs" to her, because it gave her a steady job, regular pay, and benefits. "When I got hired, I said, 'I'm going to be here two years.' They laughed at me and said, 'You're going to be here for a long time.'" She stayed for 24 years. In 2000, MacKenzie felt that TV was wonderful, giving her a great job she loved; she also felt that she could have branched out more if she had been doing camerawork on films. She wished she had not stayed with the safe thing (and "safe," as we shall see, did not mean physical safety). What scared her most about film was that as a woman

I couldn't even get into IATSE until about ten years ago. The other thing is that in film, as soon as your job was over, you had to be out there pounding the pavement, selling yourself to somebody else. I hated having to sell myself.

Budgets and Glass Ceilings

The budget played a big part in my first feature. You can tell; the production values suffer.

(Lee Meily)

The money that camera crewmembers get paid is of course part of a film's budget. Many documentary filmmakers like Turkey's Berke Baş work on what she calls "no-budget films." So she gets no money from her camerawork. The size of a film's budget affects just how large and how well paid the camera crew is; it also determines the sort of equipment that is available and how many days are available to work on the film. Many camerawomen have worked on independent films, which almost by definition have low budgets.

When people ask Kuras, as they frequently do, "How do you determine what format you're going to shoot in for any given movie?" she answers that the film's content determines much of the budget along with other key production decisions. But then she mentions that she

did cinematography for Rebecca Miller's *Angela* (1995), which won Best Cinematography at Sundance, followed by Miller's *Personal Velocity* (2002). Before they shot *Personal Velocity,* Miller told Kuras that they had only $150,000 for the project. Kuras was surprised that Miller had received so little funding, yet she said yes. She had already worked on $65 million movies, and $150,000 wasn't much money to make a feature, but she wanted to work with Miller.

In 2003 American producer Sarah Pillsbury acknowledged that "there is an unspoken sexist notion [about] women having trouble with large projects," but she argued that since "women control the family finances," there is no reason we cannot "manage large sums of money, and allocate it fairly, which is what you do around a household." Sexism, though, is not logical; it is emotional, and Pillsbury said that many in Hollywood believe in the stereotype that "the men need the money more, that they have households to take care of." Furthermore, she reminded us that making a movie means that someone has to trust another person with a great deal of money. Hollywood men prefer to entrust money to male directors and heads of department.

There is more trust in women producers; that is definitely an area where there has been headway. But when it comes to directing, when it comes to running the camera department, being the DP, those are the areas where women are still shut out. Production Design is more opened up. I have worked with many women grips and electricians. There is absolutely no difference whatsoever in their ability to perform the job.

Jessie Maple Patton agrees. One of several camerawomen who have shifted from camerawork to producing and directing their own films, Patton sees camerawomen in the United States working mostly in television, low-budget independent films, and documentaries, but not shooting big independent productions or big-budget studio features or commercials.

The people—men mostly–who produce these films and put up the money are just selfish and have no intentions of giving women the opportunity that they should have. I don't think this is going to change until we get some African American women that are heads of production companies who have a conscience, know that these women are out there, and give them the opportunity to work.

Sandi Sissel is one of those women Patton has seen working on TV and low-budget films. Sissel has worked on an enormous number of US television movies, which she finds easier to shoot than a series because you have a little bit longer to do them. In the late '80s when she started shooting television movies and miniseries, they had relatively large budgets and successful feature directors worked on them. Sissel first worked on the television miniseries *Drug Wars* (1990), produced and directed by Michael Mann. Sissel had a tremendous experience working with Mann: "We were proud of our work." After this film, Sissel continued to work on a number of TV movies with good directors and actors but with shorter shooting times (20-25 days). Still, she is sure that "we were able to do some very creative work." She was young and green, with no worries about how much time she had.

In retrospect, Sissel thinks that shooting those TV movies between 20-25 days led to the twenty-day independent movie. At the time she did not realize the difference between a big TV studio's short shoot and an independent low-budget film's short shoot until she had experienced it.

> *Give me a Musco light; I'll use it on a TV movie. Give me a crane; I'll use it on a TV movie. I really didn't know better, and the directors that I was working with didn't know better either. The one advantage to a TV movie over a low-budget independent film is that if you can accomplish it in the days that they give you, then you can ask for a lot of big lights, and they will deliver them.*

However, "the first time that I did a low-budget movie for the same period of time, I realized that not only did I have a twenty-day schedule, but I had very little equipment to accomplish the job."

Sissel contrasts the experience of working on a big-budget film with a good production designer who gave her "beautiful colors, beautiful textures, and beautiful sets" with her usual experience of coping with low budgets on independent films, finding herself working "on projects where the production designer has virtually no money to work with and the locations are not things that we envisioned when reading the script." That's when she has to make do "with what you have." Or, as Brianne Murphy put it, "You have to realize that even though there is art involved, the more technically proficient you are, the easier it's going to be to get in what you consider your art. But you'd better be on time and on budget first, or you're not going to work next week."

Shooting ads in the Philippines, one way Lee Meily copes is to give the producer options: "I can build a platform for you, which would take me two hours. You would hang the camera upside down; there would be no space to put in the lights. That means I will take time to put the lights. Or would you like to rent this $5,000 equipment? Can you compute for me?" Meily has also used her personal resourcefulness to find solutions to some of the challenges on location. For example,

> *You need the sun, and the clouds come in. Everybody looks at you—the director, the actors, the agency's producer, the client—and says, "When can we shoot?" I trained my gaffer to watch in 30 seconds. He counts, "29, 28, 27," and the movement of the leaves. When I was small, I noticed that just before the rain comes, the movement of the leaves will be different. It saved us a lot of money and time.*

Meily's practical approach illustrates Frenchwoman Dominique Le Rigoleur's assertion that "working on low-budget films allows one to explore creative approaches to the image" precisely because of the restrictions. In Britain, however, lower budgets increasingly pose a problem for Katie Swain: "The time we're getting to spend on things is becoming shorter and shorter. The climate has changed a lot with TV drama. We're making a 50-minute program

in twelve days. That's short. I remember as an assistant we'd get four to five weeks to do something like that."

Gibson says that English productions rely more and more heavily on their crew—"not just the DOP, but the entire crew." Gibson thinks a producer or a director does not need to have a lot of qualifications but does need good ideas and enthusiasm since

the crew will carry you along and make it happen for you. Which puts a lot of pressure on the crews to make the film happen in the time allowed. And budgets aren't getting any bigger, particularly in television. They're still operating on the same budget this year as last year and the year before. I don't see how that can possibly continue.

Le Rigoleur sees a negative connection between budgets and the status of women cinematographers in France. "The place of female DPs in France has changed in the last twenty years. They are accepted now, but the majority of female DPs work on low-budget films. The reason why isn't with the female DPs; it's with the producers, the directors." Champetier agrees "that the budgets we are given are often less significant than those given to men," yet she says that is "in the process of changing little by little"—and she says that men and women DPs have equal status in France. She admits that the budget differential is "obviously due to discrimination. There is a novelty in our being there. But these things will change." She is convinced that the work camerawomen do will inspire confidence in producers.

Glass ceilings are closely tied to budgets. Before Most returned to Los Angeles in 1996 for family reasons, she had to decide whether she should stay in Hollywood. She interviewed camerawomen working in Los Angeles whom she had met a decade earlier and asked them where they were now. She did not find anyone really happy with their life or career.

They had so many disappointments and betrayals and glass ceilings. I saw the guys who were camera assistants when the camerawomen had been assistants had become major DPs doing big million dollar pictures—not $1 million pictures, but $30, $50, whatever— after one movie. Whereas I knew a camerawoman from New York who has been working 35 years and she's getting the $500 [thousand] to $1 million movies.

US camerawomen's experiences of a glass ceiling correlate with the low percentages of female DPs in the country. Commenting on how things used to be, Liz Bailey turns wry: "They used to think we were all the same woman, because there were so few of us. Since then, the numbers of camerawomen have quadrupled. Unfortunately, there's still a glass ceiling." Basically, North American camerawomen, at least, agree that a glass ceiling did and still does exist. Some women have interesting theories to explain why.

Glover's "view is that as long as a woman is somebody's assistant it is OK to be a successful assistant. As soon as I moved up to operator, my head hit the glass ceiling." The pain caused by the glass ceiling's restriction is evident: Now retired, Glover is disappointed with the whole

Figure 15: Caroline Champetier, AFC. France.

of her career as a camerawoman. She had worked on three features—*Star Trek VI* (Nicholas Meyer; 1991), *Hocus Pocus* (Kenny Ortega; 1993), and *Tombstone* (George P. Cosmatos; 1993)—in a row as an A camera operator. She had also worked as an A camera operator on some big miniseries and as a B camera operator, Second Unit, on many other big features. She felt at that point that,

> *had I been a guy, I would have been a top camera operator, because I would have been allowed to work a lot more. I should have gone on to do a lot more feature work. I don't think it's that I had a bad personality or I smelled funny or anything like that. It's a glass ceiling, certainly in the camera department. Anyone that says it isn't, either they're deluded or they're lying.*

Ellen Kuras opts for a cheerfully pragmatic approach:

> *I try to think about it as not trying to break the glass ceiling but instead going up there on a ladder, cutting a little hole, and then just flipping through. [Laughter] Much more effective than smashing your way through. Just carve your own way through, do your work, and continue on. Everybody else can come through as well.*

Notes

1 Unions scare producers, however. For example, when actors attempted to unionize *The Hobbit* (Peter Jackson; 2012), Sir Peter Jackson (a significant producer as well as director) immediately "prompted" the conservative New Zealand government then in office to pass an industrial relations law that specifically identified most film workers as independent contractors rather than employees. This came after Jackson's company lost a court case while making the *Lord of the Rings* trilogy when a worker argued that he was an employee rather than a contractor.

2 Swain says that in England the Broadcasting, Entertainment, Cinematograph and Theatre Union (BECTU) has negotiated equal pay for women and men.

3 The International Cinematographers Guild IATSE Local 600, which covers the entire United States.

4 Representing the three major US TV networks at the time.

5 Omori remembers Wang as the first female DP in New York Local 644. It was a major achievement for Wang to have gained admission to the union in the 1960s. Much later Wang "died penniless and with no help from the union, which corroborates the fact that sexism is worse than racism in this business," Omori notes.

6 "IATSE Local 659, the Hollywood union that shoots most US union features and television programs, merged on 16 May 1996, with New York's Local 644 and Chicago's Local 666. Their new name is Local 600" (Krasilovsky, *Women Behind the Camera* xvi).

7 Conversation between Kimberly Myers (then Diversity Coordinator, WGAW) and Alexis Krasilovsky, 28 March 2014, Los Angeles.

8 I.e., sound was not captured simultaneously with the image, so heavy sound equipment didn't need to be carried around.

9 A portable video recording system marketed by Sony in the early 1970s.

10 Nelson Tyler is also a cinematographer, specializing in helicopter work. A pilot, he invented camera systems for shooting from helicopters ("Nelson Tyler").

11 A World War I battle in Turkey during which many Australians died, Gallipoli is a frequent subject for Australian authors and filmmakers.

Chapter 3

Documentary: A good and satisfying career choice that is statistically friendlier to women than feature fiction filmmaking

Documentary, among its other attractions, has been an important entry point for camerawomen, many of whom have worked later in their careers in feature fiction films, or managed to work in both forms. In the second half of this chapter we will survey some of this variety.

We begin, though, with a close-up on a small group of pioneer camerawomen who captured one of the most historical eras in Chinese history. These women talk about their personal interaction with figures such as Mao Tse Tung at key moments of national and international history. They talk about the (lack of) availability to them of filmmaking technology,

Figure 16: Chinese Camerawomen: Yu Yi Hua, Chen Jin Ti, Cui Shu Feng, Shu Shi Jun, Zhao Yan and Zhou Kun. Beijing, China. Photo credit: Sheila Pinkel.

and especially of film itself, and how this availability affected both the logistics and style of their shooting practice. And they talk about juggling family expectations with expectations of them as professional women. They themselves had an impact on a changing Chinese society: Just being seen working was a shock to many of their fellow countrywomen; the films that they made had an impact; and they created an ongoing legacy in that several of the younger women stress that seeing the older women's names as part of the film credits spurred them to pursue the same career. Often this second generation was taught by the pioneers as well.

Filming History Being Made in China

Chinese camerawoman Chen Jin Ti describes traveling by horse-drawn wagon into the Chinese countryside in 1949 to film with her partner/teacher, who was 30 years old; she was seventeen. Part of her job was to carry the camera equipment. She said, "When we got to the villages, all of the women, young and old, came out to see the female cameraperson. They thought my teacher must be married to me. They couldn't imagine a young girl could go outside to do camerawork. They thought it was big news." A female cameraperson in 1949 was not just news in China but around the world.

Chinese women's roles changed significantly in the first half of the 20th century. With the fall of the Qing Dynasty in 1911, followed by the May 4th Movement in 1919 (associated with the intellectual class), China's traditional patriarchal culture opened up to some degree to include women's emancipation and education.[1] By the 1920s-30s, particularly in Shanghai, Chinese women fiction writers appeared in print and, although only men acted in traditional Beijing opera, women appeared in films. The Chinese film industry emerged alongside this new China, based largely in Shanghai. During the 1930s the first film stars emerged, including the first woman star, Ruan Lingyu, who killed herself at the age of 24 (Kerlan). Her funeral procession was three miles long; her popularity was due in part to the fans who identified with her suffering as China struggled to modernize.[2]

After the Japanese occupation during the 1930s-40s and the Communists' decisive victory over Chiang Kai-Shek's Nationalists in 1949 during China's civil war, some filmmakers fled to Hong Kong or Taiwan while others stayed in the new Communist country. Meanwhile, the Communists nationalized the film industry. From 1949, there were three Chinese film industries: the People's Republic of China (also known as mainland or Communist China), Taiwan, and Hong Kong. Since the Communist government of mainland China thought film was important both for art and propaganda, the government established many new theaters, increasing the film audience from 47 million in 1949 to over a billion in 1959. The government sent filmmakers to Moscow to study and then established the Beijing Film Academy in 1956. From 1949–66 the government made "603 feature films and 8,342 reels of documentaries and newsreels" ("The History of Chinese Films").[3]

Shu Shi Jun and Chen Jin Ti belong to the first generation of Chinese camerawomen, starting work around 1949–50 in Communist China. Both women graduated from Hua Bei

Northern China University. After graduation, they were sent to Beijing Film Production Company's Media Department to train as camerawomen. Shu Shi Jun said, "At that time most Chinese women stayed home and most fields weren't available to women. The government encouraged women to go out, get jobs, and become independent." Chen Jin Ti added that in 1949 when the government called out to liberate Chinese women from being housewives, she and her friends were excited, wanting to show that "whatever a man could do, we do just as well."

The government wanted Chinese camerapeople to film news documentaries on the New China to show in the country's theaters. But Shu Shi Jun recalls that Chinese cameramen in 1949 did not want female camera assistants, as they thought women were not strong enough to do "men's work." The pioneer Chinese women decided to show the men wrong: "When it came to the equipment—the camera, the tripod, and the other heavy stuff—if a man wanted to carry one thing, we'd carry two, to show them we could do a better job than they could."

When Chen Jin Ti tried to shoot rural Chinese women in 1949, she had problems because the village women were shy, having never been before a camera. "It was difficult for us to convince them. We were only able to film them when they were working in the fields, farming. Now everything is different; the household is sometimes even controlled by the woman."

Shu Shi Jun's particular job was to cover political news including filming Chairman Mao, Prime Minister Zhou, and "important governors." Shu Shi Jin describes filming Mao's many trips to the countryside during the Great Leap Forward in 1959–61. She followed Mao around with her camera on these trips; her equipment in those days was quite heavy. She would be told to bring lots of film and report to the Zong Nan (a Chinese destination similar to the White House in the United States), but nobody would tell her where they would be going. She sat on the train with the security guards, the news reporters from the Central Media Department, and Mao and the officials who accompanied him.

Every time Mao Tse Tung saw something, he would have the train stop right there. Most of the places were wheat fields in the countryside. By the time I realized Mao Tse Tung wanted us to stop, he had already walked away to talk to farmers. I learned not to take off my shoes, so I could jump off the train as soon as it seemed to be stopping. I had the camera, batteries, and gear ready next to my bed, so I could get up anytime they needed us.

Shu Shi Jun explains China's economic policy known as The Great Leap Forward as China's desire to do better than Britain and America. At first, she said, China seemed to have bountiful harvests, but people were still hungry. Nobody had recorded the actual numbers; instead, the officials had been faking their reports. So while she did not understand at first why Mao was traveling to the countryside, "Later on I did. He was at the top and couldn't hear what was happening with the masses. So he wanted to see for himself. He found out all the reports were fake, and that's why he wanted to stop suddenly at random places to see what was really happening in the countryside."

Once, Shu Shi Jun remembers, Mao stopped at a small village so he could meet on the train with all the leaders in that area.

I started to hand-crank the camera. Mao Tse Tung was not happy about my shooting during the conversation because it blocked him from hearing everybody's answer and the leaders in the village could not hear what Mao Tse Tung was saying.

Mao Tse Tung was full of scorn for these people, saying you can't be a leader and not go down to the farmers and find out what is really happening with the crops. All of a sudden, Mao Tse Tung asks, "Does anyone here believe in God?" Nobody has the courage to say they believe in God. Then Mao Tse Tung says, "I believe in God!"

It scared people. Wow, Mao Tse Tung believed in God! That's something new. But after that, he said, "Who is God? God is the people, the farmers. Make God unhappy and they will never forgive you."

Then the security guard did not let me shoot anymore.

During the 1950s-60s, Chen Jin Ti worked as a camerawoman for Prime Minister Zhou Eng Lai in Beijing. She was deeply influenced by Zhou "not only creatively, but also because of his personality. He was always so humble, and cared about others." Like the other camerawomen, Chen Jin Ti had to carry heavy equipment. Once when Zhou was holding talks with foreign leaders on Mount Gui Lin, she and the other camerawomen walked their heavy equipment up the mountain in order to film these men. However, this time

Prime Minister Zhou asked me, "Why are you always pointing the camera at us? Look below! There is good scenery you can shoot." He moved me to his seat, pointed at the mountains that were reflected in a mirror, and said, "Look at those mountains. They're so beautiful. Why don't you shoot the mountain scenery?"

I was pretty nervous because it's hard to measure the distance from a mirror to a real object. For the camera, distance needs to be doubled; it often turns out blurry if I don't adjust the distance correctly. Also, the camera had to be manually cranked. I said, "I'm sorry, Prime Minister, I can't do it." Zhou didn't blame me for my lack of confidence. He said, "That's OK. I'll pick another angle for you." So we walked outside, and he said, "Try this angle. Is it any good?" I started shooting.

When they started back down the mountain, of course Chen Jin Ti and the other camerawomen had to haul the heavy equipment down with them. "Prime Minister Zhou told us, 'You camerawomen have to walk too far. Come into our car and go with us.' Of course I immediately replied, 'We can't because there are too many people.' Zhou told his bodyguards to help carry the heavy equipment. He really cared for us."

In 1959 Shu Shi Jun filmed the celebration of China's tenth anniversary of independence, which Nikita Khrushchev, the Russian Chairman, attended, although the Chinese-Russian relationship was tense. The hall was crowded with important people and many of the dignitaries

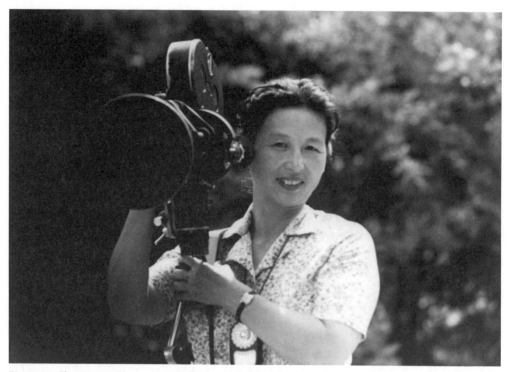

Figure 17: Chen Jin Ti, with camera, 1950s. China. Photo courtesy of Chen Jin Ti.

wanted to speak, so Shu Shi Jun was busy filming each speech. Suddenly interrupted by a call to go to Prime Minister Zhou, she found herself overhearing a bit of history: "Chairman Xiao Fu [Khrushchev] was lecturing Chairman Mao Tse Tung. I heard one phrase from Mao to Xiao Fu: 'We're not your conductor's baton!' Whatever Xiao Fu wanted, Mao refused to comply."

Shu Shi Jun worked from 1949 to 1990. During that time, she had to shoot subjects chosen for her rather than choose her own subjects. After 1976, while she still worked on documentaries to be screened in cinemas, she no longer shot the news. When such documentaries were displaced by television, she changed jobs and worked for television, still covering political news and important events. She casually mentions that "President Deng Xiao Ping, Prime Minister Li Xian Nian, and Governor Zhao Zhi Yang went to America; I accompanied them many times." As she got older, Shu Shi Jun switched to working as the director and editor for the TV media department.

Chen Jin Ti worked in the media for 30 years before co-founding the Chinese Children's Movie Organization in the 1980s. As a producer, she became the head of Children's Television at Central Television in Beijing. "Our new generation is allowed to see better movies," she said. She also visited America several times: "We brought Chinese children's movies into the American film market and got great feedback from American audiences."[4]

Shu Shi Jun and Chen Jin Ti were role models for a third pioneering Chinese camerawoman, Zhou Kun. In 1949 Zhou Kun was a high school student in Shanghai, where she watched documentaries that Shu Shi Jin and Chen Jin Ti had made. By the time she graduated high school, the Beijing Film Academy had been established, where she majored in television news. At the Film Academy both Shu Shi Jun and Chen Jin Ti were her teachers. When Zhou Kun's family needed her, she stopped school temporarily. But then the government sent her and other film students to the Soviet Union, where she studied feature filmmaking for four years. There she was lucky to study with Boris Volchek: "He paid a lot of attention to me and got me interested in being a camerawoman. He taught me shot composition and how to capture the best image with the camera." After returning to Beijing, she worked for a Chinese film company and "became a professor and taught in the Beijing Film Academy. After I retired in 1994, Beijing Teacher's University hired me as a professor. I'm still teaching filmmaking there. We teach filmmaking as learned in both Southern California and Russia. Many students have graduated from our school."

Yu Yi Hua belongs to the second generation of Chinese camerawomen. Seeing Shu Shi Jun, Chen Jin Ti, and Zhou Kun making documentaries inspired her to become a camerawoman herself, and they were her teachers at the Beijing Film Academy. After four years as a camera major, she graduated from the Film Academy in 1963. For twenty years she was assigned to China's Central Media Documentary Production Company as a camerawoman, working only in news. "It was hard work, but I wanted to do only perfect camerawork. When I turned 40, I was promoted to write and direct."

Yu Yi Hua remembers that because she was a very skinny woman her fellow students and workers questioned why she wanted to do camerawork. "But the more you don't want me to do something, the more I want to do it. I love camerawork, although it's hard and takes a lot of energy, especially for women." She filmed on Lushan Mountain, which is also difficult for men to climb. She also filmed in the countryside, in a coal-mining facility, and in a steel factory. "The men said not to go to these places because they weren't for women, but I insisted. Shu Shi Jun and Chen Jin Ti were good role models for me. We were willing to work harder than the men in this business."

Cui Shu Feng is another member of this second generation of Chinese camerawomen. When she was young, she loved to watch movie documentaries that showed the New China. The first film she saw, around 1955–56, was by Shu Shi Jun. "Somebody told me that that person was a camerawoman. That's when I aspired to be a camerawoman, in high school." After Cui Shu Feng graduated from the Film Academy in China, she worked for Xiyang Production Company until 2000 when she retired.

Cui Shu Feng refers to a particular difficulty the camerawomen had when filming pre-1990. They usually traveled to a film shoot by car or train; traveling by airplane was rare. While traveling, they were afraid of breaking their camera equipment, so they always carried the equipment cases with them. "One case could weigh over 40 kilograms [88 lb]. The case that contained all the different types of lenses also weighed 20 kilograms [44 lb]," she recalls. They also had to carry the tripod and other equipment. So when, for example,

they got off the train, they moved things little by little—"move all the cases from one side, go back to pick up the other cases, and make sure nothing got lost. Those days were tough. However, I loved this job."

For Cui Shu Feng location shooting was difficult because it could be up to 40 days before they returned home; once, she spent half the year in the field. She shot numerous news segments, about 200 short documentaries, and more than 30 long documentaries. In 1993, when China switched to longer-format television documentaries, she still carried heavy equipment. Yet after she became a director, she "missed those days as a camerawoman, because when I tell people to shoot this and that, they don't do it the way I want. Even though I'm retired, I still want to carry the camera and do it myself."

This second generation—Yu Yi Hua and Cui Shu Feng—discussed how marriage, having children, and other women's issues affected their camerawork. When Yu Yi Hua was young, the Chinese Communist government had a policy of "one couple, one child." Despite that, she says that she could have had two or three kids; however, she

> knew if I had more kids, it would have required more time to take care of them. I chose to have only one child to give me more time to do my work. Now that I'm retired, I regret that I only had one child because only children get whatever they want and they don't learn how to share. They also get lonely.

Cui Shu Feng had married a cameraman, so some of her friends advised her to change careers. She had two children because her husband was the only son in his family. "My mother-in-law wanted one more child. Plus, my first kid had some health problems. I was afraid of losing my job, so I waited and waited. Finally I decided to have another one." After the baby was born, she only had 56 days of maternity leave before going out on location for two months. "When I came back home," she said, "my five-month-old baby wouldn't even let me hold him. That was difficult for me." Sometimes both she and her husband had to go on location at the same time. "That was hard. Every time we went somewhere, my kids would hold my leg and not let go. It broke my heart." However, she adds that, "once I got on the train, I focused on my work." Despite Cui Shu Feng's experience, her daughter also went to the Film Academy and became a film director.

Cui Shu Feng loved her work, but she does not deny that her job interfered with her family life. "Just like Yu Yi Hua said, when you get old, you start to have regrets. Now I have my grandchildren. I want to make up for the love I missed out on."

Yu Yi Hua emphasizes that for "a camerawoman, work, marriage, and physical conditions are different, compared to men." She notes that women who worked in factories got three days off when their period came, but not camerawomen. They had to go on location and work as needed "because the team has to work together." Once during her period she had to film in a coal mine, carrying heavy equipment through "the mine for hours before we could reach our location underground," and then shooting for twelve hours. She thinks all camerawomen have "had an experience similar to mine once in a while." Yu Yi Hua

remembers how the film crew underground could not be contacted from above ground, and "the person in charge of the facility was worried for us because we had stayed down there so long. Twenty minutes after we got out, the whole mine collapsed."

Zhao Yan, a younger camerawoman, had all the previous camerawomen as her teachers. As in the West, pioneering Chinese camerawomen nurtured, inspired, and taught the next generation. In contrast to the pioneers' experiences, however, Zhao Yan grew up in the environment of a film production company, and she cites her cameraman father as a great influence. From 1985 to 1994, she worked as a camerawoman, shooting documentaries in different locations, including the countryside and the coal mine. "In 1990, I switched to working for television news. I also shot film for TV shows which included going into forests to shoot documentaries about animals such as wild elephants." In 1994 she not only worked as a camerawoman for CCTV, but also started writing and directing. "Now I'm working as a filmmaker for a health program, writing and directing. If we don't have a project, I also have a side-business, which is photography."

Chinese camerawomen, like Western camerawomen, have had to deal with huge technical changes in camera equipment from 1949 to the present day. When they started out, Chen Jin Ti remembers, they used cameras from both Russia and America. "They were very heavy and made of iron, and they were all hand-cranked. We had to visualize the distance and manually focus the camera and the lenses for the distance. These cameras were all old and burdensome."[5] Chen Jin Ti recalls how, over time, technology improved: "The hand-cranked cameras were replaced by battery-operated cameras. These cameras were easier to operate accurately, but we had to carry the big battery pack. This kind of operation is more stable because I could also change the speed, which was a big improvement." Now, she says, the Chinese use digital equipment, "which is even more convenient and easier to carry. Before, we carried a camera that weighed 30–40 lb. We also don't have to focus the camera because everything is automatic."

The Chinese camerawomen also commented on changes in the style and content of documentaries and then TV news from 1949 to 2000. Shu Shi Jun says that in 1949 and the 1950s, film was expensive and they had limited budgets. Nobody would sell film to the Chinese, and they could not make it themselves at the time, so "we tried not to make a mistake. We were so concerned about saving the film that we set the scene and posed the people very carefully. The acting was not natural." They also had problems with "coordinating sound and image [because] it was impossible to shoot the image and speech at the same time." Shu Shi Jin was impressed when Dutch film director Joris Ivens came to China to film around 1956–57, both because "he shot a lot of film," but also because "that was the first time we saw voice and action shot at the same time."

Cui Shu Feng remembers that their limited access to film stock in the 1950s meant they had to finish the project with those limits in mind. "We had to shoot what the boss told you to shoot. We could not be creative. We shot with a 1:2.5 ratio. If we did make a mistake, we might not have enough film for the end." There was a positive consequence to this experience: "Because we were used to getting things right the first time, we were selected to cover the news

on television." Working in television now, especially in the studio, is different, she notes, in that "when you make a mistake, you can redo it. I got so used to saving film that when I [first] used a video camera, I kept thinking of saving the film when you could simply rewind."

As for changes in documentary subject matter since 1949, Chen Jin Ti says that in the old days "we could only report the good news. In recent years, they have allowed us to report if something bad has happened, and then criticize them. They still encourage us to cover the interesting and colorful over the negative." Shu Shi Jun says that with improved incomes among Chinese, filmmakers have more material to select from than before. She mentions that after Deng Xiao Ping opened relations to foreign countries in 1992, the government allowed more cultural exchanges. "The audience's tastes changed," Shu Shi Jun comments,

> because they wanted to see something more entertaining than before, rather than always good news, which is boring. Every media station communicated with each other. Chinese media started exchanging material with international media. Everybody in society benefited, not only in politics but in culture generally.

She says that today "we have news and documentaries. The news talks more about daily life. The documentary requires government approval." However, Chen Jin Ti notes, after the reforms of the 1990s, news reporters from different states working for the new private production companies can select their own material for daily news.

Illustrating the extent of these changes, Yu Yi Hua recalls a foreign news reporter asking her in the 1970s about a horrible car accident. He wanted to know, "How come you did not show it on your news?" The Chinese people, she says, were not interested in such a subject because they considered it "just gossip. We want to let people know how to solve problems." She says in earlier decades camerawomen could not shoot documentaries on subjects like AIDS, for example, because they could not mention condoms. But now "we even report on people who have AIDS and who are abusing drugs, to show the consequences of such bad habits. We want society to see what is happening in our society. Now we have no restrictions."

Documentary: Historical and Personal

> You have to be genuinely interested in people to make documentaries. I feel so privileged to go around the world, be let into people's lives, and have incredibly intense experiences with them. Many of them have become friends for life.
>
> (Joan Churchill)

Film histories often start in France, setting up Georges Méliès and the Lumière Brothers as opposites in terms of their relation, on the one hand, to theater and entertainment, and to reality, on the other. Méliès explored the magical capabilities of cinema, using it as an

extension of the spectacles he was used to putting on 19th century stages. A magician used to creating spectacular illusions with the aim to entertain, Méliès brought those skills to his films. At the same time, he explored what magical illusions he could create through the way he shot and edited his films. That is, he created special effects for their impact on his audience. Meanwhile, and quite possibly before Méliès, Alice Guy-Blaché was doing the same thing, for example, in her widely available *La fée aux choux* (*The Fairy Cabbage*; 1896).

This is commercial, for-profit filmmaking. Creating special effects is costly. Documentary funding does not usually stretch to special effects (or any number of other expensive options). It rarely goes in for expensive special effects, though, because its aim has generally been thought to be to "capture the truth" or be a "true representation of reality." That doesn't mean that all documentaries can be taken for either. Carried to an extreme, documentary can become propaganda, just as commercial filmmaking can become exploitation films. (Which is not to say that one can't find sensationalism and exploitation in documentaries or propaganda in for-profit commercial fiction filmmaking.)

Nonetheless, it takes money to make documentaries. The commercial viability of documentary varies from era to era, but commercially successful feature-length documentaries have been the exception rather than the rule. For a while documentary was absent entirely from film screens at US cinemas. In recent decades, however, documentaries have been developing into an increasingly viable commercial form and US women filmmakers "have thrived in the documentary field as they still do not in Hollywood or in the indie world" (Taubin 1). Still, the money involved is not in the same league as, say, any male-directed action film.

Women have been filming documentaries almost from the beginning of cinema. In England, Mrs. Aubrey Le Blond (aka Mrs. Main) was credited as camerawoman on two films in 1900: *Skating* and *Figure Skating at Kulm River*—("Mrs. Aubrey Le Blond"). Jessica Borthwick was an English camera operator in the 1912–13 Balkan war, carrying with her a Newman cinematograph camera and a revolver as she "attached herself to the Bulgarian army" (McKernan). In the United States, Katherine Bleecker was hired to shoot motion pictures showing prisoners' living conditions at Sing Sing Prison for the Prison Reform Commission in 1915. One day while operating her hand-cranked camera "when hundreds of prisoners were taking their recreation period in the huge yard," Bleecker recounted for a newspaper article of 1931, "I looked about me … and saw all those milling convicts. Not a guard was in sight. I'll admit I was frightened, but I finished the job and left" (Brookman).

Adriana and Dolores Ehlers, two Mexican sisters who had studied photography and cinematography together in the United States, worked for the US government during World War I "filming subjects related to soldiers' health" (Rashkin 35). Adriana Ehlers is credited as DP and director for two documentaries in 1920, and Dolores Ehlers is credited as DP and director for the film *Servicio Postal en la Ciudad de Mexico/Postal Service in Mexico City* (1921). The Ehlers founded their own production company, Revistas Ehlers, doing their own camerawork for newsreel footage that they produced and sold between 1922 and 1929 (Rashkin 38).

Zora Neale Hurston, best known as a novelist of the Harlem Renaissance, did ethnographic camerawork in Florida in the 1920s (Bowser, Gaines, and Musser 192). Stella Court Treatt, a travel and wildlife filmmaker who co-directed the films *Cape to Cairo* (1926) and *Stampede* (1929) with her husband, Major Chaplin Court Treatt, is also credited as a camerawoman. *Stampede* was originally envisioned as a film about Sudan's game, but was expanded to include the Baggara Arabs' search for water ("Stella"). Canadian Judy Davis used a 16mm Bell & Howell to shoot films with her husband, Hassoldt Davis, in Africa and South America in the 1950s (Reynolds). The documentary feature *Albert Schweitzer*, shot by Erica Anderson over a period of seven years in what was then French Equatorial Africa as well as in Gunsbach, France, won a 1957 Academy Award.

In 1974, women at the National Film Board convinced the Canadian government to establish Studio D, the globe's first government-funded film studio dedicated to women documentary makers. As Gail Vanstone notes in *D is for Daring: The Women behind the Films of Studio D*, Studio D offered Canadian women training and a chance to make their often controversial documentaries. For example, Susan Trow broke through into cinematography at Studio D doing camerawork for two of Studio D's most successful documentaries: *If You Love This Planet* (Terre Nash; 1982), about antinuclear crusader Helen Caldecott, and *Behind the Veil: Nuns* (Margaret Wescott; 1984), which examined sexual politics in the Catholic Church. Despite its limited budget, Studio D made 100 documentaries, many of which broke taboos, to bring feminist concerns to Canadian audiences. Some of these films, notably *Not a Love Story: A Film about Pornography* (Bonnie Sherr Klein; 1981) and *If You Love This Planet*, provoked international debate. Most of Studio D's output was realist films that used cinema verité, talking heads, and voiceover narration, making connections between women's personal stories with their larger social and political contexts. The Canadian government developed films not only in English at Studio D but also at the French-language studio Regard des Femmes.

Zoe Dirse had been working as a camera assistant when she jumped at the chance to join the NFB as a camerawoman in Montreal. She loved her job because she filmed Canadian authors like Margaret Atwood and Mordecai Richler as well as social activists like Janet Rule. Dirse also shot many of what she described as Studio D's "social change documentaries but also docudramas that became defining films for our national identity." Dirse shot 72 documentaries for the NFB starting in 1981, including riveting footage of unrest in the Baltic as well as the Balkan Wars.

In 1987 Studio D began to push the previously realist documentary into new aesthetic directions. For example, Studio D produced Arleen Weismann and Lynne Fernie's *Forbidden Love: The Unashamed Stories of Lesbian Loves* (1992) that mixed genres to explore lesbian subculture in 1950s-60s Canada. Fernie praised Dirse for the camerawoman's ability to relate to the film's subjects so that they relaxed and spoke freely during the shooting. In 1991, another film unit, New Initiatives in Films, was started, giving training to First Nation (Native Canadian) and other minority women. Though Studio D became a model for women's documentary units around the globe and its films won over 100 international awards, the Canadian government cited budget cutbacks and shut it down in 1996.

Trow and Dirse are two of many camerawomen who have made brilliant documentary films from 1970 on. Many feminists in the 1960s-70s wanted women behind the camera as well as in front of it, and so for many camerawomen (as well as directors and other production crewmembers), feminist documentaries became an important training ground. Sarah Kernochan, Barbara Kopple, Christine Choy, Joan Churchill, and Nancy Durham were part of a new generation of US, Canadian, and British women encouraged by the civil rights, anti-war, and women's movements to start making documentaries in the 1970s, a trend that has continued to this day.

While women directed only 6% of the top-grossing narrative fiction films in the United States in 2013 and 18% of narrative films shown at the high-profile US film festivals in 2013–14, they directed 28% of the successful documentaries in 2013–14; and women cinematographers shot 12% of the 2013–14 documentaries, as compared to less than 2% of the top 250 films of 2013 (Lauzen, "Independent" 2014, 1). Some have won Academy Awards for Best Documentary: Nancy Hamilton's *Helen Keller in Her Story* for 1955 and Sarah Kernochan's *Marjoe* in 1972. Director Barbara Kopple won the Oscar for both *Harlan County USA* and *American Dream*. Co-Directors Christine Choy (also a camerawoman) and Renee Tajima-Peña were nominated for an Oscar for their documentary feature *Who Killed Vincent Chin?* (1987). By 2008, women made 30% of the United Kingdom's documentaries (Millward). Some though not all of these women directors hired women cinematographers or did their own camerawork.

New technology such as Portapaks in the late 1960s, Éclair ACLs in the 1970s-80s, and digital gear in the 1990s-2000s helped give women access to low cost, lightweight documentary equipment. Expansion of public television and cable gave women larger markets to sell their new films as well as greater opportunities to work for TV news.

Probably the most significant change, though, is that, as women became producers and executives in television, they moved up to positions of power, enabling them to buy documentaries directed and shot by women. In 2000 Cara Mertes became head of PBS's *POV*, the showcase for documentaries on US public television. Mertes told *Ms.* that "more than 60% of the documentaries that I've programmed since I started here were directed by women" (Taubin 2). Another top executive, Sheila Nevins, joined HBO in 1979, rising to become President of HBO Documentary and Family Programming for HBO and Cinemaxfilms. She has helped produce hundreds of documentaries that have won over 100 Emmy, Peabody, and Academy Awards (Jensen). Increasingly, women cinematographers can make a living from working on documentaries, some by working directly for networks, others through the sale of their documentaries to publicly funded networks such as PBS in the United States, Britain's Channel 4 or the BBC, Canada's CBC, and to US cable stations such as HBO, A&E, Discovery, etc.

The hot feminist issues covered in women-made documentaries vary from country to country. In Turkey Berke Baş and her colleagues made an important film about women's involvement as candidates in political elections. In Afghanistan Mary Ayubi and her colleagues filmed about women and education.

In India Sabeena Gadihoke has done camerawork for some of Mediastorm's documentaries, including *Burning Embers* (1988), about a sati incident where a widow took her own life. She has also done camerawork on a documentary about Indian sex workers, *Tales of the Night Fairies* (Shohini Gosh; 2002), which is about "a powerful collective of sex workers in Calcutta. As my colleague [Shohini Gosh] says—and I'm using her words here—'the struggle for sex workers is actually a struggle for women in general'" because when a person questions "why sex work is considered bad, you get into questions of what is morally right and what is morally bad. The moment you step out of line, you're not a good woman. That's something we all have to grapple with."

In America, abortion has been among the hottest of feminist issues covered in women-made documentaries. Here is subject matter that gives women an advantage over men for working behind the camera (a point we shall return to in Chapter 8). Even mainstream news shows on TV have been interested in doing some investigative journalism on the subject. Sandi Sissel, for example, did hidden camerawork in the 1970s, impersonating women getting abortions at illegal abortion clinics. The TV networks and also independent films wanted this footage, and eventually they wanted Sissel enough to hire her. After an early film about three women balancing family and career, Churchill's second film was about an abortion clinic. However, not all documentary camerawomen have focused exclusively on women's issues.

Joan Churchill's 40-some-year cinematography career illustrates how knowing women directors and producers as well as selling documentaries to television can make life as a freelance director-cinematographer shooting feature-length documentaries a working possibility. Churchill's career began with a job in the 1960s as an editor for Ikon Films, which taught her about editing. She only knew one camerawoman in the whole Los Angeles film industry—Brianne Murphy—and knew "there were real barriers for women as shooters" (Fisher, "Conversation"). As her film school friends got their first directing jobs, they had Churchill shoot their films, but for a time she could not decide between editing and shooting.

When Churchill was shooting still photographs on an independent feature, she met cinematographer Baird Bryant, ASC, who encouraged her. Then British director Peter Watkins, who was in California to shoot a political feature film, approached UCLA to hire a film student to shoot his film cheaply. The male dean recommended Churchill, who got the job. The film, *Punishment Park* (1971), was about overcrowded prisons and Vietnam War protesters. Churchill recalled how, with no script, they shot *Punishment Park* in the Mojave Desert with "real cops chasing real dissidents" across the desert.

> In one scene, we had a Black Panther on trial confronted by a man who was a judge in real life. [...] Things got quite heated, literally and figuratively. The film was shot as if it were a documentary. I never knew what was going to happen from scene to scene. [...] It caused a huge controversy when it was shown theatrically, because people thought it was real.
>
> (Fisher, "Conversation")

Haskell Wexler advised Churchill while she was shooting *Punishment Park* and continued to mentor her afterwards, and they have often worked together as colleagues. After *Punishment Park*, Churchill worked on music films including directing and shooting a documentary, *Jimi Plays Berkeley* (1971), about a 1970 Jimi Hendrix concert in Berkeley, California, that became a cult classic. Churchill was then able to work with famed documentary filmmakers Albert and David Maysles on *Gimme Shelter* (1970). The film has been called one of the greatest rock films ever made. Churchill next worked with Wexler and Barbara Kopple on *No Nukes* (1981), a lively antinuclear concert, and also with director Taylor Hackford on *Hail, Hail, Rock 'n' Roll* (1987) about musician Chuck Berry.

While shooting *Gimme Shelter*, Churchill met director/producer Charlotte Zwerin who also co-directed that film. Soon afterwards Zwerin became producer of the PBS show *An American Family* (1971), a cinema verité series about the Loud family. Zwerin brought Churchill on to be second cameraperson of this pathbreaking TV series—the first reality TV show—when Bill and Pat Loud, the father and mother, announced to the US TV audience that they were going to divorce. Churchill remembers "Bill talking on the phone with his new girlfriend" about meeting her at the airport in half an hour to go to Hawaii; that meant Churchill also went to Hawaii—on half an hour's notice. She reckons she "probably packed five years of experience into those seven months" of filming the Louds (Fisher, "Conversation").

Churchill describes her work in this period as "observational filmmaking" or cinema verité because "we followed the characters and tried to minimize our impact on reality. [...] [We] never used voiceovers or narration. I wasn't inventing anything. Fredrick Wiseman, Albert Maysles and Pennebaker all worked that way" (Fisher, "Conversation"). During this period, at the height of the women's movement, Churchill also made a 28-minute educational film for her father's company that screened on PBS. Called *Sylvia, Fran & Joy* (1973), it focused on women's roles in society through looking at three women's experiences with motherhood, career, and relationships.

In 1974 Churchill got a job teaching documentary filmmaking at England's newly established National Film School, where she became politicized by the miners' strike and other labor unrest. She began working with Nick Broomfield when they got a grant from the British Film Institute (BFI) to make *Juvenile Liaison* (1975), about police treatment of slightly delinquent school children in Northern England. The police leaned on the BFI to ban the film, which led to resignations from the entire BFI producing board. "Though public screenings were suppressed, that film was shown to members of [the British] Parliament," resulting in changes to the juvenile justice system. Churchill said, "I know I'm not changing the world with my films, but I think if you can shine a light on something, you can get people thinking about it and asking the hard questions" (Fisher, "Conversation").

Churchill and Broomfield then made hard-hitting political documentaries in the United States, including *Tattooed Tears* (1978), about young offenders in prison in Chino, California. After *Tattooed Tears* received the DuPont Columbia Award for Outstanding Journalism, the Pentagon gave Churchill and Broomfield the go-ahead to make *Soldier Girls* (1981), about

women army recruits. Shown in the United States on PBS and in England on Channel 4, it won the British Academy of Arts and Sciences Best Feature Length Documentary prize, the Prix Italia, and First Prize at the Sundance Film Festival.

Many of Churchill and Broomfield's films have aired on television. As the credits already mentioned suggest, Churchill's interests are wide. She and Broomfield have made films as diverse as one based on Lily Tomlin's Broadway hit *Search for Signs of Intelligent Life in the Universe* (1985; shown on PBS/Channel 4 as well as released theatrically throughout the United States) and another about female serial killer Aileen Wuornos, *Aileen: Life and Death of a Serial Killer* (2003). In 2011 the two made *Sara Palin: You Betcha!*, a critique of the US political figure in her own words.

Besides working with Broomfield, Churchill continues to work with other directors. She did music films with a political edge like *Arrested Development in the House* (1995) about hip hop; *River of Song* (1999), a four-part PBS show about music along the Mississippi; and *Down from the Mountain Road* (2001), a Blue Grass concert with the cast of musicians from the Coen brothers' film *O Brother Where Art Thou?* (2000). With director Barbara Kopple, she has made *Dixie Chicks: Shut Up and Sing* for A&E in 2007. She also continued to shoot muckraking political documentaries such as *Guns in America* (1995) with director Steve York for Showtime/Channel 4 in Britain; *Making Babies*, on surrogate mothers for Discovery Channel in 1996; *Americanos: Latino Life in the United States*, produced in 2000 by Edward James Olmos for HBO; and *Who Needs Sleep*, directed in 2006 by Haskell Wexler, about film workers' long hours in the film industry.

Early in her career Sandi Sissel became known for shooting war footage. During the 1970s-80s Sissel shot wars in Vietnam, the Philippines, Haiti, El Salvador, and Guatemala. Shooting this war footage "was very challenging, very difficult, and very exciting" for her. During the 1970s, when the United States was involved in many wars, she would shoot political documentaries that received English funding as well as money from the National Endowment of the Arts in the United States and the National Film Board in Canada, which allowed her "to do stories that were not necessarily flattering to the government at the time." She found the wars difficult to watch but "you're never going to find something that is more riveting to shoot—both the pain and the joy of it." She often tried to get to know the people, trying to "be with the underdog fighting the superpower. It was important for me to tell that story." She did not know many other people doing this kind of war camerawork at the time.

Sissel found herself changing through the experience of shooting news and wars. In the beginning she was anti-war and anti-military as well as aware of the anti-police feeling in the US anti-war movement. Yet for a couple years, while shooting news in New York City, she often found herself spending her whole day "sitting on the curbs with policemen. It was natural that you became friends with policemen." She found it "bizarre to suddenly be working so much with policemen and start seeing them as human beings." Because she saw both the police and soldiers "risking their lives all the time, you become empathetic with them." She remains "to this day liberal in most of my viewpoints," but shooting wars was "a life-changing event. Luckily, I was not truly a war cinematographer. I was working

on documentaries where our story led us to war environments, but my job was to follow individuals and tell individual stories." Still, in the 1980s, Sissel's career shifted to shooting feature films and TV movies and episodes, as well as non-war-related documentary work.

Nancy Durham's decades-long career filming wars for the CBC began in 1975 as a roving radio reporter. She worked for CBC doing radio for the next five years and also became a regular contributor to the BBC. She moved to the United Kingdom in 1984, continuing to report for CBC radio. There she met her husband, Bill Newton-Smith, an Oxford professor, philosopher, and "adventure academic." Durham was entranced by his stories about helping Eastern Bloc dissidents during the 1970s; he gave her his contacts with them when Durham started traveling and filmmaking in Eastern Europe.

Durham spent a number of years visiting and filming in Czechoslovakia before the Iron Curtain fell. She was

fascinated to be reporting on a people who needed licenses to sing rock songs or make pottery or write books. Everybody needed to have a license. Priests needed to have a license to operate. Many of them were operating underground, in their basements, illegally. After those societies started to open up, and after the people who ran them were crushed and fell, we had wars.

She spent the 1990s as a one-woman video journalist covering the Balkan Wars for CBC from all parts of the former Yugoslavia.

One of the first of these reports was from a besieged Sarajevo, about Yasmina, a philosopher whom Durham filmed applying lipstick and arranging her hair by candlelight. Even without electricity or running water, Yasmina was still trying to look her best. This particular report on a slice of wartime life that would usually go unnoticed in the news touched viewers. Durham's not sure about the impact of her war reporting, compared with the usual fare in global international news. "Whether one of my little reports can have an impact against all that, who's to say? I hope it does. I am definitely a truth-seeker. I'm one of those people who love to check back and see what happened." This habit of checking back led to some remarkable reports from Durham, but it also put Durham herself in the spotlight when one of her reports led to an extraordinary revelation.

The Road Home, Durham's video report about the expulsion of Serbs from Krajina (Croatia) and her first report as a one-woman video news crew, deeply moved Canadians who watched it on CBC; it was her big break. *The Road Home* was one of several reports from Durham on the lives of women in the Balkan Wars, during which a quarter of a million refugees were pushed out by ethnic cleansing. Durham's work provided some of the few close-up reports of these wars. In her reports, she wanted to "let people know that the agreement that was supposed to let all the people at the end of the Bosnian war go home was a joke. Because people weren't going home. I demonstrated that. That's important."

Durham's most controversial story, about Rajmonda, a young woman who became a soldier with the Kosovo Liberation Army (KLA) in Albania, resulted from Durham's

obsession with following up on the subjects of earlier reports. It raised serious questions that were hotly debated among journalists internationally. When Durham first met her, Rajmonda was lying in a field hospital bed telling Durham that the Serbs had murdered her little sister.

> *She wasn't supposed to have been a KLA soldier when I first met her, but—to avenge her sister's death—she wanted to become a soldier. To make a long, murky story short, at the end of the war I discovered that her sister hadn't been killed at all. Rajmonda, to her credit, gave me an interview on camera to tell me why she had lied about her sister. I'd felt we had an honest connection. We weren't friends. I was doing my job and she, as a soldier, was certainly doing her job. She said, "Other girls lost their sisters and didn't have a chance to give an interview, so I thought I'd give it for them."*

Durham admitted to being "absolutely stunned by that experience," even though she could understand Rajmonda's strategy of using Durham for her own propaganda purposes. Part of the debate that ensued from screening Durham's "confession" of how she had been taken in accused Durham personally of sloppy journalism and argued that revealing her mistake damaged the credibility of journalists everywhere.

Durham's practice of returning many times to the same village and seeing the same people caused her Kosovar friends to refer to her video reports as *Dallas of Kosovo*. She was not prepared for what happened when she exposed Rajmonda's lie and attempted to show the audience why it took her so long to discover it. "I wasn't looking for forgiveness; I wanted to show how it happened. More of my regular kind of reporting: How did this happen to this person? In this case, how did it happen to me?" However, when this film got shown in newsrooms around the world, the debate was intense. Durham suffered a loss of confidence: "Being a reporter, being on the other side of the camera, listening to these stories and being with people, you have to believe and respect them."

Despite this difficulty, she continued to make her video news reports from around the world. She covered the Iraq War for CBC in 2004 and was embedded with the Marines in Fallujah, Iraq, for eleven days of constant rocket and mortar fire. Three years later she filmed in Saudi Arabia at a rehabilitation center deprogramming ex-jihadists such as "a failed suicide bomber" and "men just back from Guantanamo Bay" (Durham). Her report, *From Jihad to Rehab*, was shown on PBS's *Wide Angle* series.

While North Americans Churchill and Durham have found their true vocation as documentary filmmakers and have each earned a steady income, other women cinematographers around the world have found little money to be earned from making documentary films. For example Young-Joo Byun spent six years making three films about Korean Comfort Women who were forced into military brothels as sex slaves to the Japanese army. Through their speaking out in the 1990s in public arenas, including Byun's films, these Korean women forced the Japanese government of the day to admit to these war crimes committed in an earlier era. Byun is all too aware of differences between documentaries

and feature films: Documentaries have smaller crews and their workers are often paid little to nothing while fiction films have larger crews and higher pay, and fiction features are sold in the commercial world of cinema while documentaries usually circulate through noncommercial distribution networks. To make her documentaries she raised money, among other ways, by selling sponsor badges to people on the street and begging for credit. She "raised $120,000 for one movie," at a time when "there was no government support for documentary films. After I'd started making [fiction] features, the government initiated a policy of financing documentaries."

Still, Byun spent years making documentaries—as producer, director, and camerawoman—out of her great enthusiasm for her subjects, but while she worked, she did everything in a "careful, budget-conscious way, not wanting to waste a cent. After all, it was not my own money." Berke Baş is blunt: "Documentary has no budget." Most women around the world, like Byun and Baş, make documentaries with small crews and little money.

In the 1980s Erika Addis was shooting experimental dramas and documentaries in the independent sector. She had work but not much money and was worried about making a living. Luckily she ran into Geoff Burton, who had started shooting *Don't Call Me Girlie* (1985), "the history of women in the film industry in Australia up until the 1940s […] a major film and a major body of work academically." Since Burton couldn't finish doing camerawork on the film, Addis completed it. Making her name as DP on *Don't Call Me Girlie* made her realize that "I wanted to be working in documentaries and that it was a viable area to work in for a living. I started to pursue those opportunities more vigorously."

Documentary work trains filmmakers to work on a tight budget. This training, according to Jan Kenny, helped a group of men to revive Australian cinema; then a younger group of women followed. Because of their documentary experience, Kenny says, these Australian camerapeople could deal with low budgets on feature narratives because they "work quickly and simply and come up with creative results," which in turn brought Australian cinematographers to international attention.

For Marina Goldovskaya, fiction filmmaking just was not interesting enough. "I made two fictional films when I was in film school and I hated it. I hate fake. I get bored. I am a born documentarian. I am excited when I see things unfolding in front of my camera." Goldovskaya established her reputation both in Russia and in Europe before she was recognized in the United States for her feature-length documentary *Solovky Power* (1988), the first film revealing the horrors of the Soviet concentration camps. This film is one of several films by Goldovskaya to receive worldwide theatrical distribution along with many awards.

Goldovskaya's *The House on Arbat Street* (1993) told the history of Russia in the 20th century through the lives of people in one Moscow building. In *The Shattered Mirror* (1992) and *Lucky to Be Born in Russia* (1994), Goldovskaya showed how perestroika affected ordinary people. "All the films I was making were meaningful to me. I never did anything that I didn't want to do. In this respect I am just the happiest person in the world because I work as a cinematographer."

Unlike Goldovskaya, Emiko Omori says, "When I was young I wanted to do features, but I got sidetracked into documentaries." For many years she filmed for the PBS station KQED in San Francisco and also in Africa, Samoa, and Hawaii. One thing she loves about shooting in such places is that the Indigenous populations "can see a small Asian woman using a camera."

Along with *Rabbit in the Moon* and *Regret to Inform*, Omori also made *Tattooed City* (1980), a film about Japanese-style tattooing that she calls "autobiographical, about my getting a full-body tattoo." More recently, she co-directed and shot *Passion & Power: The Technology of Orgasm* (2007), the story of the vibrator. Like Goldovskaya, she says, "I really enjoy documentaries. You meet so many interesting people, you go different places, and it's real, whereas a feature film is a fake." It is so real, in fact, that Kiwi Mairi Gunn says, "I'm beginning to feel that I'm a witness of events. Someone told us the other day that they were glad we were there [at a public protest meeting] because they felt safer."

Austrian Eva Testor also likes the ability of documentaries to capture history being made. She went to New York City to film "a documentary about eight Jewish women who had to leave Austria during the Nazi era." Rather than make a talking head film, she wanted to show the eight women's day-to-day lives. Result: "Wonderful encounters with these women who were all strong and had really lived their lives, despite having experienced such a huge trauma." Testor found that meeting these women was like witnessing valuable living history. "It's that side effect of documentary film that is so important to me. That's why I value so highly projects that make sense, that have a soul. There are so many soulless films, and I don't like them."

Testor does like the film *Draga Ljiljana* (*Dear Ljiliana*; 2000), for which director Nina Kusturica and her small crew, including Testor, went as a "mini-team" to Nina's former homeland, Bosnia, a few years after the Bosnian war to film Kusturica's search for her roots. She and the three others in the film crew were shocked to see how close the war zone was to the Austrian border. "It was a huge exposure to the reality of the war, which one had only heard about when it was taking place," Testor remembers.

This sort of documentary project deals with the past and its influence on the present. For some versions of this genre, re-enactments work very well. The camerawoman on such a project would have the opportunity for advance planning. Even some documentaries that set out to capture the moment as it is happening can provide opportunities for advance planning, according to Astrid Heubrandtner.

Most camerawomen, however, emphasize the spontaneous nature of documentary. Nurith Aviv points out that on a fiction feature film, the camerawoman knows what the end will be, so there is no element of surprise, no need to engage on a rush of adrenaline; on a documentary the camerawoman has to make choices. Chance plays a part; documentary camerawomen may have to respond spontaneously to breaking events while caught up in those events (Dirse, "Women"). Norwegian Christine Heitmann attributes the spontaneous part of making a documentary to the absence of rehearsals and adjustments that traditionally take place before shooting a feature film. In documentary, she says, "the shooting takes a

long time and is a continuous process. The script is being 'shaped' while the shooting is going on." Iranian Rozette Ghadery thinks the camerawoman

> *needs to hunt the moment; it happens only once. The cameraperson needs to be quick. His/ her movement must keep up with the subject matter. In crucial moments, a director cannot communicate with the cameraperson. So the cameraperson should decide on his/her own. The more short-lived the subject matter is, the greater the responsibility of the cameraperson.*

Many camerawomen point to aesthetic aspects of this fluidity of shooting documentary— its constant requirement of greater input from the shooter to compose, light, and edit in-camera while shooting—as reason enough to prefer this style. Israeli Irit Sharvit compares the spontaneous quality of shooting documentary to dance or tai chi. By contrast, "narrative, you have to dance with many people, so it becomes a bit more calculated."

Most camerawomen discuss the physical and creative distinctions between shooting fiction and shooting documentary, emphasizing the different demands on their perceptions and skills. Filipina Lee Meily believes that "documentaries keep your creative juices flowing." American Ellen Kuras says that her documentary experience influences her narrative work.

> *In documentaries, when I walk into a room, I have to figure out what the light is going to do, what the natural light does, and how I may be able to augment it. But more importantly, I have to figure out what the essence of the scene is, and that tells me how to shoot the scene. Because that's ultimately what I want to say with it, and that's the reason why my inquiry early on in my academic career was so important. It has enabled me to ask those questions in my mind: Why am I doing this? Why am I shooting this?*

Documentary tends to be about relatively denotative meaning, that is, stories about actual and historical people. They are often filmed on the locations associated with their subject matter. Going on location is one reason camerawomen like to work on documentaries. "I really haven't shot enough documentaries," Lisa Rinzler says, "but I love the access to worlds that I wouldn't have normal access to, like Vietnam or Portugal or South Africa."

Addis explains that she learned from Kenny how to listen in order to capture a particular location. Addis was shooting one of her first projects in Australia at the Settlement, an aboriginal community center with lots of action happening all the time.

> *It was a rich place, a complex community of people, to be filming. I was a good listener. I listened to follow the action with the camera really well. I was startled to find that a lot of the rushes were not in focus. I had put so much attention into listening and following the action that often I hadn't kept it in focus. That was a steep learning curve on that film.*

Michelle Crenshaw mentions the personal nature of documentaries. When she works on commercial projects as a focus puller to make money, although she is always "actively

reacting" to characters to keep them in focus, it's not the same sort of engagement. When she films a documentary, she feels she is doing her own personal work and has more invested than just making a living. "It's telling a story, expressing a feeling, and it becomes more personal. What I do as a living is not personable; it's just a way I make a living."

This sort of personal investment in a story has motivated many camerawomen, such as activist community filmmakers Afghan Mary Ayubi, Indian Leelaben Paben, and Fida Qishta, "a Palestinian camerawoman/editor, who has been working on news stories and documentaries in the Gaza Strip since 2006" (Qishta). Qishta's film, *Where Should the Birds Fly* (2013), "the first film about Gaza made by Palestinians living the reality of Israel's siege and blockade of this tiny enclave [...] itself breaks the blockade. Filmmakers in Gaza have never had the opportunity to make a full-length, professional documentary of their reality" ("*Where Should the Birds Fly*"). Qishta began her "filmmaking career as a wedding videographer," like other Muslim women, e.g., Khadija, a Moroccan woman who is the subject of Karima Zoubir's documentary *Camera/Woman* (2012).

Many camerawomen like to establish a certain intimacy between themselves and their subjects. For Addis this intimate relationship between herself and her subjects provides enormous joy and pleasure. Goldovskaya and Agnès Varda, for example, delight in talking with their subjects while their cameras check out the environment, lingering over both objects and relationships. In describing how she works as both director and cinematographer, Berke Baş says that, as director, she makes her own choices, fulfilling her own vision, yet without imposing herself on her subjects. Baş also creates a sense of intimacy with her subjects by spending a lot of time with them before she starts to shoot. "I give them confidence that we are making the film together. Like I'm just there with the camera. I have the tool, but actually we are making the film together. That kind of feeling helps them to trust more and the camera becomes invisible after a certain time."

Notes

1 For the beginnings of Chinese feminism in the May 4th Movement, see Koetse.
2 For a summary history of early Chinese film see "A Brief History of Chinese Film."
3 In 2011 alone China produced 526 features (Brenhouse)—far more than Hollywood.
4 One of her US visits was with Women in Film in Los Angeles on 11 June 2008.
5 The English for the Chinese name of this camera is unclear, but as Marina Goldovskaya recalls, "There was a sync 35mm camera 'Moskva' (Moscow) for studio shooting (Narrative and Documentary). They were not hand-cranked. Moskva was huge and made of some kind of metal." She says that "the American camera Mitchell (MC), the Russian Rodina, and the German Askania all had a crank and a motor; they were used for synchronous shooting."

Chapter 4

Hollywood, Bollywood, independents, and short forms

Where a camerawoman works affects what she actually does as well as the environment in which she works. There are, for example, huge differences between working on for-profit material in Hollywood, with its history of access to and use of advanced technology, and working in, say, the Philippines—or even Bollywood. But as we have seen with documentary, what type of film production a camerawoman works on, and the budgets associated with those types of productions, also affects how she works. Some of the short forms we discuss in this chapter, such as experimental film, are not commercially viable, but they are important for the commercial world because they expand our sense of what filmmaking can be and do, whether in terms of narrative structure or of visual presentation. Others might seem to be dominated by profit considerations, such as commercials. Yet setting up a business that films births might seem like a commercial venture, akin to making wedding videos (which itself should not be written off), but it involves such an extreme level of intimacy with the parties involved that it becomes a personal enterprise as well.

The mantra we've already heard—practice, practice, practice—applies to all the forms discussed in this chapter. Working on music videos can be a brilliant way to expand one's technical abilities and use one's imagination. Working on art films or films about other artists can lead to seeing the world differently, with a later impact on how one uses one's camera.

In what follows, we use the experiences of individual camerawomen to grasp some of the differences—from the point of view of camerawomen—in working in different types of filmmaking practice associated with different types of film forms.

Hollywood

The most famous name associated with film production, synonymous around the world with film itself, is Hollywood. Yet many years ago Bollywood surpassed Hollywood in terms of sheer volume. Hundreds of other feature films are made each year outside Hollywood by independent filmmakers, in the United States and elsewhere, where *independent* usually but not necessarily means unaffiliated with a studio (Paramount, say, in Hollywood, or Shaw Brothers in Hong Kong). *Studio* has traditionally meant a regularly producing entity, with funding for an ongoing slate of mainstream productions; major Hollywood studios, like smaller operations in other countries, look for co-productions involving other countries to obtain funding, or pick up independently-produced films for distribution. *Mainstream* here largely translates as targeting a young male audience, because that's where Hollywood

thinks the money is—even when films made by women for women make money. For most women wanting to make films for other audiences, working as an independent and/or in other alternative media is almost a given.

Women were involved in camerawork from Hollywood's beginning. Next to a full-page photo of her posing in trousers beside her camera, the October 1916 *Photoplay* proclaimed Margery Ordway to be "the new fall style in camera 'men.'" She was described there as having "gone into camera work as nonchalantly as other girls take up stenography, nursing, husband-stalking" ("This Is the New Fall Style"). In those free-for-all early days of Hollywood, women could be found working behind the camera as directors, screenwriters, and camerawomen. Two other camerawomen who worked in Hollywood in the mid-1910s were Dorothy Dunn and Grace Davidson (Slide 1977).

But once the Hollywood studio system established itself, women disappeared from behind the camera. Between 1920 and 1950 women did not work as camera operators in the Los Angeles film industry. From the early 1950s to the early 1970s there was just one camerawoman who worked regularly in Hollywood: Brianne Murphy.

Like many other camerawomen Murphy used photography skills as a ticket to working in film. When she arrived in Los Angeles in 1953, she started a photography business on the Sunset Strip specializing in nightclub photography, but her business failed. She had met movie producer Jerry Warren doing a low-budget film; he hired her for $50 a week to do make-up, wardrobe, script supervision, props, and even take some still photos. She found out that "the more I was willing to do and the harder I was willing to work, the more I could learn." Since the film was understaffed, Murphy helped the two-man camera crew change lenses and spent as much time as she could with the cameras, which were Mitchells with heavy batteries. She got herself a little red wagon to carry around the heavy camera equipment and found work as script supervisor, production manager, and camera assistant on more low-budget films such as *Teenage Zombies* (Jerry Warren; 1959) and *House of the Black Death* (Harold Daniel and Jerry Warren; 1965).

Murphy's first camera operating job on a feature film happened by chance. When Murphy was working as production supervisor for a low-budget monster film, *The Incredible Petrified World* (Jerry Warren; 1957), the monster suit did not fit the actor; it only fit the cameraman, Vic Fisher. Fisher agreed to wear the suit but said, "What about the camera?" The producer responded, "Bri's always hanging around the camera; doesn't she know something?" As Murphy tells the story, Fisher "took his meter belt off, came over to me and put it around my waist, and said, 'That's yours now. You've picked my brains long enough. Let's see what you can do.'" It was the first time a woman had operated the camera on a Hollywood film in 40 years.

During the 1950s some of Murphy's early camera associates—Laszlo Kovacs, ASC, Vilmos Zsigmond, ASC, et al.—were able to join IA, the cinematographers union, to get higher paying union assignments. Since her cameramen colleagues had left the nonunion work behind, she finally had a better chance to be a camera assistant on these low-budget nonunion films. Murphy also asked to join the union, but was told no because women did

not do camera. Tired of low pay, she became an organizer to form the Association of Film Craftsmen, which later became NABET 531 and eventually merged with IA.

Murphy was audacious in promoting herself. To become a camerawoman at F. K. Rockett, the oldest documentary studio in Hollywood, she took a job as production manager. She even promised the interviewer she would change her sandals and slacks for stockings and a skirt if given the job. As production manager she did the hiring for the documentaries that the studio made for the US Navy, so she hired herself as first camera and hired another cameraman as second camera. "I was in a position to hire myself. They couldn't say no because the price was right, and the footage was indispensable."

When Murphy and her husband, Ralph Brooke, also a production manager, got tired of working on low-budget horror films, they formed their own film company and co-produced *The Magic Tale* (1962), a short fiction film about a little Mexican boy and an American girl who become friends. Brooke wrote and directed; Murphy was the co-director, DP, and editor. Brooke and Murphy were very proud of their film, which won eleven international awards. Unfortunately, Murphy's husband died in the early 1960s. She said that the marriage, which lasted for three-and-a-half years, "was like a honeymoon. He was very supportive."

Murphy kept doing camerawork and was finally admitted as the first female member of IA's Hollywood Local 659 in 1973. She had a breakthrough when Gloria Steinem insisted upon a woman DP for an NBC special about the women's movement. NBC chose the only union camerawoman in Los Angeles—Murphy. NBC loved her work and wanted to hire her full-time, but she said no, preferring to work freelance so that she could also work as a DP shooting documentaries and episodic series for TV.

In 1980 Murphy was the first-ever woman DP on a major Hollywood studio picture: *Fatso* (Anne Bancroft; 1980). She was the first woman asked to join the American Society of Cinematographers. She got an Emmy in 1978 as well as many Emmy nominations and shared an Award of Merit from the Academy of Motion Picture Arts and Sciences for her role in the concept and design of an insert car and process trailer with features that safeguard the crew.

By the 1980s women like Murphy, Leslie Hill, Sandi Sissel, Susan Walsh, and Kristin Glover had managed to obtain camera work in Hollywood, but camerawomen were still few and far between. From 1980 on, a small number of women such as Sissel, Nancy Schreiber, and Ellen Kuras have worked regularly in Hollywood and New York as DPs on feature films and television. However, most camerawomen are first or second camera assistants. In 2006–07 a Lauzen study found that no 2007 episodic TV series had a female DP, while only "2% of the top-billing 250 feature films seen in US cinemas in 2006 had women cinematographers" (Fisher, "Distaff DPs")—a number which has since risen slightly, then dropped to 3% in 2013 (Lauzen, "Celluloid Ceiling" 2014). In 2014, only fourteen women were active members of the American Society of Cinematographers out of a total of 361 active members: Uta Briesewitz, Sharon Calahan, Joan Churchill, Anna Foerster, Judy Irola, Kuras, Reed Morano, Cynthia Pusheck, Tami Reiker,

Nancy Schreiber, Sandi Sissel, Amy Vincent, Mandy Walker, and Lisa Wiegand ("American Society of Cinematographers Roster").

Sarah Pillsbury never produced big blockbuster action films with violence and special effects; she leaned towards small features about women's lives, such as *Desperately Seeking Susan* (Susan Seidelman; 1985) and *How to Make an American Quilt* (Jocelyn Moorhouse; 1995). According to Pillsbury, since 1980 the economics of Hollywood blockbusters explains why so few female cinematographers obtain work on big-budget films: "Big studios are looking to get at least 60% of their profits from the global market, so they are looking for films that will play without subtitles. That's sex, violence, broad humor, and flatulence: things which are very much in tune with the adolescent boy." Despite the examples of Penelope Spheeris, Catherine Hardwicke, and Jennifer Yuh Nelson, Pillsbury is correct in suggesting that male directors are usually hired for blockbuster films.

Looking further afield for explanations for discrimination against women cinematographers, Pillsbury cited low figures for women on corporate boards in general and Hollywood boards in particular: "How many women sit on the boards of those multinational corporations [that own the Hollywood studios]? I'm certain it's well under 5%. When you look at the executive offices it's about 9% and a lot of those women were in Human Relations." Pillsbury's hope was that, as the number of women producers, agents, and executives increased in fiction film, they would hire more camerawomen. A newer producer, Susan Cartsonis, has been arguing that female producers need the backing of financial institutions: "Female ownership of media companies is key to opening doors for women on set and in the boardrooms of film companies. Women can and will open doors to other women. We need money to make that happen" (Cartsonis).

Sandi Sissel is one of the few female DPs to have worked regularly in Hollywood, in addition to her other work. She worked as a camerawoman at NBC and ABC during the 1970s-80s shooting for *60 Minutes*. Her work on *Her Majesty's Brittania* and coverage of the Vietnam War garnered two Emmy awards. Sissel's big break in features came when she filmed *Salaam Bombay!* She has worked Second Unit on fiction films that include *Dangerous Minds* (John N. Smith; 1995), *Mr. and Mrs. Smith* (Doug Liman; 2005), and *Master and Commander: The Far Side of the World* (Peter Weir; 2003), as well as DPing many documentaries, network TV shows, and miniseries.

Sissel explains why so many women want to work on Hollywood studio films by pointing to the chronology of her own work history. Working on documentaries, she made her way up to films that cost $100,000. For *Salaam Bombay!* she had $700,000 and shot in India with a non-English-speaking crew, a first-time director, and a lot of time in preproduction to design every shot in the film before shooting started. Later she was DP for director Wes Craven on the Hollywood feature *The People under the Stairs* (1991) and supervised what to her was an enormous crew of six cameras, the lighting department, and the grip department—40 people. With the $6 million budget she could get more of everything, from equipment to people, so she got more creative about her shot designs. Most especially, she could use bigger lights for better lighting: "When you start doing big lighting setups

120

and you're working with name actors and the studio is asking for larger, more complicated shots, more coverage, then it's wonderful to have 40 to 60 to 80 days [and] big equipment to accomplish that work." She as well as other camerawomen might wish to do more studio pictures, but after she was hired to shoot one studio picture, she did not immediately get another studio job. Then she got called to do a "pilot or a TV series. You think, wow, maybe I'll go do a TV series. And then, luckily, along the way, you would get another feature. But—men or women—we can rarely ever say that we have reached this plateau where we're never going to do anything but big-budget features."

Nancy Schreiber, another experienced, award-winning Hollywood DP who works on both Hollywood and independent features, likes the bigger equipment she used when shooting Second Unit camera on *Lemony Snicket's A Series of Unfortunate Events* (Brad Silberling; 2004) and First Unit camera on *Bewitched* (Nora Ephron; 2005). The drawback, she says, is that "you're following someone else's vision."

Schreiber was the DP for independent feature film *Loverboy* (2005), directed by Kyra Sedgwick's husband, Kevin Bacon, and starring Sandra Bullock and Sedgwick. All three liked Schreiber's camerawork, and Sedgwick recommended Schreiber as DP for the next film she acted in, a Hollywood studio comedy that was going to shoot for 85–90 days and cost over $100 million. Schreiber says, "The studio wouldn't meet me." She does not resent the rejection, saying she would not want a job where the producer had to fight to get her hired, because the studio would be looking over her shoulder all the time. She continues to shoot independent features for which she is highly respected.

Hollywood's film studios provide a structured work environment in which technical crew have developed hierarchical structures that regulate aspects of pay and work conditions in exchange for guaranteeing quality of work. Most camerawomen in Hollywood are in the bottom to middle of the bottom of the camera hierarchy. A number of camerawomen have experience working elsewhere as well as in Hollywood, so they can make comparisons. Teresa Medina, who has worked with female teams in both Spain and Hollywood, says, "Hollywood is a very structured system; things happen this way and this way only. In Spain there is more wiggle room to create because there is not a very rigid structure."

Madelyn Most also thought that camerapeople in Hollywood "don't get into the ideas." She likes working in Britain where, as she describes it, the "camera operator works intensively with the director. There's interaction." She dislikes the Hollywood system in which she says only the DP has control while the camera operators and assistants "are like monkeys." She prefers working on small British or French films where "everybody is working together. In Hollywood, if you moved a cable to save somebody's life, you got a bollocking [reprimand]. That happened to me on a Blake Edwards movie."

Kristin Glover was startled by how differently French and Hollywood crews operate. Working in France, she found that the French crew assumed she had been hired because she knew her job: "They expected me to be intelligent and talented. It was just wonderful. In France there's a much greater acceptance of women as creative, intelligent beings than there is in Hollywood."

Indian Cinema

Indian cinema's history is almost as long as film history itself. In 1896 the Lumière Brothers screened six of their short films in Mumbai. Three years later the portrait photographer Harischandra Sakharam Bhatavdekar made Indian motion picture history when he screened his short film, *The Wrestlers*, a recording of a wrestling match. India's first full-length silent feature, *Raja Harishchandra* (1913), was about a mythological character; male actors played the female roles ("History of Bollywood"). In 1960 the film *Mughal-e-Azam* began a craze for romantic movies all over India and in the 1970s the masala film became popular.[1] A masala film includes a mixture of genres and emotions combining action, romance, comedy, and drama in the same film. It is also immensely popular around the world, and Bollywood has long since surpassed Hollywood in numerical terms in producing films on an annual basis. According to Shanti, who works in Mumbai, Bollywood produces "about 800–1,000 films per year"—over double Hollywood's output. Still, the first internationally recognized Indian women directors who emerged in the 1980s-90s—Aparna Sen, Deepa Mehta, and Mira Nair—began making films as independents, outside the Bollywood industry. Only in this decade are women directors—Zoya Akhtar, Reema Kagti, and Farah Khan—drawing attention for mainstream, even blockbuster films.

The Indian film industry is regionalized, reflecting the country's various languages, and each region produces different kinds of films. Films shot in Mumbai are known as Bollywood films, films shot in Chennai in the Tamil language are Kollywood films, while films shot in Telegu are known as Tollywood films. There is also a vibrant independent cinema in Kolkata (formerly Calcutta), known as Bengali cinema.

Shanti and Priya Seth trained at FTI, which prepares actors and technicians for the commercial Bollywood industry as well as for independents. Seth has also worked as assistant cinematographer for Mehta's *Earth* (1998) and Campion's *Holy Smoke* (1999). She acknowledges that "we don't have as much infrastructure here as in the West, but we have a fair amount of stuff. The means are limited but the end results are comparable to anywhere."

Vijayalakshmi has worked in the Tamil film industry with directors such as Sridhar, "the one director," she says, "who inspired me." When she was young and started working with Sridhar, he treated her like a professional. Besides doing the camerawork on 22 feature films, she often directed. On one of her best-known films, *Paattu Paadava*, she wrote the script, directed, and did the cinematography. After directing and shooting films for a decade, she retired for a while after her son was born, and then returned to do camerawork for Indian TV.

Uma Kumarapurum is a camerawoman in the Malayalam film industry based in Kerala in South India. She characterizes the Kerala industry as making smaller, more intellectual, lower-budgeted story-oriented films compared to Bollywood musicals. Kumarapurum, a physics graduate who took a six-month film course, is working her way up to better camera jobs after working on four films. Anjuly Shukla, another woman DP working in the Kerala film industry, won the National Award for Cinematography for *Kutty Srank* (2010).

122

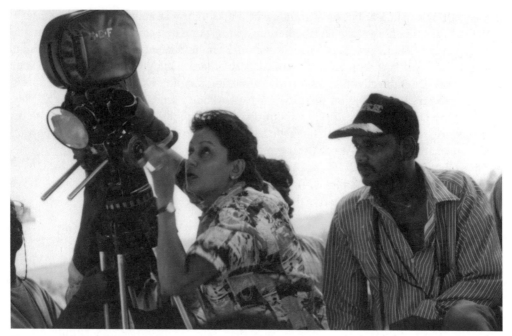

Figure 18: B. R. Vijayalakshmi. India.

Bollywood, like Hollywood, has many popular action films that center on male heroes, and a producer in both industries often gets funding once he or she signs a male star. The hyper-masculine heroes provide escape fantasy for the masses of Indian men. In Bollywood films, Seth says, audiences have expectations of how film stars, particularly male stars, should appear, affecting the camerawork. After they shot a film starring Hrithik Roshan (a major male star), Seth recalls, the producer told the DP and her, "There is a problem. We can't see Hrithik's eye. In India people don't like this. They want to see Hrithik Roshan's whole face." D. W. Griffith, film students will remember, had the same problem with his producers when he wanted to shoot close-ups; the producers said the audiences wanted to see the actors' whole bodies.

India's female directors, such as Akhtar, Nair, Meghna Gulzar, and Canadian-based Mehta, have begun to depict "taboo topics" in their films, for example, lesbianism, polygamy, surrogate motherhood, and having a child out of wedlock (Chopra). The lesbian content in Mehta's *Fire* (1996) enraged traditionalists, who attacked it when it was screened in India; the film was even banned and then unbanned. Mehta overcame death threats and the demolition of her sets by fundamentalists to complete *Water* (2005), which won several awards and an Academy Award nomination for Best Foreign Language Film. Assistant camerawomen who worked on *Water* include Lilia Sellami and Melanie Jeffrey.

Recent Indian films by women directors—both independent and mainstream—are continuing to break stereotypes, on and off screen. Akhtar's debut *Luck by Chance* (2009)

centers not on a male star but on a woman who wants to be a famous Bollywood actress. In a realistic turn, the film ends with the heroine living alone in a small apartment, acting in TV soap operas. While previous female directors in India made art house films with small budgets, these younger women often can work with larger budgets and major male stars because they are connected to established filmmaking families. Despite these connections, though, they are succeeding on their own merits. Akhtar's second film *Zindagi Na Milegi Dobara* (*You Only Live Once*; 2011), "about three male friends who rediscover themselves on a road trip in Spain," was the first female-directed film to open at No. 1 on the Bollywood box office charts (Chopra). Anna Albiac worked on it as clapper loader.

Given that in the last decade more Indian women have begun to work in technical roles such as cinematography and film editing, the rise of female directors who break stereotypes and are successful can only help female cinematographers.

The Freedom of Independent Films

US female cinematographers have achieved more opportunity and more success shooting independent feature films than shooting mainstream films. Murphy worked on low-budget independents for decades because she had few other options. In contrast, for Sissel and Churchill, starting their careers with independent film led to other opportunities. Judy Irola's breakthrough film was also a low-budget feature film, *Northern Lights* (1978), which she shot as part of the Cine Manifest collective. Irola won the *Cinema d'or* prize at Cannes for this film—a first for women cinematographers.

In the United States, Nancy Schreiber and Amy Vincent are two of independent film's leading cinematographers.[2] After studying art and psychology at the University of Michigan, Schreiber moved to New York, answered an ad in the *Village Voice*, and wound up working in the electrical department of an under-crewed film. She was good at lighting and for a decade she worked as an electrician and gaffer. When she worked her way up through the New York camera ranks on commercials and independent films, she saw the only women shooting were "doing news documentaries—Sandi Sissel, Joan Churchill. Brianne Murphy was in LA, but doing television mostly. Brianne shot *Fatso*. She was the groundbreaker for all of us."

Vincent studied theater at the University of California Santa Cruz. She came to Los Angeles in the 1980s and worked in postproduction as an assistant sound editor for four years. She then started in camera, working as a trainee, a loader, and a camera assistant for many years. After she had worked for a while as a camera operator, she returned to study at AFI. During the 1980s she could begin to see women DPs in the workplace. "The groundbreaking stuff was laid out by Brianne, and Sandi Sissel, and Nancy Schreiber, and by Joan Churchill, who's one of our greatest documentarians working. That was a decade and a half before me."

Schreiber's first feature as cinematographer, *Chain of Desire* (1992), is also her favorite. A small New York movie, it was Argentinean director Temi Lopez's second film. Schreiber said, "I took so many risks. I didn't think about the rules because I didn't know the rules."

However, she almost did not get the job. At her first interview with Lopez, he was upset about some bad casting news. Schreiber remembers it as "the worst meeting I've ever had," but the producer urged the director to meet her again. So Lopez visited Schreiber's apartment, where he saw her art books. He said, "That's what sold me—the art books." The director could see who Schreiber was as a human being. Lopez himself has a good eye, she says, but when she was shooting the film he let her alone. He "appreciated the risks I was taking," Schreiber explains.

Vincent's first film as a cinematographer was on the low-budget independent fiction film *Eve's Bayou* (1997) for first-time feature director Kasi Lemmons. She says *Eve's Bayou* is "still my favorite. There's something about your first movie, a certain level of innocence, a purity, that's hard to find again." Vincent thinks that directors and producers in the independent world were "more likely, at the time that I started, to take a chance. Hiring a woman wouldn't seem unusual to people who have a more independent vision. It still is probably easier to find a movie to shoot as a female cinematographer in the independent film world."

When Vincent was at AFI, she had already shot many student films for free when a fellow classmate asked her to shoot a short film for Lemmons because there was an amazing script. Vincent declined but her friend insisted. "So I met with Kasi and instantly we had this connection." In addition to the script for the short film, Lemmons gave Vincent the script for *Eve's Bayou*. Vincent thinks that the *Eve's Bayou* script "is still possibly the best script I ever read." After reading it, she borrowed "my friends and neighbors and the cameras, and we shot this short film so that the producer, Cotty Chubb, would have a calling card, so to speak, for Kasi as a director."

Vincent and her crew shot for two to three days on a holiday weekend. Three years later, the director finally got financing for *Eve's Bayou*. Because Chubb liked the footage Vincent had shot on the short film, he made it part of the deal that she would be DP on the feature. "I owe him for that. I felt so proud that Cotty kept me attached over a period of three years." Vincent remembers that when she and Lemmons saw the yellow location sign that said "*Eve's Bayou*" on their first shooting day they turned to each other, saying, "I can't believe they're really letting us make this movie."

Vincent also worked for Craig Brewer on his first full-scale feature, *Hustle & Flow* (2005). Brewer had trouble getting money for the film, Vincent recalls. "At one point, we had a reasonable budget," but it disappeared. "Then [producer] Stephanie Allain was going to sell her house and it became a by-any-means-necessary mini-DV kind of thing." Vincent says that over the eighteen months she was involved, *Hustle & Flow* stopped and started at least three times before they ended up shooting in Super 16.

Schreiber and Vincent both like working with first-time directors. Vincent says it is because you are "collaborating creatively with someone on the most special project that they are ever going to have. Often it's their most precious story and, perhaps, their most autobiographical." Another way she puts it is that "when someone who's been trying for so long to get their first movie made finally gets to do it, they come to it with such a sense of honor. They're so committed."

Typically, female DPs break through first by working on independent features—sometimes for first-time directors—and then they make their names when those features gain important awards. For example, although Schreiber "had never intended to do one of those little mini-DV movies," she did work on *November* (Greg Harrison; 2004). What changed her mind was "Greg Harrison, the director. [He] was so inspiring and wanted to work in a very cinematic way." She was shooting mini-DV, but she treated the project like a 35mm movie. The crew worked exactly like they worked on a larger budget movie. "We shotlisted very carefully. We had to be super-organized, even more so than a regular movie, because we only had fifteen days, and we were shooting enormous amounts of coverage." Schreiber shot multicamera where she could, and she and the director wanted to have a dynamic visual style. "It was challenging because I didn't have certain tools. Diffusion filters absolutely degraded the image, so I had to concentrate on the lighting, make it natural and as soft as possible." Schreiber shot with a small $3,000 camera, and the movie cost $150,000 for production and another $150,000 in post.[3] "We had total freedom because there was nobody on set supervising for the producer. Our dailies were for us, so we took major chances." Schreiber won the Best Cinematography Award at the Sundance Film Festival for her work on *November*.[4]

Over the years Schreiber's approach, especially to the actors, has grown increasingly collaborative. On *Loverboy*, she made sure that the actors knew "that we're [camerawomen] looking out for them. We're taking care where the camera's placed and what the lighting's like for women of certain ages. Kyra [Sedgwick] was very pleased—and also Sandra Bullock and Marisa Tomei; there were a lot of women in *Loverboy*." Schreiber says that now she cares more about how actors look in films than when she was a beginning DP who wanted to show her lighting style. "Now I would probably light them more flat than I did when I was younger and make sure that there was an eye light and make them look as young as they could unless the part called for them really being down and out."

Vincent collaborated with Lemmons on a second film and with Brewer on two more films. Vincent said that on her first films with Lemmons and Brewer she established

a foundation of creative collaboration. You know the tools that each other uses, even during preproduction, when you're trying to discover the look of the movie. And there's a trust. Craig has a tendency now to completely entrust me with things that maybe in the past would have been something that he and I would decide together.

Eve's Bayou was set in a very specific time and place, but the script clearly differentiated between memories (which describe a verifiable reality) versus dreams and clairvoyancy (which involve the intangible and unverifiable). The film had two clairvoyant people: Aunt Mozelle and Eve, who is very young. "Aunt Mozelle's visions of the past, her memories of her dead husband, needed a different look. Then you have Eve's dreams. Kasi and I made a rigorous structure, a set of rules, for what quality or characteristics each of those different things possessed."

Vincent said she and Lemmons approached *Caveman's Valentine* (2001) in a similar way by making a set of rules, but the rules had to be more elaborate because in *Caveman's Valentine* they dealt with a paranoid schizophrenic character. Since the script had twelve naked, bald, black men with gigantic moth wings dancing inside a skull, Vincent and Lemmons created "a whole world within the movie that was the inside of the caveman's head."

> *The parts in the movie that are the inside of his head are a concise example of collaboration between every department from George Dawes Green, who wrote the novel, to Kasi's adaptation of the novel, to Otis Sallid's choreography, to all of those beautiful dancers, to Sam [Jackson] and his grand piano in the middle of it all. The production designer, Robin Standefer, created this Gothic structure … .*

Vincent used Samuel Jackson's performance of the caveman and his responses to different colors of light while they were doing his hair and makeup test to inform their choices for the movie's colors. "What's so great about what we do is that we're the final puller-together and executer of all of the other collaborative visions that come together to be laid before the camera. It's a pretty awesome job."

Schreiber and Vincent both look outside of movies for inspiration. While Schreiber was working with Neil LaBute, she was inspired by Edward Hopper's paintings; she turned to William Eggleston's photographs to help her with the look for *Piggy Banks* (also known as *Born Killers*; Morgan Freeman; 2005). Vincent and Lemmons were inspired by entomology books they read before beginning *Caveman's Valentine*. On *Black Snake Moan* (2006), Vincent's third film with Brewer, neither she nor Brewer knew what they wanted the movie to look like when they started preparations. As she familiarized herself with the material and heard many outside people's responses to the materials, she decided the film had to be handled in "an extremely classical, formalist fashion." She would avoid random camera movements and shoot the film like a classical western.

Both Vincent and Schreiber hire women in their camera departments. Schreiber has an "excellent" first assistant camerawoman, Michele De Lorimier, while Vincent spent years looking for "the best assistant female cameraperson" until she found Jamie Felz. Schreiber says that both men and women like having a gender balance on the set. Vincent says that her female as well as male crewmembers have "got to be beyond excellent technically and inspired creatively."

In the 1970s-80s, when Schreiber was the only woman on sets, she worked harder than anyone else. While shooting *Visions of Light* (2005) she met older cinematographers who were in ASC, and eventually she was asked to join. Vincent, coming from a younger generation, seems to have experienced fewer obstacles as a camerawoman. She even sees an advantage to being female in that a young man graduating from prestigious film schools like the University of Southern California or AFI might compete against 500 young male cameramen, but since there are fewer women, a woman "becomes a unique individual and you get more attention for everything you do."

Vincent shot a film in Namibia called *Kin* (Elaine Proctor; 2000) that opened the Mill Valley Film Festival where she spoke on a cinematographer panel that included veteran cinematographers Bill Fraker, ASC, and Laszlo Kovacs, ASC. Vincent thinks that panel "started the ball rolling" for her to join the ASC, but she acknowledges that pioneering cinematographers like Murphy, Churchill, Schreiber, and Sissel helped her "become a member of the elite ASC—probably several movies and several years earlier in my career than if I was a man."

Both women have worked on big studio films as well as independents. Schreiber likes the bigger equipment she has used when shooting Hollywood studio films, while Vincent says that it is harder to shoot a low-budget film in 35 days than a big-budget studio film in 85 days, but she has learned at each level of filmmaking. Schreiber prefers independent cinema because she feels the stories are much more engaging, and

they take a lot of risks, story-wise, that we can then take in our visuals. My choice has been to keep my efforts in the independent world, doing stories that are either someone's passionate, personal film or some social issue that I feel passionately about. It's a more comfortable place to be as a human.

Music Videos

MTV and music videos have opened the doors for a lot of people to be creative and get into other avenues.

(Michelle Crenshaw)

While shooting a White Stripes music video for director Michel Gondry, Ellen Kuras had to do a 360-degree shot. At one point the White Stripes "go through this elevator. In the beginning I made the elevator really hot." The director was doing two takes and during the first take Kuras thought the lights were too hot, so she changed the lighting set-up and dimmed it down for the second take. But during postproduction she realized she got it right the first time, reminding her to follow her intuition.

Kuras enjoys working on music videos and films, and likes to put the same skill and care into doing her music films as in shooting a narrative film. She considers the concert film *Neil Young: Heart of Gold* (Jonathan Demme; 2006) to be one of the highlights of her career, largely because Neil Young has inspired her as a person and as an artist.

Many camerawomen besides Kuras have worked in music videos, e.g., Maryse Alberti, Sabeena Gadihoke, Mairi Gunn, Lee Meily (along with her husband), Deborah Parks, Jessie Maple Patton (along her husband), Lisa Rinzler, and Nancy Schreiber. Kim Derko did not necessarily enjoy her experience making music videos, but she acknowledges that they

helped her build her showreel (Moffat). For Liz Bailey, music videos have been good: "I love shooting music. I've shot everyone from Stevie Wonder to the Rolling Stones. I love the frame, the colors, the theater, the performance."

For Gunn and other Kiwi camerawomen, music videos have often provided a starting point for their professional careers because Creative New Zealand, a publicly funded arts organisation, has been subsidizing them for decades. Although the subsidy was provided originally in order to support the New Zealand music industry, the subsidy has had a positive side effect for New Zealand filmmakers including women directors and cinematographers. Gunn has enjoyed shooting music videos for creative and practical reasons.

You can just do fantastic ideas, one after the next. They don't have to be connected on any obvious level. They can be heavily art-directed and as wacky as you like. And you haven't had to have five thousand cups of tea saying to somebody, "I'm really good, this will be very good, I'm sure that you will be happy with this." You don't need to make a thousand submissions.

However, Medina objects that music videos may be responsible for a lack of respect for experienced cinematographers because their producers prefer camerapeople who are less classically trained. "What producers want is creativity and originality; they do not care if you have a degree or not. Your background is less important as long as you are well versed technically—maybe because of the new techniques of music videos where the crazier you are, the better you are."

Jarnagin sees these "new techniques" as a positive.

Music videos in particular are a great medium for experimentation. As long as it looks cool, you can't screw it up, which is really empowering for the creative process. I love shooting them despite how low the budgets have gotten, because it's usually highly creative and makes me grow as an artist. And you can bring the new techniques you invent there into your other work.

Music videos can also be a positive because many cinematographers enjoy working with musicians. Those connections can be useful if the musicians later decide that they want to make a film. For example, Rinzler had shot many music videos when her friend, director Tamra Davis, who is also a friend of the Hughes Brothers, said to her, "'You would like these guys and they would like you.' She showed me this film that they did in Super-8 called *The Drive-By* and my mind was blown." Rinzler had shot music videos that Albert and Allen Hughes had seen and liked. So Rinzler and the Hughes Brothers connected. She said, "'I'd love to work with you guys. Don't worry about the budget.' They said, 'Really?' I said, 'Absolutely.'" Two weeks later she got a call that they were funded for *Menace II Society* (Albert and Allen Hughes; 1993).

Commercials and Such

This section focuses on material produced in order to promote sales of goods, material that may appear primarily and historically on television as well as before film screenings at cinemas and on airplanes, but increasingly on our computers and other digital devices.

Television commercials, also known as TVCs or ads (short for *advertisements*), are an important source of work for camera crew just as they are for directors. For example, Jean-Luc Godard, Spike Lee, and Baz Luhrmann as well as Haskell Wexler and Ellen Kuras have been known to fill in their time between films with commercials. Kuras, in fact, has done many commercials.

If one can shoot feature films, why bother with commercials? Sometimes it is as simple as the money. During the London phase of her career, Madelyn Most "did documentaries, which were the most interesting; commercials, which are the most highly paid; and features." For Jac Fitzgerald, trying to make a living in New Zealand's screen industries, TVCs are her "mainstay," although she tries "to do at least two drama projects a year."

Not everyone enjoys working on commercials, despite the money. Most said, "Alan Parker's company wanted me to be a permanent clapper loader on commercials. Why would I work for Alan Parker's company? I hate commercials and I hate selling dog food." Zoe Dirse experienced analogous feelings early in her career. "I worked a lot on commercials and feature films as a camera assistant. After my third or fourth Jell-O commercial, I thought, I didn't go to university for all these years to do this."

Joan Giummo and Kristin Glover object for moral reasons, seeing the expenditure on commercials as wasteful, especially compared with what else could be filmed with that sort of money. "Once or twice," Giummo remembers, "I worked on commercials and was staggered at how much time and money and personnel went into waiting for a stream of smoke to glide up in the proper way. With the same amount of money and equipment we could have done a whole documentary."

In the 1980s and early 1990s, having worked as a camera assistant on a lot of commercials, Glover "became a rich camera assistant and lived in Malibu. That was nice. Yet there's a certain hollowness to that work." She sees commercials and big-budget films as "a sad commentary on our society. That the brilliant talents of the day are used to sell things such as cigarettes, drugs, and widgets that people have no need for because that's where the money is. It all comes from corporations." She feels grateful that she is not asked to work in commercials any more "because I wouldn't want to have to make the choice between making many thousands of dollars a day and turning that down. It is extremely seductive."

Kuras once found herself questioning animal abuse issues while shooting a beer commercial about men who were men's men versus men who were sissies. A man who makes a big deal over a little dog has a

beer can fall on him because he's being sissy. The director wanted to drop this huge thing from a crane next to this poor little dog to scare it. We had already shot it as separate

elements which they would put together later in post. I went up to the director and said,
"Why are we doing this?" He said, "'Cause I want to."

Sissel, on the other hand, remembers the positives of working with Robbie Müller. Many of our interviewees expressed admiration and gratitude for his support. When Müller came to New York to shoot a commercial, he needed an operator, not because he could not operate himself, but because in New York DPs on union sets are not allowed to shoot. He wanted a local New York camera operator because "they used wheels and Robbie was intimidated by the wheels.[5] This was true of a lot of European DPs in the late '70s/early '80s." A director introduced him to Sissel, who had been working on documentaries both pulling focus and operating, but she had never done a commercial. Müller was also the first feature film DP for whom Sissel operated. As she recalls, "We were using, I think, 400mm lenses, and I was supposed to follow football players and the football flying through the air. I did it. Robbie was very impressed; the director was very impressed. To me, this was what I did every day." Sissel acknowledges that the money she had earned on commercials made it possible for her to take the step up from operator to the poorly paid job of DP for *Salaam Bombay!*

TVCs can be an important steppingstone in other ways. For Meily, the steppingstone almost became her career. After film school, while waiting to become a production assistant for director Mike de Leon, she met his brother, who worked in commercials. The brother asked her to work with him, so she ended up working in advertising, "first as a production assistant, then a production manager, and then a line producer. I shot my first commercial in '95." While she acknowledges some frustrations involved in making commercials, she concludes on a positive note that "advertising has trained me well to be precise and to think fast. All the frustrations, the limitations, the tears, the joys: All became foundations" for Meily's later work. As DP of *Amigo* (John Sayles; 2010), Meily won the Best Cinematography Award at the 2011 Gawad Urian, the Filipino counterpart of the New York Film Critics Circle.

For Sue Gibson, shooting television commercials likewise laid the foundation for her to become a DP in features. Gibson had spent seven years working in commercials, which she described as pleasant. "You get to practice your skills and do unusual things and build up confidence. You build up a library of situations that you've been in and how to handle them." Though some of her male contemporaries from film school got to DP on a film while she was shooting commercials, she was enjoying the TVC work and eventually she did become a DP for feature films.

Working in commercials can itself provide recognition, as well as serving as an aesthetic proving ground. Erika Addis notes that "Mandy Walker, who trained with Ray Argall, is probably Australia's best known—internationally—woman DP because of the high production-value commercial [she shot] for Chanel as well as *Lantana* [Ray Lawrence; 2001]." Walker has since shot features in Hollywood, winning the Cinematographer of the Year Award at the 2008 Hollywood Film Festival and the International Press Academy's Satellite Award for Best Cinematography for the film *Australia* (Baz Luhrmann; 2008).

Medina is even more positive about her experience with commercials, remembering a director on commercials who opened a mental and spiritual door for her. The director had said that he wanted to make a commercial

> where the audience would not be lied to. I remember everybody asking if I knew what I was doing and me responding I am doing what the director requested. Everybody was, "This is a little strange; this is not done in commercials." I said, "I know, but this is what the director is requesting." It was risky because this was one of my first commercial jobs in Spain, but it turned out beautifully. Many people watch it and cry. It is so direct, so to-the-heart beautiful.

Camerawomen have also found work—paid and unpaid—shooting PSAs (Public Service Announcements), which are similar to commercials but are used to publicize the cause of a nonprofit organization or community group rather than the product of a corporate sponsor. PSAs are often entry points for camerawomen who are beginning to build their reels, but experienced camerawomen often lend dignity and aesthetic value to a cause by their participation. For example, Maryse Alberti, who shot the Academy Award-winning documentary *When We Were Kings* (1997) as well as numerous commercials for such companies as Tylenol, Revlon, Disney, Walmart, and Quilted Northern, also shot an MTV Safe Sex PSA, winner of the Cable POP Award for Outstanding PSA Campaign. Giselle Chamma shot a LIFEbeat Public Service Announcement, *The Music Industry Fights AIDS* (1995), for MTV and VH1. In India, Priya Seth shot *Violence against Women* (2011).

In addition, there is a component of the screen industry, often known as *corporates*, devoted to producing material for corporate purposes: in-house productions, not meant for general public consumption but to provide information for employees and improve corporate morale, for example, or safety messages supported by an industry's regional or national board. Detroit, for instance, has supported a significant amount of film production for wide but internal use by the automobile industry. Michelle Crenshaw, for instance, has worked as an audiovisual technician, videotaping in-house videos for medical staff at the Masonic Medical Center in Chicago. One benefit of working on corporate in-house productions is that this can be a secure day job for camerawomen who need both to support their families and to be there for their children at night, instead of on location.

Experimental/Avant-Garde Films and Videos

Experimental cinema might be thought of as the engine room of development for the exploration of film technology's possibilities. However, for its devoted practitioners, experimental cinema serves other, more personal purposes.

Cinematographers have many reasons to get involved with experimental or avant-garde films, ranging from the opportunity to experiment with lighting and camera techniques to the need for self-expression. Since experimental and avant-garde films usually involve

unpaid work, women have had opportunities there. Some male and female filmmakers have both shot and directed their own experimental films, often in search of alternatives to mainstream film and television industry practice. Filmmaker Ann Deborah Levy, who does her own cinematography, says that choosing to shoot one's own films can

> allow greater intimacy with the subjects, permit more direct control over the image, and/or open up new directions for experimentation: in-camera editing, frame by frame shooting, rewinding and re-exposing to make in-camera superimpositions, optical printing, experimental animation, hand printing, and even painting and scratching on the negative.
> (Levy)

Financial reasons, not just aesthetic choice, have often turned experimental filmmakers towards less expensive cameras such as Super-8, spring-wound 16mm Bolexes, low-end camcorders and DSLRs, and even Fisher Price Pixelvision toy cameras. Canyon Cinema Director of Operations Denah A. Johnston mentions Sadie Benning as an experimental camerawoman who used Fisher Price Pixelvision cameras, and later "transitioned into music/video/performance with her work in the first incarnation of Le Tigre with former Riot Grrrl Kathleen Hanna" (Johnston). For some filmmakers, though, experimental film remains their preferred format.

Jarnagin is enthusiastic about camera technology available now:

> Two camera developments that are especially interesting to me [in early 2014] are the Digital Bolex[6] and the GoPro[7] Hero3 Black Edition. The GoPro can now shoot 2.7K resolution at 24fps and 4K at lower frame rates (for time lapse applications). Now that their image quality is professional enough to cut in with other professional camera formats, I am using them quite a lot. I was unwilling to embrace them before due to the inferior image quality of previous models. Yes, I am talking about the TINY $300 cameras you can get at Best Buy.

When cinema began in the late 19th century, it split into two strands: realism and playful experimentation with the medium. Until the 1990s most film textbooks that paid homage to the Lumière Brothers and Georges Méliès failed to acknowledge the contributions of Alice Guy-Blaché, the world's first *auteur* director, who later wrote of having discovered "many little tricks" such as slow motion, reverse motion, double-exposures, and fade-outs (Guy Blaché 26–27). Guy incorporated these experiments in technique into early mainstream films, first in Paris and then in her own Solax Studio in the United States. Another Frenchwoman, Germaine Dulac, is arguably history's second important woman director. Dulac, having been shut out of commercial cinema where she had worked as a successful director of feature films, put Guy's and other cinematographic techniques into practice in her experimental masterpiece, *The Smiling Mme. Beudet* (1922–23)—pre-dating Buñuel's far better recognized *Un Chien Andalou* (1929) by several years.

For feminist camerawomen, one of the key satisfactions of experimental and avant-garde filmmaking can be found in the opportunity to practice what Dulac first referred to as "feminine cinematic writing," bypassing what Sandy Flitterman-Lewis describes as "the oppressive logic of patriarchal structures of thought" for a visual poetics (95). Dulac was not a camerawoman but a director, journalist, and critic. Her writings about the art of cinema as well as the film club that she founded inspired a new generation of filmmakers in their cinematographic visions: Jean Vigo, director of *L'Atalante* (1934), as well as later generations of filmmakers in France such as Agnès Varda, who speaks of her own filmmaking as *cinécriture* (Flitterman-Lewis 219), and Rose Lowder, known for frame-by-frame in-camera editing.

Dulac's theories about cinema as "visual symphony, composed of rhythmic images" stretching beyond formulaic storytelling, also laid the groundwork for avant-garde filmmakers in America, including Maya Deren, the founding figure of the American avant-garde (Flitterman-Lewis 48). In addition to directing what is probably America's most memorable and influential avant-garde film, *Meshes of the Afternoon* (1943; shot by her husband, Alexander Hammid), Deren also wrote extensively about cinematography. Her essay "Cinematography: The Creative Use of Reality" ends with the mandate that cinema "develop the vocabulary of filmic images and evolve the syntax of film techniques which relate those" in order to become "a full-fledged art form" (72). Film historian Bill Nichols has said that Deren's theoretical essay "An Anagram of Ideas on Art, Form and Film" has a brilliance comparable to the theoretical writings of Eisenstein and Godard (Nichols 7). Deren's essay explores specific techniques that she put to use in her own films, describing slow-motion as "the microscope of time" (Deren, "An Anagram" 47) and cautions would-be practitioners of film art not to kowtow to their camera equipment.

> The burden of my argument is that it constitutes a gross, if not criminal esthetic negligence to ignore the immense wealth of new elements which the camera proffers in exchange for relatively minute effort. [...] Just as the verbal logics of a poem are composed of the relationships established through syntax, assonance, rhyme, and other such verbal methods, so in film there are processes of filmic relationships which derive from the instrument and the elements of its manipulations.
>
> (Deren 48)

Supported by a 1946 Guggenheim Fellowship, Deren did her own camerawork for a film about Haitian Voudoun (*Divine Horsemen: The Living Gods of Haiti*; 1981; completed after Deren's death in 1961).

The lively post-World War II New York avant-garde scene for experimental films and videos included a number of women practitioners, such as Shirley Clarke, Marie Menken, Joyce Wieland, Gunvor Nelson, Yvonne Rainer, Carolee Schneemann, Barbara Rubin, Leslie Thornton, Su Friedrich, Cheryl Dunye, and Marjorie Keller. Many of these and other women experimental filmmakers used collaborative, nonhierarchal methods of filming, or worked in a more solitary fashion, doing their own camerawork on their own films.

What did these women make films about? Menken explored the transition within New York painting from abstract expressionism to Pop Art in the 1950s-60s. Clarke, who cofounded the Film Makers Cooperative in New York in 1962, started by exploring cinematic choreography in her dance films, moving on to direct pivotal independent features including *The Connection* (1962) and *The Cool World* (1964). Rubin's *Christmas on Earth* (1963) focused on the objectification of the body while Schneemann's early experimental films, *Fuses* (1965) and *Kitch's Last Meal* (1973–76), which she shot, evoked the colors and rhythms of female orgasm. Dunye explored her own identity as a black lesbian artist in *The Watermelon Woman* (1995), filmed by Michelle Crenshaw. The multi-talented—dancer, choreographer, performer, filmmaker, and writer—Rainer, one of the New York scene's most celebrated filmmakers from the 1960s through the 1990s, first choreographed in 1961, presenting her choreography all over the United States and Europe. In 1968 she began to integrate short films into her performances. In 1972, she made the first of seven feature films, on subjects such as a romantic triangle, a sexually dissatisfied woman, a female lion tamer, the breakup of a marriage, and film theory.

Babette Mangolte, a Frenchwoman based largely in the United States, worked as camerawoman for Yvonne Rainer, Chantal Akerman, and Sally Potter before becoming a director herself. While many of these and other women were important contributors to the experimental and avant-garde scenes, their work was exhibited in museums in token numbers compared to male film and video artists' works well into the 1980s (Rush 35). In 2002, a *New York Times* article on an impending Museum of Modern Art show commemorating the first decade of videos from Electronic Arts Intermix (a nonprofit arts organization that had been headed by Howard Wise) included this male-centric comment: "'If Nam June Paik was the father of video art,' the longtime video practitioner Shalom Gorewitz says, referring to the pioneer credited with making the first tapes with a portable camera, 'it was Howard Wise who delivered the baby'" (Rush 35). Yet the show was organized by women, and included a significant number of women video artists, as well as women performance artists who used video in their work, some of which they shot themselves.

Also renowned for her work in experimental video is Shigeko Kubota, who moved from Japan to New York in the 1960s, becoming one of the leaders of the avant-garde group Fluxus. Her extensive work, including video installations and an autobiographical series of videotapes entitled *Broken Diary* (1970-present) merited a one-person show at the Whitney Museum of American Art in 1996, where her husband, Nam June Paik, had had his own one-person show in 1982. Her personal experimental video work often features Nam June Paik, including work in the 2007 exhibition of video sculptures and installations at the Stendhal Gallery in New York, entitled "Shigeko Kubota: My Life with Nam June Paik."

In addition to the experimental films shot in New York during this period, the West Coast had experimental filmmakers such as Chick Strand, who shot her own ethnographic films, often in Venezuela and Mexico, and established the *Canyon Cinema News* in San Francisco in the early 1960s. Strand later moved to Los Angeles, where she taught film production at Occidental College. Canyon Cinema Cooperative, the largest distributor of experimental and avant-garde

films, included numerous women filmmakers, many of whom shot a significant portion of their own work, such as Janis Crystal Lipzin, Betzy Bromberg, and Barbara Hammer.

The generation of women who began working around the 1970s included pioneer lesbian artist Barbara Hammer, who has made over 80 films and videos since 1968. Hammer was the first recipient of the Shirley Clarke Avant-Garde Filmmaker Award in 2006. Lighting cameraman Amy Halpern, who had cofounded the Collective for Living Cinema, an experimental film showcase in New York, moved to Los Angeles where she shot and directed the acclaimed experimental feature *Falling Lessons* (1993). Feminist art activist, performance artist, and video pioneer Susan Mogul shot her personal experimental documentaries—*Everyday Echo Street: A Summer Diary* (1993) and *I Stare at You and Dream* (1997)—except for images of herself (unless in a mirror). Estelle Kirsh, who had enjoyed making experimental independent films in New York—"where the person with the camera was in control"—collaborated with Lyn Gerry in Los Angeles on *Abacus* (1980), a still life animated by using single framing in a myriad of lighting situations. These and other experimental films got exposure at Los Angeles-based venues such as Oasis and the Theater Vanguard. Additionally, Los Angeles' Museum of Neon Art exhibited the pro-choice hologram *Childbirth Dream* (1980), which Alexis Krasilovsky directed, filmed, and animated in New York, incorporating 16mm and 35mm camerawork.

Meanwhile, in London, Diane Tammes shot *Riddles of the Sphinx* (1977), Laura Mulvey and Peter Wollen's film about women in patriarchy. Mulvey's essay, "Visual Pleasure and Narrative Cinema," influenced many experimental and independent women filmmakers. Sally Potter started out as an experimental filmmaker, making several short films at the London Film-Makers Co-Op from 1969 to 1971, in addition to her multimedia work.[8] Potter worked as camera operator on her film *Rage* (2009), which she also wrote and directed. In Germany, Ulrike Ottinger did her own camerawork on surrealist avant-garde feature films such as *Ticket of No Return* (1979) and *Joan of Arc of Mongolia* (1989).

With every new technological development, the initial users have engaged in an exploration of the medium, with the market usually determining the ultimate results. Video cinematography pioneer Lisa Seidenberg explains that "nobody thought that video would take over the broadcasting industry. It was some kind of art form that we were playing with," although most people were unaware of the new technology until it began appearing in mainstream venues. Portapak videos gave women a chance to reconfigure how documentaries were produced and made; in the hands of Shigeko Kubota and other artists, Portapaks and video monitors proffered new dimensions to intimate and personal space within the gallery. In Krasilovsky's film and video work, *Blood* (1975) features a talking vagina, *Inside Story* (1983) uses endoscopic cinematography to tell the story of an angry cervix, and *Bay-Bee* (1988) uses ultrasound imagery.

Among the experimental and avant-garde filmmakers who have done their own cinematography on some of their work are Peggy Ahwesh, Abigail Child, Trinh T. Minh-ha, Lynn Sachs, and Anita Thacher. Even US cinematographers who have access to well-paid jobs often make it a priority to include artistic work in their roster of film projects. Rinzler is

passionate about experimental film "projects because they're personal, and working within the experimental form provides a freedom to try things" (Lumme 76). Rinzler also enjoyed working on an experimental film with Wim Wenders called *The Soul of a Man* (2003): "It was part film, part video. We used a 1928 35mm black and white hand-cranked camera. That was fantastic."

Art Films and Videos

Sometimes, a young woman is inspired by an artist to become a cinematographer. Inspiration for this book came in part from the experimental documentary *End of the Art World* (Alexis Krasilovsky; 1971), featuring Andy Warhol, Robert Rauschenberg, Jasper Johns, Jo Baer, Roy Lichtenstein, and Nancy Spero.

A visual artist inspired Zoe Dirse to change her career ambitions from teaching and psychology to cinematography when she worked for a friend as a jack-of-all-trades on a documentary for the French production component of the NFB in Toronto. The camerawork intrigued her, because of Claude Benoit, who "is a very famous visual artist in this country now. His photographs hang in the Contemporary Museum of Art in Montreal. He was inspirational; I thought if cinematography can be artistic as well, then I would like to pursue this."

After film school Erika Addis also worked on experimental art films that were financed through the Australian Film Commission (now known as Screen Australia). "I worked on some wonderful and strange films that were about artistic expression, not designed for the mainstream. They were short, fun films." She felt privileged to work on an art film about Australian painter Fred Williams. She photographed his paintings for the film, but in order to understand his art, she looked at his paintings in great detail as well as traveled to the landscapes he painted where she "photographed those landscapes, and people in those landscapes, to connect to his vision." She found his "rendering of the Australian landscape inspiring."

Addis explained that Williams often painted "the same landscape two or three times—the same view of the same landscape in different light. He would then put those paintings—one, two, three—into one frame, so that you saw the same landscape at different times of the day in different colors." She discovered how to duplicate Williams' methods on film.

We photographed the same landscape in different light from exactly the same place by meting out different parts of the frame for different views of the landscape. Two thirds of the frame would be meted out for the first pass. The top would be meted out for the second pass. Then the bottom would be exposed for the third pass. It was a direct translation in a filmic way of the way he was looking at the land.

Addis learned this technique by watching the films of Paul Winkler, an internationally recognized experimental filmmaker who discovered "challenging new ways of exposing and composing his trends. He frequently uses that multiple-pass technique."

Artists around the world have worked on films about art or on films that *are* art. Today the opportunities for creating and disseminating experimental and art films are much greater because of the Internet, even though in the United States the main distributors of these films historically—New York Film-Makers Co-Op and Canyon Cinema Coop in San Francisco—have had financial difficulties given the transition from 16mm film to digital video and new media. Camerawork in today's experimental scene includes films shot for the Internet on digital cameras—whether on high-end Panasonics or on iPhones—and performance art and installations often include digital imagery. In 2002, the *New York Times* reported:

> Today's roster of world-renowned video and media installation artists is headed by women, including Gillian Weating, Sam Taylor-Wood and Pipilotti Rist, all of whom descend from this first generation of female video artists. Also, many, like Cheryl Donegan and Kristin Lucas, can function simply as media artists without having to focus on gender.

> (Rush 40)

Whatever the format—and whatever the gender of the person behind the camera—Maya Deren's cautionary statement still applies: "The less the artist collaborates with the instrument, with full consideration to its capacities, the more he will get, as a result, film which expresses mechanics of the camera, and not his own intentions" ("Anagram" 43).

Shooting Special Material: Birth

English filmmaker Nancy McKenna has photographed and filmed more than 100 human births. In 2003 she established SafeHands for Mothers as a project to reduce maternal mortality and produced a series of videos to "be used by health professionals to deliver a message to remote and rural areas." She looked at video as a cost-effective resource that can get the message out about safe birthing procedures.

In 1983 McKenna began exploring visual imagery about birth while taking photographs for Sheila Kitzinger's book *Women's Experience of Sex*, which is about women's sexuality from birth until death. McKenna also did a book with Miriam Stoppard called *Pregnancy and Birth* (1985), during which time McKenna became pregnant. "At that point, I probably filmed and photographed 50 or 60 births." As a newly pregnant mother, she still had many unanswered questions, so she wrote and documented a book called *Birth: A Unique Visual Record* (1989).

McKenna strongly believed that if she wanted to get the message out about safe birth to women and their partners of all economic and educational levels, she needed to use video. "I was hoping to appeal to the husband who isn't necessarily going to sit down with his wife and look at a book, but he would come back at the end of the night and possibly look at a video with her." McKenna's video *Birth: Eight Women's Stories* (1993) focused on eight

women all with different labors: "a natural birth at home, the birth of twins, cesarean birth, birth in hospital, birth under water, and a whole variety of age groups." The oldest woman was 45; the youngest was in her late teens. Midwives, doctors, and parent-craft classes have used her video as a catalyst for discussion, while first-time and even sixth-time mothers find it helpful.

In doing her birth videos, McKenna found herself more in tune when using a small video camera than a still camera. Video allowed her "to bob and weave; I'm not stuck to having a tripod. I feel less removed from the people." She loves "the rolling aspect of video, [particularly] in birth, where the sound can be important." She finds when shooting birth that there is "action involved as well as passion." For her, "It is such a privilege to be at another woman's birth with her partner. They are such raw emotions [that] often we don't know what our reaction will be. [And] there is no second take."[9]

Notes

1 Masala is a mixture of spices used in Indian cooking.
2 Nancy Schreiber and Amy Vincent interviewed each other for much of the material in this section.
3 Postproduction, that is, the process required to convert raw images captured during production into the technically perfect images we expect to see on screen, e.g., editing, color grading, and soundtrack, among others. With the advent of digital technology, it increasingly includes CGI.
4 Other camerawomen who have won Cinematography Awards at Sundance include Rachel Beth Anderson, Christine Choy, Ellen Kuras, Emiko Omori, and Amy Vincent.
5 "Wheels" are a way of controlling a camera as it pans and tilts (or moves about on a dolly or crane) to follow an object.
6 "Digital Bolex is a digital camera company start-up that launched their camera as a project on Kickstarter. It got a lot of attention and the campaign was a huge success. Both of the partners in the company are young DPs and co-founder Elle Schneider is an activist for furthering the advancement of women cinematographers. She recently 'put her money where her mouth is' and announced the 'Digital Bolex Grant for Women Cinematographers'" (Jarnagin).
7 Author's note (Margolis): A New Zealand loyalty program has offered a GoPro Hero3 as a reward, for just a few points more than an iron and a bit less than a pair of binoculars.
8 Founded in 1966, the LFMC merged with London Video Arts to form LUX, the main distributor of experimental films and videos in the United Kingdom.
9 In the United States, camerawoman Liz Bailey set up the company Video Births in the late 1980s.

Chapter 5

Special skills and creativity

Handheld Camerawork

Sabeena Gadihoke's steady shoulder, much steadier than other people's, has enabled her to enjoy handheld camerawork without having to be big and beefy. Gadihoke is not small by Indian standards, though among Westerners she is petite. But as she realized, a person doing camera needs stamina, not strength, to excel at handheld shooting.

Sometimes the camera I use[d was] about eleven kilograms [22 lb]: the Betacam, the big analog camera, the camcorder with its battery and all. I operate[d] that on my shoulder. Also, it has to do with balance and agility, something I never had a problem with. I was always flexible, so those things gave me the sense that I could do the camera.

When Yolanta Dylewska shot the feature *Tulpan* (1999) in Kazakhstan, the director wanted a handheld camera. Dylewska thinks that a person has to develop a personality for the handheld camera, plus "own" the camera. "We humans are sometimes too fast, sometimes we are tired, sometimes we are young, we are old. We move too slowly and we cannot see well. The director just said, 'handheld camera,' and I immediately thought of different kinds of movements, different personalities."

For Jac Fitzgerald, practical considerations have influenced her shooting style. "I do a lot of handheld work and seem to have a natural instinct with framing and lighting when I work in this way. I don't enjoy crane shots nor Steadicam, as I can't look down the lens." Joan Hutton also speaks of an "affinity" for handheld work because she finds "it easy to do smooth, steady shots. I love that rush you get when the camera is on your shoulder and you start thinking on your feet and working and just making things happen and cutting it in your head as you shoot. That's something you don't get any other way."

Cranes

After working in Hollywood, Pakistani American Nausheen Dadabhoy travelled to Pakistan to work as the first Pakistani woman DP on a film. She had to sit on a crane for the first shot. She looked at the "black metal tubes held together by rusty bolts that were going to put me 30 feet in the air, and I wanted to go back to Los Angeles." She had heard stories about cranes used in Pakistani films that were "old, not maintained, had no seatbelts, and a cameraman

had fallen off them before." Her camera assistant, seeing her facial expression, volunteered to get on the crane to shoot the first shot for her. Dadabhoy, knowing Pakistani culture, was afraid she would lose the respect of the all-male camera, grip, and electric crew if she did not prove that she could do what "every male DP my crew had previously worked with was able to" do. So she climbed on. "I couldn't help but feel a little frightened as I bobbed up and down while they balanced the weight of the arm."

When she came down, her assistant was smiling. "He told me I was a tough woman, and I knew he meant it as a compliment." Though Pakistani DPs usually light "with hard light and use a lot of fill," her crew was fascinated by her use of "soft, bounced light" and eagerly learned from her. She later was pleased to notice that when her crew worked with a different DP, they "used many of the techniques I had taught them." She learned from them that some Pakistani men see a "woman as a DP and not a female DP."

Underwater

Camerawomen who have shot underwater include Filipina Lee Meily, Canadian Sarah Moffat, India's Priya Seth, Britain's Katie Swain, Australian Valerie Taylor, Austrian Eva Testor, and American Susan Walsh.

Swain started diving for fun, but for underwater cinematography a cameraperson needs to be a qualified diver with a commercial rather than a sport certificate. The BBC paid for Swain to take the course. When Swain started at the BBC, there were usually four or five camera teams qualified for underwater work, and "whenever you had an underwater sequence in a drama or a documentary, one of those teams would be called on to work on it." Eventually, though, there was no longer enough work at the BBC for so many underwater teams. After she left the BBC, she discovered a different environment in which some camerapeople "specialized and only did underwater stuff. Just doing it from time to time wasn't enough, so I left that behind."

Learning to shoot underwater can sometimes be challenging. Eva Testor describes what happened when she and her filmmaking partner worked on their short film called *Freiheit*:

> *Because we wanted to film underwater we took a diving course together. It was horrible. We got this bag for the camera, and when we finally could dive and it was time to test it, we put the camera in the water. It made a blubb-blubb noise; the bag wasn't watertight. It was a disaster, but it was funny.*

Susan Walsh, a pioneering Hollywood underwater camerawoman, got her diving certificate before becoming a camerawoman. In the 1970s she worked in the sport diving business in the Florida Keys. To improve her skills, she dove with more experienced divers, including a lot of ex-Seals, "getting really good training." When she first came to Hollywood, she collected the names of underwater cameramen and called them, connecting with a couple

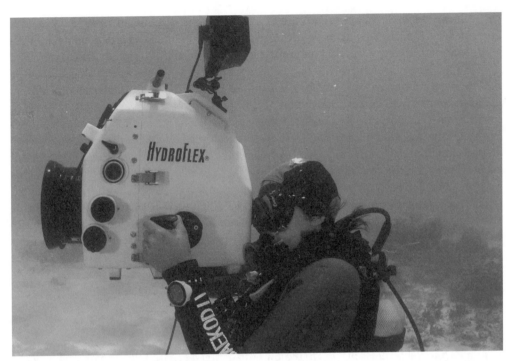

Figure 19: Priya Seth, filming underwater. India.

of those cameramen's wives, who became her supporters. "They put me in touch with their husbands and made it possible for us to work together, I think because they were comfortable with me." Walsh found that many people think camerawork is a man's job, and underwater camerawork is *really* a man's job, so they cannot "imagine a woman doing that job." She found, however, people to support her underwater camerawork: "Chuck Barbee and Al Gornick, particularly. J. Barry Herron and Jack Cooperman have been supportive and hired me."

Walsh first worked on an underwater shoot with Chuck Barbee, filming a commercial diving venture in the Gulf of Mexico. Barbee had read an article that Walsh had written on underwater assisting:

> *He just called me and interviewed me over the phone and offered me this job. I was impressed that he was that open-minded. Elizabeth Barbee, his wife, has been very supportive. I think it has to do with the kinds of relationships that these men had had with their wives. Chuck had worked with his wife; she had been his assistant for a while, so it was there for him that women could do this work, and he respected a woman who did.*

Despite supporters like the Barbees, Walsh has found skepticism in the film industry as well as in still photography that a woman is capable of doing the work. However, on location

she is surprised at the support she gets from commercial divers who never question her competence. Once she was shooting with Chuck Barbee in Canada on a large operation with some commercial divers working on hose gear.

They were working with surface-supplied air and I was keeping the dive times for Chuck as well as my own, as well as being his camera assistant in the water. At the end of the shoot, the commercial diving supervisor came up to me at our wrap party and said, "I would have you tend me any time." The person who is tender for the person underwater is making sure that person is safe. They're basically putting their life in your hands. He gave me a tremendous compliment.

Walsh loves the underwater world and enjoys bringing together the visual part of her life with the very physical part. She enjoys helping to make the "underwater world available to people who don't dive, so that they can maybe have a greater respect for the ocean and its creatures."

Helicopters

The most dangerous things for a helicopter to do are exactly what we ask them to do in filming from them: hovering and flying low. Add to that a demanding director, who might be stressed out and pushy because of the limited flight time to get the shot—and a pilot, who wants to deliver to their clients' wishes, might make riskier judgments than they normally would.

(Jendra Jarnagan)

The helicopter disaster that occurred during the filming of *Twilight Zone* (Joe Dante, John Landis, George Miller, and Steven Spielberg; 1983) was a watershed for the industry. Vic Morrow was crossing a river with two Vietnamese children while the film crews were setting off bombs to destroy the nearby imitation Vietnamese village. American camerawoman Leslie Hill was working that day. She remembers how the helicopter was encouraged to come lower and lower, and the pilot had trouble guiding it through the explosions. A film technician on the ground detonated two more charges; they harmed the helicopter. It lost its loft and came down. Hill's eyebrows were singed as the whole crew of 100 people saw three people killed—Vic Morrow and the two children. The *Twilight Zone* disaster was a wake-up call for the industry about the need for more safety precautions while shooting not only from helicopters, but wherever hazardous conditions could be found. It is still cited whenever a death occurs on a film shoot.

Helicopter work is one of those areas that BTL had explored in the form of a symposium organized by Estelle Kirsh at Clairmont Camera in the mid-1980s, so that its less experienced members could expand their technical knowledge as they mastered

the gear and safety issues. Helicopter work is also mentioned surprisingly often by our interviewees.

For example, one of Swain's most exciting moments as a camerawoman was shooting "in helicopters, working with really experienced pilots." Gadihoke recalls a wonderful experience shooting from a helicopter while working as camerawoman for an expedition of women trekking in Nepal. She found filming in a helicopter "totally different from shooting in a plane. In a helicopter you're shooting through an open window and you can go really close to the mountains and valleys." In addition, "We had taken ten days to trek to our destination, and in half an hour in the helicopter we were back in Kathmandu."

For Astrid Heubrandtner, working with helicopters became second nature while she filmed the Austrian television production *Medicopter* (1998–2006), which was an action TV series about a medical helicopter involved in various adventures. Heubrandtner worked on *Medicopter* from the beginning, first as AC, then as operator, finally as cinematographer,

> but always [on the] Second Unit, meaning that we mostly did action scenes. Very little with actors, but everything with stand-ins and stunt-people. We filmed on 35mm, which was pretty extravagant for Austria. The Second Unit crew was almost a full feature film crew, with 30 people on set. We destroyed almost everything that you can destroy: We exploded boats and trucks, and threw buses down a ravine. And of course many flying shots from the helicopter. It was fun. Often we had five cameras going. It was pretty tense work, because it was a big challenge to coordinate five cameras covering high-speed chases, car wrecks, etc.

Heubrandtner described more men than women on the set, but the show did have a few stuntwomen since a female pilot and female doctor were in the medical helicopter. "Because I had been with the crew from the beginning, and most of the crew stayed the same over the years, I was able to fit in well."

The pleasures of shooting from helicopters may become a thing of the past, though. Jarnagin recently worked as DP on Second Unit for a feature film. "We used a QuadCopter (aka drone) with a GoPro to get some really high production value helicopter shots, including some shots that could not have been achieved shooting from a real helicopter because we wouldn't have been able to get close enough." Helicopter shots are not the only way "these tiny versatile cameras" might change camera work; they are "enabling shots and content that you could never capture before," Jarnagin reports.

Special Effects

The sort of dedication that most camerawomen bring to their work demonstrates a level of commitment that goes beyond seeing their work as "just a job." Amy Halpern had worked on *Alien IV* (*Alien: Resurrection*; Jean-Pierre Jeunet; 1997) where they were simulating blood and guts fragments in space by shooting in a big water-filled tank. She recalls that

147

"various substances were being thrown into the liquid as if into space. They disperse in water more charmingly than they disperse in air, and a bit slower, so we can see things." She is entranced when she shoots different materials dispersing in a liquid tank "because they particulate in a gorgeous way." Halpern shoots for money and also for herself, and often one informs the other. While shooting her experimental film *Elixir* (2009), she created "a sort of simulated cloud effect" by shooting materials in a water-filled tank that looked cloudlike as they dispersed.

Camera operator Jo Carson has helped create spectacular special effects that have proved fascinating to millions of people, such as the bee sequence in *Honey, I Shrunk the Kids* (Joe Johnston; 1989). In that film the audience sees the kids riding on the back of the bee through a clothesline. As Carson explains it, the film crew had a small bee model out on "a rod that's held by the motion control rig and the camera is separate from that, also motion control, and there's going to be movement that is preprogrammed by me." When the bee moves, it moves around the frame and the camera's moving. "The kids that you see on the back of the bee in this case were little puppets. They were animated on a frame-by-frame basis by Pete Kuran, the animator who worked with me on that. He did a great job. You think it's the kids when you see it."

Carson worked as a camera assistant with John Fonte at Industrial Light & Magic (ILM) on *Innerspace* (Joe Dante; 1987). At ILM they had a huge tank in which they put water and various other liquids to simulate different environments while the camera remained outside the tank, shooting through a glass wall. For example, a technician squirts milk or sometimes even latex paint in the water to look like clouds—similar to what Halpern did on a smaller scale for *Elixir*. For Carson, one highlight while working on *Innerspace* came when they put various objects that looked like body parts—including one that was supposed to be inside a woman's womb—into the liquid tank. "She was supposed to be pregnant and there was this little fetus that was supposed to be eight weeks old. Fun to shoot." In *Innerspace*, once again, Carson explains that film technicians created little rubbery red things an inch across that were made to look like blood cells. After millions of these little red blood cells were in the tank, they would submerge the camera, encased in a waterproof Plexiglas housing made for the job.

> *It would be motion-controlled through the artery, so that from the camera's point of view you got all this blood moving past you. Some of that stuff was done with just a camera on a dolly and a jib arm holding the camera down in this liquid environment. One thing you saw was the heart valve, as though you were going into the heart of the person whose body you were supposed to be in. The heart valve opened and the camera appeared to go through. That was fun to work on.*

Carson worked on the visual effects of *The Matrix Reloaded* (Andy and Larry Wachowski[1]; 2003) and *The Matrix Revolutions* (Andy and Larry Wachowski; 2003) at the same time. Her DP was someone she had worked with on and off for years, shooting "huge shots, motion

control again, of this doorway that's a prominent feature of the interior environment on the Matrix." She explains that the door, which was supposed to be 500 feet wide in the film, in reality was only 50 feet wide, so the crew scaled everything around the door. The visual effects crew worked closely with the computer graphics people.

> They had pre-visualized ideas of exactly what the shots would look like and what we had to do with the camera to make the background plate work with how they were shooting the foreground and the actors. In this case they had already shot the foreground of the actors and then used motion-tracking techniques to figure out how the camera had worked on the actors. Then they fed us the data, which controlled how our camera moved. They had to be set up mathematically so we would all be proportionately correct.

Carson worked on other major Hollywood pictures, including *Back to the Future Part II* (1989), *Ghostbusters II* (1989), and *Indiana Jones and the Last Crusade* (1989). On *Star Wars: Episode II – Attack of the Clones* (George Lucas; 2002) she enjoyed shooting "huge so-called miniatures with big motion control rigs. Like the *Matrix*, we shot using data that was fed to us by the computer department to match moves they had tracked on the live actors on the plates."

Also prominent in the world of visual effects cinematography is Anna Foerster, ASC, who left her native Germany in order to further her career specialization, working on big-budget films such as *Independence Day* (Roland Emmerich; 1996), *Godzilla* (Roland Emmerich; 1998), and *Pitch Black* (David Twohy; 2000). In addition to cloud tank photography, *Independence Day* involved "every kind of effect imaginable … motion control, cotton clouds, pyro, high speed, forced perspective, plates, tiny setups, cumbersome miniature sets, and of course green/blue and orange screens" (Rogers 151).

Lighting as a Cinematographer's Dream Job

> If it's a scene where somebody's sad, for instance, you can make the lights moody, but so it doesn't stand out, so it focuses your attention on the actors.
>
> (Sue Gibson)

Throughout these interviews, camerawomen talk frequently and specifically about having access to different types of lighting equipment along with enough crew to take advantage of what is on offer. At the top end of filmmaking, cinematographers get to use what they need, when they need it, suited to the purpose. At the bottom end, good cinematographers get really creative.

Hutton explains that as a cinematographer, she has many lighting options available. She could use a safe, basic lighting setup where everything is nicely exposed or she could experiment: "What would this look like if I put some colored gels here or there? Or if I put the

key [light] over there, which is not where it is supposed to go, but it might be worth trying. What would happen if I light a black actor with blue or brown or orange gel?" Halpern even sees a religious quality about light itself: "I can't get enough of playing with lights and making changes in them. It's a miracle, even in the most mundane scene of someone's lighting someone's cigarette. It's still a play of light, which is a holy act."

Rozette Ghadery and Heather MacKenzie speak in terms of painting. "Lighting," Ghadery explains, "transforms two-dimensional space into three-dimensional and vice versa. It adds or removes perspective. For me, lighting is like brush strokes in painting: very important." Coming out of an art school background, MacKenzie continues to paint, and although she has worked primarily as a news camerawoman, she says, "I love to paint with the light, which I consider when I see a subject. I pick the background, I choose the lights, I choose the angle. It's painting in a way, just using your video or your film."

Ellen Kuras goes so far as to refer to a kind of "painting lighting," using the Neil Young documentary for her example. She wanted the lighting to resemble a painting within a painting because Jonathan Demme had used painted backdrops as part of the sets for the live concert.

> We were referencing old radio shows that had occurred in the '30s, '40s, and '50s. John [Nadeau] and I designed it, and we did the lighting before the concert, like paintings. We always strive to make these images, whether they be painterly images or whether they be harsh or whatever; he and I are very much in consort.

Kuras was very pleased when Young himself commented that the lighting was like a painting.[2]

Kuras' reference to Nadeau signals the importance of the relation between cinematographer and gaffer within the camera crew. Halpern explains more fully: "I work as a lighting cameraman and I also work as a gaffer. When I'm a lighting cameraman I'm the DP, and when I'm the gaffer I am assisting and supporting the work of the cameraman."

Carson illustrates the same point about lighting within the crew hierarchy, although in her case she was working as a camera operator in charge of lighting on the film *The Nightmare before Christmas* (Henry Selick; 1993). Carson's job was to light and shoot sets that were about the size of a couch as the animators moved the puppets "on a frame by frame basis for the individual shots. We would often have many set-ups working at the same time. Testing on some of them, shooting on the other ones. Generally speaking I would be working on two or three shots at a time. I had a couple of assistants working with me." Carson found it easy to do all the lighting while a couple of assistants did all the set-up of lights and grip equipment. "Because the sets are smaller and the characters are only this tall [indicates with hands], generally speaking," Carson explains, "we use smaller instruments, inkies, mostly, and some big lights just to set as a key light."

Though the vision of the film came from Burton, Carson had much freedom to light and shoot sets however she thought would best bring out the dream that Burton had when he

was writing the movie. "I shot most of the graveyard scenes in that movie. There's a lot of them, and it's my best work that I've ever done." Carson is choosing from many possibilities created so far from her career in special effects camerawork.

Sometimes a cinematographer's lighting options are limited or dictated by expectations imposed from outside. As Seth notes, Bollywood films are expected to be

crisp, clear, and bright. One explanation, which seems to make some sense, is that the projectors in the rural areas [of India] are very dim. So if you light something that is very contrasting, it might not show up in much detail outside the big cities. You need to take into account so many things other than what you would like to do.

When she is shooting a big star, another Bollywood restriction limits her ability to experiment much with lighting and filtration. Although "there are many ways of saturating things and changing them a bit," the stars "have to look good." So "the palette is much more limited than you would like it to be."

Meily has learned to deal with limited resources by improvising. She employs lighting tricks learned when she worked as a photographer, such as using Japanese lanterns.

When I shot my first film, the senior cinematographers were shocked that I was using hard bulbs and Japanese lanterns. I would say, "I only have ten pieces of light and I'm shooting a feature. If I order something extra, I pay for it." Last week I asked my gaffer to prepare a triangle light for a beauty shot. I would dismantle the kinoflo bulbs, rearrange them, and make my own version of a beauty light or triangle lights. Lovely, endless things you can do.

Meily learned some of these technical tricks from the Internet and from reading the ASC's *American Cinematographer*. When reading *American Cinematographer*, however, she is often amazed "at the number of lights they use making features. A regular package here would give you six pieces of 1K tungsten lights, ten pieces of inky-dinkies, one HMI if you're lucky." Her favorite lights, known in the Philippines as "sputnik lights," involve making their own soft boxes. "When I was a photographer and shot beauty products or hair, I would make my own soft boxes. My key grip and my gaffer devise boxes; the diva lights, you know, we tear them apart and make our own soft boxes. Lovely, lovely."

Kuras taught herself much about the lighting component of cinematography while making her first low-budget films, starting with *I Shot Andy Warhol* (1986) where she worked for the first time with British director Mary Harron, who had previously directed documentaries. Kuras found Harron "an exceedingly smart, astute, wonderful person" with whom she enjoyed discussing lighting, among other things. Kuras remembers herself and Harron as "fresh and young and doing this movie, and we had no money yet we were trying to do whatever we could to make it work. A little bit of aluminum foil here; we'll just put a fluorescent light here: That was the spirit of making that film." She describes shooting the

scene when Lili Taylor (as Valerie Solanas) returns to Warhol's Factory on an "overcast and really dark" day.

> I didn't have that many lights, maybe one 18, one 12K, I think, and a couple of 6Ks. Instead of trying to light the factory inside, I thought, I'm just going to expose it and make it silhouette and fill it with a lot of smoke and give it that atmosphere and time it to the blue side. It turned out to be one of the nicest scenes in the movie.

For *The Ballad of Jack and Rose* (2005), Kuras dealt with lighting options limited by the combination of a set and the particulars of an actor's face. She says that the house set was difficult to shoot in because she had only one set of windows to give access to daylight "and because Daniel Day-Lewis has deep-set eyes. It was always a battle trying to get the light into his eyes." She dealt with this problem by having two freestyle cameras nearly look at each other,

> covering the action from two points of view, staying on one actor and coming in on the other actor. It's basically choreography of the cameras, which I love doing.
> I had to be crafty about where I was going to put lights around the set so that they could pick up Daniel Day-Lewis' face or to have a special light that someone would hold so that it could be put in the right spot. That's difficult with two cameras, because you have to stay out of each other's way and stay out of the shot. You always work it out. Maybe you do a blocking rehearsal—vaguely, because often we didn't have marks; we were going on the fly.

Kuras also used freestyle camerawork on *Eternal Sunshine of the Spotless Mind* (2004); with one exception, she had no marks. Director Michel Gondry's decision to light by what was provided by sources on the set posed a tremendous challenge to the focus pullers. Kuras had to augment the light by hiding lights everywhere—but always hidden,

> because on those sets we were seeing 360 degrees. I was using lights from refrigerators. Long tubes we were hiding behind things. We were cutting holes out of lampshades so that the light would go stronger in the direction of the actor. We had light bulbs hidden behind books. We had stuff everywhere. We had clip lights that were on the ceiling; we had Japanese lanterns on the floor. We had lights everywhere.
> But it was hard to be able to light the actors' faces. To me it's part of the discovery. Sometimes they walk into shadow and that's OK. It doesn't have to always be lit.

Lighting poses different issues for different types of film. Although documentaries are traditionally associated with realism, for some decades documentarians have been playing around with elements associated with narrative film, including or perhaps especially lighting. Hence, under Errol Morris' influence, Sabeena Gadihoke has shot verité interviews but used colored cellophane around background objects to alter the impression of light behind a subject.

There is more control over lighting in a studio setting, but that does not mean that cinematographers do not attempt to control lighting when they are shooting on location. They have to, or at least work with it to their best advantage. As Jolanta Dylewska said of working on *Tulpan* in Kazakhstan, "The sun was my light and I had to make good use of it." Locations vary wildly around the world, so part of a cinematographer's skill is being able to adjust to natural environments and the challenges they pose. Celiana Cárdenas cites such a challenge as one of her best professional experiences, "during a project called *Recuerdos* [*Remembrances*; Marcela Arteaga; 2003], a feature-length documentary for which I traveled four months through nine countries. I was able to find a different light in each of these places."

Halpern expresses surprise that so few women do lighting in film. She thinks creating lighting is natural for women, "since we're raised to make beautiful environments. It's more energetic than it is mechanical. I do it because it's exhilarating and beautiful to do."

While Unit Director/cinematographer Karin Pelloni and co-cinematographer Jenny Cousins were filming our interviews between Nancy Schreiber and Amy Vincent for *Women Behind the Camera*, Schreiber—who had started as a gaffer with a great gift and affinity for lighting—interrupted the proceedings to make sure the lighting on Amy Vincent's face was up to par. "Wait," she said. "Is this enough light on her face? Can you just open up that barn door[3] and make sure it's not too harsh on her? Just a little ... the right door ... that one dark eye ... Yeah, okay. You can see the light in her eye now. That's much better." As she explained to Vincent, "I wanted to make sure you had that glint."

Digital Technology

Cinematography is about the creation of the image, whether or not cameras were used.
(Jendra Jarnagin)

We have learned to think of a camera as "a tool that we have historically used to capture light," as Jarnagin says, "but now we are seeing software that allows the creation of light." This is part of a major technological change that affects us all. "Cameras have shifted from ones that ran film through them to those with an electronic sensor that captures light." They have

become purpose-built computers with a sensor and a lens or lens mount. Computing power has allowed higher frame rates, more resolution, more bit depth per color channel (which means more accurate and more subtle and natural-looking colors), extended dynamic range (which is the biggest factor in images no longer "looking digital"), lower light sensitivity (where digital has actually surpassed film), and lower cost.

Most people around the world who have cell phones in their pockets already have the capacity to capture digital images of better and better quality, and even to modify them after the fact.

Will the knowledge required to use the technology to produce the effects discussed in the previous section soon be passé? Already "the toolset has expanded to postproduction," as Jarnagin notes, and "independent productions often lean on their DP to help steer those post choices, the producers realizing they are less technically experienced than you." Obviously digital technology is changing what a DP does.

Yet the technology that brought lighter cameras has sometimes undermined camerawomen. Sheila Calanquin was a rare broadcast camerawoman when she started her career in 1979 at KTTV by occasionally filling in for the staff minicam operator. From there she went to NBC, where she operated an RCA TK76 video camera, "the second female working in an all male-dominated business." Starting in 1982, she moved to KHJ-TV (KCCA since 1989) as a Studio Camera Operator, "a very fun and rewarding job," she says. However,

in 1996–97 technology changed my job. A new system called Robotics phased me out. I was no longer standing behind a camera. I was sitting behind a computer screen operating four cameras at the same time. This position lasted several years. That's been done away with also—as of approximately 2010. This system was phased out by an automated Control Room Switcher. The technical director in the control room now controls pretty much anything—not me.

It was not so many years ago that filmmakers were delighted when digital equipment became available, but "there was a feeling of compromise." As Jarnagin continues,

You wished you could be shooting film but you couldn't afford it, so you reluctantly tolerated the inconveniences and the inferiority. Now digital has progressed to the point that it is as good as and in some ways better than film. Certainly the pros now outweigh any cons of shooting digitally.

According to Jarnagin,

The main factor that has made modern digital cinema cameras approach the quality of film is extended dynamic range, or LOG mode. How it works is that in order to capture the most information from light to dark, the footage appears flat, desaturated and with a foggy look to it when viewed on set or in editorial, unless you apply a transformation to the footage called a Look Up Table or LUT, which normalizes its appearance. If you do this on set, you need on set color management, which requires the tools and expertise of a qualified DIT [Digital Imaging Technician]. You can create different LUTs for different scenes based on your intended look, which can be applied to the dailies, and/or carried along into post and color correction.

Not all camerawomen agree, however. Argentinian Natasha Braier, ADF, winner of Best Cinematography awards for her work on *Glue* (2006) and *The Milk of Sorrow* (2009), says,

"The digital revolution has opened a new approach but I'm still not very fascinated with that. I'm a nostalgic and I shot my last movies on 35mm. I don't feel ready to talk about the advantages of digital yet. I need to enjoy them first and really feel they are advances."

One consequence of going digital is the need to think differently while preplanning the shoot to make the most of "your post pipeline," as Jarnagin puts it. "Because each camera has different strengths and weaknesses, and different compatibilities to different kinds of post and on-set workflows, you need to know how and where your footage is being posted, as that informs some of your shooting decisions."

The cinematographer's increased involvement in post-production is "one of the most significant differences in digital production vs. what came before."[4] Has the industry kept up with this particular change? Jarnagin thinks it

> needs to catch up in paying the DP for their work in post, whether that's supervising a DI [Digital Intermediate] for weeks, or meetings for review and approval of CG [computer-generated imagery] elements and composites, etc. We all care about seeing our work through to the finish. More and more, that's becoming a part of our jobs.

Thinking about post-production and future viewing options, in other words, has become part of the process a cinematographer goes through before making decisions about camera and lighting equipment that might require a trip to the rental house; it is a process the cinematographer needs to be able to share with directors and producers.

Braier is in agreement with Jarnagin on the DI's importance:

> Even though I always try to shoot as much as possible in camera, old style, and I love the look of the optical prints more than the DIs, nowadays the DI offers the possibility of fixing what you couldn't quite achieve on set, or shoot faster on set because, you know, instead of waiting five minutes to put up some big floppies or whatever, you can do that very easily with a mask in post. That's great. It allows us to "paint" more without stealing time on set.

Because "it is now cheaper, faster, or safer to do a lot of things in post than it is to photograph them," Jarnagin says, "Computer Generated Imagery [CGI] has become a part of most productions. Big crowd scenes, fancy sets that would be expensive and time-consuming to build, distant locations involving expensive travel, etc., can now all be convincingly created on even low-budget films."

While CGI is increasingly a part of putting images on screen, those images generally need to mesh well with the "practical photography"-generated images on screen. The good news is that, although "there is no doubt that cinematography is changing and the cinematographer's role is changing," there are also hopeful signs that

> the industry is shifting into recognizing that you still need a DP, even when nothing is being photographed with cameras (except for maybe some Motion Capture or reference

plates that get used to create a CG environment). Roger Deakins, ASC, is credited as "Visual Consultant" of the animated films Wall-E *[Andrew Stanton; 2008],* Rango *[Gore Verbinski; 2011],* How to Train Your Dragon 1 *[Dean DeBlois, Chris Sanders; 2010] & 2 [Dean DeBlois; 2014], and other films and YOU CAN TELL [sic]! Those films have excellent "virtual cinematography."*

In practice, intelligent directors and intelligent cinematographers continue to work together on high-profile projects, i.e., a cinematographer's role in devising lighting for the picture as a whole can remain intact, along with other traditional aspects of the job. If anything, the cinematographer's job might get larger, if s/he ends up giving the CGI personnel their parameters for the usual sorts of technical decisions, e.g., color saturation and other elements that used to be taken care of in the processing labs. For an example of this type of experience, Jarnagin describes how one of her mentors, Claudio Miranda, ASC, worked with director Ang Lee on *Life of Pi* (2012).

As the DP from start to finish, Claudio was involved in making the decisions during prep, through extensive testing, about which approaches were best to accomplish the photography of the film. He was involved (along with Ang Lee, of course) in deciding what to photograph practically, with cameras, and what elements to do through CG, compositing, background plates, blue screen, and other techniques. He devised the lighting that the CG artists needed to match and emulate. He oversaw months and months of post to make sure the computer imagery matched and fit his and the director's vision. So he was truly the Director of Photography of that film, and he deserves the accolades for his work in that regard.

Miranda won an Oscar for his work on *Pi.* Jarnagin has frequently found herself in conversations with her peers as well as with people outside the industry about whether a film with so much CGI should qualify for an Oscar for cinematography. The issue that "fascinates" her is whether a camera needs "to be involved to define the creation of imagery as cinematography."

To me the answer is no. It all comes down to who directed the photography. From my understanding and reading and discussing with others, James Cameron, the director, in effect directed the photography of Avatar *[2009], as far as I am concerned. Mauro Fiore, ASC, was the DP of the live action unit and to my knowledge that was the extent of his involvement. Cameron listed Fiore as the DP in the credits; according to Academy (and union) rules, Mauro should get the Oscar. That's legitimate; I am not arguing that.*

Digital technology has also affected the on-set process of filming. As we learned from the Chinese camerawomen, shooting with film stock can impose a discipline so strict that it determines one's style. "Now," Jarnagin observes, "you see a lot of sloppy filmmaking"

because working with media cards and hard drives is relatively inexpensive. When film was expensive,

> you wouldn't roll until you had rehearsed. Now, often we "roll on the rehearsal," which means you can get judged on some pretty lackluster camera operating, focus pulling, and poor timing of camera movement, etc., because you are seeing the actors doing it for the first time. When you agree to roll on the rehearsal, you have to remind the director and those at the monitor that it's not going to be great for camera because you haven't practiced it yet!

Also, before digital filming, a magazine of film lasted up to ten minutes; there would have to be a break in filming to replace the magazine. Now some directors take advantage of being able to film without stopping.

> They don't want to disrupt the flow or take another minute to re-slate or have every department burst into a flurry of communication as happens once you cut. But that very communication is where you work out the issues to make the next take better, so denying people that process hurts the quality. A lot of actors resent it when they don't cut because they don't get to regroup, get feedback, etc.

"Working in digital" also means that "a lot of directors have a tendency to over-cover everything and just work it all out in the editing room, instead of doing their homework to pre-determine the best use of shots to communicate what they are trying to say with the scene."

Having people watching "the actual image on the video monitor, and not just the framing that you saw on a video tap with a film image," can mean that

> lighting by committee happens all too often. I'm referring to when the director, producer, client, or other crewmembers who have no business doing so, start picking apart your lighting or exposure or expressing their opinions about your work. Whenever that starts to happen, you need to diplomatically nip it in the bud.

Yet having the director and producer watching the monitor during shoots can have a positive effect. The first time Jarnagin "felt empowered by shooting digital," she was "doing re-shoots on a feature film" for which she had not done principal photography.

> It was my first time working with this director and producer. We were shooting a scene that was the introduction of a main character. The lighting was very bold and moody, nearly a full silhouette in front of a bright window. I was inclined to "cover my ass" by adding a fill light to make sure we could see the main character's face, so the audience could see what he looked like in these first shots of him. I looked at the monitor and said, "His face is too dark." The director enthusiastically responded, "I LOVE IT!"

Something clicked for me in that moment about the power of digital. Because the director and producer could see what I was shooting, they could sign off on what was a very bold choice. At that period of my career, I don't think I would have been willing to be that bold shooting film. In my understanding of what I THOUGHT they would want, I would have played it safe so I wouldn't get fired when the dailies came back. But them seeing it right there in the moment and liking the bold choice empowered me to be braver going forward.

Style

If it's an action movie that's dark, you don't want to make it colorful and bright. I've work[ed] on a period costume drama, The Forsyte Saga *[Christopher Menaul and David Moore; 2002], a Victorian family saga that developed a style partly because of the sort of lights I was using and my decision to make it look as naturalistic as possible. You can't apply the style of* The Forsyte Saga *to a contemporary drama about terrorists; it doesn't work. So whether somebody can look at those two things and go, "Oh, yeah, Sue Gibson did that," I don't know, because they are so completely different.*

(Sue Gibson)

Gibson distinguishes between "a style and a way of working." A cinematographer's style might refer to what ends up on screen but also to a manner of working. Both have their effect on a cinematographer's success and both reflect a cinematographer's personality, background, and training. Gibson describes how she is influenced by the painters' and cinematographers' work she has seen and her memories. She has "a compendium of styles for different situations." Most importantly, she is influenced by her understanding of where the director is coming from: "whether you have the same sense of humor, the same sense of the tragedy, whether you like big close-ups of people. It's to do with the choices."

Most cinematographers agree with Gibson in stressing that the DP and the director must be compatible on a project. Celiana Cárdenas adds that "ultimately, I work for a director who has the aesthetic vision of the film; one simply offers our sensibility or our way of seeing things. We hope that the sensibility translates." In fact, Katie Swain sees it as her job to be "on the same wavelength, for each project" with the director. She is emphatic: "I don't want to have my own style." Argentinian cinematographer Stephanie Martin agrees: "Every film a DP shoots is different. I see no reason for these films to have a similar look."

When B. R. Vijayalakshmi works with a director other than herself (she has often shot and directed her own films), her starting point in developing her style is the director's explanation of the scene to her. Then she and the director plan the sequence of shots that will best narrate the scene. The director, she says, plans the actors' movements but she tries to build the necessary "mood and ambience" through her choices to do with lighting, background, colors, composition, and camera movement. Michelle Crenshaw adds that

though some directors are great storytellers with a wonderful script, they do not know how to use the medium of motion pictures to interpret that script. "What I can contribute is to help interpret that for the medium. If there's something that the director wants that I don't know, I will look for the answer. That's the challenge."

Erika Addis says she begins developing her stylistic choices for a particular film by reading the script in order to translate it into her sensibilities. Asked what kind of lighting style she liked, Mairi Gunn quipped, "One that goes with a good script." Cinematography is not just a matter of pretty pictures or technically perfect images. Angela Rikarastu reminds us that, in the script's service, "The picture is not always meant to give brightness and beauty. If the story needs dark, grainy, or shaky pictures we should provide that to support the story. It depends on how the story wants the spectators to feel."

When Kuras asked Rebecca Miller if *Personal Velocity* could be shot on Super 16, it was because Kuras could "get a free camera package." Miller, however, replied that they had to shoot it on mini-DV because Independent Digital Cinema (Indigen) was giving them the money.[5] Kuras said, "OK, I'll just deal with it." As Kuras wondered how she was going to "do this film and make it look and feel right," she thought, "These are short stories. Well, a short story is just a little gem. It's an encapsulation. I am going to shoot it with that in mind. I am not going to make my expectations larger than what they are."

Kuras does not let herself be guided by conventions. For example, many people told Kuras she had to shoot in one fiftieth of a second, because she was shooting in PAL, but she disliked one fiftieth of a second. "I liked one twenty-fifth. But it means you have one half the information on the chip. I'm willing to take the risk because it was closer to the way I wanted it to look and feel. Afterwards everybody said, 'It looks so filmic! How did you do it?' I thought, Don't listen to everybody." Kuras went on to win another best cinematography award at Sundance for *Personal Velocity*.

Brianne Murphy had a similar story to tell about winning an Emmy for a television series that she shot. "It was simply using the 81EF filter that gave my work a different look than everybody else's work that year—and for that I got a nomination." For her, the moral of the story is, "Try something new," and like the cinematographers who recommend spending time at the rental houses, she says, "Do a test on it, one day that you're off." Although she claims that "it's not great art, it's guts," it is part of the hard work camerawomen must put in to be at the top of their game—and employed.

Although feature filmmaking can produce art, Kristin Glover argues that "formula filmmaking" serves the schedule and budget at the expense of creative cinematography.

Filmmakers follow a very hard line: How are we going to shoot this? We're going to shoot an establishing shot. We're going to shoot a two-shot. We're going to shoot a single. We're going to shoot a couple of over-the-shoulders. That's it. Scene's done. Let's get on with the next one. I've had exhilarating moments where I felt like I might have had some input. But there are constraints to the job because you're carrying out other people's wishes. You have to learn how to do that, and how to make peace with that.

Glover's view is more pessimistic than that of most camerawomen we talked to, but the point here is to consider the DP's parameters—framed largely by the budget, the script, the location, the sets, and the director's vision—for combining imagination, experience, and training into satisfactory results on screen.

Australian Jan Kenny's cinematography focuses on actors, in part a result of the years she worked in theater. Kenny stresses that a "cinematographer and an actor [should] have trust between them. I have a natural ease with actors and an instinct as to how to communicate with them, and when is the appropriate moment. You get a sense of the way they work, their process of getting to the performance pitch." Since she has learned how to watch the actors' body language, head movements, and eye movements, she uses this knowledge as a DP; how they hold their head when they are talking or how their eyes move informs the way she lights them. "Communication is one of the most important things," she says. "Even silent communication. It really does boil down to trust."

For Iranian Rozette Ghadery, a cinematographer has to use "all the visual elements (e.g., color, line, shape, texture) and the design principles (movement, balance, stability)" in order to create the film's aesthetics. Among these, camera movement is the most important visual element, particularly how it captures actors. "Movement affects all other elements and principles. It can create time and space." When she directed *Parhoodeh* (Mehdi Jafari; 2001), she made conscious choices to keep the movement focused on actors.

At the end of each scene the camera moves into black; then the camera moves from black to start the next scene. I wanted the camera to move along with the actors. I started with the actor, then passed him, and again found him in my next frames, with camera movements. With movement, you can even break the principles of time and space.

Australian Erika Addis stresses the importance of framing people in her visuals so that her framing shows relationships *between* people, as well as places people in order to be dominant in the frame, not dwarfed or overwhelmed by architectural elements. "I find ways to compose them so that they are foregrounded and what's behind them supports them." She cites an example of such placement of humans into the landscape from *Rough Riders* (Graham Chase; 1995), a documentary she shot about rodeo riders in Australia. While the film was in production, one of the young riders died.

His parents, stoic country folk, were distraught about his death, but also philosophic about the time they'd had with him in their lives. They placed themselves well, and I found a frame to put around them. They're set against the wheat-colored landscape of central New South Wales, with granite boulders behind them and with the father looking out in the foreground of the frame wearing a classic country hat and the mother standing behind, turned away a little further behind him. It has a classic quality about it which exemplifies what I'm talking about.

Some cinematographers have developed their style through their engagement with other art forms. Still photography has been a major influence on American Lisa Rinzler, especially

through the work of "still photographers Robert Frank and Diane Arbus. I reference their work and get inspiration and encouragement from looking at their imagery." Given the intensely subjective material of Frank and Arbus, it is not surprising that Rinzler tries to work from the psychology of the film's characters.

For example, in *Menace II Society*, she uses a style she calls "heightened reality" that tries to

feel the intensity of a moment through the photographic part of storytelling. Bringing it up a notch rather than being just naturalistic. It was about finding the balance of being stylized but not overly stylized. We played around with the usual suspects: moving camera, colored lighting, when to be frenetic, when to be handheld, when to be slow. Always trying to work from the psychology of a character.

She describes backgrounds as "loud subliminally or loud in a quiet way. When you photograph somebody sitting some place, you're seeing whatever is around them." She also feels inspired by color—in lighting, set design, and clothing—that can help tell a story by establishing a mood.

Like Rinzler, Korean Young-Joo Byun, both as director and as camerawoman, emphasizes character in her films. She likes "the extreme emotional shot." Jolenta Dylewska's "working method at the beginning" is to search for "who plays the main character in this scene now. What interests me in particular is the dramatic composition of the images, which is the ability to tell the story through images. The aesthetic level of the film, how my pictures look, is less important to me than the dramatic level." After the Polish camerawoman has worked that out, she considers "the light, but also shadow; the colors; the perspective, which

Figure 20: Lisa Rinzler. USA.

I compose with certain lenses, with just one or many, and so forth; there is movement as well and textures. These are the factors."

Gibson explains that *Mrs. Dalloway* (Marleen Gorris; 1997) was a difficult story to tell because the film was based on the novel *Mrs. Dalloway*, which Virginia Woolf wrote in a stream of consciousness style as the main character's interior monologue. Gibson described the film as having two halves: the present day Mrs. Dalloway of the 1920s, and her thoughts and memories. Both halves appear in a scene in which Mrs. Dalloway walks in the park, remembering a moment of her youth before World War I. Gibson decided to show the two halves of Mrs. Dalloway by using Kodak stock to shoot the younger Mrs. Dalloway while the present day Mrs. Dalloway was shot on Fuji film, "which had a completely different tonality in the way the film stock handles colors." Acknowledging the importance of wardrobe, Gibson says the airy clothes of pastel colors helped her make Vanessa Redgrave (Mrs. Dalloway) look attractive as a woman of a certain age. Gibson's shot choices "are dictated by the scene itself, the story you're trying to tell, and the locations you are using. It is only after the event you can see what you've been doing. It is almost an instinctual process."

In documentary, Marina Goldovskaya came to her "direct cinema" style through her own intuition in reaction to the naturalness of her subjects. In 1968 a friend asked her to shoot her first film, about factory workers—mostly young girls from the countryside, open and unguarded. Goldovskaya, who often directs *and* shoots her films, recalls that she "never asked my characters to do anything especially for the camera. They were living their lives, and I was trying to capture interesting moments. Sometimes to provoke such moments, I was asking a question or directing their attention to certain things." Russians call this "the observation style," which she describes as "very close involvement of the filmmaker in the life of her characters. I didn't do any planning. I lived with my characters and tried to capture their reaction, their relationships." Her agenda? Making films about subjects interesting to her. She never needed a script—only an outline for herself. "I was picturing what kinds of questions I would like to ask them and what kinds of situations I would like to follow. That was very organic, very natural. I knew what goal I wanted to achieve. Why am I making the film now? What do I want to say with this film?"

Empathy for people she is shooting also characterized MacKenzie's style. "When I put the camera up to my eye, I want my eyes to see through my heart. There are times when I can't see because of the tears. I'm really seeing and feeling what's happening; I'm not just recording. That's important as an artist." MacKenzie applied this approach when she covered "the Los Angeles riots, the Malibu fires, Princess Diana's funeral, the Pope coming to Los Angeles, the '84 Olympics, the '88 Olympics, the Oakland and Northridge earthquakes in California. Many, many things."

Gadihoke sometimes uses location to underscore her character's meaning. In *Tales of the Night Fairies* Gadihoke considered the city of Calcutta itself to be integral to the film, so markers of the city appear in many frames. "You'll see the skyline, for example, when the sex worker is saying, 'This is the red light area and this is the respectable area.'" She describes the frame as including a blur of houses since "Calcutta is full of dilapidated buildings; they're

often in the background. I've shot from a low angle so that I can get the house behind or I've shot from a high angle so that I can get the skyline behind the woman on the terrace."

Gadihoke also uses location to make the film's political point: Sex workers may not be victims; they may be respectable. So *Tales of the Night Fairies* tries

> to blur that distinction between the so-called respectable areas and the so-called red light areas. When you see these women in the film it's often difficult to tell that they are sex workers. They were not always shot in the red light areas. The idea was that Calcutta was as much their space as that of any other middle- or working-class woman.

Israeli Irit Sharvit frames locations with similar motivations. When she was shooting *Tokyo Dream* (co-director with Mirav Nahoum; 2004), she moved "a lot with the camera, matching the hectic rhythm of the girl's life style in the big city." In *Yael-san* (co-director with Mirav Nahoum; 2002), which was shot in a remote Buddhist temple, Sharvit kept her camera stationary, "letting the scene take place in the frame."

The frame also dominates Canadian Zoe Dirse's aesthetic: "Even if it's just a talking head, or I'm following someone, I'm always looking for something in the frame to add to what's happening within the scene. It depends on what's happening in front of the camera." American Emiko Omori thinks of a cinematographer's aesthetic in terms of "what you put in the frame, how you frame it." Getting to this point has involved getting experience, says Omori. "I have learned by intuition what I like. I'm always trying to push myself and the medium. It's my job to bring a new view to something. Just being short, I had a different view than anyone who is not my height (I'm 5 feet). One of my aspirations is to continually see something fresh." Kirrily Denny, also a director as well as camerawoman, says that "framing for interviews would certainly contain other elements within the set-up than just relying on the talent. Handheld movements and Steadicam are great for adding fluidity and style to a shot."

Canadian Nancy Durham is aware of the stylistic limitations of her one-woman-band video journalism. Lacking a lighting technician, she must make the best use possible of the available light. She uses a small, high-end digital camera, but "on my own it's not going to look like the most impressive Hollywood movie or even close to the best-produced news item that you're going to see on the American network TV news."

American Sandi Sissel's first documentaries were shot cinema verité style with a handheld camera on her shoulder, telling the story by following the characters and not through interviews. Her documentary experience taught her about storyboarding, ideas, lenses, etc. When she began shooting narrative films, she found that telling the story was crucial in both documentary and narrative films. In fiction film shooting, though, she used dollies and Steadicams, not handheld cameras. She also discovered that in narrative filming she was "hired by people based on your reel, but then rarely do they ask you to do something that is on your reel." She has shot love stories, action movies, and foreign films. Much of her work depends upon the story and the production designer; she and the production designer "develop a style together." She says that day-by-day she invents the camera's rhythm, pace,

and color. "If we had the choice of every job that we did, if we could always say, I want to do a film that's this kind of rhythmic shot, that has these colors, that has this pace, then we would be very lucky, and we would be among the most famous DPs in the industry."

Notes

1 Now Lana Wachowski.
2 By the late 1920s, as Keating notes, "painting with light" had become "a common metaphor for cinematography" (26).
3 Barn doors fit over the front of lights in order to shape and control shadows (Malkiewizc and Mullen 125).
4 Although this increased involvement in post-production harks back to directors' and cinematographers' practices of tweaking the chemical development of film negatives prior to the appearance of automated processes in the 1920s (Thompson 276).
5 Indigen is a New York organization that gave grants, including one for $150,000 and two cameras to make a film.

Chapter 6

Shooting around the world

Up to this point we have been trying to develop an outline of a collective figure—the camerawoman—who tries to practice her profession within a largely unwelcoming industry. We've been looking at outside pressures, primarily sexist in origin, that trip up would-be camerawomen trying to achieve their goals. After this chapter, we'll be looking more at the personal and the speculative rather than the systemic and historical in our presentation of the contemporary camerawoman's life. But first, in this chapter, we share with you some outstanding anecdotes that our interviewees shared with us from their professional experience, presented here in alphabetical order.

Erika Addis on Beginning Her Career

Geoff Burton was the director of photography on *Storm Boy* (Henri Safran; 1976), which was photographed in South Australia. The photography of that landscape is still fantastic. I had the trials that one has when one is on one's first feature film as a clapper loader. The rest of the crew came from Sydney; I was a new chum. They all wanted to see how I would deal with problems.

The last day of location shooting on that film we were filming on sand dunes a long way from the unit bus. After we filmed all of the storm sequence in the morning, I stayed in the van to unload the equipment. I had difficulties in the changing bag with all of the storm footage. The outside of the roll of [exposed] film started to unwind in my hands and the inside of the film started to entwine. The thousand-foot roll of film weighs about three kilos [6.6 lb]. There was nobody else around. It was the middle of winter and I was perspiring profusely while I was waiting for the focus puller to return. He talked me through breaking the film in a couple places to untangle the rolls of film and get them into cans. Then I could pack them up and send them to Sydney. I had to confess what had happened to Geoff Burton, who looked at me and went, "Hmm … ." The film came back on Monday and, miracle of miracles, no central footage was damaged.

Arlene Burns on Filming in the Kuril Islands

These islands used to be owned by the Japanese. The Russians took them from the Japanese during the final hours of the First World War. I was initially invited on an expedition as the token female and the token American kayaker. And pretty soon they wanted me to lead

Figure 21: Arlene Burns on the Colorado River, Grand Canyon, USA.

the whole trip, which I took on with some trepidation since I didn't speak Japanese and I had never been to that area.

But I ended up going over solo, organizing everything from the Russian side, and then taking fifteen Japanese to sea kayak up the coast and climb this mountain. It hadn't been climbed since Russian occupation, at least in 45 to 50 years. And it was inside the largest nuclear arsenal for the Russian military. This island was where the Korean airline jet was shot down.[1] The trip was a series of miracles, a mixing of cultures. For example, our shuttle vehicle was a Russian tank that we traded a bottle of Jack Daniels for. The cultural exchange between the Russians and the Japanese was fascinating. They had been enemies for a long time and this group of us were really good friends by the time the trip ended. People just wouldn't believe it if I didn't have the images. They would think that I was making it up.

Young-Joo Byun on Filming Comfort Women in Korea

It was a pleasure making these films. When I met these grandmothers—the Comfort Women[2]—I fell in love with them. Their history, especially the gender discrimination and the violence they suffered, is important to me. I think Korea has the highest rate of sexual

violence, and the lowest rate of police reports. In this atmosphere, the grandmothers were incredibly brave to speak out publicly about what they had endured as Comfort Women, and what they began fighting against. I wanted my documentaries to give these beautiful old ladies a voice.

It took six years to finish three documentaries about the Comfort Women. For a year and a half of each documentary I did no filming; I spent time living with them, getting to know them. When the moment was right, wanting to share their beauty and spirit, I picked up the camera and captured their image. I was in love with them and the project, and so were they. One old lady, knowing her death was near, asked me to film her a beautiful death.

During filming, they passed away, one by one. It was so hard, so tough, getting through their deaths. I started the project to make my own movie, but they changed my whole life.

The Comfort Women were so severe communicating with the outside world. The grandmothers' character was compelling, wanting to live differently than they'd been forced to, when most people would give up trying. Life has diverse layers: all important, understandable, and poignant. My movie is an attempt to agitate, to challenge the idea of life as nothing but routine.

Nancy Durham on Filming the Balkan War

I try to let you know my people [so] that you have some sort of understanding with them. I have a huge respect and affection for people who will spend time with me and tell me what they're feeling, thinking, wanting. I'm amazed at people's ability to survive their loss of home and possessions.

And I'll go back and go back. I went back to see Dushenka, a woman in the hay wagon [one of the Serbian refugees], six years on or something, and found out she'd died of a stroke. She was only 44 or something. She couldn't cope. That would be more like me. But most people just go on and tend to a house, a room, whatever. There is so little left for so many people who have been moved on other than to eat and breathe and sleep after you've lost everything, when there is no going home again. It amazes me that people have the courage to get up each day and do that.

The Road Home is the film that made my break.[3] I asked my editors to let me go out to Belgrade in August of 1995, the time of the expulsion of Serbs from Krajina. Many months later, following directions from the women in the hay wagon, I went back to the homes they fled, to see who was living there now. This was the Great Ethnic House Exchange Program of the Balkans. Disgusting. One of the women asked me to look for her dog. I thought, "This is ridiculous. There's been a war. I'm going to find her dog?" I went to the village and found Croats now inhabited the Serbs' houses. I was filming them as they were carrying out the annual pig slaughter, which is a ritual the people who left would have been doing had they not left. There was this annoying dog barking in the background. I was thinking, "Wouldn't this dog shut up?" Suddenly I remembered: "dog." I filmed the dog and carried on with my story. I took the video

to Belgrade to show the refugees. When the original owner saw the dog, she started to cry. It was her dog, only he'd now been given a Croat name. Ethnically cleansed dog.

This film struck a chord. It was human. It was the face of ethnic cleansing right down to the dog, and it made people pay attention. When the managers and senior editors found out that one person had filmed it alone, they were amazed. It was cheap, it was good material, nobody else was covering it: very scoopy. My ticket to future adventure and more travel.

Jolanta Dylewska on Filming in Kazakhstan

The work on this Kazakhstani film *Tulpan* [Sergey Dvortsevoy; 2009] was special. Even Sergey didn't expect to shoot for that long. The plan was to shoot for one year. It turned out to be four.

Initially, we drove—me and the director—to the Hunger Steppe, an area of semi-desert. He already knew what areas he wanted to shoot. Later I drove around there all day long to understand how the sun worked. For this purpose, I built myself a sun clock. I knew it would be extremely important where the yurt was placed and where the entrance of the yurt was. I described everything to the set builders and they built it accordingly. We also had to live somewhere. Therefore, they built us a primitive base camp: little houses with only the earth as a floor. Everything was made of bricks from animal guano. They also built toilets and showers for us but only occasionally during the day would there happen to be water.

That is how we lived, together with all the scorpions and poisonous snakes. It was especially difficult at the beginning of June when the high heat came. We had 50° Celsius [122° Fahrenheit] in the shade. The thermometers showed that, but the temperature was even higher. We only had one air conditioner of some sort where the camera and the negative were. We sent the negative once a month to the Swiss embassy, which was 1,800 kilometers away. From there it was sent to Switzerland, to a black-and-white photo laboratory.

We had the director from Russia, camera from Poland, sound from France, stenographers from Switzerland, and the main language we used during work was Russian. Kazakhstan supported us the whole time. In the beginning, it was difficult but normal. For lunch we got, for example, a soup made with bottled water, a main course, and a dessert during the first year. They prepared everything for us.

Later it got worse and worse. During the third year, there were times when we didn't have anything to eat. We didn't have a way to contact our producers. In order to get something to eat, the director had to leave his passport in a store 200 kilometers away. I was shooting with different cameras and different, old negatives, which I had left over in my fridge.

Sabeena Gadihoke on Filming *Three Women and a Camera*

I made a film called *Three Women and a Camera* in 1999. It was my first independent film, after all the educational films that I had made. It got two awards. It's about three women still photographers. One, Homai Vyarawalla, is India's first woman photographer. She

shot from the '30s and was India's first woman photojournalist. The film is also about two younger women: a feminist photographer called Sheba Chhachhi [sic] and Dayanita Singh, a photographer who exhibits a lot in the West.

Homai got incredibly candid pictures of famous leaders. One of the things she talks about is that she was able to get these images because she had the patience to wait for the right moment. That had something to do with her socialization as a woman. Women are socialized to network. They talk more easily. Dayanita is able to build a rapport with her subjects; she feels that has a lot to do with the photographs she gets. Being a good cameraperson also has to do with building up a rapport.

Rozette Ghadery on Filming in Kurdistan

My best experience behind the camera happened in 2002. We went to Iraqi Kurdistan to work on the feature film *Exorcism* [Mehdi Omid; 2002]. We had to obtain papers from both Kurdish and Iranian officials; the process took about two months. We worked in freezing weather, without necessary camera equipment, with nothing, basically. There were no facilities, no lighting/camera/rail/filter equipment. We brought a lot of equipment from Iran (a 35mm

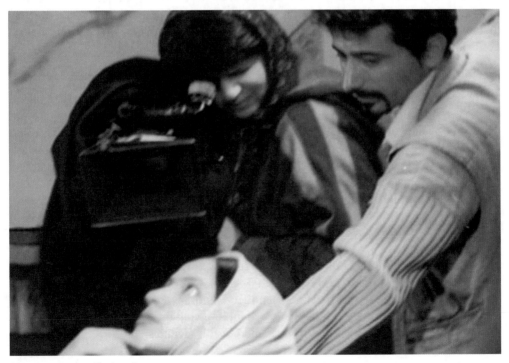

Figure 22: Rozette Ghadery. Iran.

camera, negatives, and some small things), although the director advised me against it. The director of the film was originally Kurdish Iraqi. He had a Ph.D. degree from Russia and a degree from the Netherlands in cinema. He wanted to get all the necessary equipment in Iraq as soon as we arrived. A camera crew and a sound crew were the only ones traveling with him.

It was strange. The Kurds had just declared independence and the Iraqi government had deprived them of essential needs: electricity, water …. We had lighting problems. Our lighting equipment was a few old studio lights without barn doors. Setting the filter and working with light was a whole story itself. I had to work with what we had. I couldn't even check the footage since we did not have access to a lab. For 63 days, I had no idea of how everything looked. We shot around 100 negative rolls, which we ended up watching almost two months later.

The cold, the snow, and not having enough clothing were additions to our difficulties. However, all said, it was an amazing experience for me. I got the chance to meet many strange but kind and wonderful people. I found abilities in myself that I had never discovered before.

Sue Gibson on Filming in Jordan

It was good. They've now got a Jordanian film commission [Royal Film Commission – Jordan], and they are trying to encourage productions. They basically service American international productions that go there because they've got some great locations. We were in Petra, which is one of the World Heritage Sites. If you remember *Indiana Jones*, the very first one [*Raiders of the Lost Ark*; Steven Spielberg; 1981], that is where they shoot Harrison Ford riding his horse and coming across his temple in the desert.

Q: Did you have to wear a veil?
A: No, they are very accommodating. Of course you try not to overtly offend them. It was Ramadan, which was difficult for them because they are not allowed to eat between sunrise and sunset. The guys looking after us would pick us up in the morning, having got up before dawn to have their breakfast, and they work all day with no food, but they would provide food for us. It was a small crew. There were only nine of us from the UK and a location manager from Jordan and two or three drivers. They're extremely good, and it was a good shooting experience.

Joan Giummo on Filming Homeless Women in New York

We hooked up with a woman named Jennifer Hands, who happened to be doing a dissertation on homeless women. She was helpful in giving us background as to how and why they might have been ejected from mental health facilities and how many women's shelters there were in the city.

Shopping Bag Ladies was started in 1974, I believe, and we finished around 1976. That's when it started showing. It was eventually shown at the Museum of Modern Art. It was shown on some PBS stations, though not our local one in New York. But the most long-lasting use for the tape was in the psychiatric community because when they encountered homeless women, or homeless people, frequently those people were in clinical situations, already drugged up, and they felt that this [film] was a window for them on these persons' lives in their homeless environment. It was a freer communication with the realm of homelessness than they could achieve in their clinical setting.

Elizabeth Sweetnam was my partner when I made *Shopping Bag Ladies*. She was comfortable going forward interviewing people, and I was comfortable being the camerawoman. She did all of the interviewing. If we hadn't been working together, pushing and supporting each other, it wouldn't have happened. We seesawed in our self-doubt and, happily, it seesawed in such a way that one of us was always feeling confident in pushing the other. So eventually we always got it done.

Agnès Godard Pays Homage to Beauty

The Dream Life of Angels [Erick Zonca; 1998] was a bit different than the way I usually work. I didn't know Erick Zonca and we didn't have much time to prepare for the film. When I met him, he had already done the scouting, so everything was chosen. It's strange, but I was quite alone on the film. It didn't bother me because that was the challenge: to work with someone that I didn't know well. I was working only with the script and looking around. I tried just to sit sometimes and think, I would shoot this like that, and this like that. The only thing I knew was that he wanted to have a rough image, not too precious, so 35mm was too rich. And he wanted really strong color. I decided not to do too dirty a picture, because the story is rough enough. And those two girls are young, and to be young is always a kind of beauty. So I decided that I wanted to pay homage to this beauty.

Marina Goldovskaya on Filming History Being Made in Russia

The Shattered Mirror [1992] was about what we feel, we Russians, living in the midst of the revolution after the communist system's fall. Are we afraid? What are our hopes? What are our dreams? I was asking my comrades, my friends, and my compatriots. I myself was upset. I said to my characters, "I don't sleep, I am nervous, I am worried."

Q: How did you convey that?
A: Talking to them. And when there was no question coming from me, I said it in my narration, although there was very little in this film. Also, when I was shooting in the streets, when two parts of one nation were fighting in the

streets, I was shooting and I was crying. You could hear, in my commentary, a cameraperson who was crying and shooting.

Q: Could you give us another example of a significant film for your personal style?

A: *Solovky Power* [1987], the first Soviet film about prison camps, was a scary film to make. I wanted to say that we had a troubled, totalitarian past, to reveal the crime of Stalin and the communist system, to show the resistance of the people to these crimes, and to show that the people who went through the Stalin prison camps managed to remain honest and truthful to themselves. They were not broken.

Ellen Kuras on Pivotal Moments in Shooting

For me the pivotal moments are when you feel the riveting energy of what is going on. In *The Ballad of Jack and Rose*, that occurred many times working with Daniel Day-Lewis. I was so close to him. Even though we had two cameras, I was the one that was proximal to him. There were so many moments, like when we were in the tree house, which was a tiny

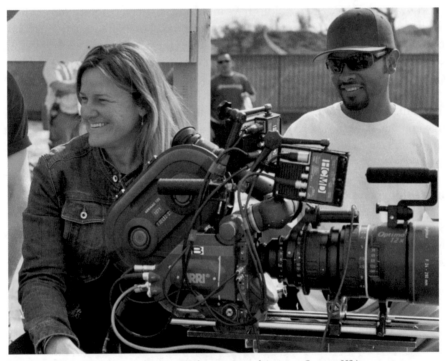

Figure 23: Ellen Kuras, ASC, with Hector Rodriguez, Second Assistant Camera, USA.

space. I decided not to take out the wall of the tree house because I thought it would give a feeling of space to the actors. And it was a real tree house, basically about four feet tall. I was hunched over, and there were four adults in it. But there were moments where it was just riveting. He came so close to the camera, within minimum focus. Yet the power of the presence was so strong.

When I did *I Shot Andy Warhol*, I was a very young filmmaker. I had only done a couple of features, *Swoon* [Tom Kalin; 1992] and *Postcards from America*. And maybe I did *Angela* (Rebecca Miller; 1995], but I was largely new to that world. *Andy Warhol* was truly an independent film. We made it on very little money. I had worked with my crew on several movies, so we all knew each other well, and it was very much a young family. It was like Warhol's group in the Factory, when they were young and just people getting together. Or like The Velvet Underground—it's that kind of group. The other huge asset of *I Shot Andy Warhol* was Thérèse DePrez, a production designer with whom I worked on *Swoon* with Tom Kalin. Thérèse came onto *Warhol*, did incredible research, and made that set and everywhere we went so authentic that she was my muse. I was helping to realize her vision in a way.

We had such a great time because there were so many ideas flying around. It was the first time I started designing the movie—in a different way than *Swoon*, where I didn't know anything. I was just very fresh.

Heather MacKenzie on Filming Romanian Orphans

One of the most difficult subjects, and one that changed my life, was a documentary we did on the Romanian orphans. Ceaușescu's regime had folded about a year before. The Romanian people had been under an insane ruler for about 40 years. Ceaușescu had created numerous orphanages. He refused to let women have more than two or three children and you couldn't have an abortion. He was trying to create an army out of these children who had been neglected in these orphanages.

One of the things they found when they went into Romania after the Revolution was that there were three or four children to a bed. If they couldn't feed themselves, they died. A lot of children made sure that the other children were living by feeding them themselves. The diapers for babies weren't changed. They lay there in the urine and the urine would eat away at the mattresses. Their bones would be deformed because they were never picked up, and their little bodies stayed in one position.

I would go into orphanage after orphanage, row upon row of beds, with two and three babies in all the beds. Their little hands were so weak. They would try to touch my hair, my clothes; they were reaching out to me and I had to continue shooting faces instead of putting the camera down and picking them up and holding them. I knew that it would be stronger for them if we documented this rather than give them comfort. There were so many hundreds of them that it was impossible to give them all comfort.

Sandi Sissel on Filming *Salaam Bombay!*

Salaam Bombay! was the first feature that I shot. It was the first feature that Mira Nair directed. It was the first feature Sooni Taraporevala wrote. I know that I was not the first DP asked to do it, but luckily it landed in my lap.

The thing about doing low-budget features, which are often the films that define your life and your career, is that as you get older and more experienced, you would never accept a job like that because you would think, I can't work for that kind of money, or, I really don't have it in me to go work with a completely foreign-speaking crew and have to be in charge. Part of the joy of being young and inexperienced in the industry is that you just jump right into something. Certainly, *Salaam Bombay!* was one of those things. I took the knowledge I had. I took the 35mm tripod I owned. I took my large assortment of filters. I took a lot of silks[4] that I had bought, and took off to India.

The greatest thing that we had going for us was India. India is just an amazing environment. The second greatest thing we had going for us was a wonderful script. How many times have I been given a political story with social value, a beautiful landscape, and wonderful, young, inexperienced actors to put a canvas together like that? We don't have that opportunity often. Not only did I fall in love, I adopted one of the children in the film. When *Salaam Bombay!* came along, I was so touched by the script. I so wanted to do it. I saw Mira at a wedding party for good friends the night before she asked me to do the movie. I was the best man for that wedding! We had a lot to drink and we danced all night long. One of my dance partners ended up being Mira Nair. That night Mira said, "I have this script I would love for you to read." The next day she got me the script, and I committed to do it.

[Once we were in India] we borrowed a dolly from Jim Ivory. Mira, Sooni, and I went over to the offices for a film that Merchant-Ivory was doing. I think that Ismail [Merchant] and Jim [Ivory] saw Sooni, Mira, and I as these sweet little girls, and they wanted to help us out. So we were able to get some equipment because they had already worked out getting equipment shipped to India. I was able to bring some lights because I owned the lights. But it was a catch-as-catch-may to put it all together.

What we did have was a different location every single day for 54 days. It was hard. Little did I know at the time that 54 days would be one of the longest shooting schedules I would ever have in my life.

Agnès Varda on Filming the Human Body

There is a way to approach the human body that can be personal and sensitive. For example, when I did *Jacquot de Nantes* [1991], Jacques[5] was already ill. I wanted, myself, to do the filming at the beach with a little 16mm camera. He sat on the sand. He let the sand run through his fingers and then I did a film sequence that was very strange for me. I wanted to sing myself a song of Prévert[6] and then film the sea foam on the edge of the water, the

rolling of the waves on the sand, and end with Jacques Demy sitting, smiling, and looking at the sea.

There were scenes that I had to do myself in 16mm. However, if at the time the little mini-DV had been available, I certainly would have been the one to film his arm, hand, hair, and eyes. But since these mini-DVs didn't exist, it was done with a 35mm by Agnès Godard. It was so hard to do the long shot that we had a video camera as a control. The guy doing the focusing had to see the focus on that camera because it was too close. This was one of Agnès' first shots on the film, and she would remember it, because it was a very strong statement of wanting to be very close to Jacques Demy's body. It was almost symbolical. When someone is sick, we say, "I stayed close to him, very close." The camera, the lens, had to obey the desire to share, to come as close as possible to love, to misery.

I have filmed naked women. For example, I did *Jane B. par Agnès V.* [1988], which was a portrait of Jane Birkin. I wanted to do Jane's body contour. Therefore she was stretched on a bed. Nurith Aviv filmed her, and we took pleasure in filming her. I don't know how to explain it to you. Her body was there and we filmed the edge of her body contour, like a drawing. It starts with her feet, stretched to her legs, the calf, the thigh, the body, and ends with her mouth. In other words, it's her body viewed as an outline. It pleased me very much to do. It was done naturally, tastefully. I am unable to do sexually explicit love scenes. But I filmed a love scene in a documentary, also filmed by Nurith Aviv. The people were actually in the midst of making love, but we filmed in such a way as to avoid their sexual relation. The lines and the subject must make one feel what is the human body. But I am not willing to film in detail the sexual frolicking of men and women, of women and women.

Figure 24: Agnès Varda. France.

Sans toit ni loi [US title: *Vagabond;* 1985] is a tragic film about a girl who says no to the whole world, who is overcome by the cold and solitude, and who dies. The pleasure of filming is apparent in this film. Pleasure that I experience in this film, a pleasure that I had in filming such a scene. It's a tragic story, but the film shows as well the pleasure of making such a film.

The film shows a very clean girl who becomes a very dirty girl and who dies completely dirty. It starts with her at the beach. She comes out of the ocean and I filmed it from far away using a long shot. I simply wanted people to understand that she is naked and she emerges from the ocean like Venus, like Aphrodite. But I wasn't a bit interested to show her nakedness even if there were men, two young men on motorcycles, who see her from afar. Because we know that as soon as there is a naked girl, there is a man there to see her if possible.

This film is sad. I filmed it with pleasure and the scenes, the long traveling shots from right to left, Patrick Blossier's images—he was a very good chief operator. The way in which it is filmed, the countryside, the gestures, the life, the last months of Mona's life superbly done by Sandrine Bonnaire. It provides a cinematic pleasure for me who filmed it and for those who see it. I have always heard that. This pleasure of being a cinematographer is infused in the film.

Liz Ziegler on Filming *Eyes Wide Shut* (1999) for Stanley Kubrick

I wish it wasn't his last picture. He was someone I always wanted to work with. I loved his films; I loved his images. When he called the house and I picked up the phone, I didn't believe him. He said, "This is Stanley Kubrick," and I said, "Yeah, right!" He said, "No, really. You can call me back." So I called him back.

It was a wonderful experience. It had its ups and downs. He could be vicious. He seemed to know just what to say to me to make me feel pretty horrible. Two things come to mind. We're way into the movie, in the bathroom scene where the girl overdoses. We were blocked by this bathtub, like a wall. I said, "Why don't we just pick it up and rotate it 180 [degrees]." He said, "That's the first good idea you've had the whole film." He was sadistic just to be sadistic. It was sort of humorous in a way.

There were shipping problems with getting my equipment over there. I'd just purchased my Moviecam, the SL; he'd wanted to do some tests. Everyone was getting really nervous about the equipment. By the time we were shooting, I think he had resolved that this wasn't going to work. Because of the equipment, the shipping stuff, he was being negative about everything. We got through the first day of shooting. The next day he called me into his trailer, wrapped his hand around my arm, and said, "I want you to know that I think you're the best."

Q: When someone of that stature chose you above all others, did that make you feel, I've arrived, I'm at the top of my game?

A: No. I feel at the top of my game when I am doing good. I think Stanley inspired people. He inspired me to be the best that I can be. And when I do good, I feel,

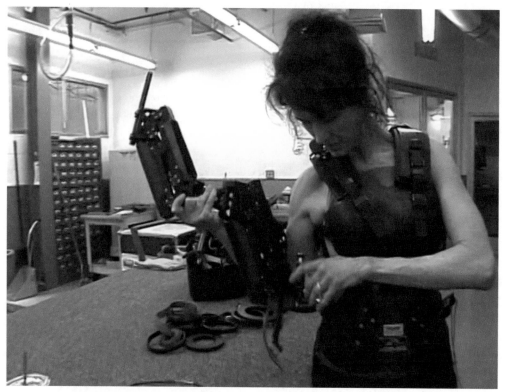

Figure 25: Liz Ziegler, Steadicam Operator. Hollywood, USA.

no matter what, that I am at the top of my game. Really. Regardless of anything. I can think of, for example, a shot I did on *Charlie's Angels* [McG; 2000] that I am incredibly proud of, and that whole thing was a horrible experience.

Notes

1 The USSR shot down a Korean commercial jetliner in 1983 when it strayed toward the island of Sakhalin without permission.
2 For "Comfort Women," see page 109.
3 *The Road Home* aired on CBC in Canada.
4 Used to diffuse light.
5 Jacques Demy was a French film director and Agnès Varda's husband.
6 Jacques Prévert was a 20th century French poet and screenwriter.

Chapter 7

Can camerawomen also be women?

Parents

Some families do not approve of their daughters working as cinematographers. For example, Lee Meily's mother, a dentist, and her father, a businessman, were both from the Philippines' provinces and very conservative. Meily found an independent filmmaker she admired, Kidlat Tahimik, when she was a pre-dentistry student and saw his first feature, *Perfumed Nightmare* (1977). She told her mother, "I'm not going to be a doctor. I'm going to make films." Her mother said, "'You're so hardheaded.' I thought she hated me."

Jan Kenny's parents would have been happy to see her continue her job as a sports mistress. When she went from teaching sports at a well-known girls' college in Australia to being an assistant manager in a theater, her parents thought she had taken a step backward. Many years later, when they started seeing her name in credits on films, they started being proud again.

Priya Seth's parents changed their minds earlier in the picture. When she was in training as a camerawoman in Mumbai, returning home at two in the morning, her parents were upset. They asked her, "'Why are you doing it? Are you sure you want to do it? You look tired every day. You say you are picking up heavy things. Are you sure?' But once they saw I was determined, they have been supportive."

Some camerawomen did get support, sometimes from family members other than parents. Austrian Eva Testor found support growing up in a male-dominated household with two brothers. Having brothers was helpful because she never thought "anything was too technical for me just because I am female. It is also a great advantage in my dealings with gaffers and other such men that I'm used to looking at men with some detachment, because I'm used to being around them." Astrid Heubrandtner grew up in an Austrian farming family who had no understanding of her chosen career, but they never tried to stop her. Her mother financed her studies and always provided help and support.

Family backing can often make huge practical differences. As American Liz Ziegler remembers, "My parents, with a lot of trepidation—I think they thought they would never see their money again—signed on a loan at the bank and I got my Steadicam."

Fathers

My father used to take a lot of pictures of the family.

(Agnès Godard)

Some fathers react negatively when their daughters choose to become a cinematographer. Rozette Ghadery's wound is still raw. Asked whether her parents in Tehran were supportive of her career choice, she responded, "To be honest, when I came back after a month [from her first location shoot], my father was furious." Norwegian Christine Heitmann's father did not encourage her at first either. "He didn't think it was a good idea for me to work in the field that I wanted." Nonetheless, he bought her a S-VHS video camera.

Other women were encouraged by their fathers to be photographers or camerawomen. Nurith Aviv, whom Agnès Varda calls "an extraordinary woman from Israel who worked in Germany, who worked with Robbie Müller, with great operators, before becoming one herself," is the daughter of a famous Israeli press photographer. At five she got her first camera and became his assistant. They would sell his photos to the newspapers and then go to a children's magazine to sell her photos. She continued as a photographer while in the Israeli army and took photos of the Pope when he visited Israel.

The magazine *Paris Match* wanted the photos and invited me to Paris. The editor asked me what I wanted to do and I said that I wanted to make pictures in cinema and he said, "Why not?" That night I could not sleep and kept asking myself why not. One year later I was at l'IDHEC [the French national film school].

(Dirse, "Women")

American Sandi Sissel's father, a still photographer during World War II, took a lot of photographs of Rosie the Riveter[1] because he covered the home front. Sissel spent a lot of her childhood in the darkroom with him. At that time people used a Speed Graphic[2] that had a big four by six negative. However, Sissel's father was part of the 1950s-60s generations who did not encourage their daughters in camerawork. Both her parents wanted her to get a teacher's certificate, and when "I chose to go a different route, they were worried. I don't think that in the '60s parents expected their daughters to go on to big careers, especially not in Texas, where I'm from."

Sissel has seen her father alter his stance, perhaps because through her he got to satisfy his own desire vicariously while she got to share her professional knowledge with him:

As I began to work, my father was proud. He felt that I was continuing something that he had not gotten to do. In many ways he stopped being a photographer because he had children, and my mother didn't want him to be on the road so much. So that led to him becoming a journalist and a newspaper editor, instead of a photographer.

In the United Kingdom Katie Swain has also been able to share with her father, perhaps even more, since from early on he shared some of the pleasures of his profession with her.

My father was a sound recordist for the BBC. I've been going out on location since I was about four; he used to take me out of school sometimes. I loved it. I started off wanting to be a sound recordist because my father was. My father's always been supportive of what I want to do. It gives him pleasure because he's had such pleasure from the work that he's done. He's felt passionately about it and so do I.

Frenchwoman Caroline Champetier also acknowledges her father's influence: "With an architect for a father, I was raised with a strong visual impulse." Angela Rikarastu's father brought her a fancy camera toy when she was a little girl growing up in Indonesia; she took pictures of everything. Her father was a designer for print advertising who liked photography, too. He taught her how "to take a picture of reality, of life so that I could amuse and entertain someone else with it." Her father knew that she wanted to be a camerawoman. "He always encouraged me to be tough at my work because it's mainly full of men, and be flexible and polite like a lady."

Other camerawomen have fathers who were cameramen. Marina Goldovskaya's father had founded the VGIK, the Russian State Institute of Cinematography, along with Sergei Eisenstein. Her father also ran the Department of Film Technology in the film school and in the Research Institute of Technology, and taught all of the cinematographers of the Soviet Union who graduated from VGIK. Goldovskaya grew up in a Soviet government-owned house where several other filmmakers also lived. "Many cinematographers in our house were famous. I remember Dziga [Vertov] sitting on a little bench at our home. He was a friend of my father's. The house had many visitors who were film directors, cinematographers, and sound engineers."

Instead of starting out in film school, Goldovskaya studied languages: English and French. Her parents hated the idea of her becoming a cinematographer:

My father always told me, "You will never have a family. You will have problems, because women have problems in this profession. It is connected with lots of traveling. You will deal only with men; it will not be easy."

He was right. I knew he was right. But I liked the idea of becoming a cinematographer so much that I thought, These obstacles exist, but not for me. I will overcome them. I had this strong drive and the profession was romantic.

Goldovskaya said her father would not have been supportive if she had wanted to become a film director either, because directors had even more responsibility than cinematographers. But she received support from two pioneering Russian camerawomen.

In the whole country there were maybe three or four camerawomen. One was killed during the war. She was in a guerilla division, shooting. Her name was Maria Sokhova. Her partner, who was in the same guerrilla division, lived in our house. Her name was Ottilia Reizman. We were good friends with her. She was my father's student.

Another woman who influenced me was my father's former student: Margarita Pilikhina. She worked at the Moscow Studio in narrative fiction film. When my father was fighting with me about entering film school, I went to Margarita Pilikhina and said, "What should I do?"

She told me, in my father's presence, "Don't listen to your father. There is no better profession than ours." And I said, "You hear?" My father said, "Do whatever you want to do. I am getting out of here." My father left for Czechoslovakia for two months. He didn't want to participate in this process of my entering film school. He was so angry. When he returned, I was already in the film school. I was the only girl.

Notice that Goldovoskaya's father did not suggest that Goldovskaya could not do the job. He was just worried that she would have no joy in her personal life. Has Goldovskaya proved him wrong? "My father was absolutely right. I don't regret anything because this life that I had is worth the problems. But when you are making a film, you have to spend all your life focused only on your film. That's why I had problems in my personal life."

Joan Churchill is also the daughter of a filmmaker. Her father, Robert (Church) Churchill, studied photography at the Art Center in Los Angeles and then made training films in the Army. After he left the army, Church and his army buddy Sy Wexler continued making films.

The Los Angeles School District placed an order for some 400 prints of their first film *Wonders in Your Own Backyard* (1948). My brother Jim and I were in that film picking up rocks and looking for salamanders, worms and lizards. We were also in *Wonders in Plant Growth, Wonders in the Desert,* and a few of his other films and later I was the slate girl and worked in the mailroom.

<div align="right">(Fisher, "Conversation")</div>

Church eventually formed Churchill Films on his own. Because he did not bring his work home, she did not grow up surrounded by film people, but he did teach her about still photography when she was about fifteen years old, and she could use his company darkroom. Inspired by her father's photography interests, as a student at UCLA Churchill and some Otis Art Institute students built their own darkroom. Although she initially majored in English, after a summer school class in filmmaking, she changed her major (Fisher, "Conversation").

In Senegal, Aminata Wade was inspired by her cinematographer father, Daour Wade, who directed her to the institution where she got her training. "I would often visit his office. From being around him, I acquired a love of editing and of images. It was hard at first, but he encouraged me." Daour Wade chose to be supportive of his daughter. He says he followed her progress closely, tried to inspire her, and tried not to impose his own opinions.

Figure 26: Aminata Wade. Senegal.

I believe that it is extremely important to show a child, boy or girl, how one does things so that maybe later it can serve as an inspiration. The fact that my daughter is the first female cinematographer in Senegal gives me a great deal of pride, but what is most important is that it finally began with one woman here in Senegal.

Deborah Parks also found her father's profession irresistibly appealing. He was a cameraman for the Canadian military who also did weddings and other still photography to make ends meet. When she was a girl, she knew her life would be behind the camera after helping her father and listening to his stories. Parks' father was supportive of her learning.

He would take me into his dark room and I would help him develop pictures. I would work with him under the enlarger and I would watch the black and white photographs come to life. But it was more just fitting me into his experience and letting me observe, just sharing his feelings and his experiences that taught me.

Parks' father helped her get started by introducing her to a local filmmaker in Ottawa, where she began as a camera assistant. After that she made her own connections.

Around the world, in other words, camerawomen have learned from their fathers' examples.[3] In China Zhao Yan says her father, a cameraman, "was a great influence. I didn't feel it was that difficult to be a camerawoman." Vijayalakshmi in India seems also to have

been destined to a career in filmmaking. Legendary director B. R. Panthulu (c. 1910–1974), a pioneer of the Indian film industry, is the father of both Vijayalakshmi and B. R. Ravishankar, who also directs films. Panthulu, Vijayalakshmi recalls,

> *directed and produced 57 very prestigious films. My father had everything, including editing equipment, cameras—we even had our own studios. From my bedroom I could hear the editing room in the next building. I have been to the sets and watched shooting since my childhood. The interest was there but I didn't know whether I was going to be a director like my father.*

One way or another, from Israel to India, and elsewhere around the world, through their own "toys" as well as their attitudes, many of the fathers of future camerawomen have inspired their daughters and contributed to their careers behind the camera.

Mothers

As a young girl, Katie Swain was much more attracted to her father's lifestyle than her mother's. "I didn't think, 'I don't want to be a housewife,' but I saw the travel that my father was doing, the life that he had, and the large circle of people that he communicated with, and I liked it. I had no aspirations to sit at home and bring up children."

Especially in earlier generations, when women's work roles were limited, it might be that more mothers inspired by negative example, but often mothers have given emotional support. Mairi Gunn's mother encouraged Gunn's photographs from the beginning. "She had a native intelligence; she could look at any situation, even if she was totally unfamiliar with it, and work out a good approach. She said, 'You can do whatever you like so long as you're happy.' She was an amazing feminist." Later, Gunn's mother encouraged her to stop pulling focus and get more demanding camera jobs.

Erika Addis' mother was proud when Addis got into AFTRS because "it was a move into an area of prestige, and potentially glamorous." Addis' mother was even prouder when Addis received an MA with honors upon graduation. Heitmann says, "My mother has always supported me and motivated me to follow my dreams. She's been excited every time something new has happened in my career as a camerawoman. She always believed in me. She always looked at things I had shot and gave her opinion."

Even if a mother's pride seems a bit quirky and perhaps misplaced, it is still heartwarming, as Australian Jan Kenny tells us: "My mother had been appalled when I went into theater. Somebody had told her that everyone in theater was from the wrong side of the tracks. So when I moved into the film industry, even though it was a lowly position in comparison with being a stage director, she was happy, although mystified."

Some mothers managed to instill an independent spirit in their daughters from an early age. Canadian Nancy Durham grew up in a family of six with her mother working to put

her father through law school, so when she was two her parents had her board out Monday through Friday with a couple who lived across town. "I would arrive home on Friday night with my little suitcase and say, 'Hi, I'm home.' There's a view in my family that I do what I do because I was made to be overly independent as a child." African American Michelle Crenshaw's mother was deliberate in cultivating this attitude: "I've been supporting myself all my life. My mother raised me to be independent."

Some mothers provided role models for working as an equal in the world, but sometimes that meant that their daughters were unprepared when they found the camera world had yet to acknowledge the possibility that women can do anything that men can do. Zoe Dirse, who had grown up in a Canadian farm family where her mother did the same work as her father, was shocked at the beginning of her career when she was turned down for jobs or singled out for humiliation because she was a woman.

We plowed the fields and drove the tractors. I had one brother and my mother and father—
the only thing I ever noticed was that my mother did everything my father did. But she
worked harder, because she had to do all the stuff in the kitchen and the house. So, when

Figure 27: Stephanie Martin. Argentina.

189

I was confronted by guys who would say, "Pick up that camera and carry it on your head around the room," I just thought, "They're crazy." I said, "You pick it up and do that!"

In Brazil, Giselle Chamma "had a supportive mother and a wonderful brother. My father died when I was nine years old. My family gave me choices." American Lisa Seidenberg's

father and mother were both involved in civil liberties and civil rights movements against the war, so it was natural that I would be attracted to doing something political. My bent was not particularly as a direct advocate as an activist, but as part of the media. It was fun to be in an exciting place and have a camera in my hands.

Stephanie Martin's mother helped confirm Martin's choice of career, even though it meant that her daughter would leave Argentina for long periods of training and employment.

You ask yourself all the time whether it's worth it. If the most important thing in your life is family, no, it's not worth it. But yes, it's worth it in the sense that I've chosen a career that makes me happy. All my friends are lawyers making lots of money, but they're feeling unfulfilled. My mother says maybe it's worth it because you're doing something you love.

Friends and Extended Family

In Afghanistan, Mary Ayubi's parents encouraged her to make films, telling her to fight for what she wanted, but her friends wanted her to stop. "They kept telling me that when I take my camera and go out, everybody would look at me in a bad way. They said people think I'm a bad person morally, but I always told them I will do what I want to do, and one day you'll see what I've accomplished."

Sabeena Gadihoke's "parents are proud that I am a camerawoman. My father often shows a picture of me with the camera to his friends." But the concept of family and support has taken on new meaning for her through her work:

I've got the greatest support from the Mediastorm Collective, this support group we all call our nonbiological family. They gave me my breaks and said, "You can do it." That's a great thing, to have that base of three or four women who say, "Come what may, you are going to do the camera for us." I don't think I needed support from anyone else after that.

Husbands

For other women, the backing of husbands has helped in practical ways. When Nancy Durham met her husband, he told her great stories about working underground in former Soviet Bloc countries.

He introduced me to his contacts and I started traveling. I was in radio then, but he gave me the inspiration. He's the first person I talk to. He has his work at Oxford teaching philosophy, but he's also involved with George Soros' work in Europe, rebuilding education. We've met up for weekends together in Macedonia, in Austria, and elsewhere.

Mairi Gunn also gets huge support from her partner, a soundman in the industry. Gunn mentions that a New Zealand female producer also praised Gunn's husband for being supportive of her:

She was so glad I'd teamed up with Mike [McKree] because she felt that she wouldn't have had a career if it hadn't been for her husband. For her to say that took my breath away; it seemed sad as well. I thought, You're such a marvelous producer and here you are saying you wouldn't have a career if you weren't married to a director.

Meily's husband, also a filmmaker, shares childcare responsibilities. "I would shoot in Bangkok and he would be home, or he would be in Hong Kong and I would be at home. We try our best to make our schedules fit each other's so that one of us would get to stay at home with the children."

A Happy Marriage

Priya Seth is married to fellow cinematographer Vishnu Rao; they both attended FTI. Seth married into a family of filmmakers: Her husband's father is a famous cinematographer, his mother runs a camera rental business, his first cousin is also a cinematographer, and that cousin's wife is a film editor. When they all get together, she says, "there is only talk about film. It is quite nice." Seth thinks her husband's being a cinematographer enables him to understand her. "He understands why I am out until two in the morning, and what's so great about what I do that makes me want to get exhausted every single day and come home tired. I don't have to explain." Instead, their common interests give them much to discuss and make for an exciting bond.

Interview with Priya Seth and Vishnu Rao

Q: How long have you been working as a cameraperson?

VR: I went on my own in 2000. I started shooting alongside assisting in 1999–98, since I left the film institute in Pune.

Q: Have you worked with any women cinematographers?

VR: I have. I am not sure whether I was assisting or just there on the set helping out, but with Shanti once, when she worked with my father for a while at the same time I was on the set. In the institute with Fozia and Bindu there was

another cinematographer called Deepti; she was senior to us. I have seen them work; it's more like everyone helps out.

Q: As a man in the industry, do you see any bias against women?

VR: I don't see it, but it may be there. The women I have worked with have been promoted. But I don't know. It could come from behind the scene or some other ways.

Q: After shooting, when guys are talking, would you discuss a woman technician?

VR: No. That's not happened. It would only happen in a good way, when a woman crewmember like a cinematographer or production person gets up and does hard work, and picks stuff up. You know, "Wow. She did that." It's appreciation rather than saying, "Wow, look at her."

Q: Has the percentage of camerawomen increased in the Indian film industry or is it increasing?

VR: Women have an opportunity; it is open. Film is kind of hereditary. If someone in your family is a director, you want to direct; if someone is an actor, all actors' kids are actors. It is like taking over a business.

Over the last ten years or so, you got access to everything from, say, circulation of *American Cinematographer* and so many things that have led to big changes for women and men in Bollywood and in the commercial world and all across the spectrum, behind and in front of the camera. There are more women behind the camera, a lot in postproduction, and a lot in art direction. I know five or six female cinematographers—not more than that; there are 50 men cinematographers. There is still a proportionate difference, but I only knew Shanti back in the early '90s. Today I know five [women] who are working every day in Bombay. So it's a good sign.

Q: What is it like being married to a woman cinematographer? Was Priya's profession part of the attraction?

VR: No, I don't think I made this a relationship because of that. We met socially, not at work. But we had something to talk about right at the beginning because we were both doing the same thing. It's fun. You watch a movie and end up discussing the boom and other technical stuff. When you are a little unsure of your approach to a film and you have someone to discuss it with outside the production office, in your home over soup or beer, it is nice.

Q: She says you are interested in working together.

VR: I would like to, just because we do the same thing. I don't think we should work together on a long-term basis, but, yeah, over one commercial for three days just to see what would happen. That would be fun.

PS: Whether we will end up married after three days we don't know.

Q: What about the household chores? Do you divide the work?

PS: We are equal on that. Suppose someone is shooting one day and someone is shooting the other; whoever is home will cook or clean, it doesn't matter who.

It is comfortable because he is not a stereotypical Indian man who will not cook or clean. It makes the relationship completely unconventional. We both do each other's jobs. I can fix a light bulb; he can cook.

VR: We share everything.

Q: When you both work eighteen-hour days and you both come home and expect a meal to be there for you …

PS: … that's when we have leftovers.

Q: Is there any professional rivalry between the two of you?

VR: I don't know if there is.

PS: How rude! I said, "No, not at all."

Q: A male cinematographer can work until the age of 60 or 65. Do you think it is possible for a woman to continue so late into her life?

VR: If she wants to. You have women directors directing in their 60s, women actors acting when they are 80, so why not? As long as your brain is ticking and interested in what you do, I think it is the same for man and woman.

Q: Do you ever have artistic conflicts?

PS: We got married about nine months ago. We had a reception in this big hall. We were into discussions on how it was going to look; what we both got obsessed by, much to the pain of everyone else, was the lighting. When we reached the reception, I got ready earlier than him so I walked in before he did. My mum looks at me and asks, "Is all the lighting up to your standards?" I said, "No, no, no, put that off, turn that down, dim that up." The guy doing the lighting was just looking at me, like, "You freak. You are a bride. What are you doing?" You tend to get obsessed by things which other people don't even understand. But because we both do it, we understand each other.

VR: That's a good thing about understanding a job. When she is out for twenty hours, or she is gone for a week, I can get it—or the same way with her.

Q: Can you give an example of what you would say to each other when you are talking about lighting?

VR: I was doing music videos with a lot of light bulbs recently. There were, I think, 1,000 light bulbs in the background running behind a series box. I was in the studio looking at it and called her. I said, "I have them three stops over, but do you think if they are running they should go more?" We had a little discussion, five minutes on the phone. You can do that.

PS: And there is no competition. It's not like you are calling up a fellow cinematographer who is going to think that she or he doesn't know. It is just between the two of you. I can share an insecurity I have on the set with him, knowing that he is not going to judge me, and he can do that with me. You can't show your insecurity and fears on the set. But you can make that phone call to the other person.

Q: If you have children, what will the childcare issues be?

PS: I am sure in the beginning I won't like to work because I won't like my kid being brought up by someone else. But there is a support system in India which makes life a lot easier. My parents live down the road; his parents live down the road. Grandparents are much better than childcare.

VR: I don't think it is a choice between work or family. It is a whole life together.

PS: I don't think it is one at the cost of the other at all.

Pregnancy

Having a baby really surprised me in terms of being a camerawoman. I thought my career was over. I was five months pregnant, on top of a crane. It was great! It kept me off my feet.
<div align="right">(Liz Bailey)</div>

Like Liz Bailey in the United States, Deborah Parks found surprises working on Canadian sets while pregnant. "I never worried about not being able to carry the equipment or doing the work or keeping up with the location, travel, that kind of thing. It was everyone else's worries about me that got in the way."

However, becoming pregnant can have serious implications for a camerawoman's career, even if, ultimately, things turn out better than expected. Pregnancy is a topic several younger camerawomen wanted to discuss, even if they had never had a baby.[4] "Now I'm still free as a woman," Rikarastu reflected. "There is no problem for me to shoot anytime and everywhere because I don't have any responsibility for family. But if I married, the dilemmas would be about how to manage the responsibility of work and family, and the physical problems of pregnancy or raising a baby."

Pregnancy sometimes occurs early in a camerawoman's career. Eva Testor was seven months pregnant when filming her first student film at the Vienna Film Academy. "It was going well, so why shouldn't I work? And the film turned out really well."

Sometimes, however, the complications of pregnancy can alter the work or put it to a stop. For many camerawomen, pregnancy means professional sacrifices. "I got pregnant at the time my career was taking off," Shanti explains.

So it came to a standstill because my doctor told me it is not advisable to work while carrying the child. After that childbirth, I was not active about going back to the producers saying, "Look, I am back. Give me work." I did maybe two days' work a month, three days' work in two months.

Similarly, Lisa Seidenberg was in her early 30s and at the peak of her career, shooting all over the world in the late 1980s. "Of course '91 was the year when communism fell. Russia had started to be what I was known for. And I had to watch it on television because I had this enormous belly. There was no way that I could go there, and I really wanted to be there."

Vijayalakshmi did not get married until she started producing television series. She thinks that marriage can work out for a camerawoman if she gets married to someone in the same trade. "My husband [Sunil Kumar] is a sound recorder, so he understands what my job is like. Like I may have to work 24 hours a day for days altogether. He also works like that, so we give each other space." Vijayalakshmi shot all her television series until the fifth month of her pregnancy. "I gave up cinematography in the fifth month because I was having a baby rather late in life; I didn't want to take the risk. There are actresses who have their baby and then get back to work. I don't think marriage or a baby is a problem any longer."

Over time there have been many changes in how society responds to pregnant women in general, and that holds true for camerawomen as well. Even the unions—some of them—have come to the party. "The unions do have a policy," Crenshaw notes, "like IA Local 600, where women who work as assistants and then become pregnant can get disability while they're pregnant." Employers, too, seem to be more tolerant. According to Gadihoke, one of her former students, "who works as a cameraperson for NDTV [New Delhi Television—one of the most important mainstream television news companies in Delhi], did get leave for her pregnancy and her baby. It would be interesting to know whether that was ordinary leave or maternity leave."

Children and Childcare

Q: I thought there were a lot of daycare centers in Russia.
A: There are. But when you are filming, you don't have a day that you can plan. Sometimes I am editing 24 hours a day. All your thoughts are there.

(Marina Goldovskaya)

For some camerawomen, having a child is simply not part of the picture, or it may be a point of concern for the future. Swain does not have children because she thought it too difficult to be a DP and have children. Filmworkers, she notes, are working longer hours now. "I've got friends with similar jobs in the industry and they have to turn down films because they can't go away for three months at a time. They have to choose things that are local. That's influenced me in terms of whether I want to have children. It's a career progression."

When Swain started in the 1980s, men who went away had traditional women to stay home and look after the children. She says that, decades later, both men and women have demanding careers. "So the two partners within the relationship, who both have demanding careers—one person has to take a back seat. Not everyone wants to do that."

Sue Gibson also chose not to have children. She says that Britain has no childcare to help women filmmakers. The long hours that cinematographers work are hard on family happiness. "If you have a husband, they don't want you chasing off around the world at a moment's notice; they'd like to have a partner who's at home. That also works for women married to men in the

business. There are lots of relationship casualties in this industry." In her 20s Gibson spent all her time in college and in her 30s her career took off, so that became the important thing.

> *I live on my own. The only thing that has suffered during my career are personal relationships, but maybe that was never going to be anyway. I don't see how I can blame it on the job. Having kids was never at the forefront of my mind. It was only toward the end of my 30s that I thought, Wouldn't it be nice to have a family? But you have to find somebody who you want to have a family with and vice versa. I had a few years of being a little lost until I decided, 'That's not to be and let's pick up the threads and carry on.'*

Ellen Kuras also stressed the difficulty of being a cinematographer and having children, especially the conflict between spending time on one's child and one's work. While shooting a movie, Kuras is out of the house seventeen hours a day,

> *between travel, dailies, everything—with very little sleep. When would you ever be able to say hello to your child? It's different with directors. A lot of directors, like Rebecca [Miller], the children come to the set, to lunch; they are able to be around. But that is the director. If you are the DP, your responsibilities are different.*

Kuras does admit that some camerawomen, despite the huge sacrifices to be made, can balance work and children. Still, she thinks male cinematographers have it easier

> *because a lot of them have wives, and the wives take care of stuff at home. There are women producers that I know that are married and the men take care of the kids. That's their job. I think it's great. It's such a nontraditional way of running a family. But, for the most part, the film industry exacts a pretty high toll.*

Irit Sharvit looks at the prospect of raising a child with mixed feelings. "It is a point that does scare me, but I have lots of support from my partner, so I guess we will be fine." Priya Seth also looks forward to having children. "You have to take the time off if you're a woman. I am proud to be a woman as well as a cinematographer and if I have to take some time off from shooting films and have babies, I am happy to do that. I would love to do it. And bring my babies up on the set. Well, that is my dream."

Speaking from experience, Seidenberg thinks it is generally impossible successfully to combine motherhood and full pursuit of a camera career. As a single mother, Seidenberg was not able to run out on short notice or shoot sixteen hours a day. She experienced difficulty because she lacked a good support system. Her partner was supportive but he also was trying to work at his career.

> *If I could have afforded a fulltime nanny, I'm not sure that I would have. I enjoyed raising my daughter and I would have missed it. Some DPs and camerawomen used to go that*

way; they miss out on a lot. I hate to say it because I come from a feminist background, but I think it's impossible to be a good mother and a good DP/camerawoman. Your child suffers. If you're going to have a full-fledged career, you probably shouldn't have children.

Vijayalakshmi also has her doubts, despite a supportive husband as well as "a good cook."

I don't spare enough time with the baby. Both of us don't. The love of the art keeps you going for hours so you don't remember you have a family or anything else. Sometimes I think you shouldn't be having children, because you are so devoted to the art that the children may or may not understand that you don't have enough time to spend with them.

For some camerawomen, having a child means subordinating camerawork to the needs of the family. Maryse Alberti, when interviewed, had a child who was seven; she had decided that her son and family came first since she got the greatest rewards from them. She strongly feels that she has to be both mother and cinematographer, and her work as a cinematographer helps her be a good mother since it is great for her son "to see that his mom really likes her work. When I go away, I call him every night and talk about what I do. He's come to movie sets. It's important that he sees that I have my life, I like it, and it's fun. I always tell him, 'Try to find something in life to do that you're going to have fun with.'"

Alberti thinks the film business is not family-friendly because the camerawoman or -man has to choose when to go away and when to stay home.

I have no recipe for that. You function on instinct. Sometimes it's hard to say no to a project. I was asked to shoot Boys Don't Cry *[Kimberly Peirce; 1999]. I knew it was a great script; I knew it was going to make a great film. I couldn't go away; it was the wrong time in my family. I had to say no. Once you say no, that's it; it's gone.*

Alberti feels she is lucky: She has a supportive husband who works freelance and can alternate working and childcare. She has, however, seen many women "have to quit the [film] business because their husbands can't leave their jobs [for childcare because] they would lose their jobs. That's a challenge. It's not impossible to reconcile the family with the job; I've done it."

Andra Lasmanis, a Swedish cinematographer with over twenty years of experience on features and documentaries, states:

These days when men are also expected to take responsibility for children, it's the same for them. I think there can be a solution for the children/work issue, but it requires innovative thinking. One can for example ask the producer whether it's possible to get help from a nanny for unexpected overtime during a production. Actors can usually make these kinds of demands, why should it not apply to us too?

(Askberger 16)

Lasmanis makes her suggestion from experience. A single parent of a son diagnosed with epilepsy, Lasmanis did not think she would be able to work as a cinematographer away from home. In one instance, her director solved the problem, asking if Lasmanis' son could come along on location if they could organize a nanny for him. Lasmanis took the job. "The nanny's salary was paid with money that was intended for my hotel room, and instead we lived with the director" (Askberger 17).

Figure 28: Joan Giummo and son. USA.

Obviously the effect of having children on a camerawoman's professional life varies widely. Key factors include one's national culture, family, husband, professional status at the time of pregnancy, and financial security, among other things. Different cultures take different attitudes to women working. In some cultures the extended family support system still functions, and while some husbands cannot cope, others are remarkably understanding and supportive. If one's reputation is sufficiently established so that one is already in demand for work, it will be easier to return to the industry, and if one is financially able to afford childcare, then of course all sorts of options become available.

The most stressful situation for American camerawomen seems to be solo parenthood. Joan Giummo, who was a single mom, said her single motherhood affected her whole life. When she did *Shopping Bag Ladies*, her son, who was then four, frequently got to hold cables while on location. He was fairly well behaved, she remembers, but "he has recollections now of being in some really strange places." Since Giummo had to support both herself and her son, she had to take jobs that she did not want along with doing her own projects.

I wasn't fully doing my video work. And when I was doing my video work I felt like I was neglecting my child. At certain points, I did work in television, but that was not the kind of work I was interested in and the schedules were hideous for a mother. I would work from three o'clock in the afternoon until eleven o'clock at night for news programs. People

on all sides were saying, "What do you think you're doing? Why are you jeopardizing the well-being of your child? You should be looking for a husband and find a job that has normal hours and pays."

Asked if her son had felt neglected, Giummo replied, "I felt I was neglecting him sometimes, but Jessie, who's now 32, told me I wasn't a bad mother. But I didn't bake any cookies."

In 2004, single mother and video photographer Sandra Butler said,

I've always felt, if you're going to bring a child into the world, the first priority is the child, which is why I believe in abortion. Parenting is a responsibility.

When my daughter was born, she needed open-heart surgery. So when push came to shove, I had a daughter who was sick, and I needed a job with a health plan. You have to join a union. I joined IATSE Local 16. They needed to bring in people who could do camera. At Local 16, I was the first woman on the Executive Board. [Starts to cry.]

My love for my daughter kept me going.

Her daughter, Ola Butler, died in 2000, after a lifelong battle with heart disease; Sandra Butler died on 22 December 2006.

Shanti is married to a cinematographer who understands her working hours and helps her. She does think childrearing is the mother's job but both parents need to be flexible. She was careful in her decision to have a child since she was aware that as a mother she would not be working that often. Her husband, Amitabh Singh, often had time free from his own camerawork, and then he would help take care of their child. He says that the child has been their top priority.

We adjust to who can take time off to attend to the needs of the child. Sometimes Shanti goes for a fifteen-day trip, leaving Aditi [their child] solely with me. The shoot is, I guess, equally important for both of us. What we shoot are our personalities; our personalities are dear to us. But a child becomes a priority. What we are very clear about, I think, within our own minds, is that the priority always rests with the child—her well-being, her happiness.

According to Shanti, "Having a child definitely changes you in a lot of ways. I have learnt to be an extremely patient person, receptive and accommodating of people," which she considers an unexpected bonus that motherhood has provided her professional work.

Testor had a supportive husband to help with childcare, but her mother's help was crucial. "I was lucky, when my daughter was very young, in that my mother lived here in Vienna. Without her, I couldn't have done it." Testor's daughter grew up with the idea that a normal mother is not around all the time.

When I am there, I have more time for her and it's also naturally more intensive time. Besides, there's of course a father, who takes care of his daughter. And I'm married to a

Figure 29: M. Shanti with her daughter, Aditi Singh, and 35mm Panavision camera. Mumbai, India (2002).

man who also looks after my daughter. In this respect, I have a good network. It was really important for me that it was like that from the beginning.

"I got pregnant three months after my marriage," Ayubi says, and although she had her in-laws' help with childcare, she slowed the pace of her work after the birth. "I tried to look at my personal life and my work on the same level, but I automatically tended to pull more toward my personal life than work." As a mother, she says, "When I was working, all my thoughts were toward my child."

Sissel agrees that balancing between camerawork and mothering is difficult. She feels that technical positions like DP, gaffer, and camera operator are the hardest for mothers since they are on set all the time. The meetings these filmworkers have are time-consuming, including meetings after a heavy day of shooting or on weekends. "Actors and directors often have down time in the middle of the day so family can visit and spend time in the trailer. Your kids can actually go to school on the set." But as a camerawoman, Sissel sometimes had to work eighteen hours a day, six days a week, so she had nannies and

good friends do childcare. When her son, Bernard, was in elementary school, she lived in a commune.

> *There were five houses in a small courtyard, and the kids went back and forth. Without my friends in those other houses, I don't know how I would've done it. Unfortunately, I was not in a fulltime relationship all through the upbringing so there's also the side of it where you are the one who has the major responsibility for parenting, and even though your partner wants to help, it's not really their job. We may want them to take more responsibility than they're willing to take, but in fact, it's our job.*

Her son spent a lot of time on sets, but Sissel did not consider it to be quality time since she was busy working. He also spent a lot of time with the grips, the electricians, and the actors. "Then on Sunday, if I had a day off, we did things together. But I was pretty tired. That's true whether it's your lover or it's your child, but it's especially important when it's your child." Sissel is happy now to see married couples who have learned how to balance work and childcare.

> *You might see a couple, one's an operator and one's in the art department, and the man works on one film and then spends time with the kids, and then the woman works on a film and then takes time off for the child, so that the child is always with one parent. I'm happy to see people beginning to take more responsibility like that. A lot of male DPs don't know their kids. You're a parent because you spend time with your kids, not because you pay for their private school.*

According to Lisa Rinzler, while not easy, balancing work and children is doable. She cautions, though, that you need to think precisely about the future when you have children. She and her husband, a musician and record producer, both freelance. When her husband is not working, he is at home with his daughters. Unable to afford a full-time nanny, Rinzler decided to hire help regularly twice a week. "When I work it goes up. I usually split it between two people, because to have one person on the clock for fourteen, fifteen, sixteen hours, is too much to ask. They have to keep their energy up for two children."

When her daughter Bess was four months old, she shot her babysitter's thesis film. When Bess was six months old, Rinzler shot her first feature film in New York. With her second daughter, who is four years older than Bess, "I shot *Pollock* [Ed Harris; 2000] when she was nineteen months old." Later, when she worked in Mexico for four months, her daughters visited her twice and she returned home twice.

> *But for me to go, say, to the Far East, or the Middle East—it's a big deal. I have to think, I want to think, about them and their well-being. I didn't bring them into this world to not be a presence. On features my husband and I get more childcare because the hours are just crazy. There's a dance to be done, too, because it's important to have consistency for the girls.*

Having a supportive family has meant that, although her son was less than a year old, in Turkey Berke Baş was able to finish one film and start shooting a second one. "I would go out for two hours to do filming, come back, play with him, feed him, and then go out again, to leave him with my mother. It's been exhausting." What is it about camerawork that makes this worthwhile? For Baş,

> the beauty of the camera is that you are looking through the lens. You are just there with your camera and with what you are shooting. There's nothing in the back of your head. I'm just there with the camera; it makes you focus. I like that, because with a child you are never focused.

She learned to juggle different tasks quickly. The help from her parents, her husband, and her sister allowed her to continue filming. While working with a film editor on *Hush* (2009) Baş was also breastfeeding, but her baby was unhappy. "It was difficult. But my editor, Catherine Gouze, was wonderful. She's also a woman, so she was sympathetic. I have plans for my son. He's already using the camera. He likes the microphone. He likes the muffler more than anything."

Sometimes the idea of supportive family has to extend beyond blood relations. In 2001 Canadian studios lacked childcare, so Deborah Parks had to find her own support system, which for Parks meant babysitters, her mother-in-law, daycare centers, and school. During the first two years of her daughter's life, Parks was filming documentaries on location. She worked in Toronto sometimes twelve to sixteen hours a day. Not wanting to admit that it was difficult, she kept on saying, "I can do this! I can do this! I can juggle." For one film she dropped her daughter off at 7:30am, but once she was at the location, she often could not work out when she would be able to collect her daughter again. She could worry about it all day only to end up unexpectedly with a late night shoot. Then she would have

> to drive across town, pick up my daughter from her day-sitter, drive to her grandmother's house for the evening, drop her off, then go back to the shoot, and work to midnight, then go back to my in-laws' house and pick her up at night, only to do it again the next day. But you can't rely on your immediate family to pick up all that work. Because it's a lot of work, raising children.

Parks found working as a mother to be especially hard because during the first six years of her children's lives she was not sleeping. After her second daughter's birth, she stopped shooting professionally but she missed it. "It's always been my first love. I miss the creative process a lot."

If one can find a good network, the rewards are great. Lee Meily always wanted to have children, and she kept shooting until she was eight and a half months pregnant. "With four kids, two grandkids, I wouldn't be able to get by without my husband, my four nannies, and

my driver. They're a big help; they're considered family. Sometimes I feel guilty, because before I was able to cook a lot, but now most of the time I come home tired." She is very proud of her children, and they of her. "My son told me last week, 'I want to be a cinematographer like you.'"

Although people told Mexican Celiana Cárdenas that if she became a DP she would not be able to marry or have kids, she did get married and had a child. "It is more complex than difficult, because of the long working hours, the locations—especially now that Daniel is bigger." When she is on location, she can no longer take him out of school.

I have to be without him for three weeks a month. Nevertheless, he knows that his mommy is fulfilling a dream, and that while it has cost me a lot of time, what I do is not only for money, but because it feeds my soul and my heart. All of that nourishment I give back to my husband and my son. But I hope one day I can pick where I want to live and how much work I take, and the three of us can be together somewhere and have the ideal life that we all want.

Figure 30: Celiana Cárdenas and her son.

Daughters

Posterity, for me, comes through my daughter and what I wish for her. Not in precise terms: I wish that she is happy to live every day, to wake up every morning.

(Agnès Godard)

For camerawomen who have daughters, those children represent both the bitter and the sweet. The balance may depend on what generation the camerawoman belongs to. Seidenberg experienced a turning point in her career when she had her daughter in the early 1990s. If she had remained childless, she would have tried to be a DP for feature films, and she admits to some envy of women who started out when she did and have since become DPs. Seidenberg became a single mother making her own films, which she loved doing and which she had always wanted to do,

> but I was at an event once, when my daughter was around eight years old, and there was a cameraman there from a television station. She said, "Look, Mom, there's a real cameraman." I wanted to cry, because she'd never seen me like that. I had stopped around the time that she was born and now I use little digital cameras and it isn't as impressive.

Seidenberg sometimes tried to take her daughter on a shoot, but found it was a nightmare trying to arrange babysitting, charge her batteries, and organize for the shoot. "I felt torn in so many directions. On one shoot out in the desert, the babysitter couldn't come that day, so I brought my daughter. At a certain point I'm filming and she started crying, but I couldn't stop." Seidenberg did not take her daughter to Russia or Mongolia because the food situation was too difficult. She turned down overseas jobs requiring long hours because she felt that her daughter needed to have her mother coming home. "I love being a mother but I don't think that everybody should be a mother. You have to make choices." As for her daughter's becoming a camerawoman, Seidenberg hopes "that she would choose something that didn't involve so much interior pain."

Rinzler loves creating a film record of her two daughters' childhoods. Usually she shoots mini-DV because it is quick, easy, and accessible, but two or three times a year she will shoot film with her Bolex or her Aaton because "film is so beautiful." She also makes projects with her daughters, such as a music video of the song "Downtown" with Isabella's second grade class. "They've started shooting a little bit with the digital still camera and with the video camera."

Coming from a later generation of camerawomen, Testor anticipates a cheerful, well-adjusted future for her daughter. At ten years of age, her daughter wanted to become both a camerawoman and an actress because her mother is a camerawoman and her father is an actor. Testor says, "It's clear that it suits her well. She has grown up with the idea that it is completely normal for me to have such a profession."

Notes

1 An iconic image representing US women at work as part of the war effort at home during World War II.
2 A type of still camera associated with news photographers then.
3 For a camerawoman learning from her grandmother's example, see the chapter in *Women Behind the Camera* on Dyanna Taylor, granddaughter of the famous photographer Dorothea Lange.
4 Many younger men at US screenings of the film *Women Behind the Camera* also wanted to discuss pregnancy and childcare issues. For male cinematographers who look forward to fatherhood, combining parenting with production work, the long hours, distant locations, and lack of health care insurance for nonunion filmmaking raises serious questions.

Chapter 8

What's it really like?

A Typical Day

When she is working, Sue Gibson gets up at 5:30am, drives herself to the location, and arrives around 7:30—although depending on the location she sometimes has to get up earlier. Typically, she works from 8am to 7pm, often watching dailies during her lunch hour, and she usually arrives home around 8 or 9pm. But sometimes after a day's filming, she has to go out scouting locations. Those days, she arrives home at 10pm. Once at home she reads the script for the next day. She usually functions on about six hours of sleep a night, six days a week. So when she is not working, she goes to the countryside to "recharge her batteries" by riding, gardening, being at home, and socializing with friends who are not in the film business. If she does not take time away from work, Gibson says, "I burn out."

Figure 31: Sue Gibson, BSC. United Kingdom.

Where Do Camerawomen Go?

Being a cinematographer brings me to people, places, and cultures that I would never meet if I had an ordinary job. I feel lucky.

(Irit Sharvit)

Camerawomen with the greatest opportunities for travel and exposure to people and cultures are generally documentary camerawomen and video journalists. Working for Russian television, Marina Goldovskaya had little choice about her assignments: "Imagine our huge country. One-sixth of the world. I worked everywhere: the North Pole, the South Pole, in villages, little towns, and capitals. I could go anywhere I wanted to go. Sometimes I didn't want to go, but I was sent and had to go."

In contrast, Lisa Seidenberg's US television bosses not only did not send her against her will, they sometimes would not let her go despite her requests. After a couple of years at ABC News, she was fed up and told her supervisor she wanted to go overseas. "They said, 'You're good, but we can't take the chance of having a camerawoman in the front line. If something happened to you, it would be bad.'" So Seidenberg became a freelancer, getting assignments "from news agencies and different productions overseas, which was what I wanted. I went to Lebanon, Cambodia, Vietnam, Syria, China; I went to a lot of interesting places."

World adventurer Arlene Burns' experience pushes the envelope. Not all camerawomen would want the range of work opportunities that she has had around the world. She went on an international raft trip in Tajikistan "using all homemade Russian rafts with people from about ten different countries." Though nobody spoke the same language they spent a month on the river and documented it, making an adventure film. Burns has also documented whitewater festivals in Costa Rica; worked on little outdoor shows in the Northwest Territories, in Newfoundland, and in the Bay of Fundy; and done corporate projects in South America. For *The River Wild* (Curtis Hanson; 1994) she was technical consultant as well as "a stunt double for the main star, Meryl Streep, and also her role model, her coach, and her stand-in."

Susan Walsh "had a lot of opportunities in my life prior to working in the film industry. I worked in sport diving and I did a lot of traveling." Nevertheless, she says that "the film industry has given me an opportunity to be in places [and] meet people I would not otherwise have met, and certainly not in such variety. Some of the best opportunities for me have been things that required specialized skills, like the underwater work."

For some women, the camera can overcome both cultural and personal barriers. Berke Baş describes her camera as an interface between her and her subject that makes her forget her usual inhibitions. She loves traveling and has traveled a lot with her journalist husband, sometimes doing stories together. She is familiar with most cities in Turkey and has also filmed in France, England, and Canada for an international documentary

about homosexuals in Islam. Baş enjoys the sense of freedom and comfort she gets from camerawork "because you see places through your camera, and it makes everybody familiar. That's been my experience. The camera sometimes works as a shield, sometimes as glass."

Sabeena Gadihoke believes the camera has allowed her to transcend the restrictions of social class. She comes from a middle class Indian background, because of which she never would have traveled "to the places that I have traveled to, had it not been for the camera," and the camera also has given her the possibility of meeting all kinds of people. For example, she has traveled with her camera into India's remotest small villages, meeting different tribes and communities, and she has traveled on a women's bus from India to Pakistan. Her father was from Pakistan, but she says, "I would never have gone to Pakistan had it not been for a camera assignment." Gadihoke also has been to Nepal with her camera and hopes to shoot in Bangladesh. She often tells her film students "that had I not been introduced to this course it would have been a loss for me."

What Do Camerawomen Wear?

I never knew how to act; I never knew how to dress.

(Lisa Seidenberg)

Making the wrong choice, as Seidenberg realized, could create problems. "I looked different from the way [the other cameramen] looked," Jessie Maple Patton remembers, "with my little short skirts and sandals in the summertime, like I was going out. They could not accept that, especially since I was the head of the crew."

Camerawomen have needed to dress within the context of their work and the local dress code, whether in Turkish rural areas, on Vancouver streets, or on Bollywood sets. Sandi Sissel's first job, right out of college, in 1970s Texas, was to shoot feature stories for the ABC affiliate in Dallas. "When I went to work I had to wear a dress. Women were not yet allowed to wear pants to work." Once she heard that a law had been passed in Dallas and women were allowed to wear pantsuits to work, she "was on the set with my nice little blue bellbottom pants and my nice little blue matching top, holding my camera, and I became the news story that night. That's not that long ago."

News camerawomen and documentarians often work on location where the dress code may be somewhat inflexible, depending on cultural expectations. Sometimes the film's subject itself affects the dress code. At one point in her career Sissel was involved with a documentary about Mother Teresa. "Mother made me wear dresses all the time when I worked with her. She didn't like my choice of dresses so one time she took me to Harrod's in London and bought me what she referred to as a proper frock for me to wear."

Yet inflexible clothes like a dress or a burka can be useful for camerawomen in certain circumstances. The iconic footage of a woman's execution filmed by the women in the Revolutionary Association of the Women of Afghanistan was enabled by a dress code that required a woman to wear a burka, which provided an opportunity to hide a camera. On the other hand, Mary Ayubi recounts that when she went to eastern Afghanistan "I always had the chador to make sure anytime we needed to we could cover ourselves." However, although she "shot under the chador, I couldn't focus the camera because the part that covers the eyes was uncomfortable. It was hard," she remembers, "but I shot some footage."

In contrast, Margaret Moth filmed in various Muslim areas, but never from behind a veil. She describes how, when she and the other news teams first went into Pakistan on their way to Afghanistan,

> the women put traditional women's clothes on, but I just wore my black jeans and bought one of those long shirts that come down to about your knees that the men in those countries wear. To me that was just more practical to work in. I didn't know for a long time that, because of that, they thought I was a man. I said, "But I wear makeup and I have earrings." They said, "But in the West you have many men wearing makeup and earrings."

On one occasion, the officials were patting down all the men at a press conference, but not the women. "When I came through, I had my camera in one hand, my tripod in the other [gesturing to show how she had tried to ward the man off]. He had no idea I was a woman. Then he was so horrified that he had touched me." She feels she had more freedom because Afghans were unsure what gender she was, but adds she was not expected to wear a veil at the time she was shooting, perhaps because before the war in Afghanistan older women did not have to be veiled, and Afghans said "women of our age didn't have to be covered. The advantages of being old!"

Some camerawomen wear items of clothing connected with the particular needs of doing the job. When she works alone, Nancy Durham stays very organized, helped by a "horrible-looking camera-jacket" she wears if she is on a day-in-day-out shoot in a difficult place.

> I know that the tiny notebook and pen and lipstick are in this pocket, that my receiver's in this pocket, my backup battery's here: I know where everything is. And my own microphone is wired through the jacket. I just pick up that jacket, put it on, and I'm ready to go. That's how I deal with the stress. I'm ready.

At times a camerawoman may wear a costume that would otherwise be out of character to serve the needs of her job. When Sissel worked on magazine shows for the networks, she once filmed undercover in Haiti, running around in a "pair of shorts with a little tiny camera called an Éclair ACL and everybody thought I was a tourist." Later when she bought a small

Aaton, she taught herself "to walk in high heels and stand a certain way with the Aaton, the magazine, an additional magazine, and a small Nagra SN recorder, so that this 30 lb [13.6 kg] of stuff was hanging off me normally."

Commenting on the difference between actresses or models in front of the camera and the camerawomen behind it, Ellen Kuras remembers shooting an art film with gorgeous, beautifully made up models wearing beautiful clothes. Then she turned around, looking behind the camera. "There happened to be all these women sitting there in their Polartec fleece jackets, with their belts on, with the gloves and tape hanging off, and in their work boots. We looked like a bunch of construction workers."

Kuras notes that her crew has treated her differently depending on her appearance. Trying to be discreet, she usually wears black shirts and black jeans; she does not usually wear makeup. However, once when she was shooting *Eternal Sunshine*, she had some extra time and wore makeup. When she came on the set, the assistant asked,

"Do you have makeup on?"
I said, "Yes, I do. What's it to you?" He said, "Wow, looks good!"
The AD said, "Do you have makeup on?"
"What's the big deal of me having makeup on?"
"We were just checking it out."

Ten minutes later, still talking about Kuras' makeup, the camera crew finished setting up the lights and camera—and Elijah Wood and Mark Ruffalo "blow in. They stop and go, 'Woo-hoo! Is that Ellen with makeup on!?'"

Generally, Kuras says, "You have to be yourself on set no matter what the costs are." She does not try to be a guy. "It's important for us women DPs to be women, and to act like women on the set." Sometimes she does wear dresses as well as makeup on set. When people ask her, "How does it feel to be in a man's job?" she says, "It's not a man's job; it's my job."

Vijayalakshmi also does not usually dress ultra-femininely on the set. "I just mingle among the men as a man and work," and the men on the set accept her as one of them. She wears jeans when she works but not usually a *salwar kameez* (traditional Indian women's outfit that involves baggy trousers and a long overshirt). Since "most of the men here have seen me in jeans, when they see me in *churidar salwar kameez*, they said, 'You are coming in mufti [disguise].' They have seen me in pants for so long that when I dress myself as a woman they find themselves surprised."

As a teacher, Sissel has her own opinion about how camerawomen should not dress.

Gender is always an issue. Young women who come to the set in hip-huggers with their underpants showing around their waist and wonder why the guys don't take them seriously should go home and look in the mirror. At the same time, if they look good, I say, go girl. But I don't see a lot of guys running around the set like that.

Working with the Crew

We spend so much time on the set, we see each other probably more than we see our families.

(Ellen Kuras)

In 2010 a popular YouTube video featured a recording of Christian Bale's on-set tirade against his cinematographer, illustrating Sissel's point that "sometimes you're not on a fun set, you're not with very nice actors, and your crew is not necessarily the most wonderful crew in the world." Sometimes the DP is the problem, as Sissel acknowledges: "We all hear the crew talk about 'those asshole DPs.' Well, you hear them talk about those asshole DPs long enough, and you start to see yourself in some of those stories they tell." When Sissel visits sets and sees "some of the egotistical behavior, I'm horrified if I see what I might have done at times."

Lisa Rinzler thinks that the first step in becoming a good crewmember is doing advance preparation, which is "planning in two dimensions [that] gives way to the third dimension of actually being there" once she is on the set. Her research and preparation are not foremost in her mind when she steps onto the set because "serendipity takes over. I rely on the preparation in order to embrace the serendipity" (Lumme 76).

Documentary camerawomen often work either with a small crew or alone. Nancy Durham thinks she has "been spoiled by wonderful crews at the BBC"; she has "enjoyed working with a terrific camera operator, producer, soundman, everything." Still, she prefers to work alone. She can film in noisy, ill-lit situations, or at least "try. And I don't have to badger some cameraman to pick up his camera when he's already shot for me for eleven hours. I can badger myself." She can also "put the camera down and not work." When she is on a long assignment, she can spend a day hanging out with people, "finding out about them and not pressuring them for yet another interview. I just love it! I love being behind the camera. Love it!"

Wildlife camerawoman Karen Edmundson Bean also often works alone filming pronghorns and bears for documentaries on which she is both director and cinematographer. She finds "similarities between filming a feature and filming wildlife" because there are "issues of lighting, composition, shot choice, and storytelling"—but also "some major differences," because "you're usually out there alone or maybe with one other person." Finally, "Your subjects can become very affectionate or try and kill you…. Mind you, that can happen on a feature, too."

Not all camerawomen like working simultaneously as director and cinematographer, however. Nurith Aviv, for example, thinks "it's a bad idea. I like […] working with a crew […] It was a weakness of mine as a director not to work with another cinematographer" (Dirse, "Women").

Arlene Burns prefers documentary or television work because she does not like fiction film's huge crews. She prefers "sleeker, smaller, and more efficient" crews where less money

is being "egotistically dangled around." Feature films can take months and months in production and often have to accommodate many different egos. Burns finds that when she is on a team with three to five members, they can go shoot a documentary, "grabbing an experience without becoming the epic experience itself."

In the late 1990s New Zealander Josie Nagel showed up for an internship with an Australian television series and became part of a camera team that worked together around Australia for years afterward. For some women, working with a team is what they enjoy most about the job. During her "first experience working full-time on a feature," Australian Erika Addis said, "I loved being on a crew. It was a small crew, probably only fifteen people. To learn that a group of people can work in a highly organized, intricate fashion and make exquisite pictures was fantastic." In Katie Swain's experience, she discovered that "a team is a team. It doesn't matter how many people work on it."

Kiwi Kylie Plunkett finds that she usually gets jobs from her friends or from colleagues: "Having good working relationships with workmates is paramount when you are often working twelve-hour days, in sometimes high pressure situations. Few people will put their hands up to work with someone they don't know, unless they come highly recommended." Once a woman gets on a team that respects her, she is more secure within the industry.

Canadian Kim Derko worked a lot as an operator in the union, "so I worked in 'families' of men. Working in the camera department, you're like a family, like a machine. You have to listen to everybody, be patient, and work fast." When Derko did not fit in, she did not return to those teams. "It's a matter of not letting the places you don't fit get you down. You have to be super determined" (Moffat).

It has been difficult for women to move up the camera hierarchy. Despite her assistant camerawoman experience and family connections, Katie Swain experienced difficulties breaking into feature film camerawork as a DP in England at a time when there were only six or seven female first ACs in the whole British film industry.

Teresa Medina points to another Catch-22: Producers sometimes "have this preconceived idea that a woman will not be able to manage a group of men." When Medina worked in the States, she "had crews of fifteen males. I can handle such a crew because of the trust the producer has that I can do it, and do it on time."

When Sandi Sissel moved from being DP on a documentary—with an assistant, a sound person, and a couple of lights—to being DP on a feature film with a large crew—six grips, a gaffer with electricians, a director, assistant director, a second operator, a focus puller, a second assistant, and a loader—she found feature work far more complex. First, Sissel "had to learn what all these people did and how to be the director of the crew." She did, of course. After all, on *Salaam Bombay!* her gaffer was "a wonderful Indian man who was one of the only people" who spoke English, while her dolly grip was a Greek who also spoke English but who knew little about being a dolly grip. She said, "We just all did what we could do, and we made the best of the situation."

Even women have had to unlearn sexist thinking. Sissel says that when she was one of only a handful of female DPs in the United States, she and others found it difficult to say,

"'I'm as good as anybody for any job,' and not just 'I'm as good as anybody for this job that requires a woman to shoot.' These were things that we had to learn." Sissel often chose to work with "a male camera assistant, a male gaffer, and a male sound person because in many ways I felt, not only physically but mentally, I needed to be supported by these men that were bringing me up to the next level." Like Kuras, she cites Spike Lee's policy of hiring black crewmembers, but remembers that the pioneer women were more cautious.

> If women directors would go to the studios and say, "I would like to hire Sandi," [the studios] would always say, "This is not an estrogen film." Nobody ever used to say that if a male director wanted to have a male DP. These barriers are breaking down somewhat, but until maybe 2000 it was difficult to have more than one woman in a high position of power.

In Sissel's own case, her encounter with episodic television director Arlene Sanford helped her to "make that leap" while working on *The Wonder Years*. The first day Sissel and Sanford worked together, the director pulled her DP aside and said, "I've always prided myself on being one of the guys. But you're the first female DP I've ever worked with. So now, I no longer know how to define myself." They became friends, and over dinner one night "the two of us formulated the idea of finally coming to grips with yourself as a woman working so that you in turn can feel as comfortable with other women in the same positions. She was influential in helping me with that."

Sissel's attitude towards hiring female crewmembers finally changed. "A little light came on in my head and I said, 'You know what, I'm as good as the men around me; therefore, I think this woman assistant could be as good as any man that does that job.'" The difficulty for Sissel was that she knew producers and directors had taken a risk to hire her as DP:

> God knows what they went through behind closed doors saying, "I want to hire a female DP." I didn't even bother to say, "I'm going to hire a female assistant and on top of that I'm going to hire a female operator and on top of that I'm going to hire a female gaffer," because I know I was under scrutiny.

When she did begin to hire more female crew, she thinks her camera assistants "were under much more scrutiny because they were working for me and being compared to a man in the same position."

Sue Gibson laments the increasing loss of such opportunities in Britain as film production shifts away from studio-supported productions to a subculture of filmmaking "where people will advertise for a crew on the Internet and not go through the accepted channels of getting experienced people such as the BSC or networking with hardcore filmmakers." In this subculture Gibson describes one person saying, "Yes, I'll be your focus puller" or "I'll be a cinematographer," and

it's the blind leading the blind. The film that I worked on this summer, I was the only person on the crew, including the director, who'd ever made a feature film before. It was like a teaching experience. It's a pity, because a director and a producer have invested so much of their time, energy, and their own money into the project. They deserved a better crew around them to make the product for them.

Several camerawomen have worked on all-women crews, with both positive and negative experiences. Early in her career Gibson was asked to substitute for another cameraperson on Sally Potter's *The Gold Diggers* (1983). The film had proper funding and Julie Christie played the lead, but the crew were novices and on this occasion Gibson lacked the authority to sort things out. "People were falling out with one another for stupid reasons. You should be there to do a job and just get on with it and not say, 'Oh, I don't like her because she won't let me do her job and I want to do that job rather than the job that I'm doing.' It all seemed a bit silly."

Yet a trained all-female crew is not just an advantage but a necessity for certain subject matters and locations. Irit Sharvit's "first experience shooting a 'real' project for TV was a documentary in the Ukraine." Since they were filming an intimate scene of "women praying at a holy grave, the crew had to be only women: two camerawomen and one soundwoman." Sharvit found this shoot to be an "empowering experience. I have always had good experiences with other camerawomen. We support each other." Baş says, "With *Women of Islam*, there had to be a woman cameraperson, because we wanted to get intimate with the characters; woman talking to woman made the process easier."

Less obvious but nonetheless true, are the examples, even among Western women, that prove sociolinguist Dale Spender's point that the presence of even one male among females will alter the way the women express themselves (Spender 126-28). For instance, when Zoe Dirse was shooting a documentary called *Sisters in Arms* (2010) about women going to combat in Afghanistan, with Carrie Green as the producer and Beth Freeman as the director, "We worked hard to keep a female crew. When I was listening to the interviews of the [female] majors and generals, their stories were just like ours, and how they prove themselves. As a female crew, we found that the [female] soldiers opened up to us in a whole different way."

Nevertheless, although none of the camerawomen interviewed argued for all-male crews and many complained about being the token woman on the crew, they rarely argued for all-female crews. Yet most of them appreciate, as Sharvit put it, "the different atmosphere on the set when the cameraperson is a woman. It usually brings more peace, gentleness, and a noncompetitive atmosphere to the set. Of course this is a very general statement." Kuras argues for a mixed crew: "It is great to have a balance on the set. I hear that from the guys; they like having women on the set. It gets boring when there's only guys."

Mairi Gunn worked on many sets with male crews "where there's been Polaroids of naked women. When those kinds of things happen there is a feeling that the women in the crew are invisible and don't have any feelings or need to be considered in any way." Gunn does

not think she is old-fashioned, "but I do believe in my ability and grace and honor and those kinds of virtues." She has joked with male crews that she was going to start "a group called Women for Equal Pornography—not because I would be particularly interested in it, but to bring that whole thing up for discussion."

When Liz Ziegler and Kristin Glover discussed their work with Hollywood crews, Ziegler thought "the crew would be cooperative to anybody responsible for putting the bread on the table. That's how people are. So I don't think they are going to do a crappy job for a woman versus a man." However, Glover's experience of both uncooperative as well as supportive crews was connected with the hiring process. When she herself hired people whom she knew would work well, she found the crew "fantastic," but when she was put into situations where she could not do the hiring, sometimes she would have to wade through their resentment of her.

English camerawoman Katie Swain finds, as have other interviewees, that crews outside her home country have been sympathetic to her. Swain has worked as a camera assistant all over the world as well as a DP in South America, North America, France, and Spain. She found that in North America the assistant camera people tend to be efficient and work in a way similar to in England, but she found grips and gaffers in North America to be more macho than they are in England. Like Glover, Swain thinks "that could be to do with the fact that I choose the people I work with here [England]. Often when you work abroad you go through a service company; you get given them."

In contrast, Sissel found it wonderful to work on Hollywood productions with an experienced gaffer and key grip—both male—because they often had

> *more experience than I ha[d]—because they could come to me with all the things they have learned from other DPs who have much more experience than I, and I could say, How does John Seale get that incredible look? How does Robbie Müller get that incredible look? And these people would share their knowledge with me and we would create together a bigger canvas. That was wonderful to be able to do.*

Sissel thinks that many women who grew up in the 1950s-60s did not learn leadership skills necessary for the film industry or for other businesses. "I didn't have the desire when I started my career to work in the narrative film business. Being a CEO of a large crew was something I learned as I started to work on feature films." Working in the film industry, she found that

> *the men that I admired and the men that I worked for were rascals. They liked to party hearty and they threw temper tantrums on the set. That seemed normal. By the time I became a DP, I had a few of those qualities myself, but I learned that it might be acceptable on the part of some of the men but not the women.*

Sissel praises Kuras' leadership abilities: Kuras is a born leader who "has the temperament and intelligence of a feature director of photography." Sissel says she has learned from Kuras how to operate on feature sets, because "she does it beautifully."

How does one learn to "do it beautifully"? Dirse, after years of doing camerawork, is now a teacher of cinematography attempting to increase the number of camerawomen. Dirse teaches her students courage: the courage not to be intimidated by the technical process. To Dirse's mind, once they can handle the equipment well, then "they're able to handle a crew. They're able to express what they want and negotiate these issues that are important on a set." Dirse does not think she "can teach anybody how to be a leader but you can give them knowledge to empower them so they can use those skills to be a leader."

Jarnagin agrees with the basic importance of learning "enough about the technology to empower you to create" the desired images; it will boost your "professional confidence." However, she stresses the importance of learning management skills, to the point that she says, "The biggest mistake I see people make is ignoring their managerial development." She cites Nancy Schreiber, among other senior camerawomen, as making the point that "the bigger the films you do, the more it is about managing people and the less it is about your art." Jarnagin continues,

As collaborators, our job relies on effective communication and people skills. Being personable, level-headed, confident, and a good leader is what separates the successful DPs from the ones who don't continue to move forward in their careers. It doesn't matter how talented you are; if you can't effectively communicate your vision, and if you lack in your ability to inspire your team to do their best in executing that vision, your work will fall short of your potential.

When Astrid Heubrandtner says that she "would have very much liked to have had a female role model for dealing with everyone on the set," she implies that there are differences between male and female managerial styles—something most camerawomen agree on. In some ways, how her crew treats a female DP depends on how successful and established she is, including how well she manages age differences.

In Russia, as Goldovskaya observes, male camera crews away from home "are a little wild." She became known "as a person with a good temperament and a good character"— one reason being that she rarely drinks. "People loved to work with me because I could resolve many situations without conflict. I could keep my men working well. That was my specialty." If she worked with 35mm, her crew would be "ten to thirteen people. If it was a 16mm camera, it could be from three to six. If it was a video camera, four to six people."

Goldovskaya has also worked in other countries, including Austria, France, Germany, and the United States (where she lived at the time of her interview). She never felt out of place because "if you are good with the crew, they are good with you." For example, she was making a film in the United States in 1990 for Turner Broadcasting, called *A Taste of Freedom* (1991). Her editor, also a Russian immigrant, had an American assistant who did not talk to her all week and looked at her suspiciously. Because "I have to work in a friendly atmosphere," Goldovskaya did something a little unusual for her.

By the end of the week I took out a box of red caviar and a bottle of vodka, and I said, "Guys, let's just hang out a bit." After a while, the assistant editor told me, "All my childhood I was told that Russians are all spies, but you're OK." I said, "I was told the same thing about Americans!"

Goldovskaya feels "that film people all around the world are the same. They are such obsessed people. We may speak different languages, but the craziness is the same."

Sue Gibson, like many other female DPs, enjoys her managerial responsibilities as DP. She relies on her team of people because everybody has a role to play in the camera department. "Ultimately, my job as Director of Photography is to direct them as much as the photography. So if you can't work in a team, then you're not going to get the best out of your team." She does not find it hard to manage the team because they enjoy what they do. "Otherwise, why would they do it? Why would they go to work seven days a week?"

Gibson admits that the traditionally male film industry's grips and gaffers may treat her a little differently than they would treat a male DP since "there is a slight sort of gentility around the camera if you've got a woman as a team leader as opposed to a man." She does not know how other cameramen operate because she has not "observed many of them at work. I approach things in my own way. If you try to emulate somebody else, you lose your strength because you can only trust your own instincts." Gibson always works closely with the chief electrician to get her vision on film. She is quite specific about the technical details such as "what choice of lamp I want to have, what diffusion I use, what color I put on it. It's something you call 'the memory,' when you shot something particularly and you have to go back to pick up the shot. I can remember exactly what kind of gel I had on the lamp."

While gender may—or may not—determine broad differences in leadership, among women DPs there are nonetheless different styles of leadership. Sissel has talked about having adopted autocratic male role models to the possible detriment of her relations with crew, while Kuras says,

in the film industry, we need to look out for each other. Being a DP affords you the opportunity to be an egomaniac or to be autocratic. It's really important for women to understand that in becoming DPs they will be the leaders of the crews, not only technically, but emotionally. For many of my friends, that work on set is their life, largely. They live on set. So it's important that it is a good experience, and my job as a DP is to make that happen. You set the tone of the way things are going to be done.

Joan Hutton argues that traditional training to be "helpmates" means that "we're made to be cinematographers" since women are "perfect for working with a director because we want to help him get his vision." Some women have the sort of diplomatic skills associated with this stereotype; others might need to learn them. Ziegler has worked with the same assistant for more than fifteen years. "Working with Annie McEveety was a good lesson for me. She's

Figure 32: Lee Meily. Philippines.

always so gracious to the rest of the crew. She thanked everybody at the end of the day. I was out in my own world and I wasn't acknowledging their contributions."

Lee Meily and Priya Seth both seem to regard their role as a sort of benign caretaker who keeps everybody happy. Seth sometimes works on a set with 60 to 70 men working under her. "For me it's not a problem because I am fine with it and I have been doing it for a while. But for the men who come for the first time you have to set the boundary and tell them who you are and [that] you mean business every time until they know you."

Usually at the beginning of the filming she gets her whole crew together, especially on big Bollywood features, to explain what they must do, but she never mentions her gender because she avoids calling extra attention to her being a woman. She also says that "humor is not possible in the beginning because they are going to laugh at you, not with you." Seth deals with her crew slowly and with care for their well-being. In response, she says, "They told me a lot, 'You are the only one who looks out for us. You make sure we have had our lunch on time, get our tea break, and we wrap at a decent hour.'" Every winter she gives them sweaters. She thinks that, because she is a woman, she is just a little more aware of the people around her. "If they are going to do a job for me, I have to take care of them; otherwise they will do it completely impersonally. They do their job because they are getting money, not because we are doing something together."

Lee Meily is used to working with her own crew in the Philippines, and they are, she feels, a solid group who are happy working together. Before Meily became a DP she was a line producer in commercials, "able to gain the confidence of not only the clients and the advertising people, but the crew themselves." In a few years, she easily formed a team, choosing

my guys for me to train. I have a very good gaffer, Giorgio. He dives, like me; we shoot underwater, above water, and he's also with me when we shoot chopper shots. I have a key grip, Raymond, who started as a utility boy, somebody who makes coffee. My key dolly grip, Ariel, is also a utility. I have a couple of electricians and grips with me regularly, but these three, plus my assistant cameraman, are always with me.

Whether she shoots commercials, MTV, or documentaries, her crew is her team. She takes them everywhere, at least within their own country. When producers hire her, she always tells them, "When you hire a team, you save time, you save money. Because with just one look they know what to do. Just hand signals. It's fast and efficient."

In contrast to her excellent experience with crews in the Philippines, when Meily shot a feature in New York, she interviewed a gaffer and was astounded when he asked to see her portfolio. The line producer came up to her and said, "You can choose not to pick him." She said, "I want to give him a chance." During the shoot when she asked him "to fly three silk butterflies"[1] for her, he said, "I can't do it." That made her "proud of my Filipino crew who will never say, 'No,' who will always say, 'Mom, I will try.'" When the New York crew saw the rushes, Meily said, "they changed. Every morning I'd eat with them, share with them what I'd seen, or how it is back home, and it became solid."

Working together on two films and plenty of commercials, Meily and her husband learned the boundaries they needed between their personal and professional relations on set. When she and her husband are on set, they do not introduce themselves as husband and wife. She calls her husband Director, and he calls her Ms. Lee. They find it easy to collaborate as well as stimulating and creative, "because there's a certain respect, beyond husband and wife: respect because [one's] a director and [the other's] a cinematographer." They became friends, and later a couple, because of film. "Luckily we were able to shoot films together."

Of course, not everyone is so lucky as Meily is to work with the same crew on pretty much all her projects. "I don't want, from film to film, to be working with strangers," Madelyn Most says. "You have to teach them; then you leave them. It's alienating. Once you have a crew you can keep, you're a family; you love each other. With globalization, the producers are telling you who you have to use because they did a better deal with someone from somewhere else."

When it all works, though, the experience can be great. Eva Testor finds "the order on set, working with a large crew, really cool." She finds that "when you're so totally in tune with the whole, and everybody on set is concentrating on the moment, it's fantastic." To insure that experience, she explains, "You have to put a good team together, and that's what I do now. I don't work with just anyone and I won't have just anyone in my crew."

What of the future for camera crews? Arlene Burns likes it that camerawomen "can pull these little cameras out of a bag and shoot. A big camera requires a major set-up, huge amounts of batteries, Sherpas to carry things." She thinks that film is moving toward "stealth crews." "The ideal crew for me is a soundman, a cameraman, a director, a producer, logistics person, and talent. A team of five is a great working cooperative. You could even do the same thing with a team of three." She admits that it was hard being the whole crew "because

often life doesn't stop around you enough." When she was doing film documentation on river trips she was "always kayaking madly to get in front of the group and set up so I didn't change the pace of their trip, then capturing them, then kayaking madly to catch up with them again." Still, she finds great validity in "a person with a camera, just walking around and being the fly on the wall. The more people you have, the more obtrusive. So I'm excited about technology getting better and smaller and into the hands of the artist."

Working with Directors and Producers

Part of my joy in making a film is spending time with the director before we get on set, because that's my time with them to be able to talk ideas, to laugh, just being by ourselves and getting to know each other as people and form a friendship.

(Ellen Kuras)

Kristin Glover and Liz Ziegler worked on a film with a difficult director who had fired various camera operators before Glover and Ziegler were hired. The director "was abusive and cursed and screamed and spit and did all kinds of horrible things." At one point when Glover was shooting a close-up, she noticed that the actor, who was looking over Glover's shoulder, had a strange expression on his face unrelated to the scene. "I took my eye away from the lens and turned around. There was the director taking a pee against a fence, just yards away from us and directly in the actor's eye line." Both female camerawomen just ignored the director's behavior, worked on, and finished the shoot without getting fired.

In contrast to working with the worst kind of director, Australian Jan Kenny discusses how lucky it is when she gets a director who challenges her "to come up with creative solutions. You get to the end of the day and feel as if you pulled something out from somewhere you haven't been before and created something really good. There's nothing like that." For example, early in her career, a director taught Kenny "how to read female actors' faces in terms of camera position." When Kenny was "shooting straight on or slightly below eye line," her male director asked, "'Can I show you something? Just take the camera up a little higher. Now have another look.' I realized I ha[d] been reading these faces differently." Every day he pushed her: "Just through a comment, or throwing me a challenge, or saying, 'I want to create this.' You've got to come up with a way of doing it quickly. Working like that is why I get out of bed in the morning. It's fantastic."

To get that fantastic feeling of working well with a director, cinematographers often talk about the need to have conversations with the director before shooting begins. Canadian Kim Derko usually gets to read the script before she interviews for the job with the director; during the interview she pitches her style, presenting different ideas on how to shoot the film, often speaking about the story's impression on her "in terms of color." If she is hired, Derko

re-reads the script, and in the first meeting with the director after being hired, she'll ask about "what style of camerawork they like. You develop shorthand from how that director is speaking to you" (Moffat).

Joan Hutton describes her chats with the director as being on the lines of "'I like this, I like that, what do you think about this?' Sometimes we don't even talk about the film for the first hour. We're just getting comfortable." After this period of getting to know one another, Hutton then starts talking specifically with the director about the film, throwing "out every suggestion I can think of, and if you like it, we'll pursue it, and if you don't, we'll toss it out. There's no ego involved." She does her best to give the director as many options as she can. When directors realize the cinematographer's flexibility, "they get really excited about work because, at that point, everything's possible. Until the first day of shooting, everything is possible."

Zoe Dirse adds that the cinematographer needs to find common ground with the director in order to interpret her or his vision. She can achieve this by "sharing ideas about other films or whether you talk about your favorite painters, or your ways of understanding light and other images. A lot of it has to do with taste." Sue Gibson thinks the DP must be capable of "understanding where the director is coming from, whether you have the same sense of humor, the same sense of the tragedy, whether you like big close-ups of people." Heubrandtner likes the process of "getting on the same wavelength with someone in order to do a project together well. How much should one suggest images; how much has the director already visualized how the image should look?" "Wavelength" comes up a number of times at this point in many interviews. Most DPs see it as their responsibility to mesh with the director's vision.

Gibson, who has often worked with young people and first-time directors, says that if they are not intimidated by working with a cinematographer who knows more than they do, she can forge "really good working relationships. It becomes a symbiotic relationship. You feed off their enthusiasm, and they feed off your experience." Hutton also enjoyed working with entry-level women directors because "they don't know what is possible or not. They have wonderful ideas that they constantly toss out." She loves figuring out how to implement the ones that are possible.

Camerawomen recall both good and bad experiences with women directors through the years. For example, Seidenberg had one of those experiences that make feminists shake their heads sadly. A director contacted her around 1986 to film the Decade for Women's Conference that was going to be in Nairobi, Kenya. Seidenberg helped the director "put together what she needed for the film, like what camera she needed." After the director got funding, she then hired a male cameraman instead of Seidenberg. "I couldn't figure that one out at all. And the punchline to the story is that I got a job working for men on a B-movie in the south of France filming half-naked women running around at the same time this guy was shooting this Decade for Women Conference."

According to Sissel, many female directors in the 1970s-80s would say "that they preferred to work with men, because it was in their upbringing and in their mindset that they needed

to be supported by a man, not by a woman." Other women have also reported women directors not wanting to work with camerawomen. Talking with Glover about mainstream Hollywood filmmaking, Ziegler wonders "why more women don't support women. Because I don't see that at all."

Ziegler complains that women directors, women producers, and women who cast do not call her; their lack of support "seems strange to me." Meanwhile Ziegler "can think of close to two dozen males who have been unbelievably supportive." Part of the problem, she feels, might be her shyness. "Quite a few women actually seemed to be making efforts to be friends. A few celebrities called me and I never returned the call because I just can't." Ziegler admits she is not the kind of person who walks into a social event and feels comfortable, but "in a working environment, I feel comfortable there."

Glover agrees with Sissel that some women directors are afraid of taking chances, wanting to work with cameramen, whom they perceive as safer choices. "Sadly," she says, "they don't have confidence in our ability even though we may have a good reputation and resume. They're so terrified that they hire who the guys tell them to hire. That's my theory." Hutton puts the point in conciliatory terms, explaining that some new women producers "are in a precarious place. They're proving themselves, so can they take the risk of taking on this woman DOP who they don't know, and they don't know if they're good?" Hutton feels that the first time for new women directors and producers is always difficult, so "you want to go with who everyone else has gone with because that's safe. The people who don't worry about being safe, and will leap and take that chance, I've got an admiration for, because I've always been a leaper myself" (Moffat).

Kuras thinks that "fear keeps people from allowing opportunity to happen. Sometimes women producers are afraid to hire a woman DP because if that DP fails, it's a reflection upon them." On the other hand, Kuras continues, "Women producers are some of my greatest supporters. On *Blow* [Ted Demme; 2001], [executive producer] Georgia Kacandes was just incredible about being supportive. I find that's more the norm than not; women want to help other women to succeed because it benefits everybody."

Mairi Gunn has gotten her biggest breaks from female directors whom she describes as confident or individualistic. "These are strong people who are honest about their own deficiencies and aren't trying to pretend that they are perfect; they don't want a machine-like perfection, a kind of terminator figure in the role of camera." Because she identifies these female directors as clever people who have experienced life, "when they give me breaks, it feels good." On the other hand, even though she might understand why, Gunn does find it galling to watch when new women directors prefer to work with a strong male cinematographer.

Claire Denis gave Agnès Godard an early break, hiring her as camera operator on *Chocolat* (1988). Godard continued to work with Denis for almost ten years, including as DP, winning awards for their work. Godard adds that in France more and more women are directing films but these films are often classified as women's films, which amuses her. Godard believes that personality, not gender, determines how we see.

Zoe Dirse got her first job at the NFB shooting for Dorothy Hénaut. "I asked her, 'Why are you picking me?' She said, 'Because you have good taste and I know you'll be very good.' That's all I needed, that confidence." This film required Dirse to do technical things like front screen projection that she found nerve-racking at first, but it was a good experience.

Katie Swain, who is more sympathetic to a female director, expects a female director to be more sympathetic to a female DP because she knows how hard it is to be a female DP in a male-dominated industry. Swain has been bullied on the set, and she has seen female directors being bullied verbally because some men see them as vulnerable. "We're the minority, and in any minority it's good to help one another," she argues. So does it matter whether the DP's director is male or female? Joan Giummo, to her surprise, found that "when I worked with men I was more apt to be deferential than I was when I worked with women. I was free to be open and participatory when I was working with women." Akiko Ashizawa also likes working with female directors: "I don't need to talk much, and that makes it easy." Kirrily Denny thinks that "female directors can bring positive energy and sensitivity to a production, which is inspiring."

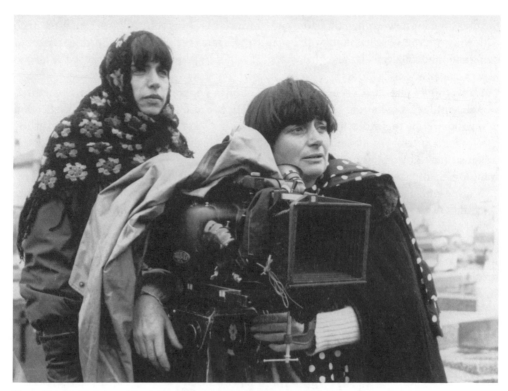

Figure 33: Nurith Aviv and Agnès Varda. Photo courtesy of Aviv and Varda.

As a director, Agnès Varda has highly praised the women cinematographers who have worked on her films, including Nurith Aviv. Varda and Aviv collaborated on Varda's film *Daguerréotypes* (1976), a documentary that they filmed at Varda's house in Paris. Aviv used a 16mm camera, mostly on her shoulder but sometimes on a tripod. Varda said Aviv has a "fabulous eye. I had an understanding with her, a formidable osmosis. Sometimes I'd make a little motion, a little tap on the shoulder; sometimes from afar I'd tell her with my eyes. She'd make a fabulous, sensitive image that was exactly what I had wanted her to do."

Aviv also described how well she and Varda worked together on this project, their first. By the second day of shooting, "there was one shot that became longer and longer; it was like magic so we stopped discussing and let things happen. Other parts of the film were precise and she [Varda] said exactly what she wanted" (Dirse, "Women"). Aviv would propose the framing and then they would try "to do it without discussing the shot," knowing what they wanted. "This happened often with Agnès. My job is to know what she wants for the film" (Dirse, "Women").

Varda and Aviv continued working together on *One Sings the Other Doesn't* (1976) and also on *Documenteur*, a film made in Los Angeles in the 1980s that Varda likes very much. "It is a fiction film but with unscripted material that we filmed at the station, in the streets, in laundromats, and she [Aviv] was at the camera. An extraordinary sensitivity. I had such rapport with her work, it was like filming myself."

Varda also describes working with cinematographer Agnès Godard, who "has become very famous and has even won a César." Varda had already started *Jacquot de Nantes* with cinematographer "Patrick Blossier, who couldn't finish it and suggested that I use Agnès Godard." Up until *Jacquot de Nantes,* Godard had not worked as a DP, but she was hired and she "did a third of the filming of *Jacquot de Nantes*. At the time she was still a beginner, a little frightened. She was even a little bit shy about her profession." Yet Varda could appreciate the "extraordinary control and talent" in Godard's work.

Varda has also had other women working behind the camera on her films, as focus pullers, camera assistants, and soundwomen. She says, "I worked with the first woman sound mixer in an auditorium. I fought hard for women to become technicians. For example, I was behind the first woman to obtain an official chief operator card in the field of cinema. That was Nurith Aviv." Varda is happy that about 40 women in France work "behind the camera as camerawoman, chief operator, or director of photography in films that have made a sensation." She acknowledges that many male directors are also pleased to work with camerawomen, the first being Bertrand Van Effenterre, "who hired Nurith Aviv to film *Erica Minor* [1973]. This made everyone understand that filmmaking is not a domain reserved for men only." The ongoing success of camerawomen and women in other technical positions whom Varda has supported by hiring them shows the influence of a well-recognized woman director.

Spaniard Teresa Medina has worked with two female directors: Ana Díez and Isabel Coixet. In contrast with the older American filmmakers, she finds that women directors tend to have more women on the crew and there is less competition. "When you work with

male directors, there is more emphasis on 'I did this,' followed by 'you have to do that.' They are both amusing to me."

Indonesian Angela Rikarastu says that she does not consider the director's gender. "A good director who could understand about teamwork—he/she doesn't think about gender anymore, just creativity, talent, and sense—can help you establish your name in film."

B. R. Vijayalakshmi seems to have had an enviably smooth introduction to DPing on her first film with K. Bhagyaraj, a famous male director of Tamil films. Because she assisted on a film that Ashok Kumar shot for Bhagyaraj, the director had seen her working on the sets. He told her he would give her a break if she continued working for one more year. He kept his word in 1985, calling her to do *Chinna Veedu*, thus providing her first opportunity to shoot independently. Bhagyaraj, who was also "a producer,"

> *gave me a lot of encouragement. He said, "Whatever equipment you want to use, and take as much time as you want. When you think back on this experience, I want you to think of it pleasantly." It was very nice. That film did very well. After that I have done about twenty films. On average I have shot two films a year. Feature films.*

For Madelyn Most, the two male directors who have most positively influenced her are George Lucas and Marcel Ophüls. Working on Lucas' *Star Wars* gave her a calling card for other jobs and access to many people in the industry. However, in terms of content, she credits Marcel Ophüls as the person who changed her life. Working with him, Most "spent a lot of time" with people who had survived the Nazi concentration camps, "interviewing them with him and then in my own films." Filmmaking for her "became so serious. It's not entertainment to watch people killing each other."

Having worked primarily with British directors, Sue Gibson says some directors are specific about what shots they want while other directors let the cinematographers be creative and guide them in choosing shots. (This reflects a split in responsibilities that goes back to early Hollywood studio practice when in general the director handled the actors, dialogue, and editing but left the "physical direction in the matter of the visuals" up to the cinematographer [Higham 7].) Some directors let her be in charge of storyboarding; others work with Gibson on the storyboards. On some films everything was storyboarded, with production meetings that lasted for three days. "We talked about every single frame in such complexity. And everybody has an input on 'how do we achieve this?' It becomes very collaborative at the end of the day when you are on the set."

Eva Testor thinks that too many Austrian directors do not want to work with camerawomen, especially compared with German directors. Testor points to Austrian camerawoman Christine Mayer, who left Austria for Germany "because she simply couldn't get any work here, while in Germany she works and works. Also, there's Birgit Gudjonsdottir [from Iceland], another good camerawoman, who's very busy working in Germany." Testor attributes the small-mindedness to Austria's being a small country with a small film industry. "It takes longer for customs to change here. Cinematography has

been a male domain all around the world; it will take longer in Austria for women to break into it."

However, Testor says Austria's mostly male producers are the biggest problem in Austria, not directors. But the Austrian film industry is beginning to develop a few female producers. She has worked for a "young production company" with a female producer: "The idea that because I'm a woman I couldn't shoot the film never came up."

Sarah Pillsbury is one US producer committed to hiring women cinematographers. For example, Pillsbury worked with Joey Forsyte on *Seeds of Tragedy* (Martin Donovan; 1991), a television movie her team did for Fox, and Forsyte "did extremely well, going to another country [Mexico], with much of her crew not speaking English. People often say, 'You can't get great cinematography on television.' She proved people wrong." On that film, Pillsbury says, "There [was] sometimes unconscious sexism. She [Forsyte] was undermined by the line producer, who created tension by pressing us so much on time." Pillsbury says that when the unit production manager is more interested in the budget than in the film, he or she creates problems. In this case, with Forsyte as DP, they came in under budget.

When Pillsbury was doing preproduction for *The Love Letter*, the star, Kate Capshaw (also one of the producers), and the director, Peter Chan, were "interested in hiring a woman DP. Most of the people [he] interviewed were women." Chan hired Tami Reiker, who had just shot *Pieces of April* (Peter Hedges; 2003) on mini-DV. Pillsbury describes Reiker as

> totally game, working with a crew that didn't have a lot of feature experience. Most of our department heads were bumped up to department heads on our movie. She was so well loved that towards the end of the movie we had a Tami Reiker Day where everybody on the crew dressed like Tami Reiker, with her trademark bandana.

The percentage of women working as camera operators and directors of photography on big-budget productions is not low for lack of ability.

Acting Like Men to Fit In

I was trying to be one of the boys.

(Lisa Seidenberg)

Must camerawomen act like cameramen? Feminist film theory has asked, how do women—who live in cultures where male perspectives dominate—escape that dominant conditioning that trains us to think, see, and speak like the dominant culture? The concept of *immasculation*, articulated by Judith Fetterley in 1978, holds that women are taught to think or write from the male perspective, i.e., to respond automatically, in the face of literature (or any other

art), *as male* (Fetterley *xx*). Camerawomen, who often talk about having been taught by men, sometimes conclude that they therefore see and act as men. The effect on their filmic visions is considered in Chapter 10, while this section focuses on the psychological and practical effects of immasculation on camerawomen's professional behavior.

Many camerawomen have spoken of the need to make themselves into men. Aminata Wade says this is not a problem for her; she has always considered herself a "*garçon manqué*," a tomboy. But many other camerawomen have consciously tried to blend into the male atmosphere. Christine Heitmann chose to "cut my hair short and wear masculine clothes to be accepted in a male-dominated field." Gadihoke notes that "many women have talked about how initially they had to become one of the boys. You sit and have a drink and a smoke with them; you listen to all those dirty jokes." Gadihoke opted out of immasculation "because I don't smoke and I don't drink. I can never have those late night sessions bonding over booze or a cigarette."

Sissel spent years and years wanting to be one of the guys. When driving around in the car with the all-male crew, she heard them talk about "this set of tits and those legs." She remembers once, in the car, she said, "Hey, look at her tits; they're great." She adds, "You just begin to be like that. You begin to talk like that. You begin to think like that." Many times when she wanted to cry, remembering that her masculine persona disallowed it, she stifled her feelings.

For Dirse it wasn't exactly a choice either. While working in English Canada, she felt bullied into acting like a man, and she imitated male behavior and mannerisms to fit in. Later, working in French Canada, the men on the crew confronted her, asking, "Why do you have to look like this? Why do you have to behave like this? Why don't you just be who you are?" Eventually, Dirse escaped feeling bullied into acting male through the encouragement of these colleagues "to develop my own sense of style and looking. I went through a transformation in terms of my hair, my clothing, and my whole perception that I could be who I am."

Interviewed in 2003, Glover felt that nothing had changed since the '70s.

> How can a young, beautiful camera assistant report that she's being harassed by her boss without fear of losing her job or being blacklisted or being thought of as a sissy, or whatever? I have witnessed a pervasive attitude among a lot of women, which makes me sad, that they have to be "like the guys" in order to succeed in the camera world.

Often being like the guys means putting up with sexual harassment—just going along and stifling feelings.

Several camerawomen talked about a sort of split personality. Medina said that, working as a camerawoman, she uses her "masculine energy," but after work, "It is a transformation between Dr. Jekyll and Mr. Hyde. No more jeans, tennis shoes, t-shirts, and the hair up. When I go salsa dancing, it is really me."

Madelyn Most relates to this split personality; she also dressed "ugly," like a boy. Once, when working on a film, she met a man who asked her, "Why are you always wearing those baggy pants?" She answered, "So I don't have to talk to people like you." Then she found

out the man who had questioned her was the producer. On the other hand, for an end-of-picture party, she wore makeup and did her hair, and they did not know who she was. For Most and many other camerawomen, the "strategy was to be a guy."

The Advantages of Being Female

As we have seen, under the influence of feminist pressure, government policies have provided huge breaks for camerawomen in some countries. In the early 1950s the Chinese Communist Party encouraged women to enter male careers, including camerawork. Three decades later Second Wave Feminism changed attitudes in Australia and Canada, where government initiatives trained women for jobs in filmmaking. Even in the United States, affirmative action efforts led to some changes in hiring practices.

Canadian Zoe Dirse became closely associated with Studio D and with women's projects. "There was a whole philosophy that women should work with women and support each other. So I was fortunate. Then I found that I would get a lot of work, especially documentary, from women because I had established myself as working with a lot of female crews." Under the leadership of Kathleen Shannon, Studio D made films for women as well as by women. Celebrating Studio D's twentieth anniversary in 1994, its executive director said, "We have to dare as we have in the past to be different, to be feminist, to be 'out,' to fight back" (Vanstone 11).

Sandi Sissel also benefited from Studio D because at first there was a shortage of Canadian women for camera crews, especially at the DP level. Early in her career Sissel often worked for the NFB—not just Studio D—on stories where they wanted a woman to shoot so as not to look threatening or because the subject matter meant that it was better to have a woman. Similarly, some Australian women think they got as well as lost jobs because they were women. Kenny, for one, states that, "for every job that I probably was not on because I was female, it's fair to say that I did get jobs because I was female." She also believes that in Australia "it's as difficult for men as it is for women to make that break from assisting to shooting."

Austrian Astrid Heubrandtner got a job on the documentary film *True Men*, which had as its subject, "Has the image of men changed?" Conceptually, the film divided into "two parts, one directed by a man working with a cameraman, and the other directed by a woman working with a camerawoman." Eva Testor, faced with the sexism of the Austrian film world, collaborated with Nina Kusturica to set up a production company called Mobilefilm. Though it was never Testor's primary goal to set up a production company, she and Kusturica are actively producing. The irony is that, because of the absence of other female production houses, Testor and Kusturica have found themselves in "relatively high demand precisely because we are women. All of our projects have been women's projects. We aren't hardcore feminists, and I don't want to be, but it's nice to be able to fill such a gap."

Sissel started working for the TV networks on their magazine shows in the late '70s, including ABC's *20/20*. She often found herself working undercover, for example, for a piece on people paying money for unnecessary abortions. She was asked to pretend she was

pregnant, "go into abortion clinics, and see if people would say that I was pregnant and give me an abortion." With the camera filming from its hiding place in her bag, she sometimes found herself in the stirrups; but before any procedures could begin, "I would suddenly freak out, jump up, and walk out."

That episode led to her impersonating a prostitute in Las Vegas for a *20/20* show about unethical doctors. She would complain to doctors about being unable to sleep and "ended up after a month with a mound of Quaaludes and sleeping pills and cocaine—all kinds of things." Next she impersonated a homeless woman on the Bowery in New York. She thought doing undercover roles in a female disguise was fun. As a bonus she learned about specialized cameras: In the late '70s and early '80s she used an Aaton camera, but later it was tiny video cameras and lipstick cameras as they developed.

Often the person being filmed responds better to a female behind the camera. For example, for a four-year period Sissel was called every few months to go off with Mother Teresa in Africa, India, South America, and all over America and Russia. Sissel had

a wonderful experience because she's a wonderful subject. It also was wonderful for me after having done so many seedy, dark stories. She didn't try to convert people; she tried to feed and help poor people. She's the only celebrity I've met who seemed absolutely real from day one until the end.

Ed Lachman and Sissel shot *Mother Teresa* together, splitting some of the shooting whenever one or the other was unavailable. If they happened both to be available, Sissel remembers, "Ed oftentimes would do the big picture off somewhere, and I would be right next to Mother because of course Mother was nervous around men."

Camerawomen are often hired to film female interviewees discussing painful subjects. For example, during preproduction for Canadian documentary *Runaway Grooms* (2005), filmmaker Ali Kazimi realized three weeks before he was to go to India to shoot stories about Indian women who were part of arranged marriages with Canadian men[2] that all of his interviewees in India were women and he had an all-male crew. A cinematographer as well as the director, Kazimi realized it might be a mistake for him to shoot those interviews and asked Zoe Dirse to shoot them. While it was obvious to Dirse that "it was advantageous to have a woman on the crew," she was nervous about shooting for a director-cinematographer, because "I'd have to get it exactly how he wanted it. [But] after the second day he said, 'Put the monitor away.'" While she was shooting, Dirse saw that the Indian women "felt so much better that I was there too instead of having a wall of men, because the man was the one that did them harm."

Dirse's gender also worked for her as cinematographer for *Forbidden Love* (Aerlyn Weissman and Lyn Fernie; 1992), about lesbians in Canada. Dirse is not a lesbian but the directors are. The directors talked to Dirse about the lighting and the framing, especially for the lovemaking scenes, the most sensitive scenes that they shot. "I had my own aesthetics [to] bring to the beauty of the female body and how [it] should look, but we had a good

relationship with the directors. That is key." For the award-winning *Erotica: A Journey into Female Sexuality* (1997) director Maya Gallus "was specific about how she wanted the film to look, and part of her discovering eroticism within the film was the framing." Being female, according to Dirse, meant that "I could—and they knew that I could—do the work that they wanted for their film."

Some camerawomen have a political explanation for why they have an advantage in some situations. Nurith Aviv notes that camerawomen, or at least Western camerawomen rather than Western cameramen, working in developing countries have "an advantage, because a white male is a symbol of power and since a woman has no power, what the subject gives to the camera is different" (Dirse, "Women"). Joan Hutton argues that even in developed countries like Canada camerawomen are not viewed as the power symbols cameramen might represent and so subjects relax more readily. She discovered this at a time in her career when she used to work on a lot of social issue films: "It was so much easier to get people to open up to me. After two days, they were my friends. They'd forget the camera was there and they'd come over and chat away as if there was no camera at all."

Hutton received one of the best compliments of her career at the end of one long day working on *The Newsroom* when director Ken Finkleman turned to her and said, "You are the most egoless person I have ever worked with." She liked the compliment because her mentality and ego did not interfere with focusing on achieving what the director wanted.

Kim Derko, who has worked on both social documentaries and lighter television fare, finds that stereotypes of women helped her work. Working on *Say I Do* (Arlene Anni; 2002), a film about Filipina mail order brides, Derko traveled to the Philippines to film women who were trying to leave their country. While the director was Filipina, there was a soundman, but Derko feels that "we wouldn't have gotten the responses and the intimacy if it had been a man who was operating the camera." When the film crew went to Clark Army Base, a notorious red light district with very young girls, Derko walked through with her camera. She recalls that "army generals would look at us like, 'That's weird; there's tourists with cameras walking through.'" They filmed a whole sequence: "Had we been a logo-bearing male camera team, we would have been kicked out immediately" (Moffat).

Derko's experience working on a Canadian TV series called *Show Me Yours* led her to an insight about the psychological effect of a camera operator's gender. Being about two sex writers, the series had a lot of sex scenes. Derko had seen that a male camera operator "is almost invisible to the male actors, but the women actresses have a self-consciousness that erupts, which turns into man-photographer and women-subject." When she shot *Show Me Yours*, she found that the actresses "were relaxed and there was none of that self-consciousness, and the men were a little self-conscious" (Moffat).

Gadihoke has taken advantage of the stereotype that underestimates women to gain better access to certain subjects. She went to Ayodhya in 1991 to visit the Babri Mosque, which was a focus of conflict at the time because both Muslims and Hindus claim the site as a holy place. Gadihoke went there with the Mediastorm Collective only to find it surrounded by "barbed wire and security forces." The security police were not letting any media crews

inside the inner sanctum. Nonetheless, Gadihoke asked the guard if she could go in. The guard "probably thought to himself, 'She's a girl. What is she going to be able to do?'" He let her in and Gadihoke was the "only one who got a shot of the inner sanctum at that time."

Some Western women have found it easier than Western men to do camerawork on assignment, specifically in Muslim countries. In another example of how camerawomen have benefited from examples of negative stereotyping of women, Canadian Deborah Parks found that "working in Egypt was easier than most people think. Being women, nobody took us seriously. They all thought we were school kids, university students, making home movies." The experience was even better for Heubrandtner. "When I was in Damascus shooting *Marhaba Cousine*, we were never taken seriously. We could film anything. That combination of not being taken seriously and having great opportunities to work was very pleasant."

Working within her own culture in Afghanistan, Mary Ayubi had a mixed experience. She found that most Afghan women talked to her and her female crew more comfortably than they would to Afghan men. However, the men only "wanted to know how we use the camera and if we know how to use it. If we wanted to interview men, they rejected us." She was cautious when talking to men, always respectfully calling them "brother," and "tell[ing] them we want to help. They would say, 'We don't talk to women. Who are women and what do they have to say?' There were some who would say, 'Sister, we want to help you. What's your question?' And sometimes women would flee from us." For women, talking to the media carried its own dangers.

In contrast, Rozette Ghadery's experience as a camerawoman working in Iran was more consistently positive: "You won't experience difficulties solely because you are a woman. You might even get treated better as a woman. You know guys." She did admit that there is an old boys' network—"the old school supremacy who won't welcome new perspectives"—and explained that these Iranian male cameramen "don't like having more new camerapersons in the group. This applies to cameramen and camerawomen to the same extent." Ghadery has since moved to Toronto.

Notes

1 Framed silks used to cut down on light.
2 Dirse explains that the Canadian grooms went to India, took huge dowries from these women, and slept with them. After returning alone to Canada, the grooms sent the women "divorce papers six months later, having taken all of their money and ruined their reputations and their lives forever."

Chapter 9

Magic moments, worst moments

As technology changes, some of the magic moments described here—the ones to do with the physicality of operating equipment, of using hard-won skills to produce moments of beauty—may become increasingly historical in kind. However, as technology changes and operators adapt, people always discover new ways of deriving pleasure from working with the equipment. Meanwhile, the general goals of filmmaking— to tell a story that can be useful and/or entertaining—remain the same since Horace introduced the phrase *dulce et utile* into our vocabulary of literary, philosophical, and aesthetic knowledge.

As for some of the worst moments described here, they are powerful lessons for changes in practice that need to be made. The industrial accident that ended Estelle Kirsh's career is unfortunately not an isolated incident. The social and economic issues associated with such tragic moments also raise legal questions about responsibility. As the industrial structure of gathering images for commercial purposes changes, the question of who has responsibility for worker safety remains. In the past, paternalistic employers have used safety as a way to block women from the workplace. Once again, though, improving conditions for camerawomen can lead to improvements for all involved.

Satisfactions

Q: *What, to you, is the most meaningful thing about being behind the camera?*
A: *It's magic.*

(M. Shanti)

Sabeena Gadihoke notes that, although playing with technology is generally part of male socialization, she takes great pleasure in the technical mastery of the camera that she holds in her hands. "There's a sense of power, of sexiness, with the camera, which I must admit that I do feel." She experiences other pleasures built on her technical mastery, especially aesthetic pleasures, along with something more that she cannot "rationalize." She enjoys "taking technically perfect images as a feminist woman," but there is also the pleasure in using that technical mastery to give herself "the power of representation," not least because "it forces me to think of ways of representation that are perhaps alternative."

Gadihoke as well as many other camerawomen around the world have discovered they enjoyed taking things apart and putting them back together again. Erika Addis had traveled

around Australia on a motorcycle, "which involved a lot of tinkering with the engine"; she says she is "absolutely drawn to anything with machinery and technology." After her first contact with the actual processes of making a film, she was especially drawn to the technical side of camerawork.

Even camera trainees can have a moment of satisfaction dealing with a challenging situation, as Estelle Kirsh experienced. She was a trainee on a Hollywood show that was on location one day at a West Los Angeles high school watching teenagers play basketball. The crew had built platforms that were fifteen feet high; the regular assistant got sick and went home while the second assistant was an elderly gentleman who could not climb up the ladder. "So they made me the first assistant. There I was, the trainee, pulling focus. It was a great experience. This was one of the assistants who did not want me there, but who said, 'Since you're here, I'm going to train you properly.'"

Many jobs lower on the camera hierarchy can be routine. As camerawoman-turned-director Sabrina Simmons said, "Being an assistant doesn't call for any real creativity. Once you've got it down, you've got it down" (Krasilovsky, *Women Behind the Camera* 176). As a camerawoman moves up the hierarchy, she has more chances to have real input. Jan Kenny found a secondary role offered her satisfactions when she DPed Second Unit for Gary Hansen on *We of the Never Never* in Australia. She had an "extraordinary" experience on "a difficult and trying" twelve-week shoot on the Northern Territory along the Roper River, where the source novel was set: "Half the crew had gone troppo,[1] the food was crook,[2] the accommodation was crook, the showers didn't work most days," and the crew were living in cabins and campervans. After she arrived, she looked at the rushes and talked with Hansen as to what visual style he wanted her to get. Then she was

> given quite a lot of freedom to go off with my tiny unit and shoot our stuff, most of which I also directed. I found that enormously satisfying. Shooting Second Unit's great anyway. You get the fun and less of the responsibility. I loved that and I loved finding a way to emulate the look that Gary was creating.

As camerawomen move up the camera crew hierarchy, they have some input into creative decisions, e.g., lighting, camera movement, angles, distance, filters, lenses, film stock, and so forth. At the camera operator level, American Kristin Glover remembers "exhilarating moments where I felt like I might have had some input." Filipina Lee Meily talks about the aesthetic empowerment: "Because the cinematographer is the one who sets up and you're there most of the time, *your* voice will be heard."

As DP, Kiwi Mairi Gunn enjoys seeing the director's and the scriptwriter's ideas come to fruition: "The art department has done their bit, and the actors. You feel lucky to be in that position because you've definitely got the best look at what's going on. To see a frame through a lens is a great privilege; it about takes your breath away. It's magic, really." Spaniard Teresa Medina calls it the "magic moment" when she sees all the elements of the film coming together:

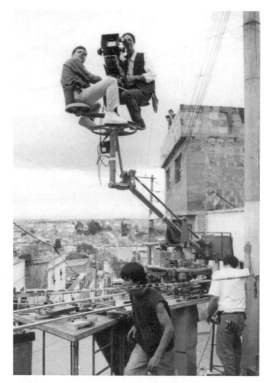

Figure 34: Teresa Medina, AEC, on crane. Spain.

When you are doing a take, and then you do one more, and then you feel that all the elements align themselves, and you are the first one that is seeing it. All elements—actors, lighting, décor, the framing—it has all aligned. To be on this side of the camera, watching it, you feel like an alchemist.

Liz Ziegler acknowledges that often "things are bumpy and lumpy, and they don't fall together well." Then she refers to a shot she did on *Magnolia* (Paul Thomas Anderson; 1999) that is on her reel. "The camera was Dutch and I was wearing a speed aperture control on my back, but every element of it just flowed perfectly. I did take after take and it felt right every time. I like that. I just feel kind of right in the moment with the shot." The satisfying moments may seem like exceptions—but they are often the culmination of a process.

Mexican Hilda Mercado provides a refined analysis of the multiple moments that are key for her as DP in any production, whether in Hollywood, Mexico, or on location in other countries. The first important moment for her takes place in preproduction when she reads the script, understands the characters, and develops a "look" through meetings with the crew. She is preparing and visualizing certain images in her brain. The second important moment comes

after she is on the set when all those meetings with her director and the production designer start to become reality. "This is a very beautiful moment, when it all seems to be falling into place. I then feel like all the effort and time has been worth it. When you have a crew that is behind you it is brilliant." Another wonderful moment happens when she sees her problems being solved. "Sometimes because of these problems you learn how to be more creative with your craft. When the problems are being solved, it is as if the story is thanking you for giving it so much of your effort. It is better than getting a million dollars for your help."

Iranian Rozette Ghadery also loves the discovery that working with the camera offers. She thinks that the cinematographer's play with light, especially when it leads us to see something differently, is a major part of the pleasure and satisfaction of filmmaking. She calls discovery "search and questioning. A person starts experiencing the new, finds new structures, and discards all of the established standards and meanings that one has master[ed]." She finds this discovery is important in cinematography and camerawork when

we discover new rhythms, forms, and shapes. We change the way we saw things or thought about things beforehand. For example, Kieslowski in The Double Life of Véronique *[1991] shows a coffee cup in a close-up, but because of the lighting, it does not look like a coffee cup anymore. You may even ask yourself what it is. By changing the way we normally present or see things, we create new things: new objects, new forms.*

Other women talk about the pleasure of meeting people whom otherwise they never would have met. One of American Kristin Glover's most thrilling experiences came to her when she volunteered on a documentary about the Dalai Lama of Tibet. "That documentary afforded me ten days in close proximity to him, which changed my life. It was another experience where I worked for free and came away greatly rewarded—much more rewarded than I had been in my regular work."

For other camerawomen the high point has been filming in a particular location, as when Mexican Celiana Cárdenas found herself "aboard a three-propeller helicopter at 35° below zero without a Tyler—only being strapped down—while flying over the Baltic Sea." Russian Marina Goldovskaya considers the two months she spent filming at the South Pole as one of the biggest thrills in her career. Once she returned, she remembers

standing for two weeks at the developing machine watching my footage come out. In Antarctica the conditions for shooting are difficult: lots of sun, light, and snow everywhere, and the faces are dark. I was not sure I did a good job. Until I watched it all, I didn't have a quiet minute.

Camerawomen like Canadian Deborah Parks speak of enjoying the intensity of the work as well as loving collaboration with sound technicians, directors, etc. In addition, Australian Erika Addis speaks of "energy," especially connected with the intensity of the physical experience, something many camerawomen highlight. The intensity of working out lighting, the mental

concentration it requires, becomes transcendental for British DP Sue Gibson, along with providing the pleasure of self-expression. When she is lighting the set she is creating her own little world: "It's like somebody's giving you a box of paint to paint the picture. You can go, Yes, I like that, or, No, I don't like that. Why don't I like it? OK, I'll just lower the lamp two feet. Having an ability to create something that is peculiarly your vision." Turkish camerawoman Berke Baş also loves the need to focus to the extent that "there's nothing in the back of your head. I'm fully concentrating, so it takes me away from all the other things."

Working with the camera has revealed new parts of herself to Baş. Usually shy, she behaves differently with her camera. For example, attending a wedding as a guest she would usually sit in the back, but with her "camera I can be on the stage." She filmed a concert and again found herself going onto the stage. "I would have never, ever done it if I didn't have a camera in my hand. It gives you such courage, and such a sense of being."

When she was young, Gibson was also shy and timid. "In social situations with strangers, I would hide in the corner and not say anything. The camera gave me a means to interact and it's still that way." Gibson learned to befriend the actors, making them feel secure. "You make them feel comfortable with you so when you are behind the camera, they trust you; if they have a relationship with you as a person, the camera is just a person." As Gibson gained more experience with camerawork, she learned how to use the camera to form relationships on the job.

Like Baş, American Joan Giummo feels working with the camera has changed her personality, giving her more confidence. When she could perceive "what was important to me, to shape it, and frame it, and present it in the way that I thought was appropriate to the subject matter," she felt independence and pride in what she had produced. Video also enabled Giummo to march into situations with her camera that she would otherwise have been hesitant about approaching. She says that "going around with a camera separated me from a sense of danger." She knew that safety was an illusion, but she "often moved into places that were dangerous. Because I was approaching it through the lens I felt some protection." She developed not only self-confidence but also courage working with the video camera. Gadihoke calls the thrill of satisfaction in overcoming difficulty "a very empowering experience. I'm very happy that I'm a cameraperson; it gives me a high."

Camerawork has taught Canadian Nancy Durham how to get through difficult times. When on a job in a strange city, after work she goes to her hotel room. "It doesn't matter what city in the world or how nice or how horrible a place you go," she feels "alone out here. What am I going to do? I don't know anybody. What restaurant will I sit alone in tonight?" On these difficult assignments she has to conquer "something in myself, maybe some fear of not being able to survive or fear of loneliness or whatever. Then you get past that and it's wonderful."

American Lisa Rinzler enjoys challenges: "Like shooting in a country where you're communicating with people who are speaking another language, or where you're trying to make things out of very little, I mean, not the exact tools that would make it the easiest or the smoothest." Sometimes the content of a film poses as much challenge as the technicalities of capturing images. For example, French DP Agnès Godard found shooting *I Can't Sleep*

(Claire Denis; 1994) difficult because the subject was homosexuality and the male criminal, but she took enormous pride in a part of *I Can't Sleep* because "I finally found things, but I realized I found things only when I saw the film." Godard shot another challenging film, *Beau travail* (Claire Denis; 1999): "It's a very minimalist film, but I'm happy about the texture of the film." Her camerawork on it won several nominations and awards.

Sometimes the boost to one's self-esteem comes from within as one recognizes that one has done something difficult, exposed the truth, or created something of beauty. Part of the reason for satisfaction with doing camerawork is how it allows these women to think of themselves. Asked how it felt to be one of the few camerawomen in Iran, Ghadery replied, "I feel great. It definitely helps my self-esteem." Gibson has a caution about finding that self-esteem: "You can only get satisfaction in this job from yourself. You can't measure it in terms of whether your cinematography is better than somebody else's because everybody has a different style."

The physical experience of camerawork, many of these women say, is quite simply what gives them pleasure. Austrian Eva Testor says, "Now that we have a production company and I sometimes make my own films, it is simply a joy; I see that as my calling. However, my focus remains camerawork; it gives me a heartfelt satisfaction." Asked how she feels about being a young woman in a man's world, Senegalese camerawoman Aminata Wade replied, "I feel at ease. I'm comfortable with my work because I do it with pleasure. It is my passion."

For Kiwi Mairi Gunn, shooting *Erin's Exiled Daughters* (Shirley Gruar; 1997) in Ireland was a wonderful experience, especially catching a bird in flight. She found that keeping the bird in the frame was quite different from sports photography where she follows, for example, a golf ball: "It's a bit like that, but there is something to do with the connection between the camera, myself, and something happening in the outside world." Another shot, involving a pan onto a piper sitting on a rock in the Irish moors gave her a feeling of spiritual understanding of the location. "There is some sort of connection, some sort of relationship sense, and not of one dominating another, not voyeurism, but a kind of connection, a communication."

One of the things American Arlene Burns likes best about the profession of camerawork is alternating between very hard work and a lot of free time. When she is shooting a documentary, "You're thinking it, eating it, living it, and breathing it. But there's a beginning and an end." She loves these alternate cycles because "it keeps you awake and alive; it means when you're finished with a project you totally have your own time." She acknowledges the lack of security: Camerawork is not "a nine-to-five thing for the next twenty years of your life." Since so many elements are involved in making the deal for a film, sometimes she goes through

> *periods of drought that make you wonder if you should get a job at McDonalds. Then you'll have five projects that overlap and you have to choose. That part is harder, especially if you have commitments and responsibilities that require a substantial amount of income coming in on a regular basis.*

She has simplified her life so she can cruise through these dry spells.

Many camerawomen talk about the pleasures of looking. What Indonesian Angela Rikarastu loves most about being a camerawoman is "that I become an eye for everyone. From my eye I can entertain, give information, influence by persuasive personality, by representing reality, and can even change people or conditions with this visual medium which can talk more than the spectators see."

Like Rikarastu, French director and camerawoman Agnès Varda refers to the basic pleasure of looking, what film theory calls "scopophilia." Emphasizing the driving force of the experience of looking, Varda connects it first with the physical pleasure of operating the camera and then with the pleasure of sharing what she sees with other people:

First, I love to look. My eyes are in a constant state of pleasure or displeasure. I'm constantly looking at what could give me satisfaction, whether it may be shapes, colors, or details. I cannot imagine saying to a chief operator or a woman who is at the camera, "Do what you want. You tell me." Impossible. I frame, myself. I discuss the frame with those who are at the camera. Sometimes I rehearse the movements of the camera myself. I repeat them three or four times and then whoever is behind the camera interprets it and does it his way. I always look at the fixed frames and when I film myself, I'm always happy.

Varda questions her desire to be behind the camera to capture images, "to seize a bit of life." She asks herself, "Is it the continuous desire to seize the moment, to give a form to the moment in order for it not to escape us completely?" But, she answers herself, by definition, "the moment" has to disappear even before it is done: "The moment transforms itself into a memory at the precise moment when we live it." When she films this moment, "this memory has a form, a color. It has a frame." She explains that her desire to be a filmmaker and cinematographer does not center on "making films that will be in theaters, or becoming famous, or earning money." Instead it is "the connection with people that is wonderful, that is really interesting." For Varda, cinema involves engagement, and her films involve her audience in something of her own experience in capturing the images that she puts before us.

For other camerawomen, storytelling provides their greatest pleasure in being behind the camera. "Being a camera operator," Kylie Plunkett says, "gives you a real and practical way to tell stories." Plunkett has always been fascinated about the cinematography elements that allow "you to take a story and inflect amazing things into the story with your style." Gibson's best experience remains *Hear My Song* (Peter Chelsea; 1991), a low-budget feature shot in Ireland that was surprisingly successful. Since it was her first film as DP, she put her heart and soul into it. Although "it was hard work," because "it was a comedy, we had fun." For her the main thing was its "great" script, because without "the script, whatever you do will never make it any better than it is."

Michelle Crenshaw's interests have shifted away from the camera itself toward storytelling. In her early career she had to be pragmatic about earning a living through her camerawork. Success and experience have brought changes. "I'm very secure in my role in the industry,

and I've been blessed to work with and know people that support me in this industry." Now she can be "passionate about a lot of stories that are not being told." She's excited about new "technology, which is lending itself to be so accessible to working class people. If you have the drive to tell a story, you can now."

Satisfaction and pleasure in telling people things they do not know through moving images comes not just from fictional stories, of course. Emiko Omori recounts, "I had a niche. There were women trying to make films about feminist issues. There were minority filmmakers wanting to hire a minority person." In her documentaries, Omori told stories about Japanese American culture as well as Japanese American women. "I had plenty of work on films about the outsider. I have loved every minute of it."

Palestinian Fida Qishta's pleasure in being able to tell the world her story of what has been happening to her people and their land even though she can't be fluent speaking the world's languages harks back to the silent era, when film was frequently described as a universal language that could help bring peace to the world.

For news camerawomen, the magic is about the impact they can have. Nancy Durham remembers clearly the first time she shot a news piece and felt that she was getting a story that people really "need to see." It showed Albanian women fleeing Kosovo in hay wagons, as well as "refugees resting on the wooden floor in a big gymnasium somewhere." For Durham, it was a "moving and exciting" experience because she "was in a place recording something that wasn't being recorded, and that really needed to be."

African American Jessie Maple Patton had her best moment behind the camera when she discovered she could "edit the story in the camera and prevent the editor from taking a positive story and making a negative out of it." It happened too many times "when I was shooting the news," she says, that in stories with a race aspect "they would leave the black person out of the story. I would shoot it in a way where they couldn't cut the black person out of the story. They had to see both sides of what happened and what they had to say."

Similarly Mary Ayubi sees her work in Afghanistan as engaging with the social policies of her community: "Where there is a problem that women can't talk about with men, they trust me and tell me their secret; I feel so happy." Before being a camerawoman, she suffered

when I was seeing things in my community that nobody could talk about. I was thinking that there are many journalists. Why don't they talk about these things? Now, when I record these things with my camera, I feel such a relief that, although I'm a woman and I don't have many rights in my community, with the camera I can raise my voice, and talk through my camera about our rights and about what people don't see.

While some camerawomen like Ayubi give voice to their own communities, others like Joan Giummo work with communities not their own. As a pioneering video documentarian in New York, Giummo moved into making educational videos for immigrants—work that provides her satisfaction through the use of her skills. She has worked as a staff developer for adult education where she produces videotapes for training and for student use. "I am

very involved with the immigrant population. They need English and they need to adapt to the American culture. I'm making things for that population, and for the training of teachers who work with that population." Although this material is unlikely ever to be aired, Giummo says, "it serves a social function in my community. It feels good to me."

Other camerawomen speak of their individual visions. Cárdenas enjoys how she sees the world as a camerawoman even while acknowledging that it is in the service of someone else's vision. Being able to translate other people's images "into a reality through framing, lighting, and lenses gives me satisfaction. Films are dreams, and dreams allow us to be alive. For me, this is cinematography: a way for people to dream." On the other hand, Norwegian Christine Heitmann says the best thing about being behind the camera is "to try to get my inner pictures and fantasies out and for them to become alive."

As this section has shown, camerawomen find much satisfaction and many different satisfactions in their jobs. In response to the question, "Will you always be a camerawoman?" Sue Gibson says that without filmmaking there "would be a big hole in my life." She compares being a camerawoman to being a painter: "You have a blank canvas in front of you and you begin and it carries you along. I don't know if painters can ever stop painting. Hopefully, cinematographers never retire; they just grow old." After all, as Young-Joo Byun says, "Some people earn their living by what they can do, others by what they are compelled to do. Wanting to make films and earning a living making films—what a lucky life."

Worst Moments, Dangers, and Risking One's Life

If I'm somewhere and I see a tank or patrol come in, I quickly turn my camera side-on so they can see it's a camera, it's not a weapon. You see the tank turn around and I know they're watching me, and I stand there, still, with the camera until they're past. I know they see me, they accept I'm there, and I can go on filming.

(Margaret Moth)

Some camerawomen's worst moments have come while working on commercial sets. Working on commercial films, Celiana Cárdenas lives "the worst moment every day," because she must "accomplish a number of scenes each day in a specific time." Cárdenas is proud of her work in a stressful atmosphere where a crew can work from ten to seventeen hours a day or more under intense pressure to finish the film quickly. Cárdenas knows that she must help to carry the rhythm of the set. "Every day, whether shooting a commercial, feature, documentary, or whatever, the way I accomplish this is to be as prepared as I can, so as not to stop production, which benefits the whole production."

This pride is something Katie Swain shares as well when evaluating her work experiences. Her worst moment on the job is when she has disappointed herself. Her most obvious

mistakes, not surprisingly, happened when she was a camera assistant: "You can fog a roll of film, or check out camera gear and you haven't checked if it's got the right ground glass in it. You get to location and it's the wrong ground glass. Mistakes that you kick yourself for." While Swain thinks it is good for a camerawoman to be self-critical, she adds, "You have to see the good as well as the bad. I'm never completely happy with what I do. Ever."

Mairi Gunn's worst moments are when she does not have a camera job because she has "this incredible desire" to work a lot. She really wants to "marry beauty with a fantastic script," and then get acknowledged for her work—"which is rare as hen's teeth. There was a while a couple of years ago where I said, OK, just give me some crap [to shoot]. I'll just do crap for a while so I can earn some money and get my flying hours up."

For some camerawomen, the worst moments have been filming the suffering of others. Rozette Ghadery and Mary Ayubi have both filmed in Afghanistan, where they have documented some of that country's misfortunes. There was also the incongruous: Ghadery remembers "the image of hungry kids each holding a beautiful doll sent by other countries to them as gifts." Her worst moment was seeing "people getting killed every day," which "is something that I will carry all my life." Ayubi filmed a sixteen-year-old-girl who had been kidnapped and raped: "The most painful moment was shooting a close-up of her eyes. I was crying because she was young, ashamed, and had so much pain. She hated herself."

Besides witnessing the suffering of others, camerawomen face real dangers on their job. Potential hazards were once reasons to keep women from becoming video journalists. American newscamerawoman Heather MacKenzie got her break only because one sympathetic boss, John Myrick, "believed women belonged in the field, shooting outside, in the danger zone."

What follow are stories of camerawomen whose lives were threatened by the hazards of nature, civil uprisings, unfriendly police, and deadly snipers. As part of their professional work, and among the other things they have done, our interviewees have recorded political change, rebellions, and wars in the Balkans, China, the former USSR and its satellites, Vietnam, the Middle East, and Afghanistan. It might seem obvious that a news camerawoman who ventures into coverage of war zones may encounter more upfront dangers than a camerawoman working in a Hollywood studio, but Hollywood productions— on sets or on location—can also be dangerous. The experiences of camerawomen around the world show that physically threatening aspects of working behind the camera occur everywhere, and while the hazards of working behind the camera are probably not what first comes to mind for those considering careers in the screen industries, they should not be overlooked.

From its origins people associated the motion picture camera with danger. Etienne Jules Marey, who in 1882 invented the first motion picture camera, gave it the same size and shape as a rifle and described it as "*une sorte de fusil photographique*" (Burton 49; a *fusil* is a rifle). Filmmaking began as a dangerous activity, involving, for example, flammable materials with no oversight of regulations concerning health and safety for cast or crew. "In 1928," American writer and director Karen Dee Carpenter tells us, "torrents of water inundated the

actors and three were drowned," along with a dozen extras being seriously injured, during "filming of the climactic flood scene of *Noah's Ark*. Though the producers were not held liable, the first safety regulations were introduced in 1929 as a result" (Carpenter).

The cliché that "the show must go on" has sometimes applied not just in the movies, but also while making them. Haskell Wexler and Kristin Glover remember an accident that occurred during the shooting of the *Rolling Stone Tenth Anniversary Special* in 1977 when the actress Lesley Ann Warren's eyebrows caught on fire. "They rushed her to the hospital and then she came back. We always remembered what kind of trooper she was," Wexler says.

During the 1980s Hollywood had increased fatalities and injuries in cast and crew due to more realistic, sophisticated stunt-work and special effects. The *Twilight Zone* tragedy became a catalyst for change. In the 1980s, Carpenter explains, the Los Angeles film and TV industry created the "Safety Pass Program" to satisfy California's Occupational Safety and Health Administration's (OSHA) rules that "employees be trained in the safe use of equipment and work practices on the job." After this program began, Hollywood reported fewer work injuries and deaths, but only the State of California legislated safety training for film or TV workers.

Working long hours on a Hollywood TV or movie set—ten, twelve, fourteen hours or more—five or six days a week, presents health hazards to the crew and actors. In 1997 camera assistant Brent Hershman, after working a nineteen-hour day on the film *Pleasantville* (Gary Ross; 1998), fell asleep at the wheel of his car on the drive home and died in the ensuing accident. After Hershman's death, union representatives (including Wexler) demanded the "twelve on-twelve off" regulation where crewmembers would not work more than twelve hours at one stretch, followed by a twelve-hour break. Since many movie executives still believed that long hours on the set were a necessity, in 2005 Wexler directed the documentary *Who Needs Sleep?* which demonstrates the dangers of sleep deprivation for workers and argues for decent worker protection legislation in the film and TV industries. Wexler told Glover that "the social aspects of how our work becomes our life" are "almost as important as the safety issues. The hours we work, and the balance between life and work, is askew. It's wrong, it's unhealthy, and it's unsafe."

Kirsh, one of the first women to complete a union-sponsored training program for camera crew in Los Angeles, was seriously injured on a nonunion set in Hollywood. She had taken the nonunion gig at a time when she had recently moved up from camera assistant to camera operator and could not find enough union work. The accident occurred on 1 April 1987; Kirsh was backing up with a camera. Someone left a trap door open "and I went down an airshaft twenty feet onto concrete and metal. I was in a coma for several weeks, in addition to broken bones and other visible injuries. The accident was a result of neglect and stupidity." Yet more was to come. After the accident, Kirsh received neither adequate medical care nor rehabilitative therapy, for which she blames "the doctors/lawyers/insurance companies." "My life was taken away not so much by the accident, but the aftermath, and the lack of rehabilitation. Less than a year after I had been injured, the expectation was that

I would get back to work as soon as I was better. That did not happen." Officially designated as disabled, she never returned to work.

Kirsh thinks her own accident is typical of the lack of safety on film sets, and recalls that she worked "with a star who was almost killed in an accident on film, me focusing all the way." She has another story about a crew shooting a car chase with multiple cameras: "The car ran into the lights and then into the camera assistant. No one was killed. The director said, 'Call the union. Get another assistant. Let's keep shooting.'"

In 2014, 27-year-old Sarah Jones was less fortunate while working as a camera assistant on *Midnight Rider* (Randall Miller), a biopic of Gregg Allman put on hold pending the investigation of an accident involving a train that killed her and injured several other people. The US OSHA got involved with the investigation, following reports that the shoot occurred despite permission having been denied for using the railroad trestle as a location. Jones' father vowed that her death would not be in vain, Jones' union local in Atlanta called the accident "avoidable," and an international campaign using social media persuaded the Academy of Motion Picture Arts and Sciences to recognize her death at the 2014 Oscars ceremony and called for improved safety conditions for film productions (Johnson). Veteran line producer C. O. Erickson told the *New York Times* that

the biggest Hollywood films [...] are overseen by studio safety officers who check and crosscheck potentially hazardous situations, making an accident of the kind that killed Ms. Jones almost unthinkable. But smaller productions [...] rely heavily on the professional skills of production managers and, especially, assistant directors, who check details that might escape a harried director.

(Cieply)

In 1982, Brianne Murphy shared a Technical and Scientific Academy Award from the Motion Picture and Television Academy for inventing the Mitchell camera car "in which," as she explains, "you mount cameras to get fabulous moving shots." She was inspired to invent her camera car by a tragedy: "Rodney Mitchell, an assistant cameraman, was working on the back of a converted pick-up truck [which] made a sharp turn and rolled over. People working on the back were severely injured. Rodney was killed. My sister Jillian and I decided to put all our resources into building a safer camera car." As she said, "No shot is worth a life, yours or anyone who works with you. To know that I've done something to make other cameramen's lives safer is very important to me."

For Ellen Kuras, the DP's job is not only to handle the light and place the camera but also to make sure her crew is safe. She thinks that "people don't question enough on set" nor are safety regulations consistent, even within the United States. In order to work in California you must take safety classes to get on the union roster, but not in New York. She learned things from her safety class that can make a difference, for instance, whether it is safe to climb up a piece of scaffolding—as Kuras often does. Because of her safety class, Kuras has enough information to say "this is not safe" if the situation calls for it.

However, even safety classes may not be enough. A commercial left Kuras coughing for three weeks. The special effects department started burning highly toxic smoke, and Kuras asked for masks. They said, "Yeah, they're right over there"—but they were only paper masks.

On the other hand, Kuras has put herself at risk to get a shot by hanging "out of helicopters with just a seat belt on. But that's my call, and I know when to pull back. It's really important to inform yourself of what the parameters of safety are."

The result of Kuras' care for "the safety and well-being of my crew," whom she refers to as "my soul," is that crewmembers have sent her emails saying, "Thank you so much. This is the first time that any DP asked me, 'Are you doing OK?'" To Kuras these emails show other DPs' lack of concern, which reflects badly on the film industry as a whole, whether it is a studio picture, an independent film, or documentaries. "People forget there are people involved."

Unfortunately, Indian commercial cinema, which has lots of stunts and choreographed fights, can compete with Hollywood in terms of its lack of care for crewmembers. Vijayalakshmi once shot a stunt with a famous actor that required her to lie on the ground with the camera and film him doing a somersault. Two other people were supposed to catch him, but

those two guys just left the hero—and he weighs around 90 kg [198 lb]—so he landed on my eye. Luckily for me, the camera was an Arri III. It has a big sponge [on the eyepiece], so it only just broke through [...] You can't leave the camera because it was very expensive. I gave it to my assistant and checked my eye, and blood was pouring. So I attended a clinic, came back, and started shooting with my left eye.

Cinematographers shooting on location can be exposed to diverse dangers associated with the location itself. Rikarastu was happily filming on one of the highest mountains in Indonesia, shooting beautiful creatures and landscapes for a wildlife documentary, when she slipped and "almost died. But then I realized, this is what I was born to—and maybe this is how I'll die, too." When Giummo was videotaping high school dropouts in the South Bronx at a time when the Bronx "was just a destroyed area, into my shot came a pack of dogs. I kept shooting. I thought, if I weren't, I would probably run for my life."

Just carrying a camera can be enough to change how others perceive camerawomen, sometimes leading to danger. Baş, who has filmed in many different countries, comments that in France, the United States, Canada, and Istanbul, people find it natural to see camerapeople on the street. However, traveling in rural Anatolia with her camera was difficult "because you suddenly become someone to be watched." In southeastern Turkey especially, because of the Turkish army's long conflict with the Kurdish separatist militia, it was "impossible to work openly with a camera, because the civil police will follow you. When I was filming in my hometown, I had police asking me, 'What are you filming?'"

Heather MacKenzie faced a variety of dangers while shooting the news in Los Angeles for decades, since she drove "in the most unbelievable places by myself at night" or by day. For example, the 1991 Los Angeles riots were sparked by the beating of African American Rodney King by four Los Angeles policemen—an incident that had been caught on videotape. The

four policemen were tried in Simi Valley, a conservative suburb of Los Angeles, where the jury acquitted them. MacKenzie says she "drove right through the intersection of Florence and Normandie twenty minutes before the verdict that started" the rioting. Not long after she drove through that intersection, four men pulled Reginald Denny, a white driver, from his truck and beat him badly.

The Simi Valley verdict coincided with an economic recession that hit Los Angeles' poorest neighborhoods hard. After the verdict, thousands of people looted food as well as electronics stores. MacKenzie's station "lost two or three cameras to people coming up with guns, saying, 'Give me your camera or I'll kill you.'" Yet MacKenzie kept driving around to get her story, carrying gear that she knew was "worth a lot of money on the street." One night MacKenzie was shooting across the street from where an electronics store was being looted.

There were people running in and out; everything was on fire. I was rolling on this one fellow who had come out with a big TV. He was carrying it across the street toward me. I was shooting him and he saw me. He dropped the TV, took out a .45, and pointed it right at me. He went to pull the trigger and I kept shooting. I don't know why. I was crazy. He just changed his mind and ran away. ABC uses that shot over and over again.

The next day she and a reporter, down in Long Beach, left their truck to continue covering the unrest. She says, "Another guy who was also working with me refused to get out of the truck. He stayed in the truck with the locks down the entire day." When she and the reporter were finishing up late at night, they "had just done a live shot with a Boys Market [a grocery chain] burning to the ground in the background." No police or fire truck was nearby but some 50 men who were

screaming "Feel the heat! Feel the heat!" came over to us as we were putting the gear away. It was just myself and the reporter. The reporter started backing up toward the truck. I had to stare them down; if I showed them fear, the whole situation would have changed. So I did everything in slow motion. I wrapped the cables as slow as I could, I never turned my back to them, I kept eye contact with them. They didn't attack us.

MacKenzie says she is unafraid because she feels impenetrable when looking through the camera, "that somehow the fact that the camera's documenting what's going on will protect you. Which is completely false." She thinks the events she is documenting are so important "that you have to reach deep inside, because what you're showing is bigger than anything. It's documenting history. It's changing the world."

Like filming urban unrest, doing camerawork in war zones carries risks. American Lisa Seidenberg, who did camerawork during the Vietnamese/Cambodian Wars and the civil war in Lebanon, found that filming in Cambodia was more dangerous than in Vietnam because when she went on patrol with the militia in Cambodia, "in order to get the shot, you had to be ahead of" the soldiers. Because there were landmines all over Cambodia, "I was never

quite sure as I was backing up to get a shot if I was going to step on something. But you can't think about that. I was getting my perfect shots, and fortunately nothing ever happened." She admits to having "a little bit of macho in me [that] wanted to see what I could handle, to see if I had what the big boys had. I did my best and it was exciting."

Seidenberg went to Lebanon and Syria in 1983 although people warned her not to go. Once there she "never knew if it was dangerous because I was living in a war zone, because I was a Jew in an Arab country, or because I was part of the press and the press is often targeted," but she found doing camerawork there strange and exciting. "There was an erotic element to it because sometimes I would be out there shooting and there would be these young militia, these teenage boys with guns." Once again, she did not feel the danger because "having the camera was kind of a protection in a way."

In the early 1990s, a decade after Seidenberg's Lebanese experience, Jan Kenny went to the Red Sea on the Australian frigate HMS *Sydney* as part of the First Gulf War. The Australians "were part of an international task force set up to blockade the Gulf of Aqaba." Kenny says that when she started as a camerawoman in the 1970s, no Australian TV station would have offered that kind of work to women, and indeed, during the Gulf War Kenny "ended up crushing a vertebra through an accident" involving one of the *Sydney*'s inflatable boats. Her back healed, however, and when she reflects on that shoot, she does not remember her injury as much as she remembers "all the other experiences of flying around in the helicopters and so on. When I'm asked if things are any better now for women, I would say that's an example of absolute acceptance that a woman can do that kind of job."

Nancy Durham had been a camerawoman reporting from the Balkans long before the wars started there in the 1990s, so she continued shooting during the wars, starting in 1994, when the Bosnian war was beginning to wind down. Durham's working solo with unobtrusive equipment "seemed to allow me to approach people who were nervous and in dangerous situations. It also allowed me to get around without looking like a television crew." She says that cameramen seem to have more "guts to stand on the front line and get those shots of front line war. They're drawn to it; they have the nerve to do it. I admit that I would be interested in witnessing war up close. But I haven't got the nerve." She did, however, have her hostile environment training course under her belt, as well as her flak jacket and her helmet, and she spent a great deal of time ensuring she would be able to exit safely.

Durham thinks that "reporting is all about deciding what sort of risks you're willing to take." However, the Syrian civil war has been so hazardous for journalists that many news sources have pulled their own employees out of the area and even refused to accept work produced by freelancers. Professional journalists have expressed concern about adventurous young travelers with smart phones or other easily portable and concealable digital equipment that can capture images. The professionals, who have safety networks provided by their employers and developed on their own through years of experience, worry that these nonprofessionals have no idea what they are getting into nor any idea how to protect themselves: Not knowing what the risks are, they can't know how reasonable it is to be willing to take those risks.[3]

Instead of shooting the battles up front, Durham herself has been drawn to recording "the more human stories, the people stories—this sounds awfully corny." She realized that during wars most people "are surviving one way or another. I found it amazing that that was the case. I wanted to report on how people were coping in war."

Durham finds it fascinating that someone like herself can take a plane or bus or even walk in to a war zone and yet be relatively safe. For example, it was "quite easy to move around" in Kosovo, she explains, because the lines between the Kosovo Liberation Army (the Albanians) and the Serb Military Police were clear.

Whenever you tried to cross those boundaries, you could be in trouble because you would have to go through checkpoints, and you might be coming closer to a situation where there's fighting or shelling or something. But the rules and lines are often quite clear. So you always know where you're safe to go.

Before the 1990s Canadian Zoe Dirse had never been a war camerawoman because she felt "there is always somebody else's war going on, and I have a long life to live, and a lot to do." However, two days after she arrived in Moscow to attend a conference called "A Dialogue of Cultures" as a delegate, "Gorbachev sent troops into Lithuania and fourteen civilians without weapons were killed protecting their TV station and their press." Dirse's father is from Lithuania while her mother is from neighboring Latvia. Both parents had escaped the Soviet occupation in the 1940s, immigrating to Canada, where Dirse was raised within the Lithuanian community. In Moscow she suddenly felt that what was happening in the Baltic states "was my revolution, and I should witness it." She immediately went to Riga despite the danger, because "I thought that the Soviet troops would hit there next."

On 21 January 1991, Dirse was watching from a window while her friend Andris Slapins, a cinematographer/director with Riga Films, and his crew filmed events outside. Slapins was killed by sniper fire. The next day a BBC crew she knew gave her "their backup camera, which was a Hi-8 Sony PAL, and a box of tapes. I went into the streets and started shooting." She decided to make

a personal story of what was going on in that part of the world as an observer from the West who had links to people [there]. This cameraman who had died—it struck a chord in that I suddenly felt that I had made the right choice, that this was what I was meant to be doing. I was meant to be a cinematographer: I was meant to be there at this point in time, in history, to tell this story.

(Dirse, "Gender" 442-43)

According to Dirse, because the Soviets felt threatened by the foreign media in Riga, they had "an order out to shoot camerapeople." After Dirse's friend was killed, his camera assistant died a few days later, shot as well, and a Russian cameraman was wounded in the head.

Nevertheless, Dirse walked around filming and talking to people. Riga's streets were all barricaded and Riga's citizens "camped inside the city and made campfires everywhere. The women were feeding the men that were guarding the apartment buildings and the TV stations." While she was filming, she was amazed she was there, but "maybe because I was a woman with a camera, [the Soviets] didn't take me seriously. Nothing terrible happened to me." She remembers people from Riga asking her, "Was I not afraid, because I was a target? And I said, 'If you're not afraid, how could I be afraid?'" What she shot there became part of her first documentary, the award-winning *Baltic Fire* (1993).

After *Baltic Fire*, Dirse became the cinematographer on *Balkan Journey* (Brenda Longfellow; 1996), which is about women's groups from Croatia, Bosnia, and Serbia that were resisting the Balkan Wars. Although the filmmakers on *Balkan Journey* did not seek out dangerous situations, Dirse remembers that "a bomb was dropped the day before we arrived in a spot we could have been filming at. There was always an element of danger. But that story needed to be told. It was important for people to see it." Dirse assumed the director wanted her to work on the film "because she knew I had done *Baltic Fire*, and she knew I wouldn't run away if something happened."

When Dirse films women who have been in a war zone or who have been victims of rape or torture, she feels compassion: "Often I find myself weeping behind the camera, behind the eyepiece, because I'm so moved by their stories." She also felt humbled by those stories, commenting that if she has "a tough time being a cinematographer, I can say that that is nothing compared to what these women have gone through."

Margaret Moth (1951-2010) was a news video journalist known for filming in dangerous war zones in Bosnia, Sierra Leone, Baghdad, Chechnya, Tbilisi, Somalia, and Kosovo for CNN.[4] Moth has been called the leading war camerawoman, winning numerous awards, such as the International Women's Media Foundation Courage in Journalism Award. Yet she always said she was just a news cameraman covering the news wherever she was asked to go.

Moth was always daring, convincing a New Zealand news colleague to go with her after a full day's work in a newsroom to do two or three skydiving jumps in the evening. In fact, she gave herself the name "Moth" because of her love for the Tiger Moths she originally jumped from ("Moth"). A later colleague, former CNN correspondent Stefan Kotsonis, said that when Moth was in Georgia covering a large protest, the militia strode forward, shooting at the crowd. While other news people dived behind the cars, as one of the cameramen remembers, Moth stood in front of the cars filming the gunmen, totally unafraid. Jessica Ravitch of CNN described Moth as "the kind of woman who not only kept the camera rolling while under fire, but zoomed in on a soldier who was shooting her" ("Fearless").

In Sarajevo Moth and other CNN crew had been shot at many times while driving in "Sniper Alley," always escaping injury. However, on 23 July 1992, a sniper shot three rounds into the car and she was shot in the face. At first the news was that she would not live. Not only did she survive—although it took over twelve operations to reconstruct her face—

but she returned to film again in Sarajevo in 1994. Her boss at CNN, Tom Johnson, may have been apprehensive, but she was determined to go back. Her concession was to wear a bulletproof vest.

Once back in Bosnia, she visited the doctor who saved her life. She would tell him, "'I was out on the front line and they were trying to flush a tent out on the other side and then the tent fired at us,' and he'd say, 'Margaret, if you get injured again, I'm not going to save your life next time.'" Moth says that the doctor "couldn't believe I was back there doing the same thing again. Like, hasn't she learned her lesson?" Moth did most of her war zone work after Bosnia.

Moth could even put a positive spin on having been shot. In war zones, when "we asked the militia or someone to take us to a different line and they saw a woman cameraman, sometimes they were a little bit, well, maybe they think I'm going to be more frightened on the front line." After she was shot, "The journalist would often say, 'Do you mind if we tell them what happened to you?' The fact they know I've been in Bosnia, I've been shot, I'm not freaking out—gave me an advantage."

During 2002 correspondent Michael Holmes and Moth covered the Israeli invasion of the West Bank. In Ramallah, Israeli tanks, snipers, and soldiers had surrounded the headquarters of the PLO with Yasser Arafat inside. A group of doctors and other medical people marched in protest down the street, and then the doctors walked up to the Israeli armored vehicle in front of the building and past it. When Holmes looked around for Moth, she was in the middle of the medical group walking across the compound, so Holmes ran twenty yards to

Figure 35: Margaret Moth in New Zealand.

catch up with her. When they got to the building, Arafat, who knew both Holmes and Moth, called them up to him. Holmes started asking questions while Moth filmed.

Moth recalled that CNN had let her and other camerapeople take more risks "and do our own thing" in earlier days, but now "we have security with us, we have armored cars." CNN was more likely to interfere, saying, "'We don't want you taking risks. Are you sure it's safe?'"

Most of the time Moth was able to detach herself while filming, but on rare occasions she got so upset she cried. Her wry comment on that was, "It's hard to film when your eyes are blurry." She said she never got post-traumatic stress disorder from filming in war zones because she would deal with the emotion "at the time it comes," and when she was home, she did not dwell on the dangers that she had been through. She did acknowledge that camera work could be dangerous, although even so she maintained her high standards: "If shooting starts, the reporter can go down, but cameramen have to get up and film it." Colleagues said she was a funny companion on the job because she knew how to relax. Before Moth died of cancer in 2010, her CNN colleagues made a short documentary tribute about her, called *Fearless: The Margaret Moth Story* (2009).

Safety was always the main issue for Mary Ayubi in her own homeland. Ayubi said she and the other Afghan women trained by Aina were never safe when they went out to shoot. "It was necessary to have a man with us all the time. We weren't relaxed, because we were the first camerawomen," and Afghans were not ready for camerawomen. When they were among people in rural areas as well as other smaller cities, the camerawomen "were afraid people would attack us with a knife or shoot us."

On one occasion when Ayubi was filming for Aina outside Kabul, she "was threatened with death from the mayor of the city and the head of the education department." Another time when filming in a crowded area, Ayubi got into a fight with an eighteen-year-old boy who was harassing her. "I had to hit him to get rid of him. It was scary." After the fight Ayubi "was afraid that other men, or his friends, would attack us." Despite these and other threatening conditions, Ayubi and her female colleagues were able to complete their first film, *Afghanistan Unveiled*. Six months after that, Ayubi was asked to direct another film, *Shadows* (Ayubi and Polly Hyman; 2005).

When Ayubi still lived in Afghanistan, "when I was getting ready to work, I was worried. What if I see someone dead or injured? How could I shoot a bloody scene?" Both her brother and her father died in the war. Post-traumatic stress disorder is now a constant of her life.

One of our interviewees' most frustrating stories comes from Heather MacKenzie. She and her partner, television news reporter Adrienne Alpert, both got seriously injured on the job as the result of a simple and entirely preventable mistake. This is no story of choices and courage—just plain bad luck, with horrific consequences that the victims now must live with for the rest of their lives.

When MacKenzie describes her years of work at KABC, it is obvious that, although her usual beat was Los Angeles, she experienced dangers on a par with war video journalists such as Durham and Moth. MacKenzie shot the news on a daily basis during an urban rebellion, floods, the Northridge earthquake, and the huge Malibu fire.

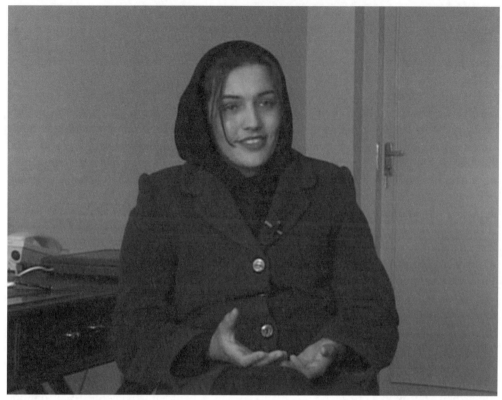

Figure 36: Mary Ayubi. Afghanistan/USA.

Although MacKenzie grew up thinking she would teach or be an artist or make children's books, she wound up as a camerawoman "digging through mudslides and walking five miles with the gear and putting the mast up[5] in the rain during thunderstorms and being outside in the freezing cold covering snowstorms." Basically she "was tempting fate every single day of the week. We all did. It finally met up with me. But we were all doing unsafe things because we didn't know any better and because [KABC headquarters] never told us."

MacKenzie observed that "a lot of the people who are not outside with you, who are inside with deadlines, put extra stress on you to cut corners. You cannot cut corners in the field." Budget cuts also made MacKenzie's job more dangerous. When she started shooting TV news, there used to be two people on a KABC camera team, so each cameraperson had "somebody to watch your back, to make sure that nothing happened." Then KABC reduced the camera crew to one person. Although this arguably made working at night more dangerous for women, MacKenzie never refused to work nights any more than she refused to work in unsafe situations.

Before her accident, MacKenzie and other crew who shot and reported on location had been asking for various forms of safety training, "such as fire training for when you've got a fire storm coming at you. Camerapeople don't go through the fire safety training that the firemen and the police go through." MacKenzie had even been on the safety committee at work, which for ten years had been begging for safety training on how to work with dangerous power lines. "It's documented," she said. They never got the training.

MacKenzie and Alpert "loved 'kicking butt,' as we called it." They would go into a situation "like a smooth, oiled machine and shoot quickly." MacKenzie described her partner as "a good writer" who "wrote to the pictures. She was quick and accurate and a dream to work with." And the two had worked together all around Southern California. "We even took [Alpert's] son, who was five years old at the time, to Legoland when it first opened," and used him as a barometer for what a five-year-old would think of the rides. Because they "did a 10 o'clock, an 11.30 live shoot, a 4-, a 5-, and a 6-live shoot," it was "a difficult day running in and out of the park, having to lug all the gear in, shoot a little bit, lug the gear back, edit a little bit, do a live shot, go back inside to do the remotes, then come back out to edit the piece, feed the tape, go back in to do remotes." Yet MacKenzie says the day "was really neat."

The accident that ended all this happened on a typical workday: 22 May 2000. MacKenzie and Alpert were sharing notes about the previous weekend in the KABC van that morning, on their way to cover a police event promoting the use of safety belts. Near the Hollywood Forever Cemetery they pulled up to do the live shoot and discovered a problem with parking. MacKenzie remembers they said to each other, "Great, they've put this entire function underneath high tension wires. Now what?" They explained their problem to a policeman who was in charge of setting up the event and asked, "How about if we park over in the cemetery parking lot?"

The policeman said no, so MacKenzie and Alpert tried without luck to find another parking spot. Finally, deciding they were going to park on a sidewalk in front of a shop, they got permission for that. MacKenzie recalls that she angled the truck back and forth, so that it was as far away from the tension wires as she could maneuver the van. She did her typical chores: setting up the microwave and starting the generator. At the back of the truck she put the mast lever up and watched the mast rising for a while. It looked fine.

Back inside the truck she was trying to reach the co-worker at the station who was setting up with her. She had to wait a while until he called her back, and then they were talking. When she stuck her head out the truck to see which direction the mast needed to go, she realized that it was only a foot away from the power lines: As the mast continued to go up, it had leaned horizontally toward the power lines. So even though they were not parked directly under the power lines, they were still in danger.

"At that very moment, this kid came up to me and says, 'Lady, lady, you're near the wires.' I jumped out of the truck, ran around to the back, and tried to open the door," which gave her "a terrific shock." Then she alerted Alpert, who stepped out. "There was this huge explosion, and 17,000 volts of electricity went through her body." Later Alpert said, "I literally looked at my hands and watched my muscles wither." MacKenzie had to watch as Alpert "lay there

not being able to breathe for what seemed like an eternity. At the burn center they said she had a 3% chance of living. She made it. Unfortunately, she's a double amputee. She still has her husband, her son, and her life, and she's going to make the best of it."

MacKenzie suffers hugely from regret about what happened. "I obviously had bad judgment that day. I want to go back in time but I can't." What she remembers of the event itself is that when she tried to open the rear doors to put the mast down, "The shock threw me back and I could barely stand up." While the physical pain remains, the emotional pain has been the more difficult burden. MacKenzie felt "responsible for Adrienne. I feel responsible that I almost killed myself. Luckily I didn't die, nor did Adrienne, nor did anybody else."

I still feel that if I could take her place, I would. I can't believe that I'm OK and she's not. It was an instant between me jumping out and her getting out. It was the way she got out that was wrong; she was holding the truck handle and made ground. It was also probably the fact that the compressor was still going up, still filling with air. Even though I turned the compressor off, the mast continued that few extra inches that was the difference between me jumping out and the explosion.

After the accident Alpert waited until she could talk in a normal way, and then asked to see MacKenzie. "She was missing her arm and her leg by then, but she still looked so beautiful. She said to me, 'Heather, there's no blame.'" She told MacKenzie that, as a team, they made decisions together. "We both decided to park the truck where we did."

The accident drastically changed both women's lives. MacKenzie said she and Alpert had both worked "on this fast-paced, stressful conveyor belt to nowhere for so long that we didn't even see what was important, which is our family and our friends, and enjoying life." They were never home. They would work sixteen-hour days, come home to sleep, and then start again the next day. MacKenzie said, "Now I'm not working and don't have that constant pressure, I think in some ways that I was addicted to it."

Before the accident, MacKenzie says, KABC management, apparently more interested in easing the pressures of meeting deadlines and acing the competition, ignored the importance of putting safety issues first. Cutting corners led to unsafe work conditions. She is emphatic about this:

In fast-paced news and filmmaking, having to shoot so many pages of dialogue per day, trying to cut and cut to the point that time and the dollar are almighty, we have let safety become a gray area that has to fit into our schedule. It's part of the producer's responsibility to have safety as the utmost, but in the reality of getting things done and saving money, it moves onto the back burner. There've been a lot of accidents in television photography, in video productions, and in films that didn't need to happen.

MacKenzie is certain that had she been given the safety training about wires and power lines that she and other members of the safety committee had demanded, she "would have known

not to set that truck up in that manner." After Alpert and MacKenzie's accident, KABC News did institute new safety training measures.

MacKenzie did not return to work for many months: KABC held her responsible for everything, giving her four months' suspension without pay. Yet "a lot of people don't see me as the victim." Although she was afraid of losing her job, she did return to work for nine more years for KABC as a TV news editor. She has since returned to painting, and has moved from Los Angeles to Cape Cod. She exhibits her paintings in galleries and teaches photography to at-risk teenagers.

Like Estelle Kirsh, Heather MacKenzie was let down by her employers twice: first, because of what they did not do to prevent her accident and second, because of their failure to accept responsibility after the accident. A victim herself, MacKenzie also has to live with her feelings of guilt because someone else, a close friend, was even more seriously injured.

This chapter earlier mentioned MacKenzie's reference to the man who gave her the opportunity to work because he believed women "belonged in the field, shooting." Let us not forget that the camerawomen who have shared their stories chose to be where they were. They would not wish anyone to deprive them of that choice.

Notes

1 Antipodean slang for going slightly mad, usually due to challenging circumstances (heat, excessive drinking, etc.).
2 Antipodean slang for being a bit sick, or a bit off.
3 See, for example, Jamie Dettmer's discussion, "Syria's Media War."
4 Moth also worked in such danger zones as Kuwait, Israel, Lebanon, Zaire, and Rwanda ("Moth").
5 Hoisting up the satellite dish that is on top of a long pole to make contact with the station's studio technicians.

Chapter 10

What do camerawomen see?

I just see in light; I see visually.

(Nancy Schreiber)

Representation and Gender

I cannot film a woman, an actress, like men film her. They have a tendency to cut up women in pieces of sexual desire. A woman who films another woman perceives her as a whole and complete body.

(Agnès Varda)

I remember doing a short film with [a male cinematographer]; he was watching Kevin Smith [an extremely handsome New Zealand actor] doing push ups and had to do some shots of flexing muscles. I was thinking to myself, "I could do that better."

(Mairi Gunn)

Do men, as Agnès Varda says, tend to see women in parts rather than as whole individuals? Do camerawomen engage in different sorts of objectification? Can camerawomen make a difference in the ways that people see and understand gender? Class, too, as Sabeena Gadihoke notes: "As a feminist, as a woman, it's important for me constantly to interrogate the way we shoot, not just women, but underprivileged people." Most of our interviewees are comfortable referring to themselves as feminists even if they do not see themselves as activists. They have thought about how women are shown in film and television, which women's stories are usually ignored or misrepresented, and what they have been able to do about these issues in their own work. Their responses reflect their diverse national, cultural, and class backgrounds. They do not reach the same conclusions.

What if a camerawoman who is working for hire is supposed to film a scene in which women are stereotyped? In Celiana Cárdenas' description, Mexican cinema usually stereotypes women as homemakers, prostitutes, or abandoned victims. She does not think Mexican cinema has films about real Mexican women except for those by director Maria Novaro, "who shows women as complex characters in Mexican society." Priya Seth described shooting a dance scene in a Bollywood film that offended her because "the woman is being

portrayed in a way she shouldn't be"; "the men sometimes can't see that, because for them it's sexy. So a woman does bring something which a man would not." When Seth has spoken up, saying "That shot is not OK. You have to do this again," sometimes the men listened. But Seth has been secure enough in her job to speak her mind. Although Sandi Sissel has worked as a DP on a "series where I've said to the writers or the director that I don't think that's a just portrayal," she warns, "that's a quick road to being fired."

Bollywood, like Hollywood, makes few films realistically representing women's lives. Within India itself a debate has raged about the limited image of women in Bollywood films: chaste bride, loving mother, or sexually loose woman. Seth criticizes these Bollywood films for presenting hypermasculine heroes and one-dimensional women: "It has been excused as being what the people want to see, but I disagree." Gadihoke, however, loves the fantasy element of Bollywood films. "The fantasy women in Bollywood films are probably far removed from our own lives, but then we see so much of our own lives," she says. "We see documentaries for that." She sees these fantasies as important to India's huge audience: "Bollywood women sing songs; they dance. They change costumes every three minutes. They travel. One minute they're in Switzerland and the next they're in Kenya." She argues that people who call all Bollywood films escapist do not understand. "The song sequences—however bizarre they may seem—give space to the woman protagonist. Somewhere in the song she acquires power to be a sexual being."

While Gadihoke acknowledges criticism of Bollywood images of women as sex objects, she argues that Indians read images in film differently than non-Indians. She also praises the variety of images of women in Indian films, from the realism of documentaries to the fantasy of Bollywood. Since India has had satellite broadcasting, she notes, Indian audiences have been exposed to even more images of women from foreign films and television programs.

Like Bollywood, Hollywood has been criticized for its limited representation of women, once again heavily reliant on sexist stereotypes. Besides being a place where commercial films are made, "Hollywood" also refers to a style of filmmaking associated with fictional stories, lavish expenditure of money on resources to make these films, and a lack of imagination on big-budget action films. Since the 1960s, along with NOW (the National Organization for Women), writers, academics, and women who work within the Hollywood system have criticized how Hollywood films represent women. In 1973-74 three books were published in the United States—Joan Mellen's *Women and Their Sexuality in the New Film*, Marjorie Rosen's *Popcorn Venus: Women, Movies and the American Dream*, and Molly Haskell's *From Reverence to Rape: The Treatment of Women in the Movies*—followed by Laura Mulvey's "Visual Pleasure and Narrative Cinema" (published in 1975 in *Screen*, a British magazine associated with the teaching of film and film theory). These publications marked a change in film studies that has had practical consequences not just across academia but in the world, especially the worlds of journalism and popular culture. For example, discussions of "objectification" as well as the limited representations of women across all genres have become part of general public discourse. There would be no discussion of the Bechdel Test[1] now without the work these women did then.[2]

Haskell provides a feminist chronological history of film, with a central chapter on the genre she calls "the woman's film." Given its focus on a female protagonist, the woman's film seemed to offer hope for feminists in search of something good to say about Hollywood. Haskell, though, identifies four themes—sacrifice, choice, competition, and affliction (163), none of which tends to produce films that pass the Bechdel Test. Like Madelyn Most, Haskell compared Hollywood unfavorably with Europe, because Europeans accepted as part of mainstream film material the subject matter, especially the domestic subject matter, relegated by Hollywood to the woman's film. Haskell's very title, *From Reverence to Rape*, describes the primary options available for female characters. Ironically, *Saturday Night Fever* (John Badham; 1977) identifies the same choice when a young man tells a young woman she is a "good girl," so she cannot act like a "bad girl." The creation of these cinematic stereotypes and clichés is not something in which camerawomen participated. As the feminist arts activist group Guerrilla Girls points out, "female stereotypes have not begun to catch up with the tremendous changes in women's lives fomented by the liberation movements of the 20th century—civil rights, feminism, and gay rights" (Guerrilla Girls 89).

In 1986 historian Andrea Walsh's *Women's Film and Female Experience, 1940-1950* pointed to a decline in the representation of strong, complicated female characters beginning with the 1950s; her analysis of the "before and after" images takes into account major social factors such as the First Wave of feminism, the Depression, World War II, and then the return of male soldiers to the factories and of women workers from the factories back into the home. One Hollywood film, *The Holiday* (2006), also notes this historical shift in the representation of strong women, when an elderly male mentor shows the Kate Winslett character some of these films to help her gain self-confidence and achieve her goals. *The Holiday* was written and directed by Nancy Meyers.

In her 2011 documentary *Miss Representation* actress/filmmaker Jennifer Siebel Newsom criticizes Hollywood films and TV for providing stereotyped images of women or no images at all. Historian Diane Purkiss argues that these "dumber and dumber" female protagonists are "hysterical, weight-obsessed and only think of men" (Hill). These cartoons of image-obsessed women, according to analysis by the Geena Davis Institute on Gender in Media, are too thin to bear children and so buxom that women think of surgery to change their bodies to conform to what they see on the screen. Furthermore, the percentage of female characters on screen, compared with male characters, is lower generally; they are also limited in age range to childbearing years, and associated with looks rather than power or achievement.

The word *lookism* attracted the *New York Times*' "On Language" columnist's attention in 2000; he cited sources that identify its first usage in 1978 and its meaning as "discrimination based on looks" (Safire). Hollywood contributes to lookism, as Sissel observes, because most women on screen do not resemble the way most women look off screen. For example, most female cinematographers do not in real life look like Hollywood stars yet Sissel is sure Hollywood would make them look unrealistically attractive if camerawomen appeared as characters in a film. "But that's true in all cases," she says. "An actress portraying a female journalist is going to be more attractive than [a female journalist] might normally be. This

is Hollywood." She quickly adds, "Independent films have become a low-budget version of Hollywood in many cases."

Melissa Silverstein, founder of the blog *Women & Hollywood*, told the *Observer*, "One-dimensional female characters are created because the men making and directing the films are only interested in one thing: that these women titillate male audiences on the least challenging, most obvious of levels" (Hill). Silverstein explained that one contributing cause of the stereotypes is that women write fewer than 10% and direct fewer than 6% of Hollywood films (Hill).[3] Is it a camerawoman's fault if the image she sees through her camera and helps to create with framing, angles, and lighting perpetuates the stereotypes? Or if what she creates may perpetuate acceptance of violence against women?

Many camerawomen *are* bothered by the representations of women on screens around the world. Teresa Medina objects to the Hollywood image of the perfect woman: "All girls in movies come out with perfect hair, lips, wardrobe, jobs, and smile. This is not real; this is a strip of film; it does not exist. We admire what is young, what we have decided is aesthetically beautiful. And what is that? Blonde, light skin, no wrinkles, big breasts, small waists." Medina is amazed when she sees women all over the world get lip implants and breast augmentations, or remove ribs—all to become more like the Superwoman fantasy that Hollywood has helped create—and saddened that men admire the fantasy and ignore women who look normal.

Ellen Kuras feels strongly about violence against women in film. She thinks people have a responsibility for what they are doing at work. At her work, though, the problem "really is a case-by-case situation." She films violence when it "is appropriate to the scene being shot." For example, because violence against women is real, Kuras acknowledges that it is sometimes necessary to show this real-world violence. "It's naming it, in a way. That's one of the things I like about working with Spike Lee. He wasn't afraid to name it" in *Summer of Sam* (1999), in which, Kuras explains, "when the girl holds the book up and gets shot in the face, that's something that happened, so the violence was a legitimate part of the story."

However, another film involving violence against women bothered Kuras so much that she had to challenge the director when, in order to emphasize how violent the male character was, he wanted to make a particular scene more violent. Kuras recognized that "they were going to quote from another film and have this guy take a bottle and smash it in this woman's face," but, to her, the scene did not move the narrative forward and there were other ways to show how terrible the character was. So she spoke up: "Why do we have to show this? I'm sure that people in real life do something like this, but showing it in film almost says it's OK. I can't condone this. Violence in the cinema starts with us." She refused to be part of the scene, explaining, "I am not going to generate these images because they are bad for people to see." Furthermore, she asked, "why did it have to be a woman" on the receiving end of the violence. The scene was filmed, but Kuras didn't shoot it.

However, Katie Swain notes that by the time a camerawoman is on set it is difficult to promote a change because a script has already been written, and the camerawoman simply

has to accept that script for what it is or refuse to do the job. She suggests talking to the director, the DP, and the rest of the team about visual ways of presenting something so it is "portrayed in a way you consider suitable." The truth is, if a camerawoman wants to work in mainstream film production, she may find herself shooting material that offends her personally.

Filming accurate images of women during wartime in news and documentaries is a different challenge. According to Margaret Moth, her CNN team made an effort to cover women's stories when they were filming in Afghanistan during the US-Afghan War. Of course Moth and her team had to cover the hard news, but she said, "Hard news isn't every day. On the other days, you look for more human-interest stories." Moth thought that "women's issues are dealt with very well, really, in those situations." And although women are often victims of sexual violence in wartime, sometimes in countries that traditionally censor sexual material, Moth felt that a country's feelings about women's sexuality were irrelevant to her as a CNN news camerawoman. "If we felt that that woman's life would be endangered through speaking to us, then we would blur her face, or silhouette her. It wouldn't stop us from doing the story."

However, from within a country with conservative attitudes toward women and toward sexual material, Mary Ayubi saw things differently: Most issues dealing with Afghan women are missing. Ayubi has tried to show aspects of normal life for women in Afghanistan as well as the trauma of war because she wants people to see positives as well as negatives: "We're proud that, for the first time, Afghan girls, with help from French women, made a documentary." However, although the film, *Afghanistan Unveiled*, circulated internationally in film festivals around the world and on PBS (receiving an Emmy nomination in 2005), it was not screened in Afghanistan. So Ayubi did not have direct access to her target audience—the men and women of Afghanistan.

According to Ayubi, the many problems associated with filming women's issues in Afghanistan include the things "that women are ashamed of talking about, or if they do talk, [they fear that] their family would be ashamed. If their family wants to talk, other people around them are ashamed. I've seen and heard stories that as long as my camera was on I was crying." These sensitive subjects rarely covered in the media include whether a woman was harassed sexually, disfigured, raped, or forced to get married, and whether she has to keep secret whom she loves. Ayubi thinks that "these issues, before and after war, are rarely covered in the media."

The points that Ayubi mentions are part of a larger issue that has taken on heightened significance in the last two decades: the representation of Muslim women. For instance, Lee Meily reflects an international interest in significant Muslim populations within countries that are not necessarily predominantly Muslim when she says, "I would like to shoot the Muslim women in the Philippines." The fascination with Muslim women often involves such questions as, Do they veil themselves? Are they literate? Do they need to be freed?

Gadihoke is not Muslim but, as an Indian, she lives in a country with one of the highest Muslim populations in the world. She also works at a Muslim university and is a feminist. It is

therefore unsurprising that the representation of Muslim women has been one of her interests throughout her career. Her films, for example, include one for US consumption "[about] a Muslim community that's practicing family planning." The Mediastorm Collective was founded to shoot activities around controversial legislation dealing with divorce that would change the legal status of Muslim Indian women. "Divorce is easy for Muslim men. Most of these were poor women affected by this legislation, because they had children to look after and they had no maintenance from their husbands," Gadihoke explains. Mediastorm successfully collected donations to make the film, *In Secular India*; however, it "didn't get a censor's certificate because it was critical of Rajiv Ghandi's government. But it got us a lot of recognition."

Countries with large Muslim populations differ greatly. Under the Ottomans, Islam was officially dominant, but religious and ethnic groups lived together in a mix of European and Asian cultures. In 1921 Turkish leader Kemal Ataturk established a government that made huge social and political reforms, secularizing Turkish society and emancipating Turkish women. Living in Turkey, Berke Baş' perspective is intriguing, especially given that, apart from making her own films and working with Turkish friends from her own film collective on their projects, Baş has frequently worked with directors and crews from other countries on films with Muslim subjects. For example, Baş worked as cinematographer for Lebanese director Olga Makar on a film about secular as well as religious women of Islam, particularly in the part of the film "about how, in Turkey, different sides come together." Although "the director said that I don't know anything about Islam," Baş concludes, "she was happy with my camerawork."

Baş describes some foreign crews with whom she has worked as coming to her country "with this template in their mind that Turkey is this country of clichés, like women are covered. They don't want to get deeper into what the society is experiencing." While foreign filmmakers, she says, always represent Turkey as an Islamic country, and although it is getting more religious, she nonetheless maintains that Turkey "is a very secular country. Foreign crews say that they want to interview a covered woman, but if that covered woman doesn't have anything to do with the story, why would I have to put that woman in front of the camera?" For example, while filming *Jihad for Love* the director—an Indian—kept pointing out veiled women and saying things like, "Oh, look at this woman wearing a hijab. Film that." As Baş describes the situation, "There is this one single woman crossing from the other side of the street, and I'm filming my characters, and he wants me to zoom to that woman." To her mind, "Either we follow the story, to experience the city through the eyes of our own characters, or you just want to get postcard images of the city."

Asked if they seek changes in the representation of women on screen, many camerawomen say yes, especially those who also work as directors of their own work. Baş says that Turkish films shot by Turkish women "will play a big role" in opening public debates and helping women's issues move forward because they are circulating through festivals "and some are screened on TV."

Are there gender differences in camerawork? Or is the idea of gender differences in camerawork "too simplistic"? At the heart of the problem is *essentialism*, a term for the

assertion that some characteristics are innately male while others are innately female. Feminist film studies has wrestled with essentialism, with some feminists arguing for essential female qualities in women's film work while others have argued against the idea. The stakes are high. In a male-dominated world, women have had to argue that they can do a "man's job" as well as a man can and that there is nothing gender-specific about the job of working behind the camera. Arguing that there are essential differences between men and women might undermine women's attempts to work in what is de facto a male area of employment.

For documentary work, Baş thinks that "male camerapersons are more methodical. Maybe they have scenes in their minds in advance." She thinks she works differently because she goes with the flow, "engaging with the conversation." She does not focus on the frame or the close-up or the medium shot, but instead on "the people that I spend time with."

In New Zealander Kylie Plunkett's experience, women not only see differently, but also work together and tell stories differently in both documentaries and fiction filmmaking: "ABSOLUTELY! A female perspective is always going to be different to a male's, as their entire life experience has been viewed through a slightly different lens." She cites one female DP she (as director) hired who was fantastic "at trying to discover the mood and tone of the film we were making together. She was keen to help. She wanted to uncover the inner story of the film." Plunkett compares this woman to male cinematographers who were more interested in "what type of equipment we had and more practical inquiries about crew and logistics." As a director, she prefers to work with female cinematographers "because of the vision that they bring to the project, and also because of the way that they relate with the actors and with the rest of the crew." Plunkett, however, acknowledges that analyzing differences up on screen is difficult at present because there is an insufficient body of work by camerawomen to consider. "I wouldn't say I could recognize a female cinematographer just by looking at her work. There aren't enough well-known female cinematographers out there yet to even think about trying to do that."

While Plunkett argues that their different experiences acculturate women and men differently, Kirrily Denny argues that men's and women's brains are wired differently, so they have a different "sensitivity." Acknowledging that the technical aspects of postproduction might smooth out some gender-related differences, Denny argues that, while men focus on more purely aesthetic aspects of a shot, such as the beauty of a face or a building, women bring "deeper emotional insight into the art of visual storytelling" because they focus on emotional aspects such as "the tears in the eyes or movement of the body," revealing "more about feelings."

Emiko Omori is also sure that women see differently because something she calls "sensibility" underlies seeing; sensibility is gender-specific and that translates into seeing. She associates sensibility particularly with color and with different interests. Omori uses words such as "soft" and "feminine" to explain herself. For example, she refers to an experience

working on a film with three friends, especially to the way the women would dress a set or do cutaways: "How can I say this? It's feminine, or softer; it has things in it—like colors, flowers, and all—that appear in a lot of documentaries." She also feels that women emphasize more feminine aspects—such as the colorful, graceful fish swimming at the end of her film *Rabbit in the Moon*—while men use violent or warlike language and images that "ultimately translate into some sort of aesthetics that comes out visually."

Siew Hwa Beh believes women and men have different innate value systems. She thinks on the one hand that "women see things as a whole human being" and on the other that "we see details." Men, meanwhile, "see the world in patriarchal terms. Only big issues are important to men—whether a war is happening, who got elected as president." Beh thinks women should have the camera to be able to look at issues "that are totally significant that men don't think are significant," especially issues "surrounding women and children." Although they "may not be obviously earth-shaking," images associated with these issues can "radicalize people's lives every day." Also, when women ask questions such as "who controls the media—radical, political questions," they are "open to seeing these issues from a whole other angle."

Austrian Eva Testor also believes that camerawomen are "more sensitive, better, or just different for some material." For example, when she filmed a birth, she says, she did a really good job because, as a mother, she has a "different access to the experience." In contrast, when a male assisted her while filming a Caesarian, "he was completely wiped out by the experience" despite taking "herbal medicine [he got] from his girlfriend so he wouldn't pass out."

Kuras takes a middle position on gender differences. She is pretty definite that seeing is not gender-specific, but a physiological process that men and women share. Still, she also believes women have a different sensibility than men. She argues that women cinematographers have an advantage "because part of what women are usually criticized for—being too emotional—informs my work and helps me to shoot with my heart as well as my head." For example, she says "there's a big difference between doing a shot where you pan left from right and doing a shot where you discover as you go along in your shot. There's some sort of emotion involved in it, some sort of subjective take in it," and this matters because "part of the look of the film is the feeling that goes into it."

While taking a similar position, Lisa Seidenberg adds an important point, which Kuras is unlikely to dispute. Seidenberg argues for a cultural aspect to how she sees, not just an innate quality, because "cameramen taught me to shoot. So I don't know if I have a distinctly different eye." However, she identifies one specific distinction from what she was taught and her end results: "A lot of cameramen go for the 'money shot.' I look for feelings or people that would be overlooked."

For Arlene Burns, the presence of women as part of the camera crew makes for a better work environment because women do not need to be in the spotlight but can cooperate to create a team. She says that on one project a male director can be yelling commands to people who are "being told what to do and are doing their job because they're getting paid"

while on another project women have nurtured "the relationships that are the foundation of people's enthusiasm or passion." Therefore, Burns says, women's team approach can help make a better crew and a better film than the aggressive, competing-for-the-spotlight male approach.

Can male cinematographers take a feminine approach? Jac Fitzgerald thinks so, saying as well that they have told many sensitive stories—although she acknowledges that she cannot tell if any given image on the screen has been shot by a man or a woman. Other camerawomen—like Jessie Maple Patton, Lisa Rinzler, and Moth—insist on general differences among human beings rather than gender-specific differences between men and women. Patton is among those who think that analysis in terms of style requires a substantial body of work to consider: "I don't think if you put a film on television, you can say a woman shot this or a man shot that. We all have different styles. You can look at a film and if you know that cameraperson's style, you can say that was this person or that person. But you really have to have seen a lot of that person's work before you can identify it." Moth says, "There's a difference between how people shoot, but I don't think because you're a man or a woman would make the difference. Different people approach things in different ways, have different ideas, and maybe different sensitivities." Lisa Rinzler agrees with Moth in not believing in gender differences: "It's about specific people and how they see, how they relate with the director, how they relate to the material. That's where I would put the focus, not women vs. men, men vs. women."

Agnès Godard says she engages behind the camera "as a person, not as a woman." In trying to help the director, she has never felt she makes suggestions that come from her being a woman. Working with a woman director, she sometimes expects that she and the director will be able to understand each other easily: "But sometimes it's not true, because we are all different. In each case it's the combination that is interesting, that is constructive." Godard thinks that "everyone has to find his [or her] own way to work, to find his inside rhythm, to find what is necessary to do a job." She describes operating with a DP who "was doing the lighting. I was fascinated by the way he was working. I realized that I will never work like that. I admire him, but I discovered that I would be another kind of DP, because it's a difference of personality."

Zoe Dirse has worked as an operator with a male DP who was also operating: "I would set a frame and he would be furious with my frame. I would think, But this is much nicer. Sometimes I'd wonder, Is this aesthetics? Is this the male/female perspective? Is this cultural?" Dirse has analyzed her documentary cinematography within the context of female gaze and "the audience's response to that gaze" in her essay, "Gender in Cinematography: Female Gaze (Eye) behind the Camera." She concludes as follows:

I believe it is crucial for women to take control of their art (and, in my case, of the cinematic images that show the world who we are) in order to subvert patriarchal assumptions concerning gender. If, in fact, the female gaze is almost absent from dominant culture, then the challenge is to change the patriarchal way of looking by

imposing the female gaze on our cultural life, even if, as Hélène Cixous suggests, we must "steal" in or "fly" by.

(27)

Seth opposes the idea that there are essential gender differences. She hopes that her visual style as a cameraperson has nothing to do with her being female because "that would tend to color the job because I am a woman as opposed to being a good cinematographer." Because she believes she has her own unique visual sense, she does not like it when "people tell me they would like to hire a woman cinematographer." She would rather be hired because she is good at her job, and being good on the job "is not gender specific."

Gadihoke also opposes "any essentialist argument about women being inherently different"; feminists would be wrong to think that, because of being female, a camerawoman will suddenly "right all the wrongs of the past, inherently start shooting these empowered images of women, and not shoot women in a voyeuristic way" nor "objectify women." As a young feminist, Gadihoke found feminist film criticism extremely important to her. However, she notes that Mulvey, who was fundamental in establishing discussions of differences between the male gaze and the female gaze as they occur in films, has "herself refigured her own position in terms of the male gaze. Your looking through the lens has to do with your politics and your socialization." While she thinks that a feminist camerawoman "who's clued into feminist debates will try to shoot differently, she may not succeed."

Sissel's concerns about essentialism have to do with its practical consequences. She thinks that if a person did not see an identifiable name first, s/he could not know if a man or woman shot or directed a film; but she dislikes the idea of people making hiring decisions based on essentialist ideas about "women's nature." Sissel has a female friend who has complained of being offered only love stories and stories about children, but "she hasn't been in love in ten years and she's never had a kid. So why does she, as a woman, always get those kinds of scripts?" Sissel, who is a mother, tells how some female DPs including herself had "to bring out their toughest sides many times on the set" but also were motherly at other times. She also mentions that there are "extremely sensitive men in our industry, in all aspects of the business."

Sometimes the reality of film production practices seems to settle the argument about gender and style. For example, Gibson once told Agnès Godard that Godard's shooting seemed particularly feminine in how it flowed with movement and how the camera moved up a man's body. Godard replied that, as she usually worked with a camera operator, "it is usually a man behind the camera rather than me." So did the male camera operator have the "feminine" style?

Finally, there are the responses that the demands of the project in question override both differences of gender and individual inclinations. Celiana Cárdenas does not believe in gender differences in shooting because the project is primary. She has worked with a female director shooting car races or soccer commercials and with male directors shooting stories about children. She believes that each individual has a unique sensibility that "has

nothing to do with our gender. It depends on the project," because the cameraperson uses a certain type of visual language depending on how the director visualizes the project. She feels that a person's "sensibility comes from your family background, your culture, and the environment that surrounds you."

Nor does Akiko Ashizawa believe in gender differences in shooting, though her "cinematography is reduced to 'feminine' by many spectators." When she worked with the "dry, clever"—and male—Kunitoshi Mada on *Unloved* (2001), she says that the audience responded to the film "for its fascinatingly feminine taste." A few women also worked on the set for art direction and producing, and her first camera assistant was a woman.[4] However, "the crew weren't selected because they are women, but because those most suited to this feature about love were excellent female crewmembers." The director's vision dominated the film; as DP, Ashizawa felt her job was to interpret Mada's vision.

Besides the issue of gender differences in camerawork, camerawomen also argue whether the language of film making is gender-specific. Testor objects to male aspects of film terminology itself: "'Shooting,' well, it's military vocabulary. I avoid saying, 'We'll shoot in this direction.' I think it's possible to use other words." For example, for documentaries "gathering" works better for Testor than "shooting."

In a conversation with Agnès Godard, Dirse makes an analogy between feminist film language and First Nation film language.[5] She recounts filming a First Nation artist in Venice, Italy, who had brought over masks made in Canada. The First Nation artist had given his masks traditional qualities, but his art is political since "he makes statements with them and changes perspectives." Dirse tells how other First Nation artists had labeled this political artist as "not authentic," but he theorized "that if his culture had not been stopped at a point in time, then the art would have evolved differently." Dirse makes a similar point about women in film because only a few women like Alice Guy-Blaché or Germaine Dulac were producing and directing in the early decades of cinema, but women got pushed out, especially after World War I, "and in Hollywood in particular. I wonder whether things would have evolved differently."

In this conversation Godard admits that she has never thought how cinema could have developed differently but insists that she starts instead with the cinema of today. She appreciates that today more and more women work as directors and camerawomen. "It should continue like that and pass to something else. The past is the past. Today it's a really good energy. We have to keep on like that. It's not a fight. If it's something that is transmuting slowly, it will be even more considerable." Seth agrees: "It is just going to be better and better if there are more women out there doing it."

Asked if she uses a feminist film language, Young-Joo Byun replied that women use "an already determined, existing language. Female language should be invented. It should be constructed from every woman's life. It's not yet been created and does not sound difficult in theory, but to invent or discover a female or feminist language is hard." Byun believes she makes movies with a "women's *Weltanschauung*—women's identity," but she does not know if her films are therefore feminist films. She argues that for feminist films to exist,

"they'd need female language, female imagery." Furthermore, Byun argues that nationality is also important to women cinematographers' style: "Watching Agnès Varda's films, I don't think Varda's language is the same as Korean female language. The responsibility of Korean women filmmakers is to adapt the feminist lexicons that women filmmakers in the West have constructed to this particular culture and space: Korea."

Ethics

To me, beautifying the world is part of why I'm here, and underlining or exposing some sort of truth, whether it's a philosophical or emotional truth.

(Mairi Gunn)

Gunn's aspirational statement about the relation between self, on the one hand, and truth and beauty, on the other, rings true for many of the camerawomen interviewed for this book. Equally committed to being a credit to her country and doing well by it, Cárdenas has a strong personal ethic that requires her to produce work of which she can be proud. She aims to work on projects "that are within my ethics, my values, and that I believe in, because in the end movies are forever." For her, quality matters more than quantity, since when she dies, "the credits will always say Director of Photography: Celiana Cárdenas."

Many camerawomen share Gunn and Cárdenas' ethics and have acted on their ethics on the job. Fitzgerald has refused work on a film project because she found the content of the script "too violent, too macho for me!" Madelyn Most also has said, "This film has too much violence," and refused to work on it.

Before working in Hollywood, Estelle Kirsh had mostly watched art films. When she moved to Hollywood to work, she did not realize she would be shooting violence: "I was naïve, wasn't I?" She thinks that the Hollywood film business has perpetuated violent images and wonders about "people who are responsible for making it possible that this stuff hits the screen and poisons the minds of American kids. Whether they feel responsible in any way for it."

Sissel stresses the importance of a careful reading of the script before a camerawoman takes the job. She has read many scripts that were so bad that she did not even go for an interview. Luckily she has been offered so many jobs that she could cherry-pick among them. "I don't feel that I've ever done something that was sexist or racist or violent because that kind of work hasn't attracted me." She does remember that on Wes Craven's *The People under the Stairs* one day they got a call sheet for the next day's work that said, "disembowelment scene." She asked, "Wes, when did you add a disembowelment scene?" Craven said, "Sandi, we've had the disembowelment scene from the beginning; you read it the way you wanted to read it." Sissel is aware that this "kind of thing happens. I've read scripts and said to the directors, 'I'm somewhat offended by this particular thing,'" only to be assured "by them that that's not quite

the way that it's going to be portrayed. But if we only worked on certain kinds of subjects, it would be really hard." Furthermore, while she mentions that she hates exploitation, "to take people into a world that you would never be part of otherwise, and to see how horrible that world can be, can often make a person think more deeply about a subject."

Kuras, having worked on big-budget Hollywood films as well as big-budget TV commercials, recognizes ethical failings in both areas. She thinks that filmmakers "all have a social responsibility to each other as people and to our culture and society." She is well aware that the films she makes will not please everyone, but still feels that film industry workers "are aware and that they question when something is wrong or seems to be wrong." She brings her standards and morals to every film project she works on: "I'm a responsible citizen. I bring myself behind the camera. That's what people hire."

While many independent films focus on ethical issues, the independent arena also includes sexploitation, blaxploitation, and other genres with questionable ethics. Pioneer camerawomen Brianne Murphy and Roberta Findlay in the United States, as well as Akiko Ashizawa in Japan, worked on sexploitation films as camerawomen when starting out. From the late 1960s through the 1980s, Findlay worked as DP on sexploitation and horror films such as *The Touch of Her Flesh* (1967), written and directed by her husband, Michael Findlay, eventually becoming a director and DP of horror films such as *Blood Sisters* (1987).[6]

Arlene Burns' criticism of the US film industry has led her to eschew working on feature films, although she still expresses some hope for the system. She is most frustrated by the values manifested by people in the feature film industry; she thinks that the values "that often come from the big deals are 'devour and discard.' If you need something, you're really nice to someone and the moment you get it, you throw 'em out." When she first worked on a feature film, she was shocked, not being able to believe that "these were the rules of the game." She hopes that people in television and film realize that they need to treat people decently "because if you can come from a place of cooperation and integrity and honesty and fairness, then the final product can't help but reflect that, too."

News camerawomen also express concerns about the ethics of their medium. Watching Boston-area news coverage of the serial killer known as the Washington Sniper, Nancy Durham "was disgusted by what I saw on television. The presenters were actually taunting him." Joan Giummo shares Durham's concerns about the system, at least regarding network coverage of the news. When she worked for the networks, it seemed as though she were "working in the belly of the beast, because they were shaping the news in ways that frequently were misleading. [...] Not that I think networks don't do good work," but they often "were missing the point, ignoring the point, or going in directions that were beside the point."

Perhaps there is room for hope despite the difficulties for camerawomen in shooting news. Heather MacKenzie speculates that during her years working camera at KABC, "in bringing subjects that are difficult for us all to face into people's homes, I've changed people's vision on certain subjects"—a sentiment expressed by several of our interviewees. Even better, English-born New Zealand-based Kirrily Denny, part of a younger generation of women filmmakers, reports, "I've enjoyed working [in television] with female presenters who aren't

always the stereotypical presentation of women on screen. I certainly prefer working with and promoting women who present intelligence on screen."

Documentaries as well as news demand an ethics, according to many of the camerawomen interviewed. Jan Kenny is careful to choose which documentary jobs she takes, since she is aware that when a cameraperson shoots a documentary "it's easy to color a situation by the way you cover it. Every time you are shooting, you have to keep in mind truth to the people that you are filming." For Kenny, truthfulness is the bottom line because "in documentary you're recreating someone's life and putting it on the screen. That carries responsibility with it." And for fiction films, Plunkett also says, "My role in the screen industries does carry a social responsibility. What we see on our screens has an impact on how we create ourselves in society."

For Christine Heitmann, being a responsible camerawoman "means to show the public stories that can make them become more tolerant towards 'strange' people and people with problems and pain inside." Burns also aspires to improve the world by showing how people sustainably live in the natural world. She wants "to encourage a dialogue with people on what is happening on this planet and how we need to change our own life habits in a way that becomes sustainable for the bigger picture." The outdoors is Burns' church, which we must "connect with and keep in some form where the air we are breathing is sustaining us and not poisoning us. Film is taking me more and more to the deeper places with environmental political issues."

Burns is well aware that many people turn off what they do not want to see and watch only what their "tribe" watches, "whether it is auto racing or Wimbledon tennis or Christian religion or Buddhist religion." Despite the difficulties, to her it is important to document what is happening in our society and "to try to communicate that, especially to the kids, who are going to inherit the problems of our shortsightedness." She hopes to get programming in places where many people can see it so the films can "have a huge transformative effect on how people live their lives. That might be a bit of a dream," she admits.

Because the integrity of the system within which they work matters to them, some camerawomen have chosen to work with certain directors. For instance, Madelyn Most chose to work for Marcel Ophüls whose projects about Nazi crimes made her feel, "This is real." Most thought she had a duty to make the world aware through her films of people who had been children "when their parents were shot in front of them." She filmed women who as members of French Resistance groups in the 1940s hid bombs and grenades in their baby carriages. "It gives you strength to see what those women did." Most says she learned from filming interviews with concentration camp survivors talking about "the dangers, the fear, the having nothing, losing your family and all your friends, watching people go up in the chimney. It gives you a certain focus in life and what you have to do in your life." Most wanted to film these witnesses "before these people die, to hear how they lived and survived. They fought for a better humanity and I think it's my job to do the same." After Most had that documentary experience, she could no longer work, for example, on a Bruce Willis film: "I just couldn't. Why are they making films about all this violence?"

When Gadihoke and Shohini Gosh were shooting *Tales of the Night Fairies* they refused to do any "secret shooting" of sex workers. Although films in India have been made with the filmmakers accompanying police raids, Gadihoke thinks that practice is "reprehensible. I'd never want to do candid camera: on the fly, hidden camera" shooting. Gadihoke wanted to "respect the essential dignity of the people" she was shooting and not shoot people who were drunk or unaware of what they were saying, because she "wouldn't want to be shot like that. We would never do that with people of our own class." Gadihoke and Gosh had their subjects' consent, but "wherever people said, 'Don't shoot,' we wouldn't shoot."

For Gadihoke, Baş, Ayubi, and Rozette Ghadery, who have worked on documentaries in countries where they are largely on their own or in the company of members of a film collective, a greater degree of control comes along with the relative absence of funding. So Gadihoke could choose to make her early films about sensitive, noncommercial subject matter. Because she was working so closely with the director, who was often a friend, "I would get involved in the debates around these shoots about subject matter as well as manner of presentation. I'm not a traditional cameraperson in that sense."

Baş has a thoughtful concept of her role as a specifically Turkish filmmaker. While she acknowledges that "Turkey has serious problems, serious women's issues like honor killings," she nonetheless wants to find images that best represent Turkey in a positive way, "because there are so many negative images and we have to address these as Turkish filmmakers as well. Complexity has to be there. There are different sides. You have to listen to people."

Ghadery, too, situates herself in terms of her specific cultural time and place in Iran, where for centuries, "art has had a manifest, a statement." "I have always believed that I am not only creating images as a camerawoman. I was born in an era and place with its own political, social, and economic situation." She stresses that films are the filmmaker's written statements:

I need to think why I was born, what I am doing in this world, what responsibilities I have, where I am going afterward. These questions encourage me to make my own films. God promises us infinity when he creates us finite. Every artist does the same thing with what he/she creates. Nothing in the world is everlasting.

Ghadery is not alone in speaking of her role behind the camera in terms that emphasize the power of images and the power of the camera as it captures images. While some camerawomen talk about their relation to the camera in physical terms, some speak of the camera—beyond its function as a recording or capturing device—as having a power within society generally and in more individual interactions. Irit Sharvit is emphatic: "I have in my hand a powerful tool that I must use very carefully." For MacKenzie as well, "the camera is a tool, but it can also be a weapon. It can be a peacemaking weapon." By "peacemaking weapon" she means that the camera can "record, but be its own power. Just like they say, 'The power of the pen. The power of the press.' It is a powerful weapon because it can be used to change people's opinions. And it doesn't lie." It is in this sense that Palestinian Fida Qishta

can say, "My camera is the only weapon I have against attacks on Gaza" (*Where Should the Birds Fly*).

Moth's wartime experiences shaped her own ethics. She said she would never put the camera down when something was happening, but she always worried about what she would do if she were first on a scene with injured people.

> *My first obligation is to help those people, but as a cameraman I need to be filming. It only ever happened once. A bomb landed, and I was the first one there. People were injured and I had to run, with the camera rolling. About that minute, other people started arriving to help. So I didn't have to worry other than the first few seconds.*

For Moth, the conflict between two responsibilities was serious, because "where a bomb has just landed, it's also news that needs to be filmed."

Though she spent years filming news during wartime, Moth did not believe in war. "Every war I know of isn't necessary. I believe in negotiation. I think there's too much fighting, but I don't feel it's women's moral obligation to stop it. It's people." She did not differentiate between a man or woman shooting or making decisions since she refused to categorize women as the world's moral negotiators. "No, people should be the negotiators. It's not just women. If a woman is shooting the gun or a man is shooting the gun, I don't see any difference. And the same with a camera."

Camerawomen Teaching

> *My professors inspired me so much when I was in college. I made a promise to myself that I would try to be as inspiring as they are so that future filmmakers would have something. The best teachers are the ones that can share their experiences.*

> (Lee Meily)

For many camerawomen, teaching is a way of giving back; they teach as a commitment to the future and an acknowledgment of the past. Michelle Crenshaw, who taught herself on her first jobs, feels she is constantly learning on the job in Hollywood because things are always changing. She has trained several people on the job, but she has only been interested in training newcomers who specifically want to learn how to be assistants. "You have to want to do this job to make a living. Especially as an assistant, because it's not a creative role. You don't get the benefits of having a piece of work and claiming it as your own." When people ask her for help, she looks at them and asks, "Do you want to be an assistant or do you really want to be a Director of Photography?" If the answer is, "Well, someday I want to shoot," Crenshaw replies, "You know what? Don't waste your time. Just shoot." While preparing for a show, she has invited newcomers who want to be assistants to the shoot to show them the

basics and has even introduced them to people who could hire them for a job as a loader or second assistant cameraperson.

Crenshaw was surprised that "a lot of people have laid claims to me as a trainer, that I had that kind of influence." Training and the job market have both changed during her career. Twenty years before she started, the Hollywood camera union had a training program at a time when the industry needed new people; twenty years after, the union had no training program, the job market was saturated, and few newcomers were needed. She suggests that women who seriously want to become cinematographers seek training in schools, workshops, and other training programs.

Vijayalakshmi, who trained on the set, has also trained newcomers on the job. When she does this on-the-set teaching, she will spend perhaps ten minutes telling the trainee what she calls the theory portion: what she is doing and why she is doing it. She thinks training comes more from "their observation of the work happening on the set." Because she is an established camerawoman, her trainees give her respect: "The people who want to learn photography from me are very well placed. They become independent themselves."

Meily has trainees on the set and she teaches at a school. She tells trainees about using her lens and camera, from which she thinks they will learn more than from books. As she gets older and choosier about her projects, she is also more involved with teaching.

Camerawomen are becoming teachers at universities and film schools around the globe, having earned their place there through their professional skills. Gunn may have wanted to go to film school in New Zealand but such training was not available until well after she began her film career. Now she has made it to film school, as a teacher.

The many places camerawomen have taught include the three leading US film schools: NYU, UCLA, and USC. Sandi Sissel, who heads the graduate-level cinematography program at NYU's Tisch School of the Arts, also does workshops outside of NYU as well as trains "a loader on a film crew or it might be a young electrician who wants to be a DP." Like Gunn and Meily, Sissel enjoys teaching and mentoring young people who want to work in film. At NYU she feels that she and director Spike Lee, who also teaches there, have inspired women and African Americans to become cinematographers and directors "because they've seen me do it, they've seen Ellen [Kuras] do it, they've seen Spike [Lee] do it. So it doesn't scare them to think they can get involved in it."

In Sissel's NYU classes, film students learn all aspects of filmmaking, unlike the directing class where students work with actors, or the writing class where students learn about scriptwriting. In her cinematography class one student has to direct, a second has to work with the actors, a third has to be the assistant director, a fourth has to be the DP, a fifth has to be the camera operator, and a sixth has to do the lights. She teaches her students how to keep track of time so they finish filming in a certain period of time. "The five to six hours I have them is our time to make mistakes. It's a time for me to tell them how tough it can be with an AD [assistant director] looking at their watch all the time. How tough it can be when a director doesn't understand the lens and so they insist on something that the lens doesn't do."

Sissel enjoys bringing the politics of gender and race into the classroom along with discussions of the responsibility that comes with being an artist. She also stresses one's "responsibility as a boss, when you're taking on this kind of job, and what that means. How you need to present yourself. How you need to treat other people." She has often found that her best students at NYU were women, in that "they did the best framing and the best lighting." Yet, despite her female students' excellent technical skills in camera work, to her most of them lacked "that tough veneer. They were not naturally inclined to be bossy of the crew." So Sissel has tried to teach them how to deal with all aspects of the job on and off the film set. "That's with the producers, with the studios, with Kodak, with Panavision, with Arriflex, with every aspect of the industry. It's a big job. It's not just about talent. And it's tougher for women than it is for men. It's even tougher for minorities than it is for some white women."

Sissel learns from teaching. When she watched her first NYU graduate students do their thesis films, "All they had, if they were lucky, was a 35mm camera with five or six lenses. Most of the time they had a 16mm camera, but they had few lights, few crew, few permits, not even a generator." She watched what they accomplished with so little, saying that she experienced a "re-baptism of what one could do with nothing but desire and creative ability. We sometimes need to see younger people do it to remind ourselves how creative we used to be and how creative we can still be."

Zoe Dirse has cited a solution Judy Irola found, in Irola's capacity as head of the cinematography program at USC,[7] to one of the problems identified by some of the US pioneer camerawomen. It is an example of the positives of not just having women teach, but also administer the teaching of filmmaking. As Dirse describes it, Irola

tells her cinematography teachers that they should let every student line up and do every exercise. Usually what happens is the male instructors come in, they say this is how you do white balance, this is how you set up a camera, and then they walk away. All the boy students rush in and do it, while the girls stand back.

("Women behind the Lens")

Marina Goldovskaya first taught cinematography and filmmaking in Moscow University's Department of Journalism in 1966, teaching journalists how to work with cinematographers. After establishing an international reputation as a documentary filmmaker, she went to the United States, becoming a professor at UCLA in 1995. Since nobody was teaching documentary there, she created and headed a new documentary program in which she taught both the history of documentary film class, which was usually large, and the production class, which was small. "For the first year I had only women," she said in 2005. "Then the next year I had maybe two men. This year, I have 25 students: maybe eighteen men, seven women." Goldovskaya retired in 2014.

Women head their film school's cinematography programs in countries other than the United States, e.g., Jan Kenny at AFTRS. Kenny brings the senses into play when she teaches documentary; she especially tries to get her students to listen. "By nature, young

cinematographers are learning to look and see. To learn to listen is a skill you need to acquire, that doesn't come naturally." Learning "to listen to the conversation that you are filming, to understand it," will help you "know when to move from one person to another, or to pull back or get in closer." Listening to what is happening around you also matters because "what's happening behind you may be the story, not what's in your frame at that moment."

Berke Baş does not live off her documentary camerawork; she teaches documentary production at Istanbul Bilgi University, which, she says, provides a supportive environment for its female students. She always has "more female than male students" because the women "are probably more into documentary, which is a great sign that there will be many more female documentary filmmakers in the future in Turkey." Her course, "Documentary in Process," stresses the idea for the film: "It's from the idea to actual production, like how to develop the idea, find the characters, get in a relationship with the characters, structure the story." Since most of the students who take her class come in with some practical experience behind them, she can talk about the "intellectual" process. She encourages her students to "approach real stories in an aesthetic way: how they can bring out a story from a real incident, and how they can bring themselves into the event and create a filmic story." Baş finds that once her female students are behind the camera "they enjoy it and want to continue. At the beginning they always think, I can work with a friend of mine who can shoot for me. Later they discover the beauty of filming."

Zoe Dirse, who teaches at Sheridan College outside Toronto, is concerned about the sort of experience that female students have in class. She found her own role models in European female cinematographers, but she has noticed that in Canada "women [aren't] coming up and joining the ranks of cinematography." When she was headhunted to teach at Sheridan, she did not expect to be hired, but two female faculty members wanted to hire a woman to teach film technology because they thought it would help their film and TV program attract more female students. During Dirse's first year at Sheridan, there was one female student in her cinematography class, who "got pushed out halfway through because directors wouldn't choose her to shoot their final films." After teaching for some years Dirse could report an increase in female students. "Not all of them want to be cinematographers, but they've had me from the first year. They see that it's safe for them to come into the classroom and that I teach differently."

Dirse thinks that more women should teach in film schools "so that girls can see themselves in those jobs." When Dirse teaches her classes, she shows her students the documentary *Women Behind the Camera* "because in the first year, the male teachers show *Visions of Light* and there's only one female in it." Dirse also brought Judy Irola from USC to the NFB for a workshop to teach a new generation of women cinematographers. According to Dirse, it is important for more experienced camerawomen to nurture younger women who still are having a difficult time in film school.

Gadihoke's main job is teaching camera at Jamia Millia Islamia University in New Delhi, but she also teaches video and television production, "which means I teach camera, editing, and sound. I teach direction; I look at the scripts." She enjoys teaching camera, and over the years has overcome her "technophobia. Being a teacher, you have to know your facts."

As she grows older and the distance between Gadihoke and her students grows, she feels she has more authority. When Gadihoke began, she was only four or five years older than her students. "It was tough. The boys on the backbench were tripping me up on technical questions. They didn't know it much better, but the idea was, Let's trip this woman up. I used to resent that." Over the years she has grown more confident in part because she is more experienced both at teaching and at making her own documentaries. Another reason for her confidence is that she has realized that, while the technology is constantly changing, the skills and knowledge she teaches transcend the constant novelty of the equipment. She is no longer intimidated by new technology, having realized that "when you're already technophobic, it's added to by the mystification of technology around you."

Jarnagin experienced less of that sort of mystification. Still, she acknowledges that, while "the constant introduction of new cameras and tools is exciting and inspiring," it

can be overwhelming trying to stay abreast of all the latest news and technology. It can feel like a full-time job. On the other hand, the widespread acknowledgment about how much work it takes to stay informed has inspired countless opportunities to provide the information to as many people as possible.

According to Jarnagin, this era is "a really exciting time" because "if you want to learn, the information is readily accessible."

Unlike earlier in film history where there was a certain amount that was expected to be known to be qualified to work on a professional project, now there is so much to know that there is widespread acceptance that no one can know it all, so there is no shame in admitting what you do not yet know. I used to try to test every new camera that came out because I thought it was my job to know them all. Now I just need to know how the new cameras compare to other choices and I'll wait to test them and learn more in-depth about them when I am considering which camera to use for a new project.

For beginners, "There are podcasts, tutorial videos, instructional blogs, online and print magazines, panels, presentations and events that are hosted by manufacturers, rental companies, film festivals, and filmmaking organizations." Jarnagin would know, because she has participated in many of these activities as the teacher.

"Just Do It"

I would hope that you would be as naïve as I was in terms of ignoring the obstacles. The best way to move forward is to not see the obstacles.

(Kristin Glover)

What advice do current camerawomen offer to potential camerawomen? First of all, according to Teresa Medina, "You have to be patient. If your profession is a passion for you, then keep going; otherwise, forget it. It is too much work for it not to be your passion." "Passion" is a word that camerawomen use frequently, in a number of contexts. Elaborating upon Medina's advice, Eva Testor says that

> *when anyone comes to me and says she wants to become a camerawoman, I say, "OK, then do it. Just do it." I can't say everything's great just because it's great for me. Each person must find out for herself. Everyone who really wants to do something, who recognizes her calling, will be good at it; and everyone who's good will find work.*

Asked about advice specific to getting into special effects camera work, Jo Carson responded that all people who want to enter new fields, no matter what sort of work is involved, need to find a mentor: "Find someone they think they might be able to hook up with, write them a letter, initiate the contact." Then the beginner should politely and respectfully "maintain the contact over a period of time, until maybe the person's willing to meet with them and give them advice and help them out." She adds that if the first mentor does not work out, then the second one might. She's definite: "A person with a mentor is going to travel further, get better jobs, get more of them, and be more satisfied with their career than a person who doesn't have a mentor."

Madelyn Most suggests that prospective camerawomen research current camerawomen's experiences. Learning from earlier camerawomen is important because not only can you find out what the possibilities "are out there," you can also "find out what you love," which is important because you may have "to live with this for the rest of your life." Not surprisingly, Most says that women need to think carefully "about whether they could live with the challenges of Hollywood" since many people who go there with unrealistic fantasies wind up being unhappy.

Gunn, Maryse Alberti, Crenshaw, and Goldovskaya are all emphatic: "Just do it!" Although Gunn suggests that the aspiring New Zealand camerawoman go overseas to get into the industry, she has an alternative suggestion: "Get a camera and just shoot and shoot and shoot and shoot and shoot and shoot and shoot. There is more than one way to the top of the mountain." Gunn also stresses finding people "you respect and trust, who are good at something where you're not, and work along with them."

Alberti is an example of someone who found her passion and went for it. She "grew up on a farm [in France], finished high school, came to the States, hitchhiked around the country, [and] started to take pictures." Her first on-set experience was as a still photographer for porn films, but she became a celebrated cinematographer in the early 1990s when she began working with directors such as Todd Haynes and Todd Solenz and producer Christine Vachon. She favors documentaries, including the Academy Award-nominated *Enron: The Smartest Guys in the Room* (2005). She has also worked on TV series, including *Sex and the City* (1998). For her, cinematography is "a fantastic job. When you look through the little

rectangle and it works, that's the greatest high. Or when you go to the movie theater and see your film, that's the reward. To have accomplished something." Alberti offers familiar advice: "If you want to shoot movies, take a little camera, and go shoot movies."

Marina Goldovskaya has similar advice as Gunn and Alberti: "Take the camera and shoot from morning to night until you feel that the camera is the extension of your arm, eye, ear, your body. Do this until you can say, 'I don't feel the camera; I am breathing with the camera.'" She concludes: "When you get to this point, start making your film."

And what did Michelle Crenshaw tell a young African American woman who came up to her and said, "I'd really love to be a DP"? She said, "Do it. Shoot, shoot, shoot, do it, interact, get out there. Just do it." Like Goldovskaya, Crenshaw wants students to practice with the camera a while "for you to feel comfortable with your craft." Realistically, she adds, "It's also going to take a while for you to make money. People will call you to shoot, but a lot of people can't afford or don't want to pay you."

All camerawomen stress the importance for those wanting to start a career in cinematography of networking while learning technical skills. In previous sections camerawomen have described networking by establishing groups like film collectives in a variety of countries as well as through established organizations like Women in Film. For example, in Chicago Crenshaw joined Women in the Director's Chair, an international film festival organization, when she was just out of college. "It was quite big, and we lasted for about ten years[8] but funding is very hard for organizations like that."

While she was involved with Women in the Director's Chair Crenshaw "got excited about being able to shoot and work" because she discovered many other women "telling stories out there, whether they were the photojournalistic or educational type of story, or dramas and comedies." The group had workshops and women maintained contact with each other. "That's how, when I first got out of college, I was shooting, because we became a network. This industry, really, it's about networking and knowing folks." Crenshaw recalls that after other "people heard that I shot, they'd call me up and we'd get together and if we connected, we shot something. If we didn't, we moved on." Throughout her career, if a person hears about her and calls her, she has tried to be supportive. And she does have female assistants who work with her.

From Ellen Kuras' point of view, a camerawoman needs to use three things all the time: passion, intuition, and knowledge. She thinks passion and intuition are closely related and influence one another. "Passion drives me forward to discover, to explore, and to be a person of inquiry, whether it has to do with a certain color palette, a certain setup, a certain shot, a certain way of being on the set. My intuition informs me as to what feels right." However, both passion and intuition need to be informed by technical knowledge: "I need to have knowledge about my equipment, about my film stock, about the development, about what the print stock is going to do, so that it informs my creative choices."

For example, as DP for *Eternal Sunshine of the Spotless Mind*, she needed passion to work for "24 hours a day, seven days a week, because I wanted it to be right." She also had to know "what the final print stock would do when we printed it because I was color correcting

to that print stock." She had to know what "the contrast was of the stock. I knew what it could handle. I knew what it couldn't handle." This knowledge of film stock "informed my intuition about what to do in the color correction." Kuras stresses that a camerawoman need not "have all the answers, but you should ask as many questions as you need in order to understand."

Jessie Maple Patton's advice is based on her having been asked so often how she managed to become a union member. She stresses that those who desire to be union camerawomen need to learn as much as they can about the equipment, "get as much education as you can about the field, work on independent films to get the experience, find out what the union requirements are, and then fill out an application to become a member."

Meily provides very specific technical advice for her students: Do not move the camera "when it's not needed." For her, the camera is "a powerful machine and you can take it to a lot of places, but once you become obtrusive, you're useless." Instead of attracting attention, the cinematographer's presence should be felt only on an unconscious level. "If you don't need to dolly, if you don't need to somersault your camera, stay put. And be true to what you're seeing: a particular scene, a particular movement, and a particular emotion."

Networking either by joining formal groups or informal networking on jobs or by making friends helps new camerawomen learn about producers, directors, and cinematographers. In networks women can gain new skills, get hired for the first time, or meet mentors. Networking, for example, could help new camerawomen figure out which directors or producers or cinematographers will hire women.

Sarah Pillsbury acknowledges that the producer does a lot of hiring, including the department heads who then hire their assistants and other staff. Pillsbury says she and her coproducers have tried to hire as many women as possible for their crews because they love working with women. So she was not surprised to read Martha Lauzen's study "that showed, when women are producers and directors, their crew, the number of women, expands to 150% greater than they are in films done by men." For example, on *Desperately Seeking Susan* (Susan Seidelman; 1985) the producers did not do a lot of hiring, but on *River's Edge* (Tim Hunter; 1986), they got more involved, resulting in more women on the crew. On *Eight Men Out* (John Sayles; 1988) they had a male director "who was a strong feminist, with female producers; the crew was almost 50-50. It was really fun, and you could tell the difference." She says the feelings on the set of *Eight Men Out* were very positive—and "not just on the set. We had a party every weekend. It was a group that really got along."

Many women cinematographers are taking more risks and hiring more women. Both Priya Seth and B. R. Vijayalakshmi are in positions where they can hire other women. Seth says, "When I was working with this other DP there were many women who would come and work. I was his chief assistant and they would be under me." The word from Vijayalakshmi is not as positive: "I keep telling women to be focused. What happens is either they get married or get a chance to act. So that lures them away. I had two assistants who want to act. They have chosen that career." Katie Swain speculates that "people are too protective of their own career and they're blind to other women's." But for herself, "I try to

promote other females within my profession. I actively search out female assistants. I will help them when they're students, to let them decide what they're going to do, or come out on location, or whatever."

As camerawomen move up the ladder, they often become friends with other camerawomen, forming friendship networks that extend to employment. The friendship network that included Sandi Sissel, Joan Churchill, Christine Burrill, and Judy Irola stretched from London to Los Angeles via New York. Globalization and social media make this kind of networking even more possible and, one can hope, even more productive.

When Kuras saw Churchill and Sissel making documentaries year after year, Kuras "thought to myself, if [they] can do it, I can do it." Churchill became Kuras' mentor and friend as well as introducing Sissel and Kuras. Having been befriended by Sissel, Kuras returned the favor. When she was doing *Blow* and needed to bring on a B camera, she called up Sissel: "Hey, you're in LA. Do you want to work on this movie with us?" Kuras enjoys working with people who are friends and "that you know can do the job. She ended up doing all the Second Unit action stuff, which helped her to do all of the Second Unit stuff" on *Master and Commander* (Peter Weir; 2003).

Just as Churchill was the center of a network in three different cities, Agnès Varda has been the center of a network in the French film industry, hiring women on her films as focus pullers, camera assistants, set decorators, and sound mixers. She is pleased that now male directors are hiring more women on their crews and that more Frenchwomen are behind the camera.

In Austria there is a similar network of women. Astrid Heubrandtner hired Eva Testor for her first jobs, and Heubrandtner continued to help afterwards. Testor worked relatively rarely as a camera assistant because she did not enjoy it that much, but she has helped with lighting. "Once I worked as a gaffer for Jürgen Jürges, which was a dream." For her own documentary films, Testor has hired a "female assistant who has studied camera and wants to become a camerawoman and who will be great." She also has two women gaffers as well as two student interns for her feature film. Meanwhile, Austrian camerawomen network into Germany as well because some Austrian camerawomen have shot films in Germany, and vice versa.

As camerawomen from different countries cross borders—sometimes meeting at international festivals such as Camerimage in Poland or the International Cinematographers Film Festival Manaki Brothers in the Republic of Macedonia—the networks spin out, crossing the globe. Margaret Moth started out as the first camerawoman in New Zealand, moved to Houston, Texas, for seven years, and then worked around the world for CNN until shortly before her death. Madelyn Most has worked in London, Hollywood, and France. Giselle Chamma has worked in Brazil and New York. Stephanie Martin left Argentina to work in the United States, and now works out of the United Kingdom. Lee Meily has made films in San Francisco and New York as well as in her native Philippines. Seth has worked in Bollywood, Hollywood, and Australia, while Sissel has worked in Canada as well as the States. The expansion of WIF chapters around the world helps

women to make helpful contacts wherever they need to work. What camerawomen stress is that newcomers one way or another should start to network through joining film groups, film collectives, going to film school, finding mentors: Any way you can network, do so.

For those already working as part of a camera crew, the advice is a little more specific. Chamma's advice focuses on actively seeking support to overcome obstacles. She says that while there are nonsupportive people and discrimination still exists, she only listens to supportive people and walks away when she experiences discrimination. A camerawoman, Chamma says, should try to do three things at once: "Be true to yourself. Be professional. The most important thing is to have fun. With the crew, try to entertain them. Your attitude matters."

Kuras identifies self-confidence as a necessary character trait for success on the job. She knows from personal experience that it can be difficult to be unique on the set—for example, the only African American or the only woman there. Therefore minorities need both "self-confidence and having that self-confidence reaffirmed in order to succeed." Hilda Mercado talks about the need for self-confidence because facing her fears was one of her biggest challenges. But "once you get that confidence to say that your knowledge and experience will guide you, then you have won over your fears."

Mercado cautions that a camerawoman should have the self-confidence to fight for her point of view on the set, but also the maturity to know when it is better to let go, to be able "to be on set and admit that you made a mistake that needs rectifying." For her, "all these small challenges make you better at your job, and a better person as well."

Hutton is adamant about women's need to be thick-skinned and tough in order to pursue careers in camera crew. "You have to just get in there and do it. Don't stand back, and don't let them marginalize you." Instead, "women have to take charge of their destiny. It's important that girls learn this in school. When I first got into film school I was shy. But there comes a

Figure 37: Hilda Mercado, AMC. Mexico.

point where you have to barge ahead because if you don't, you get left on the floor." Hutton says a camerawoman cannot be discouraged by all the jobs she deserved but did not get. Instead a camerawoman needs to "keep looking and keep focusing on what you can do, because if you think about what you can't, you'll go nuts."

Now Crenshaw's priorities have changed. She is less interested in working for others and wants to do her own projects, and "the only way to do your own projects is just to do it. That becomes a priority." She cautions that even if you are the cinematographer, "it's still not your story. It's the director's story. It's the producer's story. I got into the industry to be a storyteller. But it took me a long time to get to that."

Based on her experience, Sissel cautions about rushing up the Hollywood ladder. She feels lucky that the first film she DPed for got her international recognition, but she wishes she had spent more time as an operator because, working "with Jan de Bont, Robbie Müller, Haskell Wexler, and other people, I might have learned more about the politics of being a DP on the set." She often tells younger DPs now, "You're going to learn more from other DPs by working on their sets than you're ever going to invent in your own mind."

Sissel often tells "young women going into the industry, 'You have just as much talent as your male counterparts, but you're going to have to bring a side of yourself out that is not necessarily going to be natural to you as a woman'" because "a lot of women haven't been raised that way and haven't worked that way." Sissel can "look at undergraduate and graduate film students, men and women, who want to be DPs [and] tell you point-blank who's going to make it and who's not because I can see who has that kind of armor and talent."

Like many other camerawomen, Sissel describes herself as "shy": "I don't like hustling, which has affected my progress in the industry." She has not worked at promoting herself at professional meetings, parties, or film festivals, nor has she gone "visiting" on sets to make contacts and remind people she is there. If a camerawoman wants "to stay viable in the industry," she warns, "this is part of the job. You don't just sit back and think that because you did a good film" you can expect a future of good films to fall into your lap. A camerawoman will always have to hustle.

Jarnagin agrees: "Learn and get comfortable with the art of self-promotion." She admits she has had to learn this through experience.

Many of us are drawn to this industry for the artistic side of it, and for being a nontraditional career. Most people lack the business skills to succeed. Certainly I wasn't taught any of it, or even taught that I needed to concern myself with such things at all. It took me years of struggling to realize I needed to understand how to be a small business person. Being a freelancer, that is exactly what you are. Your product is you, and you have to learn to sell yourself. And of course how to do it appropriately for our industry. You can be the most talented person on the face of the earth (in any field) and if no one knows who you are,

then you won't get hired, while others who aren't as good as you do. When I first started out, I ignorantly believed that my work would speak for itself and other people would spread the word about me and soon I'd have it made. It took me years of being broke and unknown before I learned that it doesn't work that way. You have to invest the time and effort in yourself, and, dare I say it, your brand.

Sissel is realistic about economic drawbacks to being a cinematographer and unhesitatingly explains them to her students. "I work with directors who make more money in residuals in a year than I make working nonstop." She says that even a DP with a long resume never gets any residuals, so "go be a director, be a producer, be a writer." Even Brianne Murphy said, "The reason I moved from Director of Photography to director was frankly to make more money—and being a director is a lot easier and a lot more fun." Once again, a cinematographer needs to have passion to stick with her career.

But once you are a DP and jetting around the world, keep in mind the voice of experience, in this case, Liz Ziegler's, who advises, "Have the production be responsible for shipping the equipment. Then, when everything goes to hell, it's their problem. They are paying for it anyway." Ziegler also offers some tough love advice: "Stay centered on what you love to do. It's about handling the politics and the people. Dealing with other humans is really hard. Just keep focused on what your goals are. You want a better place to put your energies."

Susan Walsh has watched the Hollywood industry change as work has left the Hollywood area. Furthermore, work that used to be done on film is increasingly being done digitally. "There's a lot of re-arranging going on, and the dust hasn't settled yet." As a result, Walsh repeats her father's advice to "do work that you love or at least that you can enjoy and that means something to you." Following your passion is the key to longevity in the film industry, but an aspiring camerawoman needs to recognize when her choice is not working. Walsh has "never put all my eggs in one basket. I've always had something else going on while I was doing camera work." For example, she "was also working as a self-defense instructor whenever I could," partly because it was a flexible job that she could do on and off between her film jobs. She also became a writer as well as "a marriage and family therapist. It's important to have some fallbacks because it's an unstable industry. You have to plan your finances, and you have to realize that you're probably not going to get rich. So be clear about what you want."

Glover agrees with Walsh that a camerawoman has "to know what the obstacles are and you need to acknowledge them but not be defeated by them." She likewise thinks that one should find ways to get around obstacles if you have the passion to be a camerawoman. "In order to pursue a career as a cameraperson or as a director, writer, whatever it might be, you have to have the fire in your belly for it. If you don't have that, it's going to be way too hard to walk through what you have to walk through, whether you're male or female."

Aspirations for the Future

I had no idea that a little girl from Baton Rouge could come to LA and fulfill her dreams.
(Liz Bailey)

The aspirations of the women we interviewed cover personal concerns, such as Stephanie Martin's hopes that "this career will take me all over the world," to aspirations for camerawomen's advancement as a group, for the film industry in a particular nation, for the film and television industries across nations, and for the world. Celiana Cárdenas, for example, sees herself as part of a group of women who believe they can make changes; she also believes "that Mexican cinema, beside its other qualities, is a cinema that has social conscience, political conscience, human conscience. That's why I think it's a universal cinema."

For Teresa Medina, what camerawomen in the Spanish and US film industries need for a better professional future is self-respect. "If we do not respect ourselves, nobody is going to respect us. When we do, then society, the producers, and the directors respect us. It is a collective effort." Medina dislikes seeing women who fail to support and respect each other; she would like to "foment more self-esteem in women. It is fundamental."

Lee Meily's hopes for the Filipino film industry center on the many good, young filmmakers she sees and she hopes as they start to go mainstream "that they maintain good attitudes." While some say "the Filipino movie industry is dying," Meily thinks that "it will be reborn, maybe with these new filmmakers." Meily is also hopeful about the digital format, which "gives everybody a chance to shoot films fast. But I keep reminding [my students] that not [just] anybody who can afford to buy a camera can automatically be a filmmaker."

Many women hope for higher numbers of female cinematographers in the future. As we have seen, several American women singled out Haskell Wexler for his assistance with their careers. When Glover asked him why there were still so few actively working camerawomen today compared to cameramen, Wexler pointed to the producers and directors—the employers who do the hiring.

Jessie Maple Patton provides an historical perspective and a vision for the future for African American female cinematographers in the United States. She thinks that challenges facing African American women cinematographers now are the same as when she started in 1974 when she became the first black female member of the camera union in New York. Over four decades later, more women are graduating from film schools, "but the shortage of jobs is still there."

Teresa Medina agrees that producers are the gatekeepers for women behind the camera. She thinks that men and women get out of school with the same level of knowledge and producers should be sensitive to that fact and give women an opportunity. According to her, producers in Spain as in other parts of the world "should look at the women's reels." If producers see women cinematographers "have handled large pressures, then they will trust

you. But," she adds, "how are you ever going to have that under your belt if you are not given the chance?"

The history of women cinematographers around the globe suggests three possible ways to increase the number of women behind the camera. Two have historical precedents, reflecting the power of earlier feminist efforts; the third is aspirational, but grounded in some parallel examples. First of all, there has been government intervention. Then, as part of social changes resulting from the simultaneous rise of television and Second Wave Feminism, a number of female executives have been in a position to forefront documentaries, which has been advantageous to women. Third, there are the general strategies women have learned, often from feminism, for our collective advancement in a male-dominated world.

So, as we have seen, China, Australia, and Canada provide excellent examples of how government intervention on behalf of women can increase the number of women behind the camera. After mainland China's civil war ended in 1948-49, the 40-year-old feminist movement there influenced the Chinese Communist Party to encourage women to enter male jobs, including camerawork. As mainland China developed, the experienced camerawomen became teachers and mentors for the next generations of camerawomen. In Australia, the government began a series of initiatives in the early 1970s that also encouraged women to enter into film work. Addis, for example, got her first training in a government-funded women's film workshop. The Canadian government also encouraged women to participate in film work, most especially through establishing Studio D. Government intervention in all three countries increased the numbers of camerawomen making news and documentaries for government-owned media as well as for the commercial film industry.

In the United States, Martha Lauzen has urged "regulation, tax incentives and hiring mandates" as ways to increase the number of women working in Hollywood ("Hiring Mandates"). "Broadcast and cable networks are now vertically integrated, meaning they produce and distribute their own programming." But "in the 1970s and '80s," she reminds us, "federal regulation stipulated that the broadcast networks could produce only a certain percentage of the programming on their stations," which gave "independent production companies" a chance to survive. As Lauzen continues, "In the early 2000s, the Caucus for Producers, Writers and Directors (unsuccessfully) proposed that networks and large cable and satellite interests be prohibited from producing more than 50% of their programming." She is perhaps being idealistic when she suggests that

if this legislation were coupled with significant tax incentives for women-owned production companies, this one-two punch might help redistribute resources, making greater diversity a real possibility. Perhaps such regulation could be collected in some sort of Gender Equality in Media Act that would also require the major film studios to hire a certain percentage of women in important behind-the-scenes positions.

("Hiring Mandates")

This sort of gender equity is part of the Geena Davis Institute's goals along with better representation of women on screen. However, as Davis' President Mackenzie Allen argued at the end of *Commander in Chief*'s "inaugural" season, if the Equal Rights Amendment had passed in the 1970s, US women might not be fighting these battles today.

On a happier note, even in the United States something positive has happened to the documentary world since the mid-1960s and that in turn has led to an increased number of camerawomen everywhere. The feminist movement's emphasis on feminist collectives and festivals, on networking among women, and on pushing into existence affirmative action programs as well as union training programs for women helped a number of women to train, to get first and subsequent jobs, to move up the ladder, and to grow exponentially to the point that in 2013-14 women cinematographers filmed 12% of the feature US documentaries screening at high-profile US film festivals; and women directors, who are often their own cinematographers or hire camerawomen, directed 28% of these documentaries, including winning many important awards (Lauzen, "Independent Women" 2014).[9] Historically, the feminist demand for material useful to consciousness-raising and other educational purposes encouraged women to make films. Crucially, though, women have been able to pursue camera careers in the United States and Britain in large part because of the rise of women executives in TV and cable networks such as the BBC, PBS, and HBO. This is because these women executives have bought increasing numbers of documentaries directed and/or filmed by women, enabling women to establish a record of making brilliant documentaries.

This point leads to the third way to increase the number of camerawomen. As outlined by Zoe Dirse, "It has to change at the top, where producers and directors are willing to work with women and bring them in." She is talking about a situation in which confident producers and directors are open to considering the work of confident camerawomen. She notes that France has a higher percentage of women DPs per capita than Canada, the United States, or the United Kingdom, and that French women DPs all have similar ways they developed their careers. She points out that in France, women cinematographers started working for one famous director, "whether it was Agnès Varda or Claire Denis or Truffaut or Eric Rohmer." Since these well-known directors are so confident in their craft, "they were willing to work with women right off the bat." In addition, Dirse notes that these famous directors will "stick with them for several films, so that these women are really able to build their reputation. They can say, 'I've just done three films with [Jean-Luc] Godard.'" After that the camerawoman can "do her next film with Truffaut or Akerman or whomever." If other countries followed the French model, then established directors in Canada, the United States, and the United Kingdom would choose to work with female cinematographers in the future for narrative films as well as documentaries.

When Alberti urges women to "support each other," she means "not only women cinematographers, but producers and directors," and she means "not be afraid to hire a woman to shoot a big Hollywood film." For its 2009 brochure, Sweden's Doris Film collective asked a female producer, "How can you as a producer practically change the situation?" Maria Karlsson Thörnqvist, the producer, responded, "You have to search actively...It's all

about old thinking-patterns one actively has to break" ("Search Actively"). For Dirse, having "an equal playing field—50% men and women" means that "eventually things are going to change."

Eventually you're going to start getting a different way, because of our socialization and how we are as women. We will be able to express ourselves. There are way more women directors and producers than there were ten, fifteen years ago. They just have to feel encouraged and want to work with women as well, [to] open up more opportunities.

Pointing out that "women like Brianne Murphy, Nancy Schreiber, Sandi Sissel, or Judy Irola have opened up the doors," making "it a bit easier for me to go in," Alberti therefore believes that, as the number of women cinematographers increases, the next group of women will have an easier time as cinematographers in turn. She hopes "there won't be the need to make a movie or book about women cinematographers" because "there'll be just the cinematographers—equal numbers." Akiko Ashizawa's impression is that "the number of camerawomen and women directors is increasing, and the variety of their expression is reaching greater dimensions than ever before." Sissel agrees and is "thrilled" because "now I have no idea who many of the women are whose credits I see on films. There are so many people that we don't all know each other."

Sometimes the suggestions for increasing the number of female cinematographers seem obvious on the surface, like saying that if you want to be a camerawoman you should "just do it." Gadihoke has a point, however, in saying that the more there are women who do it, the more women there will be doing it. She notes that India has many women editors, so young women see editing as a career option. Indian television companies are increasingly willing to employ women, she says, "but women have to be interested enough to be camerapeople. Once women choose to become camerapeople, companies can open up employment opportunities. That is where the big change will come."

A fourth possibility that might lead to more women working in camera positions for movies is that, as digital videogames continue to gain market share from movies, men will move out of filmmaking in favor of producing games. The history of other professions and industries suggests this will happen and perhaps is already happening. That is, there's more money (hence more prestige) in videogames, so men won't mind if women take jobs in the "lesser" field of movies. Given that some women and girls are also interested in playing videogames, and that some girls are learning to code via programs set up to alleviate a gender imbalance in computer skills, there is also a chance that the videogame industry will develop in a less sexist way than the Hollywood-style film industry did.

As we have seen, reasons abound for producers and directors to hire women in greater numbers. They include their achievements in shooting around the world, winning awards, and heading national camera organizations; their experience shooting in a variety of formats and genres; their contributions to the profession by starting unions and improving safety conditions; and their courage in filming in dangerous environments.

Meanwhile, camerawomen recognize that relatively inexpensive, lightweight portable cameras are increasing the number of camerawomen worldwide. In Ahmedabad, SEWA began Video SEWA and trained Indian village women to use cameras to report on issues like police harassment, the lack of clean water, or suffering after an earthquake. These videos have helped women get real, practical aid into their communities. Nancy Durham enthusiastically observes that digital cameras allow women as well as men, veteran and novice journalists, to go out into the world uncovering news in places that are usually hidden. Ellen Kuras agrees that digital cameras "give everybody an opportunity to take the camera and shoot." She finds it outstanding that women in India or Africa have been taught to use mini-DV cameras and are shooting for themselves; many "other points of view are going to come into play. How we envision the world is no longer in the hands of a few, but in the hands of many."

Other female cinematographers agree that digital cameras and computer technology offer much to camerawomen in the future. Arlene Burns remarked that digital cameras make it more affordable for people to make feature films on a low budget, and Michelle Crenshaw pointed out that with a "mini-DV and Final Cut Pro and AVID, and all that software that's accessible to you at home, filmmaking is available to working class people." Joan Giummo believes that, along with the Internet, mini-DV[10] "has enlivened and activated whole realms of people who can invent their own styles and document what is important to them."

Early feminist critic and filmmaker Siew Hwa Beh hoped in the late 1960s that Portapacs and Éclair ACLs—the new lightweight, inexpensive camera equipment of that time—would empower more women to make their own films. One of the problems then as now was getting access to media outlets to put those films in front of audiences. Now there is the Internet and the various social media it facilitates; they help to distribute and promote material ignored by mainstream media. As Beh observes, the US media are owned increasingly by fewer and fewer corporations, but she now hopes for a much more alternative media provided by women who have digital cameras and "run around in their village, their country, the world, taking films about everything that's been happening so we have constant, different aspects of everything." If women were making films and videotapes all around the world, she thinks there "would be true democracy." Because "the camera can be such a radicalizing tool," Beh is sure that the democratic use of the camera, including women's work behind the camera, can have a profound impact on our world.

Notes

1 The Bechdel Test is a rating system for feminists. To do well, a film must meet three criteria: "(1) it has to have at least two women in it […] (2) who talk to each other, about (3) something besides a man. The test was popularized by Alison Bechdel's comic *Dykes to Watch Out For*, in a 1985 strip called *The Rule*" ("Bechdel"). It has since been included and expanded

upon by The Representation Project to incorporate questions about representation of race, ethnicity, disabilities, and sexual orientation (Siddiquee).

2 Much feminist film criticism and theory has been written since these texts appeared, but we are not pursuing theory here. We mention these works because they were part of the feminist *Zeitgeist* that directly affected many of our interviewees, along with the fact that many of the points made there that pertain to our discussion remain valid.

3 Women writers on the 250 top-grossing films increased to 15% and women directors increased to 9% in 2012, with women cinematographers accounting for 2% (Lauzen, "The Celluloid Ceiling" 2012), but these figures dropped to 10% for women writers and 6% for women directors in 2013, while women cinematographers increased to 3% (Lauzen, "The Celluloid Ceiling" 2013).

4 Yoshiko Osawa, who also shot the interview with Ashizawa for *Women Behind the Camera*.

5 "First Nation" is a Canadian term for its Indigenous Canadians.

6 According to IMDb, Findlay also worked as "Anna Riva" and "Robert Norman".

7 The current head of cinematography at USC is Linda Brown.

8 It lasted for 25 years (http://www.widc.org/; 25 August 2009) – not to be confused with Women in the Director's Chair on Facebook or the Canadian mentorship program of the same name.

9 As Lauzen notes, this is "down from 16% [of cinematographers] working on documentaries in 2011-2012, but up from 11% in 2008-09."

10 Now replaced by HD.

List of camerawomen whose interviews are included in this book

Additional production details for many of these interviews are available online: http://www.womenbehindthecamera.com/.

Addis, Erika (Australia) Interviewed in Sydney by Jan Kenny, ACS, 24 Aug. 2005; transcription by Christopher Buzzini, Bjorn Ko, and Harriet Margolis. Camera: Jan Kenny, ACS.

Addis studied cinematography at the Australian Film & Television School; she received her MA with honors in 2001, by which time AFTS had become AFTRS (Australian Film Television & Radio School). One of Australia's foremost documentary cinematographers, Addis' awards include Most Popular Australian Documentary (*Emily's Eyes*; 1999 Sydney Film Festival). She has also worked in feature films and television (for the BBC and Channel 4 in the UK as well as in Australia). A cinematography lecturer at AFTRS, Addis has given workshops on camera assisting, color, light, and storytelling through the lens, and camera placement.

Alberti, Maryse, ASC (France/USA) Interviewed in New York City by Giselle Chamma, 8 Dec. 2000. Camera: Giselle Chamma.

Based in New York, Alberti is a French-born DP of independent features, documentaries, and commercials who has twice won Sundance Film Festival Cinematography Awards—for the documentaries *H-2 Worker* (1990) and *Crumb* (1994). Alberti has also won Independent Spirit awards for Best Cinematography on *Velvet Goldmine* (1998) and *The Wrestler* (2008).

Ashizawa, Akiko, JSC (Japan) Interviewed in Tokyo by Dr. Kiseko Minaguchi, 19 May 2005; translated by Dr. Kiseko Minaguchi with additional translation by Mieko Koyama. Camera: Yoshiko Osawa.

Ashizawa, whose career began in 1982, became Japan's first female DP; she remains one of the few female members of the JSC. She has shot documentaries, features, and television series. Her awards include Best Cinematography at the Yokohama Film Festival for *Tokyo Sonata* (2009), which also won the Jury Prize at the 2009 Cannes Film Festival. She shot the feature film *Unloved* (2001) and the television series *Penance* (2012). The documentaries she has shot include *Don't Ask for Your Mother's Breast*, about mother-to-child AIDS infection and AIDS orphans.

Aviv, Nurith, AFC (Israel/France) Zoe Dirse's interview with Nurith Aviv was published on the Canadian Society of Cinematographers website (http://www.csc.ca/news/default.asp?aID=862) in Feb. 2001 and is used with the kind permission of Dirse and Aviv.

Born in Tel Aviv, Nurith Aviv was the first DP in France officially recognized by the CNC (Centre national de la cinématographie). She became a camera operator in 1969, and shot Agnès

Varda's films *Daguérrotypes* (1976), *Mur murs* (1981), and *Jane B. par Agnès V.*, in addition to films by other directors. She has also directed several films herself, including *Langue sacrée, langue parlée* (2008) and *Traduire* (2011). Aviv is currently a professor at La Fémis.

Ayubi, Mary (Afghanistan) Interviewed in Kabul along with Mehria Aziz by Setara Delawari, Mar. 2006; and in Pacific Palisades, California, by Mojde Afsary and Alexis Krasilovsky, 5 Nov. 2007; transcribed and translated by Mojde Afsary.

Ayubi and Aziz are two of Afghanistan's first camerawomen, trained by the Aina Media and Cultural Center in Kabul. They filmed the Emmy-nominated documentary *Afghanistan Unveiled* (2003) with other members of the Aina Women Filming Group and Brigitte Brault. Ayubi also co-directed *Shadows* (2005), about women's rights in Afghanistan. She currently lives in the United States.

Bailey, Liz (USA) Interviewed in Northridge, California, by Alexis Krasilovsky, 25 Dec. 2000. Camera: Vanessa H. Smith.

Liz Bailey began at WBRZ in Baton Rouge as the first camerawoman in Louisiana. A member of IA 600 and IBEW 45, Bailey served as vice-president of the Society of Operating Cameramen (1988-90) as well as president of BTL (1985-88). Bailey worked on *Independence Day* (1996) and *Innerspace* (1987), the television shows *Star Trek* and *Murphy Brown,* and on music videos and commercials.

Baş, Berke (Turkey) Interviewed in Istanbul by Alexis Krasilovsky, 10 Mar. 2009; transcribed by Shirley Kim.

A Turkish documentary filmmaker, university teacher, and member of the Istanbul-based *filmist* collective, Baş won the Best Documentary award at the 2006 Nuremberg Film Festival for *Transit* (2005), which she directed. Baş' credits as cinematographer include *A Jihad for Love* (2007), winner for Outstanding Documentary at the 2009 GLAAD Media Awards and of other awards, and *Hush* (2009), which she also directed.

Bean, Karen Edmundson (USA) Interview from 2005 provided by Bean; transcribed by Alexis Krasilovsky.

A wildlife documentary filmmaker and member of the International Cinematographers Guild who has DPed features and television, Bean is also a writer, teacher, and avid beekeeper. She has served as producer/cinematographer on the *Walking Wild* DVD series, which won two WorldFest Houston Gold Awards and other accolades. Bean has backpacked through five continents, filming every kind of wildlife including grizzly bears.

Braier, Natasha, ADF (Argentina/USA) Interviewed by Alexis Krasilovsky via email, 2 Aug. 2014.

Born in Buenos Aires and currently based in Los Angeles, Braier attended Argentina's Escuela de Fotografía Creativa, later earning an MA in cinematography from the National Film and Television School (UK) in 2001. DP of *XXY* (2007; winner, best film, Cannes' Critics' Week), and *The Milk of Sorrow* (*La Teta Asustada*; 2010; winner, Golden Bear, Berlin Film Festival; nominated for a foreign-language Oscar), Braier has won several Best Cinematography awards.

Burns, Arlene (USA) Interviewed in Oregon by Vanessa Smith, 8 July 2001; transcribed by Christopher Elam.

Wildlife cinematographer, producer, and director (as well as the technical advisor and stunt double for Meryl Streep on *The River Wild*) and a member of the US Women's Whitewater Team.

Butler, Sandra (1943-2006) (USA) Interviewed in San Francisco, California by Teri Lang, 6 Nov. 2005; and in Los Angeles by Alexis Krasilovsky, 10 Mar. 2006.

After receiving an A.A. in cinematography from San Francisco City College and a B.A. from San Francisco State University in film and women's studies, Butler studied with Shirley Clarke at UCLA, receiving her MFA in 1983. Butler was the first woman on the Executive Board of IATSE Local 16.

Byun, Young-Joo (South Korea) Interviewed in Seoul by Sun-Young Moon, 10 Dec. 2001; transcribed by Sun-Young Moon; translated by Sun-Young Moon with Estelle Kirsh. Camera: Il-Lan Kim.

A founding member of the feminist film collective "Bariteo," Byun worked as a documentary cinematographer before becoming a director. She shot and directed an award-winning trilogy on the Korean Comfort Women (1995-97), as well as directing the feature films *Ardor* (2002), *Flying Boys* (2004), and the South Korean box-office hit *Helpless* (2012).

Calanquin, Sheila (USA) Interviewed by email on 22 Jan. 2012 and by phone 5 Mar. 2012 by Alexis Krasilovsky.

Calanquin was one of the first US camerawomen to work in television broadcasting, starting as a part-time minicam operator in Southern California in 1979. She became a studio camera operator in 1982 until the era of robotics changed her hands-on camera job to a computer job, operating four cameras on-screen (a position which has since been phased out). She also worked as camera operator on the television series *Movie Macabre* (1981).

Cárdenas, Celiana, AMC (Mexico) Interviewed in Mexico City by Hilda Mercado, AMC, 12 Feb. 2005; transcribed by Hilda Mercado and translated by Luis Albert Sanchez.

Cárdenas is a DP on features and documentaries in Canada and Mexico. One of her first credits behind the camera was focus puller/second assistant camera on *Danzón* (1991). Her credits as feature cinematographer include *Portrait of a Serial Monogamist* (Canada; 2014), *Liz en Septiembre* (Venezuela; 2013), *Foreverland* (Canada; 2011), and *No eres tú, soy yo* (Mexico; 2010).

Carson, Jo (USA) Interviewed by Alexis Krasilovsky, 8 Jan. 2005; transcribed by Jessica Sheeley. Carson has a BA and MFA in film production from UCLA. She made a prizewinning documentary about Nepal, *Himalayan Pilgrimage* (1973), before shifting into special effects camerawork, including camera operator on *The Nightmare Before Christmas* (1993) and camera assistant on *Indiana Jones and the Last Crusade* (1989), *Back to the Future Part II* (1989), and *The Matrix Reloaded* (2003). President of BTL in the mid-1980s, Carson encouraged IA 659 to open the Camera Assistant Training Program and a Loader Training Program to more women. She shot and directed the documentary *Dancing with Gaia* (2009).

Chamma, Giselle (Brazil) Interviewed in New York City, 11 Jan. 2006 by Jendra Jarnagin.

Born in Rio de Janeiro, Chamma got her MFA at NYU in 1994 after working as a still photographer for features in Brazil. Chamma was the first female cinematographer in Brazil, serving as camera operator on the historical drama *Guerra de Canudos* (*The Battle of Canudos*; 1997). Based in New York, her US cinematography credits include the television series *Women: Stories of Passion* (1996), the features *Personals* (1999) and *Happy Hour* (2003), and documentaries. She also shot the Austrian feature *Dreamland* (1997).

Champetier, Caroline, AFC (France) Interviewed in Paris by Junie Terrier, 30 Aug. 2001; translated by Anne Allen. Camera: Alexis Krasilovsky.

Winner of a 2011 César for best cinematography for *Of Gods and Men*, Champetier chaired the AFC from 2009 to 2012. A DP since 1987, she has worked on over 100 films, TV series, and TV programs, including Jean-Luc Godard's *Hélas pour moi* (*Oh, Woe Is Me*; 1993) and Margarethe von Trotta's *Hannah Arendt* (2013). She won two Best Cinematography awards for *Holy Motors* (2012)—from the Chicago International Film Festival and from Camerimage (the International Film Festival of the Art of Cinematography). As director, her credits include the feature *Berthe Marisot* (2013).

Chen, Jin Ti (China) Interviewed by Angus E. McNelis in Beijing, Mar. 2005; translated by Mei Gu, Lawrence Gu, Tan Yanrong, Jean Chen, and Albert Margolis. Unit Producer Angus E. McNelis. Camera: Sheila Pinkel. For this and other interviews with Chinese camerawomen (who were interviewed together), special thanks to China Central Television; Dr. Justine Su, China Institute, California State University, Northridge; Mei Gu; and Tan Yanrong, Film Archivist.

The youngest member of China's first generation of female cinematographers, Chen Jin Ti began her camerawork when she was sixteen years old. After graduating from Huan Bei University in 1949, Chen Jin Ti began work at the Beijing Film Studio, transferring to the Central Newsreel and Documentary Film Studio in the early 1950s. She served as camera assistant and cinematographer in the 1950s and '60s in Premier Zhou's news documentary unit, filming Zhou's talks with foreign leaders on Mt. Gui Lin. Between 1949 and 1981, Chen Jin Ti filmed more than 200 documentaries and narrative films, many of them award-winning. Later, she became head of Children's Television at China Central Television.

Churchill, Joan, ASC (USA) Bob Fisher's interview with Joan Churchill was published on Kodak's OnFilm website (http://motion.kodak.com/US/en/motion/Publications/On_ Film_Interviews/churchill.htm#ixzz1Pvhs02ad) on 27 Apr. 2011 and is used with the kind permission of Churchill and Fisher.

After graduating from UCLA Film School, Chuchill began shooting documentaries such as *Gimme Shelter* (1970), the PBS series *An American Family* (1973), and *Dixie Chicks: Shut Up and Sing* (2006). She has co-directed films with Nick Broomfield, including *Juvenile Liaison* (1976) in the UK; *Tattoed Tears* (1979), shot inside a California maximum security prison; and *Aileen: Life & Death of a Serial Killer* (2003), which won first prize at the Tribeca Film Festival. Churchill also directed/shot the British Academy Award (BAFTA)-winner *Soldier Girls* (1981) and has worked on American TV reality series as producer/cinematographer. Churchill has taught at the National Film School in England. She serves on the Documentary Branch Executive Committee of the Academy of Motion Picture Arts and Sciences, and was the first documentary cinematographer to be accepted into the ASC.

Crenshaw, Michelle (USA) Interviewed in Los Angeles by Mairi Gunn, 4 Nov. 2005; transcribed by Chris Buzzini. Camera: Kristin Glover. Special thanks to Panavision.

A graduate in film/video from Columbia College in Chicago, Crenshaw worked as a union camera assistant from 1985-2006 on Hollywood features such as *Home Alone* (1990) and television series such as *American Dreams* (2002-05). As camera operator, Crenshaw has worked on documentaries, commercials, web series, and features such as *Office Games* (2009), as well as numerous television programs such as *CSI: NY* (2010). Crenshaw was cinematographer on

Cheryl Dunye's award-winning independent narrative feature *The Watermelon Woman* (1996), and co-shot the documentary feature *The Man Who Drove with Mandela* (1999), which won the Best Documentary Film award at the Berlin International Film Festival. She has taught at Hollywood CPR (Hollywood Cinema Production Resources) and currently serves on the Executive Board of the International Cinematographers Guild. Crenshaw is also a member of the Society of Camera Operators.

Cui, Shu Feng (China) Interviewed in Beijing by Angus E. McNelis, Mar. 2005; translated by Mei Gu, Lawrence Gu, Tan Yanrong, Jean Chen, and Albert Margolis. Camera: Sheila Pinkel. Cui Shu Feng was born in 1945 in a Chinese village where she was one of two people who graduated from high school in 1964. Cui Shu Feng graduated from Beijing Film School, majoring in cinematography. She worked as cinematographer and director at the Chinese Central Newsreel and Documentary Fim Studio, where she shot over 30 film documentaries and over 30 television documentaries, as well as covering more than 200 news topics. In 1993, China began making longer format television documentaries, including Cui Shu Feng's *New Look of China* and *Express Delivery*. Her award-winning documentaries include *The Gun Shot from Sixty Years Ago*, *Chinese Stamp Collecting in 2000*, and *Three Generations in Steel City*, which won a directing award.

Dadabhoy, Nausheen (USA/Pakistan) Interviewed by Alexis Krasilovsky via email, 16 Jan. 2002. Born and raised in Southern California, Dadabhoy received her MFA in cinematography from the American Film Institute. Based in Los Angeles and Karachi, Dadabhoy was one of the first female DPs to work in Pakistan. *Josh* (2014), the US-Pakistani co-production that Dadabhoy shot, won the ARY Film Award for Best Independent Film - Viewers Choice. She also served as cinematographer on the Swiss film *20 Regeln für Sylvie* (2014) and as director/co-writer of the documentary *The Ground Beneath Their Feet* (2014), set in Pakistan. Her recent projects have been shot on Alexa Plus, RED Epic and RED MX.

Denny, Kirrily (England/New Zealand) Interviewed by Harriet Margolis via email in 2010. English-born, New Zealand-based writer-director-producer-cinematographer with Feral Films Ltd. in Auckland. The owner/operator of a Sony HVR-ZIP camera kit, Denny has produced stories in the UK for TVNZ. She has also worked as a producer for the National Geographic Channel, and directed *Aunty Moves In* (2009) for Maori Television.

Dirse, Zoe, CSC (Canada) Interviewed in Toronto by Alexis Krasilovsky, 4 May 2001; transcribed by Deborah Parsons. Assistant in Toronto: Holly Craine. One of Canada's first female DPs, Dirse joined IATSE 644 in Toronto in 1979; she is also a member of the Quebec-based union, AQTIS, as Director of Photography. Dirse worked with the National Film Board in Montreal from 1982-97, shooting over 70 documentaries and dramas, including Alanis Obomsawin's *Kanehsatake: 270 Years of Resistance* (1993), which won Best Canadian Feature Film at the 1993 Toronto International Film Festival; and the Genie Award-winning film *Forbidden Love: The Unashamed Stories of Lesbian Lives* (1992), which was shot for the all-female Studio D. As director, she is known for *Madame President* (2004). She has also filmed in war zones, notably on *A Balkan Journey: Fragments from the Other Side of War* (1996). She is a professor of cinematography at Sheridan College and the author of "Gender in Cinematography: Female Gaze (Eye) behind the Camera."

Durham, Nancy (Canada) Interviewed in London by Vanessa H. Smith, Nov. 2002; transcribed by Michele LeBlanc and Ellen Johnson.

A video journalist who worked first in radio, Durham reported on events in the Balkans for the CBC during the 1990s, finding herself part of the news when her practice of checking back on previous subjects of stories revealed that she had been lied to. In addition to filming in the former Yugoslavia, Durham has also filmed in the former USSR, Africa, Europe, and Iraq.

Dylewska, Jolanta (Poland) Interviewed in Skopje, Republic of Macedonia, by Alexis Krasilovsky, with the interview questions translated from English to German by Hans-Günther Dicks, 30 Sept. 2008; German transcription and translation of the interview by Stefanie Kim.

DP on over thirteen feature films. Dylewska has won several awards including an Asian Film Award for Best Cinematography on *Tulpan* (2008) and a Golden Frog award at Camerimage for Agnieszka Holland's Oscar-nominated *In Darkness* (2001). Dylewska has directed her own documentaries and taught at various European film schools. She has shot and directed internationally.

Fitzgerald, Jac (New Zealand/Australia) Interviewed by Harriet Margolis via email in 2010.

One of Fitzgerald's first jobs was on the *Lord of the Rings* trilogy as a loader and then focus puller. Now based in Sydney, Australia, Fitzgerald is a DP of features, including the Kiwi film *Two Little Boys* (2012), shorts, documentaries, and commercials.

Gadihoke, Sabeena (India) Interviewed in Delhi by Alexis Krasilovsky, 10 Jan. 2004; transcribed by Michele LeBlanc, Christopher Elam, and Harriet Margolis.

A documentary filmmaker and founding member of the Mediastorm Collective, a New Delhi-based, all-women media organization. Gadihoke shot Mediastorm documentaries on the Muslim Women's Bill, sati, and other feminist topics, along with Shohini Ghosh's documentary *Tales of the Night Fairies* (2002), which won Best Film at Jeevika in 2003. Gadihoke directed the award-winning *Three Women and a Camera* (1998), about India's pioneering women photojournalists. Her book, *Camera Chronicles of Homai Vyarawalla*, about India's first woman photojournalist, was published in 2006. Gadihoke is Associate Professor, Video and Television Production, at the AJK Mass Communication Research Center at Jamia Millia Islamia University in Delhi.

Ghadery, Rozette (Iran) Interviewed in Tehran, 10 Sept. 2005; translated by Mona Kasra; Unit Director, Mona Kasra.

One of Iran's first female DPs, Ghadery studied cinematography at the University of Tehran in the 1990s and received her MFA in film production at York University in Toronto, Canada. A producer and director in Iran, she shot Mehdi Omid's *Exorcism* (2002) in Iraqi Kurdistan, and Fereshteh Hali's *United in Childhood* (2003), which won Best Photography, Documentary Film, in the 2003 Sima Festival, Iran. Ghadery was also the co-cinematographer for Soudabeh Moradian's fiction television series *Name Man Fardast* (*My Name Is Tomorrow*; 2003), and produced, directed, and shot a personal journey through the history of Iran, *Flowing Letters from My Successive Lives* (2011). Currently based in Toronto, Canada, she is a freelance cinematographer for Meow Films. Ghadery's cinematography credits include news, sporting events, documentaries, and 3D films.

Gibson, Sue, BSC (England) Interviewed in London by Madelyn Most, Dec. 2001, by Vanessa H. Smith, Nov. 2002, and in Bitola and Skopje, by Alexis Krasilovsky, Sept. and Oct. 2008; transcribed by Deborah Parsons, Shirley Kim, and Philip Rankin.

Born in Derbyshire, England, Sue Gibson graduated from the cinematography course at National Film and Television School near London and became the United Kingdom's first female DP of the modern era. Her features include *Mrs. Dalloway* (1997), *Hear My Song* (1991), and *Resident Evil* (Second Unit; 2002); her TV dramas include *Forsyte Saga* (2002), *Agatha Christie: Poirot* (2006), and *Agatha Christie's Marple* (2005-07). She has won awards for her cinematography on commercials, TV dramas, and features, including a *Lion d'or* at Cannes in 1988, Women in Film's first Technical Achievement Award in 1991, and Women in Film's Contribution to the Medium Award in 2005. In 1992 Gibson was the first woman invited to membership in the British Society of Cinematographers; she joined its Board in 2003 and served as President from 2008-10.

Giummo, Joan (USA) Interviewed in New York City by Lisa Seidenberg, 17 Nov. 2002; transcribed by Michele LeBlanc.

A pioneer of video documentaries and co-founder in 1968 of the Feminist Video Collective in New York, Giummo co-directed the controversial video *Shopping Bag Ladies* with Elizabeth Sweetnam. She has moved into making educational videos for immigrants and adult education.

Glover, Kristin (USA) Interviewed by Alexis Krasilovsky, 20 July 2003, 5 Oct. 2003, 22 Feb. 2006, 26 Mar. 2006, with additional conversations and correspondence in 2011; 2003 and 2006 interviews transcribed by Ellen Johnson and Liz Shimkus. Camera: Michele Crenshaw, Parish Rahbar, and Susan Walsh.

Glover studied painting at the Art Institute of Chicago and received her BFA from Washington University in St. Louis. Glover entered the Hollywood film industry in the early '70s, and became the first woman to operate A Camera on a major studio picture, *Star Trek VI* (1991). An active member of the International Cinematographers Guild (IATSE Local 600) since 1979, Glover continues to serve on the National Executive Board. She founded and was the National Chair (2004-07) of the first Local 600 Diversity Committee. Glover also wrote, directed, and DPed *Ah Paris!* (1987), winner of two Cine Golden Eagles, and is currently a member of WAL (the Writers & Actors Lab in Hollywood).

Godard, Agnès, AFC (France) Interviewed by Zoe Dirse at the Festival International du Film de Creteil et du Val de Marne, France, 1994 and in Paris by Madelyn Most, 4 Dec. 2001.

Born in France, Godard graduated from IDHEC in 1980. She has worked as focus puller, camera operator, and DP on films directed by Wim Wenders, Joseph Losey, Alain Resnais, Henri Alekan, Agnès Varda, and others. After serving as Claire Denis' camera operator on *Chocolat* (1987), she has regularly DPed other Denis films, including *Beau Travail* (1998), which won the 2001 César and the 2001 National Society of Film Critics Award for Best Cinematography. Her other awards and nominations include the Mar del Plata ADF Cinematography Award for Ursula Meier's *Home* (2008). Godard is a member of the AFC.

Goldovskaya, Marina (USSR/Russia/USA) Interviewed by Alexis Krasilovsky, 12 Mar. 2005; transcribed by Jessica Sheeley.

Goldovskaya is one of the former Soviet Union's most important documentary filmmakers and cinematographers. Her best-known Russian films as director—for which she also did camerawork—include *Vlast Solovetskay; Svidetelstva I dokumenty* (*Solovky Power*) (1988), about the Soviet concentration camps, which won the Special Jury Award at IDFA

(International Documentary Film Festival Amsterdam) in 1989; and *The House on Arbat Street* (1993). She also won Best Documentary awards at festivals in Warsaw and Montreal for *A Bitter Taste of Freedom* (2011), about Glasnost. Goldovskaya taught documentary filmmaking at Moscow State University for three decades, until 1995, when she moved to California to head UCLA's documentary program. Her 2013 film, *The Art of Observing Life*, is about the pioneers of cinéma verité. Goldovskaya is also author of a memoir, *A Woman with a Movie Camera* (2006). In June 2014, Goldovskaya returned to Russia after retiring from UCLA.

Gonzales, Mary (USA) Interviewed in Hollywood by Alexis Krasilovsky, 23 Dec. 2005. Camera: Karin Pelloni. Special thanks to Todd Bennett, Clairmont Camera.

Gonzales has worked as first assistant camera on many TV series, including *Shades of LA* (1990-91), *Love & War* (1993-95), and *My Wife and Kids* (2002-05). She has also assisted on the film *Dumb and Dumberer* (2003) and did camera utility on the TV series *Whodunnit?* (2013).

Gunn, Mairi (New Zealand) Interviewed in Auckland by Harriet Margolis, 26 Sept. 2003; transcribed by Deborah Parsons. Camera: Alan Locke; sound: Mike McCree.

New Zealand's first female cinematographer of the modern era, Gunn studied photojournalism at London College of Printing. In the 1980s, she started working as a camerawoman on music videos, documentaries, and TV dramas. She won the 1994 International Television Association NZ Award for Best Cinematography for her work on *Community Video on Domestic Violence*; was awarded the WIFT Unsung Heroine award in 2006; and shot and co-produced the award-winning eco-documentary *Restoring the Mauri of Lake Omapere* (2007). Gunn is currently producing "panoramic video about people and land among NZ Maori and Highland Scots" for an MPhil, shooting a documentary for Maori Television, and teaching at Auckland University of Technology.

Halpern, Amy (USA) Interviewed in Los Angeles by Michelle Crenshaw and Alexis Krasilovsky, 5 Dec. 2005.

One of the founders of the Collective for Living Cinema (a showcase of avant-garde films in New York), Halpern studied film at UCLA. In Los Angeles she joined other experimental filmmakers to found the Los Angeles Independent Film Oasis (1975-80). She is best known for her experimental feature, *Falling Lessons* (1992), which she directed and shot. Halpern's many credits include cinematographer on David LeBrun's *Dance of the Maize God* (2014) and *Cracking the Maya Code* (2008). She also works as a Hollywood lighting cameraman and is a member of IATSE Local 728, the film lighting union. Halpern has taught cinematography at the University of Southern California.

Heitmann, Christine (Norway) Interviewed via email, 21 May 2008.

Oslo-based DP known for her cinematography on the Norwegian television series *Verdens Beste SFO* (2011), *Linus i Svingen* (2004), and the mini-series *Berlinerpoplene* (2007). Heitmann is part of a group of Norwegian women cinematographers called "The Polish Society," as they all met at the Camerimage International Cinematographers Film Festival in Łodz, Poland. (Other Norwegian women cinematographers include Tone Gjerde, Cecilie Semec, Anna Myking, and Ellen Ugelstad.)

Heubrandtner, Astrid, AAC (Austria) Interviewed in Vienna by Herbert Krill, 20 Oct. 2005; translation by Herbert Krill and Harriet Margolis. Camera: Eva Testor.

After studying at the Film Academy of Vienna and in Paris, Heubrandtner has worked as a cinematographer as well as a director, notably on the documentary *Marhaba Cousine* (2005), filmed in Syria. Her Second Unit credits on television series include *Medicopter* (2001) and the Dutch series *Marjolein en het geheim van het slaapzand* (*Marjolein and the Secret of Sleeping Sand*; 2010).

Hill, Leslie (USA) Interviewed in Winston-Salem, North Carolina, by John Jackman, 9 Dec. 2005; and in Winston-Salem, North Carolina, by Vanessa Smith, 19 Apr. 2002; transcribed by Michele LeBlanc. Sound/additional camera: Liz Shimkus.

The first woman chosen for the IATSE-AMPTP Camera Training Program in 1975, Hill was one of Hollywood's first female camera assistants, working on such films as *Looking for Mr. Goodbar* (1977), *Exorcist II: The Heretic* (1977), *American Gigolo* (1980), *Richard Pryor Live on the Sunset Strip* (1982), and *Twilight Zone* (1983). Hill has directed several documentaries, Schoolbreak Specials, and television series as well as writing, producing, and directing for Reality Television. Her work has garnered Emmys, Golden Cine Eagles, and many other awards. She currently lives in North Carolina, where she taught filmmaking at the University of North Carolina School of the Arts from 1995-2000.

Hutton, Joan, CSC (Canada) Interviewed by Alexis Krasilovsky, 2 May 2001; transcribed by Deborah Parsons.

Hutton, one of Canada's first female cinematographers, is both the first female member and a Past President of the Canadian Society of Cinematographers. She won CSC Awards for documentary cinematography in 1989, 1995, and 1999; a Gemini Award for Best Photography in a Comedy for *The Newsroom* (1998); a WIFT-T Crystal Award for Outstanding Achievement in 1994; and other awards.

Jarnagin, Jendra (USA) Interviewed via email, 15 Mar. 2014.

A graduate of NYU's Tisch School of the Arts, Jarnagin has been shooting features, TV and web series, commercials, music videos, and documentaries for over 25 years. She made her living as a gaffer and electrician for many years while furthering her DP career. She is a pioneering expert in digital cinema.

Kenny, Jan, ACS (Australia) Interviewed in Sydney by Erika Addis, 24 Aug. 2005; transcribed by Bjorn Ko, Michele LeBlanc, and Harriet Margolis. Camera: Erika Addis.

Born in Melbourne, Kenny was the first woman in Australia to work on a camera crew; in 1981 she was the cinematographer for the documentary *Flamingo Park*. In 1985, Kenny became the first woman in Australia to shoot a feature-length drama—*Fran*, about a single mother; in 1986, she became the first female member of the Australian Cinematographers Society. She worked as DP on the Australian television series *Round the Twist* in 1989 and shot the documentary *Mary* in 1994. In 1997, she became Head of Cinematography at AFTRS.

Kirsh, Estelle F. (USA) Interviewed in New York City by Alexis Krasilovsky, 7 and 18 Aug. 2002; transcribed by Michele LeBlanc.

An independent filmmaker and cinematographer in New York City, Kirsh moved to Los Angeles and participated in 1978 in IA 659's Camera Assistant Training Program. Acknowledged as a mentor, she was actively involved with BTL in the 1980s, and edited the *Behind the Lens Newsletter*. An accident on the set of a feature shortly after she had moved up to camera operator left Kirsh unable to continue her career in Hollywood, although she

was successful in winning a class-action suit against her insurance company for gender discrimination.

Kumarapuram, Uma (India) Interviewed via email Alexis Krasilovsky, 24 May 2012.

Kumarapuram came to the Malayalam Film Industry (Kerala) with a BSc in physics from Calicut University, Kerala (2007) and a certificate in cinematography (2010) from the Mindscreen Film Institute in Chennai. As an assistant camerawoman, Kumarapuram worked on several feature films, including *101 Weddings* (2012) and *Crocodile Love Story* (2013). Recently promoted to associate camerawoman on features, she is cinematographer on the documentary-in-progress *On Refugees of Srilankan War* (working title), and has been cinematographer on short films and music videos. Kumarapuram is based in South India.

Kuras, Ellen, ASC (USA) Interviewed in New York by Alexis Krasilovsky, 15 Oct. 2005; by Colleen Delaney, 29 Mar. 2006; and by Jendra Jarnagin, Apr. 2006. Unit Director/DP: Jendra Jarnagin. Camera operator: Denise Bailie; transcribed by Michele LeBlanc and Liz Shimkus.

Arguably the most significant female cinematographer in feature filmmaking, Ellen Kuras won the Best Dramatic Cinematography award at the Sundance Film Festival three times: for *Swoon* (1992), *Angela* (1995), and *Personal Velocity* (2002). Among her many feature and documentary credits, Kuras DPed *Eternal Sunshine of the Spotless Mind* (2004). She has been a member of the ASC since 1999. As a director, Kuras was nominated for an Oscar for her documentary, *The Betrayal/Nerakhoon* in 2009.

Le Rigoleur, Dominique, AFC (France) Interviewed in Paris by Madelyn Most, 23 Nov. 2001; translated and transcribed by Anne Allen and Harriet Margolis.

Le Rigoleur, a graduate of IDHEC, worked with Nestor Almendros on films by François Truffaut and Marguerite Duras before becoming a DP herself. Her credits include cinematographer on the documentary *Etoiles: Dancers of the Paris Opera Ballet* (2001) and the feature film *La Lectrice* (1988) and co-cinematographer (with Agnès Godard) on *The Dreamlife of Angels* (1998).

MacKenzie, Heather (USA) Interviewed in Los Angeles by Alexis Krasilovsky, 7 Oct. 2000; transcribed by Harriet Margolis.

A Los Angeles video journalist at KABC-TV for twenty years, MacKenzie had to fight blatant sexism to keep her position behind the camera when management wanted its female camera operators to become editors. After years of asking management to provide appropriate safety training, MacKenzie and the reporter she was working with were seriously injured in an accident that could have been avoided. MacKenzie currently teaches photography to at-risk teenagers and works as an artist in Cape Cod, Massachusetts.

McKenna, Nancy Durrell (USA) Interviewed in London by Vanessa H. Smith, Dec. 2001; transcribed by Michele LeBlanc. Camera: Katie Swain.

Filmmaker/author specializing in work about pregnancy and birth in the UK and developing countries; Executive Director of the charity Safehands for Mothers.

Martin, Stephanie (Argentina/Los Angeles/UK) Interviewed in Los Angeles by Hilda Mercado, 13 Dec. 2005; transcribed and translated by Luis Alberto Sanchez.

Martin grew up in Argentina, graduated from Wellesley College, and studied cinematography at the American Film Institute, receiving her MFA in 2002. As a DP, Martin has shot narrative films, documentaries, commercials, and music videos in countries around the world, including Argentina, India, and Morocco. Her many credits as cinematographer include the Mexican

feature *31 días* (*31 Days*; 2013), the television series *Police Women of Broward County* (2009), and the reality TV series *Shadows* (2005). She also worked as B camera operator, Second Unit, in Italy for *Eat Pray Love* (2010) and C camera operator for *World War Z* (2013).

Medina, Teresa, AEC (Spain) Interviewed in Hollywood by Eleanor Vera, July 2002; translated by Luis Alberto Sanchez and Linda Espitia-Garcia. Unit Producer: Jace Rothschild. Camera: Mary Gonzales.

Born in Madrid, Medina is Spain's first female DP and the recipient of a Kodak Vision Award at the 1999 Women in Film Crystal + Lucy Awards. Her feature credits as cinematographer include Isabel Coixet's *Cosas que nunca te dije* (1996), which won the Audience Award at the 1997 Turia Awards, and Nancy Savoca's *The 24 Hour Woman* (1999).

Meily, Lee (Philippines) Interviewed in Manila by Jasmine Kuhn, June 2006; transcribed by Chris Buzzini.

Meily studied communication arts at De La Salle University in Manila and is the winner of nine Best Cinematography awards. Her camera career began in 1995, shooting commercials in the Philippines. Among her numerous credits as DP in the Philippines and the US are *American Abodo* (2001), John Sayles' *Amigo* (2010)—which won Best Picture at the 2011 Gawad Urian Awards, the Philippines' most prestigious film awards, and *Trophy Wife* (2014). She has also worked under the name Lee Briones-Meily.

Mercado, Hilda, AMC (USA/Mexico) Interviewed in Los Angeles by Jace Rothschild, July 2002 (camera: Liz Bailey) and in Los Angeles by Stephanie Martin (camera: Stephanie Martin), 3 Dec. 2005; transcribed and translated by Luis Alberto Sanchez and Linda Espitia-Garcia.

Born and raised in Mexico City, Mercado was the first female DP in Mexico City's camera union, STPyC. She is also a member of the International Cinematographers Guild, Local 600 (Hollywood). She received her MFA in cinematography at the American Film Institute in Los Angeles. Mercado started as a clapper loader/second assistant in 1998. She won Emerging Cinematographer Awards in 2006 for her work on *Un pedazo de tierra* (2001) and in 2007 for *La primavera* (2006). Mercado shot the American television series *Unfabulous* (2005), and was Series Cinematographer on *A Guy Walks into a Bar* (2011-), and several features, shorts, music videos, commercials, and documentaries. In 2006, Mercado was invited to join the Mexican Society of Cinematographers (AMC).

Most, Madelyn (USA/Europe) Interviewed in Northridge, California, by Vanessa H. Smith and Alexis Krasilovsky, 2001 and via email, 6 Apr. 2006, 27 July 2012, and 7 Aug. 2012.

An American educated in the United States, France, and England, Most was the first woman hired by the BBC to work as part of camera crew. She worked as camera assistant on feature films such as *Star Wars: Episode V - The Empire Strikes Back* (1980) and *Sunset* (1988); and the television series *Rags to Riches* (1987). She was B camera operator on Marcel Ophüls' documentary feature *Hôtel Terminus* (1988). She moved from London to New York, where she joined NABET 15 in 1980 and IA 644 in 1982; she then relocated to Los Angeles, joining IA 659 in 1987, after which she returned to Europe. Most segued from a career in cinematography to producing and directing opera, theater, and dance films through her company, Most Films, before working as a journalist. She currently lives in France.

Moth, Margaret (1951-2010) (New Zealand) Interviewed in Turkey by Dr. Leyla Ozalp, 26 July 2008; transcribed by Harriet Margolis.

New Zealand's first television news camerawoman, later famous for taking a sniper bullet in her jaw while covering the Balkan wars, Moth was an inspirational CNN camerawoman known for being "fearless." Additional assignments included the Persian Gulf War, the civil war in Tbilisi, Georgia, the rioting after the assassination of Indira Gandhi, and the 2002 Israeli invasion of the West Bank. She won the 1992 Courage in Journalism Award from the International Women's Media Foundation (IWMF).

Murphy, Brianne, ASC (1933-2003) (USA) Interviewed in Puerto Vallarta, Mexico, by Alexis Krasilovsky, 28 Dec. 2001; transcribed by Deborah Parsons. Parsons. Camera: Jose G. Curiel; additional camera: Hugo Lynn; production coordinator: Irma Lucia Quiroz; special thanks: Club Embarcadero Pacifico.

Born in London, England of Irish parents, Murphy studied at Pembroke College (now Brown University) and attended the Neighborhood Playhouse in New York City, intent on an acting career. Instead, moving to Hollywood as a still photographer, she began working on low-budget horror films such as *Man Beast* (1956) until she got her first break as camera operator. Murphy was an Emmy Award-winning DP from the 1950s through the 1990s; the first female member of the ASC, remaining its only female member for fifteen years and eventually serving on its board of directors; and winner of a technical Academy Award for her invention and development of a safer camera car for moving shots. She was the first female DP on a major studio picture in the modern era—*Fatso* (1980). Her television credits include *Trapper John MD* (1979-86), *Breaking Away* (1980), *Little House on the Prairie* (1981-82), and *Highway to Heaven* (1985). Murphy died in Mexico, the country where she and her husband, the late Ralph Brooke, had filmed the Oscar-winning short *The Magic Tide* in 1962.

Omori, Emiko (USA) Interviewed in Berkeley, California, by Alexis Krasilovsky, 4 Dec. 2004; transcribed by Elise Lobenstein. Unit Producer: Siew Hwa Beh.

Omori is an American cinematographer and director who pioneered as a news camerawoman and editor at KQED in 1968. In 1969 she organized NABET Local 532 in San Francisco, becoming its first president. She regularly hired women as her camera assistants. Omori won the Best Cinematography Award twice at the Sundance Film Festival: for Barbara Sonneborn's *Regret to Inform* (1998) and *Rabbit in the Moon* (1999), a documentary/memoir which Omori also directed, about the internment of Japanese Americans during World War II. *Rabbit in the Moon* also won a National Emmy and other awards. Among her many credits, Omori co-produced, co-directed, and co-wrote the feature documentary *Passion and Power: The Technology of Orgasm* (2007) with Wendy Blair Slick, as well as serving as the documentary's cinematographer. Omori has taught at her alma mater, San Francisco State University, as well as teaching documentary camera at the University of Southern California.

Paben, Leelaben (India) Interviewed in Ahmedabad by Video SEWA, 16 May 2005; translated by Jalnia Haria.

Formerly a fruit vendor, now a camerawoman for Ahmedabad's Self-Employed Women's Association. Her film on water saved her community during a severe drought.

Parks, Deborah (Canada) Interviewed in Toronto by Alexis Krasilovsky, 5 May 2001; transcribed by Deborah Parsons.

A documentary producer and cinematographer, Parks was the first woman in Canada to win the Best Cinematography Award from the Canadian Society of Cinematographers, for

Shahira (1987). Among her other credits, Parks has shot a documentary about the lives of five teenage girls, *Talk 16* (1992), and co-produced with Silva Basmajian *Out of Mind, Out of Sight* (2014), which won Best Canadian Documentary at the Hot Docs Canadian International Documentary Festival.

Patton, Jessie Maple (USA) Interviewed in Atlanta by LeRoy Patton, 15 Aug. 2005; transcribed by Tamala Wattree.

Patton joined the IA in New York in 1973. The first African American woman to become a union DP, Patton had to sue the major networks to gain employment. She has also directed several films. A graduate of the American Film Institute's Directing Workshop for Women, Patton was one of the first African American women to direct a feature film in the modern era, *Will* (1981), later followed by *Twice as Nice* (1989), about twin basketball players. As Jessie Maple, she wrote the book *How to Become a Union Camerawoman: Film-Videotape* (1977).

Plunkett, Kylie (New Zealand) Interviewed by Harriet Margolis via email, 2010.

Plunkett worked as clapper loader and camera assistant on *Lord of the Rings: The Fellowship of the Ring* (2001), *The Lord of the Rings: The Two Towers* (2002), and *Lord of the Rings: The Return of the King* (2003). In 2006 she went back to school for a Graduate Diploma, studying documentary filmmaking at the School for Film and Television at the Victorian College of the Arts in Melbourne, winning the Best Student Award at the 2007 Melbourne International Film Festival for her film *The Butcher's Wife* (2006), which she wrote, directed, and shot. Plunkett also worked as clapper loader on the Australian television series *Rush* (2009) and *The Elephant Princess* (2008-09).

Rikarastu, Angela Andreyanti (Indonesia) Interviewed by Alexis Krasilovsky via email, 18 June 2008.

Rikarastu studied cinematography at the Jakarta Institute of Art and is a member of the Indonesian Cinematography Association. She has filmed wildlife documentaries in the mountains of Indonesia, and was the DP of *Jali Toni* (2008). As camera operator, Rikarastu has worked on several documentaries, television commercials, shorts, and features, including *Ketika Bun Di Ende* (2013), *Habibie dan Ainun* (2012), and *Sweet Heart* (2009). She also worked as a loader on several feature films, including *Hati Merdeka* (*Hearts of Freedom*; 2011), about the 1947-48 Indonesian revolution.

Rinzler, Lisa (USA) DP/Interviewer: Jendra Jarnagin, 20 July 2006. Camera operator: Denise Bailie.

A New York-based DP on features, documentaries, and music videos, Rinzler won Independent Spirit Awards for Best Cinematography on *Menace II Society* (1993) and *Three Seasons* (1999), which also won the Sundance Film Festival's 1999 Cinematography Award. With over 50 credits as cinematographer, Rinzler's other features as DP include *Dead Presidents* (1995) and *Pollock* (2000). Rinzler won a Primetime Emmy for Outstanding Cinematography for Nonfiction Programming for Wim Wenders' *The Soul of a Man* (2003).

Schreiber, Nancy, ASC (USA) Interviewed in Hollywood by Amy Vincent, ASC, 11 Jan. 2006. Unit Director/camera: Karin Pelloni; co-camera: Jenny Cousins.

A member of ASC since 1995, Schreiber has filmed documentaries, television shows, music videos, commercials, and feature films, and has regularly hired female crewmembers. Schreiber won the Best Cinematography award at the Sundance Film Festival for her work on *November* (2004).

With close to 100 credits, Schreiber began as a gaffer on the documentary *The Other Half of the Sky: A China Memoir* (Shirley MacLaine and Claudia Weill; 1975) and has continued her passion for lighting as cinematographer on such films as *The Nines* (2007) and *Book of Shadows: Blair Witch 2* (2000), the television series *Lauren* (2012) and *Blue* (2012), and the award-winning documentaries *The Celluloid Closet* (1995) and *Visions of Light* (1992).

Seidenberg, Lisa (USA) Interviewed by Alexis Krasilovsky, 5 Aug. 2002; transcribed by Mary Anne Fronda and Kelly Browne.

Seidenberg is a director and cinematographer who pioneered as the first female video engineer, working at WPIX in New York in 1977, afterwards becoming a camerawoman for UN Television and PBS, Channel 13. In the early 1980s, after shooting news for ABC, she started her own company, Metro Video. Travelling extensively with her camera throughout the world, she covered the Vietnamese troop withdrawal for *Wall Street Journal Reports* (CBS) and *World Monitor* (The Discovery Channel). Videos she has directed and shot include *Being Human* (2003) and *The Road Taken … The Merrit Parkway* (2008). In recent years Seidenberg has transitioned to making installations and short video art pieces such as *Slippery Slope* (2010), which screened at the 2011 Berlinale.

Seth, Priya (India) Interviewed in Mumbai by Anuja Ghosalker, 26 Dec. 2003. Unit Producer: Meenakshi Shedde; camera: Divya Pande.

A Mumbai-based DP, Seth is also a CMAS1 Star Diver specializing in underwater filming in 35mm format, including on Kiran Rao's *Mumbai Diaries* (2010). She has also shot numerous commercials, including for Benadryl, Oral B, and Ponds. Her early feature credits include third assistant camera on Deepa Mehta's *Earth* (1998) and clapper loader on Jane Campion's *Holy Smoke* (1999). Seth DPed Raja Menon's feature comedy-drama *Barah Aana* (2009).

Shanti, M. (India) Interviewed in Mumbai by Anuja Ghosalker, 26 Dec. 2003; transcribed by Jalni Haria. Unit Producer: Meenakshi Shedde; camera: Divya Pande.

A Bollywood camerawoman working in the early 2000s.

Sharvit, Irit (Israel) Interviewed via email, 22 June 2009 and 21 July 2012.

A graduate of the Tel Aviv University Film School, Sharvit began her work as cinematographer in 2002. She has worked on narrative features, documentaries, music videos, and commercials, filming in Israel and Japan on such films as *Yael-San* (2002). She also participated in the Maine Media Workshops, receiving a certificate in cinematography studies in 2008. She recently shot the Israeli documentary feature *Ladies First* (2013), featuring 48 women in the entertainment business.

Shu, Shi Jun (China) Interviewed by Angus E. McNelis in Beijing, March 2005; translated by Mei Wu, Lawrence Gu, Tan Yanrong, Jean Chen, and Albert Margolis. Camera: Sheila Pinkel.

Born in 1930, Shu Shi Jun was China's first female news cinematographer. After studying at the University of North China, she worked at the Beijing Film Studio as a camera assistant, and then, after a strict examination, she became Chairman Mao Tse Tung's accompanying news cinematographer, traveling with him throughout the new People's Republic of China in the early 1950s. Some of her most important documentaries include *Song Qing Ling Visits Indonesia* (1956), *Premier Zhou and Son Qingling Visit Ceylon* (1957), *Chairman Mao Works with Us* (1958), and *The Arts from Farmers of Huxian Countryside* (1975).

Sissel, Sandi, ASC (USA) Interviewed in New York City by Jendra Jarnagin, 30 Jan. 2006. DP: Jendra Jarnagin; camera operator: Rachel Levine. Camera courtesy Plywood Pictures; microphone courtesy Gotham Sound; grip equipment courtesy Eastern Effects; special thanks to TCS and Brian Wengrofsky.

Texas-born Sissel joined the IA in 1974 to shoot news, winning the first of many Emmy Awards for her work at NBC and ABC. She worked as DP on several features, including Mira Nair's *Salaam Bombay* (1988), which won the *Camera d'or* at the Cannes Film Festival. Her cinematography credits include the documentaries *Before Stonewall* (1984), *Mother Teresa* (1986), *The Endurance* (2000), *Free Angela and All Political Prisoners* (2012); the Emmy-winning show *Wonder Years* (1988); commercials; and movies of the week. She also directed several films, including the Sundance award-winning *Chicken Ranch* (1983). Her Second Unit work includes many major features, such as *Austin Powers: The Spy Who Shagged Me* (1999) and the Oscar-winning *Master and Commander: The Far Side of the World* (2003). In 1994 Sissel became the second female to be asked to join the ASC; she received the Kodak Crystal Award for lifetime achievement from Women in Film that same year. Sissel was invited to join the Academy of Motion Picture Arts and Sciences in 2006. She is currently Head of Cinematography for NYU's graduate film program.

Swain, Katie (England) Interviewed in London by Alexis Krasilovsky, 3 July 2001. Assistant: Margaret Brookes.

Born in the United Kingdom and trained in cinematography at Ealing Film Studios, Swain is a DP on music videos, commercials, films, and television series such as the BAFTA-winning BBC Two comedy series *Help* (2005), *Little Britain* (2005), and *Playhouse Presents* (2014). Her most recent credit is camera operator on the Ron Howard-directed feature *Heart of the Sea* (2015).

Testor, Eva, AAC (Austria) Interviewed in Vienna by Herbert Krill, 20 Oct. 2005; translated by Herbert Krill and Harriet Margolis. Camera: Astrid Heubrandtner, AAC.

A documentary cinematographer, producer, and writer, Testor is co-CEO of Mobilefilm in Vienna, Austria. Testor has shot such documentaries as *State of the Nation: Austria in Six Chapters* (2002), *Birth Movement: Preventive Obstetrics and Postnatal Care* (2008), and *Oh Yeah, She Performs!* (2012). Testor also shot and co-wrote Sabine Derflinger's award-winning *Tag und Nacht* (*Day and Night*; 2010).

Varda, Agnès (France) Interviewed in Paris by Alexis Krasilovsky, 1 July 2001; transcribed and translated by Anne Allen.

An internationally acclaimed film director, Varda started as a photographer, studying art history and photography at the École du Louvre. Winner of many awards, she received France's National Order of the Legion of Honor in 2009. Since the arrival of small digital cameras, she has sometimes shot her own work, including parts of *The Gleaners and I* (2000). Known as the mother of the New Wave, she has written and directed numerous features and documentaries. Varda currently teaches at the European Graduate School in Switzerland.

Vijayalakshmi, B. R. (India) Interviewed in Chennai by Sabeena Gadihoke, 13 Jan. 2004; transcribed by Jalni Haria. Camera: Sabeena Gadihoke; co-camera: Rani Breslow.

Chennai-based, Vijayalakshmi is India's first female feature DP. She learned on the set of acclaimed cinematographer Ashok, rather than going to film school. She has shot over twenty successful feature films for the Tamil film industry, including *Pattu Paadava* (1995), which

she also directed. She first segued into production, including *Eera Vizhi Kaaviyangal* (1982), the feature film directed by Ravi Shankar, and more recently she has segued into television, where her credits as television producer include *Velan* (2002). She is currently producing a feature film based on Anuja Chauhan's novel *Battle for Bittora*.

Vincent, Amy, ASC (USA) Interviewed in Hollywood by Nancy Schreiber, ASC, 11 Jan. 2006. Unit Director/camera: Karin Pelloni; co-camera: Jenny Cousins.

Vincent received her MFA in cinematography at the American Film Institute in 1992. Invited to join the Academy of Motion Picture Arts & Sciences in 2004, Vincent's awards include the Kodak Vision Award at the 2001 Women in Film Crystal Awards and the Sundance Cinematography Award for the feature film *Hustle and Flow* (2005). She is known for her work as DP on Kasi Lemmons' award-winning feature *Eve's Bayou* (1997) and *The Caveman's Valentine* (as Amelia Vincent; 2001), as well as *Black Snake Moan* (2006); the television series *Wayward Pines* (2014-15); and music videos and commercials. Vincent has also shot Second Unit on a number of major studio features, including *Lemony Snicket's A Series of Unfortunate Events*.

Wade, Aminata (Senegal) Interviewed in Dakar by Alé Seck, Feb. and July 2002; translated and transcribed by Anne Allen. Camera: El Hadji Samba Sarr.

Senegal's first female television camerawoman, working at Senegalese Television since 2000. She recently participated along with Bineta Wague and Khady Racine Diop in a short film project about the artisans of Dakar through Germany's DW Akademie-sponsored *Histoires Africaines II*.

Walsh, Susan (USA) Interviewed in Los Angeles by Alexis Krasilovsky, 20 July 2003; transcribed by Liz Shimkus. Camera: Kristin Glover.

A specialist in filming underwater and on mountaintops; also a psychotherapist, martial arts instructor, and expert on sexual harassment issues. Elected to the Executive Board of IA Local 659 in 1982-84; first president of BTL in 1984-85. Walsh worked on the documentary about the 1984 Olympics, *Sixteen Days of Glory*. Walsh's underwater credits include *A Cry in the Wild* (1990) and *Hot Ticket* (1996). She also worked as an assistant cameraperson on the Hollywood features *Continental Divide* (1981) and *Silverado* (1985).

Wise, Naomi (Canada) Interviewed in Toronto by Alexis Krasilovsky, 5 May 2001; transcribed by Michele LeBlanc.

Wise is an award-winning director/cinematographer of dramas, documentaries, and documentary television series based in Toronto, Canada. Her work has appeared on Discovery, CBC, Oxygen, TLC, and the Life Channel. Her film *Art in Darkness* (2008) is about the experience of art by blind individuals. She also served as DP on an episode of the TV series *Breeder of the Pack* (2011) as well as on *Heart of a Poet* (2006) and *Urban Angels of Medicine* (1999). Wise teaches at York University.

Yu, Yi Hua (China) Interviewed by Angus E. McNelis in Beijing, Mar. 2005; translated by Mei Gu, Lawrence Gu, Tan Yanrong, Jean Chen, and Albert Margolis. Camera: Sheila Pinkel.

Born in China in 1941, Yu Yi Hua graduated from Beijing Film Academy in 1964, where she majored in cinematography. She worked as cinematographer and film director at Chinese Central Newsreel and Documentary Film Studio on such documentaries as *Great Future Potential* (1979), *The Home Village of Kong Meng* (1992), and *Study in America* (1993).

From 1994-97, Yu Yi Hua co-produced popular TV movies such as *Spotlights on Chinese Civilization, Yungang Stone Kiln, Dream of Red Mansions*, and a film about the first female Chinese queen of the Tang Dynasty, *Wu Ze Tian*.

Zhao, Yan (China) Interviewed by Angus E. McNelis in Beijing, Mar. 2005; translated by Mei Gu, Lawrence Gu, Tan Yanrong, Jean Chen, and Albert Margolis. Camera: Sheila Pinkel.

Zhao Yan was born in 1962 and graduated from the Beijing Film Academy, where she majored in cinematography. She worked as cinematographer and film director at the Chinese Central Newsreel and Documentary Film Studio on such films as *Ghost City in Si Chuan* (1991), *The Story of Ren Ji Mei* (2006), and *The Road to the West Wing* (2012). One of Zhao Yan's most beautiful memories is of shooting wild elephants in Yunnan Province in 1999.

Zhou, Kun (China) Interviewed by Angus E. McNelis in Beijing, Mar. 2005; translated by Mei Gu, Lawrence Gu, Tan Yanrong, Jean Chen, and Albert Margolis. Camera: Sheila Pinkel.

Zhou Kun was the first Chinese cinematographer to study in the former Soviet Union under the tutelage of one of the Soviet Union's most famous cinematographers, Walter Cech. She graduated from the Soviet Union Film Academy in 1960, returning to Russia in 1988 for her master's degree and Ph.D. Later Zhou Kun taught in Beijing Film Academy's Cinematography Department and authored papers such as "On Cinematography Modeling Emotional Force" and "Dialectics of Tradition and Innovation" as well as 30 academic books. Zhou Kun is noted for *In the Name of Revolution* (aka *Lenin and the Second Generation*; 1960) and *Neighbor*, which won the Chinese government's 1981 Award for Outstanding Movie. She currently works in the Art Department of Beijing Normal University, where she has trained over 300 television camera and directing staff.

Ziegler, Liz (USA) Interviewed in Hollywood by Kristin Glover, 13 Mar. 2004; transcribed by Christopher Elam and Elise Lobenstein. Camera: Kristin Glover.

Hollywood's most important Steadicam operator, Liz Ziegler (also known as Elizabeth Ziegler) has been a member of the Steadicam Operators Association since 2002. Among the many features for which she has worked as Steadicam operator are *Ghost* (1990), *Wayne's World* (1992), *Magnolia* (1999), and Stanley Kubrick's *Eyes Wide Shut* (1999). Ziegler won a Kodak Vision Award in 1998 and a Lifetime Achievement award from the Society of Camera Operators in 2001.

The following interviews were also conducted for the *Women behind the Camera* project

Allred, Gloria, Esq. (USA) Interviewed in Los Angeles by Alexis Krasilovsky, 23 Oct. 1987; Nagra recording by Liz Bailey; transcribed by Reseda Mickey and Alexis Krasilovsky.
Feminist rights' attorney.

Bhatt, Ela (India) Interviewed in Ahmedabad by Alexis Krasilovsky, 5 Jan. 2005. Unit Producer: Tavishi Alagh.
Director, SEWA (Self-Employed Women's Association).

Beh, Siew Hwa (USA) Interviewed in Berkeley, California, by Alexis Krasilovsky, 25 Jan. 2005; transcribed by Ryan Arciaga.

Founder and co-editor of *Women and Film,* the first US magazine to focus on women filmmakers (1970s).

Pillsbury, Sarah (USA) Interviewed in Los Angeles by Alexis Krasilovsky and Kristin Glover, 19 Nov. 2003; transcribed by Michele LeBlanc.

Academy Award-winning producer whose credits as producer include *Desperately Seeking Susan* (1985), *River's Edge* (1986), and *The Love Letter* (1999), whose DP was Tami Reiker.

Male Cinematographers interviewed

Mehta, Ashok (India) Interviewed in Mumbai by Meenakshi Shedde, 28 Dec. 2003. Unit Producer: Meenakshi Shedde; unit director: Anuja Ghosalker; camera: Divya Pande.

Mehta is a DP whose awards include Best Cinematography for *36 Chowringhee Lane* (1981) and for *Moksha: Salvation* (2001) at the National Film Awards, India, and a 2006 Award for Technical Excellence from the Bombay International Film Festival.

Rao, Vishnu (India) Interviewed in Mumbai by Anuja Ghosalker, Dec. 2003. Unit Producer: Meenashki Shedde; camera: Divya Pande.

A Mumbai-based DP, Rao, who is Priya Seth's husband, is known for his cinematography on *Meerabai Not Out* (2008), *Prince* (2010), and *Aashiqui 2* (2013).

Singh, Amitabh (India) Interviewed in Mumbai by Anuja Ghosalker, 26 Dec. 2003; transcribed by Jalni Haria. Unit Producer: Meenakshi Shedde; camera: Divya Pande.

A Mumbai-based DP, Singh, who is M. Shanti's husband, shot and produced *The Good Road* (2013), India's entry in the Best Foreign Language Film category at the 86th Academy Awards.

Wade, Daour (Senegal) Interviewed in Dakar by Alé Seck, 2002; transcribed and translated by Anne Allen and Alex Donoghue. Camera: El Hadji Samba Sarr.

The father of Aminata Wade, Daour Wade is a cameraman based in Dakar, Senegal.

Wexler, Haskell, ASC (USA) Interviewed in Los Angeles by Kristin Glover, 1 Apr. 2005. Camera: Kristin Glover.

Wexler is an Oscar-winning DP, director, and producer who won a Lifetime Achievement Award from the ASC in 1993. His DP credits include *Who's Afraid of Virginia Woolf?* (1966), *In the Heat of the Night* (1967), *Bound for Glory* (1976), and *Matewan* (1987). Wexler has also directed many documentaries, including *Who Needs Sleep* (2006), about the long hours of overtime worked by Hollywood film crews. He directed his first feature, *Medium Cool,* in 1969; it is now on the US Library of Congress National Film Registry. Wexler is also well known for his support of women behind the camera.

Bibliography

1989 Membership Directory. Santa Monica, CA: Behind the Lens, 1989. Print.

"About." *Jendra Jarnagin Director of Photography*. Floating Camera, n.d. Web. 17 Mar. 2014. http://www.floatingcamera.com/jendra/about.cfm.

"About Haşmet Topaloglu." *Present Tense*. Simdikizaman, n.d. Web. 29 July 2012. http://www.simdikizaman.com/pt/filmbufe.html.

"About Us." *Geena Davis Institute on Gender in Media*. Seejane.org, n.d. Web. 13 Jan. 2013. http://www.seejane.org/about/.

"About the Women's Steering Committee." *Directors Guild of America*. DGA.org, n.d. Web. 30 Sept. 2011. http://www.dga.org/The-Guild/Committees/Diversity/Women.aspx.

"Aina Mission." *Aina*. Aina.world, n.d. Web. 16 Feb. 2010. http://www.ainaworld.org/mission/.

Almira, Milena. "Re: Director of Photography Yanay Arauz." Message to Alexis Krasilovsky. 3 Nov. 2013. Email.

"American Society of Cinematographers Roster." *The American Society of Cinematographers*. Theasc.com, n.d. Web. 29 Nov. 2014. www.theasc.com/ac_society/index.php?pagename=ASC_Roster.

Askberger, Astrid. "Where Did All the Girls Go." "How to Doris" [pamphlet]. Göteborg, Sweden: Doris Film, 2009. 15-17. Web. 29 Oct. 2012. http://dorisfilm.se/wp-content/uploads/2011/05/DORISbooklet_eng_low_res.pdf.

Bailey, Julie James. "Jan Kenny." *Reel Women: Working in Film and Television*. North Ryde, NSW: Australian Film Television & Radio School, 1999. 11-25. Print.

Bautista, Miriam. "A Career Path for Women." Womenbehindthecamera.com, n.d. Web. 22 Oct. 2011. www.womenbehindthecamera.com/career.html.

"Bechdel Test Movie List." N.p., n.d. Web. 6 Jan. 2013. http://bechdeltest.com/.

Blaetz, Robin. *Women's Experimental Cinema: Critical Frameworks*. Durham, NC: Duke UP, 2007. Print.

Blonski, Annette, Barbara Creed, and Freda Freiberg. *Don't Shoot Darling!: Women's Independent Filmmaking in Australia*. Richmond, Australia: Greenhouse Publications, 1987. Print.

Bowser, Pearl, Jane Gaines, and Charles Musser. *Oscar Micheaux and His Circle: African-American Filmmaking and Race Cinema of the Silent Era*. Bloomington: Indiana UP, 2001. Print.

Brenhouse, Hillary. "As Its Box Office Booms, Chinese Cinema Makes a 3-D Push." *Time*. 31 Jan. 2011. Web. 31 Mar. 2014. http://content.time.com/time/world/article/0,8599,2044888,00.html.

"A Brief History of Chinese Film." *Cinema China 07*. U of Edinburgh, n.d. Web. 31 Oct. 2011. http://www.llc.ed.ac.uk/cinema-china/briefhistory.html.

Brookman, Laura Lou. "She'll Be the Nation's Social Secretary." *Daily Capital News and Post Tribune* 30 July 1931: 20. Web. 18 Aug. 2012. http://newspaperarchive.com/daily-capital-news-and-post-tribune/1931-07-30/page-4.

Burgess, Diane. "Leaving Gender Aside: The Legacy of Studio D?" *Women Filmmakers: Refocusing*. Eds. Jacqueline Levitin, Judith Plessis, and Valerie Raoul. New York: Routledge, 2003. 418-33. Print.

Burton, Julianne. "The Camera as 'Gun': Two Decades of Culture and Resistance in Latin America." *Latin American Perspectives* 5.1 (1978): 49-76. Print.

Carpenter, Karen Dee. "Safety Segment." Message to Alexis Krasilovsky. 2 July 2011. Email.

Cartsonis, Susan. "Finance, Track, Research and Promote." *New York Times* 14 Aug. 2012. Web. 16 Aug. 2012. http://www.nytimes.com/roomfordebate/2012/08/14/how-can-women-gain-influence-in-hollywood/finance-track-research-and-promote.

"Chapter Profiles." *Women in Film and Television International*. WIFTI, n.d. Web. 2 Sept. 2014. http://www.wiftichapters.org/class_classmates.cfm.

Chopra, Anupama. "In Bollywood, Female Directors Get New Respect." *New York Times* 2 Sept. 2011. Web. 9 Dec. 2011. http://www.nytimes.com/2011/09/04/movies/zoya-akhtar-and-farah-khan-bollywood-directors.html?_r=0.

Choy, Christine. "Draft of Newsreel/Third World Newsreel Article for Yamagata Film Festival." *Newsreel.us*, n.d. Web. 5 Nov. 2011. http://www.newsreel.us/NR@SLC/choy.htm.

Cieply, Michael. "Death Raises Questions about On-Set Safety." *New York Times* 23 Mar. 2014. Web. 25 Mar. 2014. http://www.nytimes.com/2014/03/24/business/media/death-raises-on-set-safety-questions.html?hpw&rref=movies.

"CineWomen New York." *NYWIFT*, n.d. Web. 30 July 2012. http://www.nywift.org/article.aspx?id=2629.

Deren, Maya. "An Anagram of Ideas on Art, Form and Film." *Maya Deren and the American Avant-Garde*. Ed. Bill Nichols. Berkeley: U of California P, 2001. 1-52. Print.

———. "Cinematography: The Creative Use of Reality." *The Avant-Garde Film: A Reader of Theory and Criticism*. Ed. P. Adams Sitney. New York: Anthology Film Archives, 1978. 60-73. Print.

Dettmer, Jamie. "Syria's Media War." *The Daily Beast*. The Daily Beast, 4 Apr. 2013. Web. 4 Aug. 2014. http://www.thedailybeast.com/articles/2013/04/04/syria-s-media-war.html.

"DGA Report Assesses Director Diversity in Hiring Practices for Episodic TV." *Deadline Hollywood*. Deadline Hollywood, 14 Sept. 2011. Web. 30 Sept. 2011. www.deadline.com/2011/09/dga-report-assesses-director-diversity-in-hiring-practices-for-episodic-tv/.

Dirse, Zoe. "Gender in Cinematography: Female Gaze (Eye) behind the Camera." *Journal of Research in Gender Studies*. 3.1 (2013): 15-29. Print.

———. "Women on Camera [Interview with Nurith Aviv]." *Canadian Society of Cinematographers*. CSC, Feb. 2001. Web. 1 Apr. 2010. http://www.csc.ca/news/default.asp?aID=862.

"The Doris Manifesto." "How to Doris." [Pamphlet.] Doris Film Board. 2009. Web. 29 Oct. 2012. http://dorisfilm.se/wp-content/uploads/2011/05/DORISbooklet_eng_low_res.pdf.

Drexler, Doug. "Translights." N.p., 19 Mar. 2009. Web. 19 June 2009. http://drexfiles.wordpress.com/2009/03/19/translights.

Dubber, Beth. "Re: Camerawomen Los Angeles." Message to Alexis Krasilovsky. 19 Mar. 2014. Email.

Durham, Nancy. "*From Jihad to Rehab*" [Filmmaker Notes]. *Wide Angle*. PBS, 17 Dec. 2008. Web. 5 Nov. 2011. www.pbs.org/wnet/wideangle/episodes/from-jihad-to-rehab/nancy-durham-filmmaker-notes/3839/.

Fetterley, Judith. *The Resisting Reader: A Feminist Approach to American Fiction*. Bloomington: Indiana UP, 1978. Print.

"The First Camera-Maid." *Photoplay* Feb. 1920: 80. Print.

Fisher, Bob. "A Conversation with Joan Churchill, ASC." *InCamera Online*. Kodak, 1 July 2011. Web. 27 Apr. 2011. http://motion.kodak.com/motion/Publications/On_Film_Interviews/churchill.htm.

———. "Distaff DPs." *Documentary*. International Documentary Association Spring 2008. Web. 10 Jan. 2013. http://www.documentary.org/content/distaff-dps.

———. "Red Reelers Reunion: 'Cine Manifest' Celebrates '70s Film Collective." *Documentary*. International Documentary Association Nov. 2006. Web. 5 Nov. 2011. www.documentary.org/magazine/red-reelers-reunion-cine-manifest-celebrates-70s-film-collective.

Flitterman-Lewis, Sandy. *To Desire Differently: Feminism and the French Cinema*. New York: Columbia UP, 1996. Print.

French, Lisa, ed. *Womenvision: Women and the Moving Image in Australia*. Melbourne: Damned Publishing, 2003. Print.

Friedan, Betty. *The Feminine Mystique*. New York: Norton, 1963. Print.

Gaines, Jane, and Michelle Koerner. "Women as Camera Operators or 'Cranks.'" Jane Gaines, Radha Vatsal, and Monica Dall'Asta, eds. *Women Film Pioneers Project*. Center for Digital Research and Scholarship. New York: Columbia University Libraries, 2013. Web. 27 Sept. 2013. Https://wfpp.cdrs.columbia.edu/essay/women-as-camera-operators-or-cranks/.

"Gender Equality in Swedish Film." *Swedish Film Institute*. Swedish Film Institute, 17 Oct. 2011; rev. 16 May 2013. Web. 13 Dec. 2014. http://www.sfi.se/en-GB/statistics/Gender-equality/.

Glover, Kristin. "Diversity Committee Accomplishments." Report to IA National Convention. [n.d.]. Print.

———. Letter to Matthew D. Loeb, IATSE International President. 10 May 2011. Print.

———. Letter to Olophius E. Parry, Los Angeles District Director, EEOC (Equal Employment Opportunity Commission). 29 July 2010. Print.

Goldovskaya, Marina. *Woman with a Movie Camera: My Life as a Russian Filmmaker*. Transl. Antonina W. Bouis. Austin: U of Texas P, 2006. Print.

Goldstein, Patrick. "The Big Picture: Films Pass over People of Color." *New York Times* 26 Jan. 2011: D12. Print.

Gottlieb-Walker, Kim, ed. *Setiquette: A Guide to Working Effectively on the Set for Each Classification in the Cinematographers Guild*. 3rd ed. Hollywood, CA: IATSE Local 600, 2011. Web. 25 July 2012. http://www.lenswoman.com/union/setiquette.php.

Gregory, Mollie. *Women Who Run the Show: How a Brilliant and Creative New Generation of Women Stormed Hollywood*. New York: St. Martin's, 2002. Print.

Guerrilla Girls. *Bitches, Bimbos and Ballbreakers: The Guerrilla Girls' Illustrated Guide to Female Stereotypes*. New York: Penguin, 2003. Print.

Guy, Alice. *The Memoirs of Alice Guy Blaché.* Ed. Anthony Slide. Trans. Roberta and Simone Blaché. Metuchen, NJ: Scarecrow, 1986. Print.

Hammer, Barbara. *HAMMER! Making Movies Out of Sex and Life.* New York: Feminist Press at CUNY, 2010. Print.

Haskell, Molly. *From Reverence to Rape: The Treatment of Women in the Movies.* Harmondsworth, England: Penguin, 1974. Print.

Higham, Charles. *Hollywood Cameramen.* Bloomington, IN: Indiana UP, 1970. Print.

Hill, Amelia. "How Hollywood Made Its Heroines Weight-Obsessed and Man Mad." *Observer* 8 Feb. 2009. Web. 6 Jan. 2013. http://www.guardian.co.uk/film/2009/feb/08/hollywood-cinema-female-leads.

"History." *Third World Newsreel.* TWN, n.d. Web. 27 Mar. 2014. https://www.twn.org/twnpages/about/history.aspx.

"History of Bollywood." *BollywoodTourism.* Bollywoodtourism.com, n.d. Web. 3 Nov. 2012. www.bollywoodtourism.com/bollywood-history.

"The History of Chinese Films." *ForeignerCN.com.* ForeignerCN.com, n.d. Web. 6 Mar. 2011. www.foreignercn.com/index.php?option=com_content&view=article&id=207:the-history-of-chinese-film&catid=64:china-movies&Itemid=131.

"History of Local 600." *Film 480.* U of North Carolina School of the Arts, n.d. Web. 11 Dec. 2011. http://faculty.uncsa.edu/film/480_Prof_Career/union info/history_of_local_600.pdf.

Hunt, Darnell. "Rewriting an All-Too-Familiar Story." *Writers Guild of America, West.* Writers Guild of America, West, May 2009. Web. 30 Dec. 2012. http://wga.org/uploadedFiles/who_we_are/HWR09.pdf.

———. "TV Staffing Brief." *Writers Guild of America, West.* Writers Guild of America, West, n.d. Web. 21 Mar. 2014. http://www.wga.org/uploadedFiles/who_we_are/tvstaffingbrief2013. Pdf.

Jensen, Elizabeth. "The Force behind HBO's Documentaries." *New York Times* 11 June 2010. Web. 9 Jan. 2013. http://www.nytimes.com/2010/06/13/arts/television/13nevins.html?pagewanted=all&_r=1&.

Johnson, Scott. "A Train, a Narrow Trestle and 60 Seconds to Escape: How *Midnight Rider* Victim Sarah Jones Lost Her Life." *The Hollywood Reporter* 4 Mar. 2014. Web. 16 Mar. 2014. http://www.hollywoodreporter.com/news/midnight-rider-accident-sarah-jones-death-gregg-allman-685976.

Johnston, Denah A. "Re: Further Revised Chapter on Experimental/Avant-Garde Camerawomen." Message to Alexis Krasilovsky. 14 Oct. 2012. Email.

Juhasz, Alexandra, ed. *Women of Vision: Histories in Feminist Film and Video.* Minneapolis: U of Minnesota P, 2001. Print.

Keating, Patrick, ed. *Cinematography.* New Brunswick, NJ: Rutgers UP, 2014. Print.

Kerland, Anne, ed. "Ruan Lingyu (1910-1935)." *VCEA Project.* TGE-Adonis, 26 Feb. 2013. Web. 14 Dec. 2014. http://www.vcea.net/Ruan_Lingyu/Visual/Movies_en.php.

Koetse, Manya. "Gendered Nationalism and May Fourth: China's 'New Woman.'" Manyapan. wordpress.com, 9 Feb. 2011. Web. 31 Oct. 2011. http://manyapan.wordpress.com/2011/02/09/gendered-nationalism-and-may-fourth-chinas-new-woman/.

Krasilovsky, Alexis. "First Step." *Behind the Lens Newsletter* 2.2 (Jan. 1985): 4. Print.

———. "Interview: Attorney Gloria Allred." *Behind the Lens Annual Newsmagazine* Jan. 1988: 1. Print.

———. "Ne Plus Ultra?—Camerawomen Check It Out." *Behind the Lens Newsletter* 2.2 Jan. 1985): 1. Print.

———. writer/dir. *Shooting Women*. Rafael Film, 2008. Film.

———. *Some Women Writers Kill Themselves: Selected Videopoems and Poems*. Rafael Film, 2007. DVD.

———. "Women behind the Camera: A Love-of-Vocation about Camerawomen." *Moving Pictures: The Stories behind the Movies* Mar. 2008. Web. 25 Mar. 2008. http://www.movingpicturesmagazines.com.

———. *Women behind the Camera: Conversations with Camerawomen*. Westport, CT: Praeger, 1997. Print.

———. writer/dir. *Women behind the Camera*. Rafael Film, 2007. Film.

Lang, Brent. "Women Prevailing despite Sexism in Slowly-Changing Below-the-Line Industry." *Variety* 29 July 2014. Web. 31 July 2014. http://variety.com/2014/artisans/news/women-prevailing-despite-sexism-in-slowly-changing-below-the-line-industry-1201270573/.

Larsen, Elizabeth. "Our Bodies/Our Camcorders: Video and Reproductive Rights." *Independent* 15.2 (1992): 26-29. Print.

Lauzen, Martha. "The Celluloid Ceiling: Behind-the-Scenes Employment of Women on the Top 250 Films of 2009." *Center for the Study of Women in Television and Film, San Diego State University*. Womenintvfilm.sdsu.edu, 2010. Web. 28 July 2012. http://womenintvfilm.sdsu.edu/files/2009_Celluloid_Ceiling.pdf.

———. "The Celluloid Ceiling: Behind-the-Scenes Employment of Women on the Top 250 Films of 2010." *Center for the Study of Women in Television and Film, San Diego State University*. Womenintvfilm.sdsu.edu, 2011. Web. 28 July 2012. http://womenintvfilm.sdsu.edu/files/2010_Celluloid_Ceiling.pdf.

———. "The Celluloid Ceiling: Behind-the-Scenes Employment of Women on the Top 250 Films of 2011." *Center for the Study of Women in Television and Film, San Diego State University*. Womenintvfilm.sdsu.edu, 2012. Web. 28 July 2012. http://womenintvfilm.sdsu.edu/files/2011_Celluloid_Ceiling_Exec_Summ.pdf.

———. "The Celluloid Ceiling: Behind-the-Scenes Employment of Women on the Top 250 Films of 2014." *Center for the Study of Women in Television and Film, San Diego State University*. Womenintvfilm.sdsu.edu, 2015. Web. 20 Jan. 2015. http://womenintvfilm.sdsu.edu/files/2014_Celluloid_Ceiling_Report.pdf.

———. "Hiring Mandates and Tax Incentives Would Help." *New York Times* 14 Aug. 2012. Web. 16 Aug. 2012. http://www.nytimes.com/roomfordebate/2012/08/14/how-can-women-gain-influence-in-hollywood/hiring-mandates-and-tax-incentives-would-help.

———. "Independent Women: Behind-the-Scenes Employment on Festival Films in 2013-14." *Center for the Study of Women in Television and Film, San Diego State University*. Womenintvfilm. sdsu.edu, 2014. Web. 29 Aug. 2014. http://womenintvfilm.sdsu.edu/files/2014_Independent_Women_Report.pdf.

———. "Independent Women: Behind-the-Scenes Representation on Festival Films (2012)." *Center for the Study of Women in Television and Film, San Diego State University*. Womenintvfilm.

sdsu.edu, 2012. Web. 30 Aug. 2012. http://womenintvfilm.sdsu.edu/files/2012_Independent_ Women_Exec_Summ.pdf.

Lei, Zhen Lin, ed. *Looking Up and Beyond: Three Generations of Chinese Camerawomen*. Beijing: Hualing, 2006. Print.

Levy, Ann Deborah. "Experimental Women Cinematographers." Message to Alexis Krasilovsky. 6 Sept. 2012. Email.

"List of Diversity Sensitivity Trainings Taken and/or explored by International Cinematographers Guild." Los Angeles, CA: ICG Local 600 Diversity Committee, 2004-2007. Print.

Lucas, Christopher. "The Modern Entertainment Marketplace, 2000-Present." *Cinematography*. Ed. Patrick Keating. New Brunswick, NJ: Rutgers UP, 2014. 132-57. Print.

Lumme, Helena. *Great Women of Film*. New York: Billboard, 2002. Print.

Madsen, Roy Paul, with Vilmos Zsigmond. "The Cinematographer." *Working Cinema: Learning from the Masters*. Belmont, CA: Wadsworth, 1990. 211-59. Print.

Malkiewicz, Kris, and M. David Mullen. *Cinematography*. 3rd ed. New York: Simon and Schuster, 2005. Print.

"Mania Akbari." *Wikipedia*. Wikipedia, n.d. Web. 15 Mar. 2014. http://en.wikipedia.org/wiki/ Mania_Akbari.

Maple, Jessie. *How to Become a Union Camerawoman: Film-Videotape*. New York: L. J. Film Productions, 1977. Print.

McKay, Susan, and Dyan Mazurana. *Raising Women's Voices for Peacebuilding: Vision, Impact, and Limitations of Media Technologies*. London: International Alert, 2001. Print.

McKernan, Luke. "Jessica Borthwick Homepage." *WSBC*. Womenandsilentbritishcinema.com, n.d. Web. 19 Aug. 2012. http://womenandsilentbritishcinema.wordpress.com/the-women/ jessica-borthwick/.

McLellan, Dennis. "Brianne Murphy, 70; Pioneering Woman behind the Camera." *Los Angeles Times* 27 Aug. 2003. Web. 27 Mar. 2014. http://articles.latimes.com/2003/aug/27/local/me-murphy27.

Mellen, Joan. *Women and Their Sexuality in the New Film*. New York: Dell, 1973. Print.

Millward, Rachel. "Are Documentaries a Woman's World?" *Guardian* 20 Mar. 2008. Web. 5 Nov. 2011. www.guardian.co.uk/film/filmblog/2008/mar/20/aredocumentariesawomanswor.

Minaguchi, Kiseko. "Interviewing D.P. Akiko Ashizawa: A Woman behind a Camera." *Bulletin of Teikyo University Junior College* 26 (Jan. 2006): 185-94. Print.

Miss Representation. Dir. Jennifer Siebel Newsom. GirlsClub Entertainment, 2011. Film.

Moffat, Sarah, moderator, and Zoe Dirse, Kim Derko, and Joan Hutton, participants. "Women behind the Lens." Women in Film and Television panel. Toronto. Nov. 2009. Transcript.

"Moth Drawn to Hottest Flames 'Got Everything Out of Life.'" *Dominion Post* [Wellington, New Zealand] 23 Mar. 2010: A1. Print.

"Mrs Aubrey Le Blond (Mrs Main) Homepage." *WSBC*. Womenandsilentbritishcinema.com, n.d. Web. 19 Aug. 2012. http://womenandsilentbritishcinema.wordpress.com/the-women/ mrs-aubrey-le-blond-mrs-main/.

Mulvey, Laura. "Visual Pleasure and Narrative Cinema." *Screen* 16.3: 1975. 6-18. Print.

"Naomi Kawase." *IMDb*. IMDb.com, n.d. Web. 15 Dec. 2014. http://www.imdb.com/name/ nm0442905/?ref_=fn_al_nm_1.

"Naomi Kawase." *Wikipedia*. Wikipedia, n.d. Web. 14 Dec. 2013. Http://en.wikipedia.org/wiki/Naomi_Kawase.

"Nelson Tyler Inducted into MPPA." *Moviepilots.com*. Moviepilots.com, n.d. Web. 26 Aug. 2009. http://www.moviepilots.com/announcements/nelsontyler.htm.

Nichols, Bill, ed. *Maya Deren and the American Avant-Garde*. Berkeley: U of California P, 2001. Print.

O'Dell, Cary. "A Station of Their Own: The Story of the Women's Auxiliary Television Technical Staff (WATTS) in World War II Chicago." *Television Quarterly* 30.3 (2000): 58-67. Print.

Olds, Guy. "Report to the National Executive Board on the 2004 Member Survey [Local 600] by the Membership Services Committee." Report. June 2005.

Pahoyo, Rudy, comp. "Loaders." Gottlieb-Walker, Kim, ed. *Setiquette: A Guide to Working Effectively on the Set for Each Classification in the Cinematographers Guild*. 3rd ed. Hollywood, CA: IATSE Local 600, 2011. Web. 25 July 2012. http://www.lenswoman.com/union/setiquette.php.

Qishta, Fida. "Feedback from Womenbehindthecamera.com." Message to Alexis Krasilovsky. 12 Mar. 2010. Email.

Rabinovitz, Lauren. *Points of Resistance: Women, Power, and Politics in the New York Avant-garde Cinema, 1943-71*. 2nd ed. Champaign, IL: U of Illinois P, 2003. Print.

Rashkin, Elissa. *Women Filmmakers of Mexico: The Country of Which We Dream*. Austin: U of Texas P, 2001. Print.

Ravitch, Jessica. "Fearless to the End: Remembering Margaret Moth." *CNN.com*, 21 Mar. 2010. Web. 10 Aug. 2012. http://edition.cnn.com/2010/LIVING/03/21/margaret.moth.obit/index.html.

"Report Finds Director Diversity in Episodic Television Remains Static." Press release. *Directors Guild of America*. Dga.org, 2 Oct. 2013. Web. 21 Mar. 2014. http://www.dga.org/News/PressReleases/2013/100213-DGA-Report-Finds-Director-Diversity-in-Episodic-Television-Remains-Static.aspx.

Reynolds, Glenn. "Canadian Women behind the Camera, 1920–1960." Message to Alexis Krasilovsky. 18 Mar. 2013. Email.

Rogers, Pauline B. *The Art of Visual Effects: Interviews on the Tools of the Trade*. Boston: Focal Press, 1999. Print.

Rosen, Marjorie. *Popcorn Venus: Women, Movies and the American Dream*. New York: Avon, 1973. Print.

Rush, Michael. "No Longer an Orphan, Video Art Gives Itself a Party." *New York Times* Art & Architecture Section, 10 Feb. 2002: 35, 40. Print.

Safire, William. "The Way We Live Now." *New York Times* 27 Aug. 2000. Web. 13 Jan. 2012. http://www.nytimes.com/2000/08/27/magazine/the-way-we-live-now-8-27-00-on-language-lookism.html.

Schaefer, Dennis, and Larry Salvato. *Masters of Light: Conversations with Contemporary Cinematographers*. Berkeley: U of California P, 1984. Print.

Schroeder, Allison, and Elizabeth Martin. [Draft of letter by Co-Chairs, WGAW Women's Initiative, to Richard Stayton, Editor-in-chief, *Written By* (Writers Guild of America West).] 18 Feb. 2014. Print.

"Search Actively." "How to Doris." [Pamphlet.] Doris Film Board, 2009. Web. 29 Oct. 2012. http://dorisfilm.se/wp-content/uploads/2011/05/DORISbooklet_eng_low_res.pdf.

Seger, Linda. *When Women Call the Shots: The Developing Influence of Women in Television and Film*. New York: Henry Holt, 1996. Print.

Shepard, Deborah. *Reframing Women: A History of New Zealand Film*. Auckland: HarperCollins, 2000. Print.

"Short History of the Guild." *Film 480*. U of North Carolina School of the Arts, n.d. Web. 12 Nov. 2011. http:/faculty.uncsa.edu/film/480_Prof_Career/union%20info/history_of_local_600.pdf.

Siddiquee, Imran. "Grading Hollywood: The Representation Test." *The Representation Project*, 28 Feb. 2014. Web. 8 Mar. 2015. http://therepresentationproject.org/grading-hollywood-the-representation-test/.

Siegel, Andrea. *The Lives of Kong: Labor and Moviemaking in Three Acts*. Dissertation, CUNY. Ann Arbor: ProQuest/UMI, 2009. UMI Number: 3378972.

Silverstein, Melissa. "The Celluloid Ceiling Just Keeps Getting Higher and Higher." *Women & Hollywood*. Indiewire, 1 Feb. 2011. Web. 8 Jan. 2013. http://blogs.indiewire.com/womenandhollywood/the_celluloid_ceiling_just_keeps_getting_higher_and_higher.

———. "The Success of Women Documentary Filmmakers." *Alternet*. Alternet.org, 20 June 2008. Web. 5 Nov. 2011. http://www.alternet.org/story/88642/the_success_of_women_documentary_filmmakers.

———. "There Are Women Working as Cinematographers." *Women & Hollywood*. Womenandhollywood.com, 4 Mar. 2009. Web. 5 Nov. 2011. http://womenandhollywood.com/2009/03/04/there-are-women-working-as-cinematographers/.

———. "Women Directors – Speak Out Now about Sexism in the Industry. *Women & Hollywood*. Indiewire, 3 Nov. 2014. Web. 7 Nov. 2014. http://blogs.indiewire.com/womenandhollywood/women-directors-speak-out-now-about-sexism-in-the-industry-20141103?utm_source=whDaily_newsletter&utm_medium=sailthru_newsletter.

———. "The World Is Round, People and Other Thoughts from a Potentially Game Changing Oscars." *Women & Hollywood*. Indiewire, 3 Mar. 2014. Web. 17 Mar. 2014. http://blogs.indiewire.com/womenandhollywood/the-world-is-round-people-and-other-thoughts-from-a-potentially-game-changing-oscars.

Slide, Anthony. *Early Women Directors*. Cranbury: A.S. Barnes, 1977. Print.

Smith, Stacy L. "Gender Oppression in Cinematic Content? A Look at Females On-Screen and Behind-the-Camera in Top-Grossing 2007 Films." *Annenberg School for Communication and Journalism, U of Southern California*. Seejane.org, n.d. Web. 3 Sept. 2012. www.seejane.org/downloads/2007 Films_GenderReport.pdf.

Smith, Stacy L., and Marc Choueiti. "Gender Disparity on Screen and behind the Camera in Family Film." *Annenberg School for Communication and Journalism, U of Southern California*. Seejane.org, 2010. Web. 3 Sept. 2012. www.seejane.org/downloads/FullStudy_GenderDisparityFamilyFilms.pdf.

Spender, Dale. *Man Made Language*. 2nd ed. London: Routledge and Kegan Paul, 1985. Print.

"Stella Court Treatt Homepage." *WSBC*. Womenandsilentbritishcinema.com, n.d. Web. 19 Aug. 2012. http://womenandsilentbritishcinema.wordpress.com/the-women/stella-court-treatt/.

Sunga, George. "A Brief History of the PGA Diversity Committee." Message to Alexis Krasilovsky. 7 July 2011. Email.

Taubin, Amy. "Documenting Women: Female Directors Rule the Hot Nonfiction Film Market—Except on the Big Screen." *Ms.* Summer 2004. Web. 15 May 2012. www.msmagazine.com/summer2004/womenonfilm.asp.

"This Is the New Fall Style in Camera 'Men.'" *Photoplay* October 1916: 103. Print.

Thompson, Kristin. "Initial Standardization of the Basic Technology." *The Classical Hollywood Cinema: Film Style and Mode of Production to 1960.* David Bordwell, Janet Staiger, and Kristin Thompson. New York: Columbia UP, 1985 262–80.

Tierney, John. "Daring to Discuss Women in Science." *New York Times* 8 June 2010: D1. Web. 6 Aug. 2010. www.nytimes.com/2010/06/08/science/08tier.html?th&emc=th.

"Tyler Camera Systems." *Tylermount.com.* Tylermount.com, n.d. Web. 15 Feb. 2010. http://www.tylermount.com/frameshome.html.

Vanstone, Gail. *D Is for Daring: The Women behind the Films of Studio D.* Toronto: Sumach, 2007. Print.

Vernier, Richard. "WGA Report: Minority and Women Writers Make Few Strides in Hollywood." *Los Angeles Times* 19 May 2011. Web. 20 July 2011. http://articles.latimes.com/2011/May/19/news/sns-la-minority-women-writers.

Walsh, Andrea. *Women's Film and Female Experience, 1940-1950.* New York: Praeger, 1986. Print.

Where Should the Birds Fly. N.p., n.d. Web. 4 Aug. 2014. http://whereshouldthebirdsfly.org/index.html.

Williams, David E. "Another View: Alexis Krasilovsky's 'Women behind the Camera' Sheds Light on a Diverse Array of Female Directors of Photography." *DV Magazine* Jan. 2008: 26-27 and 54. Print.

Writers Guild of America, West. "Successful TV Pitching in Today's Marketplace" [calendar entry for 26 June 2012]. *Writers Guild of America, West.* Writers Guild of America, West, n.d. Web. 14 July 2012. http://www.wga.org/content/default.aspx?id=902.

Index

Organizations best known by their acronym are alphabetized that way. Bold numbers refer to illustrations.

New Delhi Center (*see* Jamia Millia Islamia
 University)
New School (New York, United States) 6
New Wave xxvi, 311
New York Film–Makers Co-Op 136, 138
New Zealand xii, xvi–xvii, xxi, xxii, 6, 25–26,
 41, 45, 49, 60, 74–75, 90, 129, 130,
 139, 191, 215, 253–54, 263, 269, 275,
 279, 283, 286, 301, 302, 304, 307–08,
 309, 322
news (*see also* journalism *and*
 videojournalism) xv, xvi–xvii, xxiii,
 3–4, 7, 41, 45, 47–48, 49, 53, 55, 65,
 71, 72, 74, 80, 81, 94–95, 97, 98, 99,
 100–01, 102, 104, 105, 107–09, 113,
 124, 150, 163, 184, 195, 198, 205,
 210, 211–12, 244, 246, 249, 251, 253,
 255–56, 258–59, 267, 275–76, 278,
 282, 291, 294, 300, 301, 302, 308, 310,
 311, 312, 313,
The Newsroom 233, 305
NFB (National Film Board of Canada) xxiii,
 6, 7, 21, 41, 51, 77, 103, 137, 226,
 231, 281
The Nightmare before Christmas 150, 299
NOW (National Organization for Women;
 United States) ix, xix, xxiii, 35,
 39, 264
NYU (New York University) xxiii, 5, 16, 21,
 279–80, 299, 305, 311

O
objectification 70, 135, 263–64, 266, 272
Olsson, Sophia 31
O'Malley, Val 4
Omori, Emiko xi, xiii, xviii, 12, 53, **75**–76, 80,
 90, 111, 139, 163, 244, 269–70, 308
operator (*see also* camera assistant) xiii, xiv,
 xviii, xxv–xxvi, 7, 8, 14, 16, 46, 47,
 48, 49, 65–67, 68–69, 71, 74, 75, 79,
 81–82, 83–84, 88–89, 102, 118, 121,
 124, 131, 136, 147, 148, 150, 154, 178,
 179, 184, 200, 201, 214–16, 223, 225,

227, 229, 233, 237, 238, 243, 247,
 271, 272, 279, 288, 297, 299,
 300–01, 303, 305, 306–07, 308, 309,
 311, 313, 317
Ophüls, Marcel 228, 276, 307
Ordway, Margery 3, **52**, 118
Osawa, Yoshiko 295, 297
Oscar (*see* Academy Award)
Ottinger, Ulrike 136
Owen, John 25, 64

P
Paben, Leelaben xx, 32–**33**, 34, 113, 308
Paik, Nam June 7, 135
painting 6, 11, 12, 13, 16, 127, 133, 135, 137,
 150, 155, 158, 164, 224, 241, 245, 259,
 303
PAL xvii, 159, 252
Panavision (the company) xxii, 8, 26, 28, 37,
 200, 280, 300
Parks, Deborah 128, 187, 194, 202, 234, 240,
 308–09
passion xii, xx, xxii, 24, 30, 111, 128, 136,
 139, 185, 242, 244, 271, 283, 284, 289,
 299, 308, 310
Patton, Jessie Maple xvi, 9, 10, 53–54, 64, 73,
 86, 128, 211, 244, 271, 285, 290, 309
Patton, LeRoy 9, 53–**54**, 64, 309
Pelloni, Karin 153, 304, 309, 312
Philippines 11, 74, 87, 107, 117, 151, 183,
 221–22, 233, 267, 286, 307
Pilikhina, Margarita 185–86
Pillsbury, Sarah 61, 86, 120, 229, 285, 314
Plunkett, Kylie 6, 25, 74–75, 215, 243, 269,
 276, 309
Poland xii, 19, 22, 170, 286, 302, 304
pornography (*see also* sexploitation films,
 exploitation, *and* objectification) 103,
 218, 311
postproduction 36, 124, 128, 139, 154, 192,
 269
Potter, Sally 135, 136, 217
Primes, Bob, ASC 28, 71